PhotoGraphic Encounters
The Edges and Edginess of Reading
Prose Pictures and Visual Fictions

W.F. GARRETT-PETTS and DONALD LAWRENCE

PhotoGraphic
Encounters

The Edges and Edginess

of Reading Prose Pictures

 The University of Alberta Press Kamloops Art Gallery

and Visual Fictions

Published by
The University of Alberta Press
Ring House 2
Edmonton, Alberta T6G 2E1
and
Kamloops Art Gallery
101, 465 Victoria Street
Kamloops, British Columbia V2C 2A9

ISBN 0–88864–362–4
Printed in Canada 5 4 3 2 1
Copyright © The University of Alberta Press 2000
Copyright for all artwork included in this book is retained by the individual rightsholders; all artwork
herein is reproduced by permission.

CANADIAN CATALOGUING IN PUBLICATION DATA

Garrett-Petts, W. F. (William Francis), 1954–
Photographic encounters

Copublished by: Kamloops Art Gallery.
Includes bibliographical references and index. ISBN 0–88864–362–4

1. Art and literature. 2. Visual literature—History and criticism. 3. Visual literacy. 4. Canadian
literature—History and criticism—Theory, etc. 5. Art, Canadian. I. Lawrence, Donald, 1963–
II. Kamloops Art Gallery. III. Title.
PN53.G37 2000 709'.04 C00–911169–7

Printed and bound in Canada by Quality Color Press, Edmonton, Alberta.
∞ Printed on acid-free paper.
Index prepared by Carol Berger.
Copyediting by Chris Wangler.
Cover design by Alan Brownoff. Front-cover image: "The Boat Photograph" by Ernie Kroeger. Back-
cover images: (top left) *Wounded Foot* by Fred Douglas; (top right) "Eiffel Tower and Golden Gate
Bridge, Mel Affleck" by Brenda Pelkey; (bottom) detail from *Sojourner* by Sharyn Yuen. All images
used by permission of the artists.

The University of Alberta Press gratefully acknowledges the support received for its program from the
Canada Council for the Arts. The Press also acknowledges the financial support of the Government of
Canada through the Book Publishing Industry Development Program for its publishing activities.

THE CANADA COUNCIL | LE CONSEIL DES ARTS
FOR THE ARTS | DU CANADA
SINCE 1957 | DEPUIS 1957

Canadä

For our parents present and absent,
Raymond and Margaret & in memory of Bill and Margaret

Contents

Acknowledgements

Since the book and the accompanying art exhibition draw upon the same resources, the help (direct and indirect) from the Kamloops Art Gallery has been crucial to the production of *PhotoGraphic Encounters*. In particular we want to thank Jann L.M. Bailey (Director of the Gallery) and Susan Edelstein (Curator) for providing funding, steady encouragement, and a wealth of expertise in managing so complex a project. Others at the Gallery to whom we are indebted include Beverly Clayton and Trish Keegan, for the general coordination of visual arts materials and correspondence; and Kim Clarke, for his superior photographic contributions.

Production of this book was further supported by a Social Sciences and Humanities Research Council of Canada Research Grant; a Canada Council for the Arts Dissemination Grant; a Publication Award from the President's Office, University College of the Cariboo; a Scholarly Activities Grant, also from the University College of the Cariboo; and a Summer Research Fellowship from the University of British Columbia.

The overall look of the inside of the book would not have been possible without the publication design and typesetting genius of Dennis Keusch. No doubt hypersensitive to the look and feel of books generally, we wanted *PhotoGraphic Encounters* to communicate through both word and image. We wanted the margin images, notes, and commentaries to establish a sometimes direct, sometimes oblique dialogue with the main text. Dennis Keusch's page design enabled such a dialogue and, in many respects, both illustrates and performs our critical intent.

This book would have been impossible without the generous cooperation of the artists and authors, many of whom gave us access to their notebooks, sketches, maquettes, and personal stories.

For their help in locating and securing copyright permission to reproduce individual images, particular thanks go to George Barandak and Anna Wilkinson, Special Collections, University of British Columbia; Richard Bolton, for permission to reproduce an

image of his article; Michael Carter and David Mattison, the British Columbia Provincial Archives; Anna Checchia, Oxford University Press Canada; Sarah Cooper, McClelland and Stewart; Felicia Cukier, the Art Gallery of Ontario; Evelyn Douglas, for sharing stories about her husband; Susan Cross and Elizabeth Duckworth, Kamloops Museum and Archives; France Duhamel, National Gallery of Canada; Holli Facey, Teresa Healy, Trevor Mills, and Melanie Stidolph, Vancouver Art Gallery; Linda Favrholdt for her photograph of Clapperton Album; Jacky Foraie for images of the Proffitt album; Rachel Grant, the Vancouver Maritime Museum; Norah Haque and Stanley Triggs, Notman Archives; Kiyo Kiyooka, for permission to reproduce images of Roy Kiyooka's work; Margaret H. Knox for permission to reproduce the work of Lawren Harris; Hamish Lawrence for access to the Chapter 2 postcards; Gary Lundell, University of Washington Library; Lorelie Sarauer, Kenderdine Gallery, University of Saskatchewan; Kay Shelton, State Historical Library, Juneau; and Tulin Valeri, assistant to Michael Ondaatje.

Our thanks to Leslie Vermeer, Managing Editor of the University of Alberta Press, for shepherding us through the publication process; to Chris Wangler, for his keen-eyed editorial assistance; to Alan Brownoff for his cover design and coordination of the book's final layout; to Bronwen Boulton and Nancy Garrett-Petts for copyediting assistance; to Shima Iuchi for her photographic assistance; and to our research assistant, Roxann De Gabeo (Boucher), who died too young and to whose memory we dedicated the exhibition.

In addition to the editorial guidance from the University of Alberta's staff, and that of the referees' reports, we wish to acknowledge the notes, suggestions, and critical feedback from friends and colleagues, especially, E.D. Blodgett, Richard Cavell, Graham Coulter-Smith, Frank Davey, L.F. Evenden, Gillian Gane, Helen Gilbert, Evelyn Hinz, Paul Hjartarson, James Hoffman, Henry Hubert, Michael Jarrett, Smaro Kamboureli, Eva-Marie Kröller, Rowland Lorimer, Margaret Mackey, Fabio Mugnaini, Shirley Neuman, Helga Pakasaar, Diane Penrod, Daphne Read, Jamie Reid, Alan Seager, Robert R. Wilson; and our colleagues at the Centre for Multiple Literacies Research, Alan Brandoli, Karen Day, Helen MacDonald-Carlson, David MacLennan, Dan O'Reilly. We want to give special thanks to Edward Pitcher for first alerting us to the frozen words motif, and Glen Huser for sharing some of the more obscure references.

As we note in Chapter 1, the idea for this book came out of our teaching, in particular out of our team-teaching experience with a

senior-level Photography and Literature course at the University College of the Cariboo. We want to thank those students—and those we have taught since—for their generous feedback and participation and patience as we worked out our ideas in dialogue with them.

Portions of individual chapters, now substantially revised for this book, first appeared variously as the introduction to *Integrating Visual and Verbal Literacies* (Garrett-Petts and Lawrence, 1996); "The Idea of Water: Frozen Words, Frozen Images," in *Acqua: Realtà e Metafora* (Garrett-Petts and Lawrence, 1998); "Developing Vernacular Literacies and Multidisciplinary Pedagogies," in *Miss Grundy Doesn't Teach Here Anymore: Popular Culture and the Composition Classroom* (Garrett-Petts, 1997); "The New Vernacular: Alternative Frontiers in Visual and Verbal Narration," in *Alternative Frontiers* (Garrett-Petts and Lawrence, 1997); "Garry Disher, Michael Ondaatje, and the Haptic Eye: Taking a Second Look at the Literate Mode of Critical Response," in *Children's Literature in Education* 31 (Garrett-Petts, 2000); "Thawing the Frozen Image/Word: Vernacular Postmodern Aesthetics," in *Mosaic* 31 (Garrett-Petts and Lawrence, 1998); "Novelist as Radical Pedagogue: George Bowering and Postmodern Reading Strategies," in *College English* 54 (Garrett-Petts, 1992); "Preface to a Rhetoric of Reading Contemporary Canadian Literature," in *Signature* (Garrett-Petts, 1990); and "Reading, Writing, and the Postmodern Condition: Interpreting Margaret Atwood's *The Handmaid's Tale*," in *Open Letter* 7 (Garrett-Petts, 1988). We note our appreciation to the editors and journals for permission to reproduce, revise, and refine those ideas here.

Finally, we thank our families, Nancy, Kate, and Samantha; and Darlene—who have suffered our obsession with things visual and verbal, and whose presence provides a constant reminder that, *contra* Derrida, there *is* something outside the text.

On Contending Literacies and Literacy Narratives 1

When we use the term "literacy" we usually mean the ability to read and write. The word is also often invoked as a battle cry against the forces of popular culture—especially photography, television and film—that are thought to deflect attention from the academic pursuits of a book culture. A recent article in *English Quarterly* rehearses a common anxiety about the loss of print literacy in an increasingly visual world:

> today's world is one where visual learning is becoming more and more dominant, and where television and movies engage our young people in increasing proportions of time. In this context, the novel is seen by some as an outdated vehicle for educating young minds. Yet the simple fact that novels are presented to students in a classroom setting can validate the learning, and set it apart from the experiences gained through exposure to electronic media. (Wall 25)

The author doesn't state explicitly that reading print is inherently more morally uplifting and educational than watching television—she doesn't have to. Indeed, the rhetoric surrounding "literacy," with its opening lament for the decline in standards and the loss of past values, has become so familiar that few readers would stop to question the underlying pedagogical assumption: that literacy is a relatively static set of skills retrievable by setting oneself "apart from experiences gained through exposure to electronic media." The message is clear: to validate print culture we must first deny (or at least suppress) the value of our visual experiences. As Matthew Arnold advised in "Culture and Anarchy," we should cultivate our best selves by rejecting the vain pursuits of the material world.

Martin Jay, Philippe Hamon, Richard Bolton, Jonathan Crary, and Ellen Esrock have traced the history of resistance to visual culture generally: from the forbidding of "graven images," to the

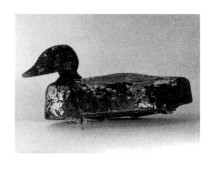

Turn-of-the-century hand-crafted duck decoy. Collection of Jann L. M. Bailey.

First Epistle of John with its "condemnation of the 'lust of the eyes'" (Jay 55), to the contemporary critique of vision in the work of Paul Ricoeur, Michel Foucault, Richard Rorty, Luce Irigaray, and many others. Visual images are said to offer only a superficial snapshot of reality—sight without insight. Even visualization during reading is counselled against as wrongheaded by such literary critics as William Empson and I.A. Richards. According to Richards, "'visualizers' are exposed to a special danger" (qtd. in Esrock, *The Reader's* 4), for too much attention to mental images distracts readers from the important and (by the 1930s) highly specialized work of interpreting the words on the page. That distrust of the visual becomes still more acute when the image moves from metaphor to metonymic element: when actual photographs or drawings are combined with the verbal narrative. Seeking to assert the primacy of word over image, these writers have helped create an intellectual climate deeply suspicious of the sense of sight.

Even many media studies programs, where one might expect a sympathetic treatment of visual culture, present visual literacy as a means of inoculating the unwary against the snares and baits of advertising, television, music videos, photography, and visual representation generally. Visual literacy is frequently cast as "something practised on us by others." Kay Ellen Rutledge, for example, calls the purveyors of visual culture a "professional" class of "advertising experts, politicians, government propagandists, and activists…[who] influence our behavior and alter our perceptions by creating illusions—illusions so skillfully crafted that we easily confuse them with reality." "These professionals," we are told, "sometimes distort reality" (204); "unless taught to recognize and analyze visual doublespeak," she says, "our students are in danger of becoming sitting ducks for professional persuaders, lured by attractive, convincing decoys" (205). Similarly, Roy Fox warns that immersion "in images" and exploration of "new symbolic spaces" can carry us "away from actuality and nature," which he describes as "our best model for any type of representation—indeed our best model for how we should live" (89). Such views are framed most tellingly by John Richardson's assertion that "to speak of 'visual literacy' would be to utter an oxymoron" (64).

Guardians of print-literacy have long valued imagination over image, what is recollected over what is seen. In one respect, the literary bias (or blindness) remains a matter of class consciousness. Those who confer legitimation (universities, museums, granting agencies, academics) have traditionally placed literature, painting, and classical music above photography, film, and jazz (as, in turn, these middle-ranked arts sit above the crafts and trades of oral

storytelling, advertising, and popular music). Pierre Bourdieu, whose *Photography: A Middle-brow Art* informs our own understanding of how cultural legitimacy is achieved and maintained, offers a concise rationale for singling out photography as the "in-between" art most likely to trouble the guardians of book culture: photography represents a "popular aesthetic" that is "defined and manifested (at least partially) in opposition to scholarly aesthetics"(84)—just as scholarly literacy has been defined by a withdrawal from popular discourse. Bourdieu argues that

> the position of photography within the hierarchy of legitimacies, half-way between 'vulgar' practices, apparently abandoned to the anarchy of tastes and noble cultural practices, subject to strict rules, explains . . . the ambiguity of the attitudes which it provokes, particularly among the members of the privileged classes. (97)

These "in-between" practices, principally forms of vernacular expression, interrupt the movement of mainstream culture; by intruding upon or resisting the mainstream, such practices offer a moment of held breath, a cultural pause, wherein we can reflect upon the normally invisible social, historical, and cultural forces that shape what we read and see. We should not be surprised that "postmodernist writers have adopted photography as a virtual analogue to their own art" (York, "Violent Stillness" 194).

Any integration of visual and verbal literacies, photographic or otherwise, presents a potentially disruptive challenge to the hegemony of word over image—and openly suspicious (even hostile) characterizations of the visual should be seen, at least in part, as an anxious reaction to that challenge. As Stephen Behrendt puts it, "the print-literacy establishment has revealed itself to be surprisingly entrenched in what is ultimately both a reactionary and fundamentally elitist attitude to a new sort of cultural literacy that is profoundly interdisciplinary in nature…" (45-6).

For many educators, however, the advent of Cultural Studies and Feminist Studies, together with the development of postmodern and postcolonial pedagogies, is prompting a revision of what should be taught. Notions of interdisciplinary and multidisciplinary learning have highlighted a pressing need to theorize and teach an integrated set of literacies. Not surprisingly, then, cultural critics outside the visual arts community are now beginning to recognize the value—and respond to the challenge—of integrating visual culture as a legitimate subject of academic study and practice. David Radcliffe, for example, suggests that visual works

This discussion puts aside, for the moment, the histories of photography which have been constructed since the mid twentieth century by such figures as Ralph Greenhill, Beaumont Newhall, and John Szarkowski. These histories, and the canons of photographic representation which they have endorsed, are of interest to several of our key subjects and have particular connections to the work of Robert Minden and Ernie Kroeger. However, we are interested here in exploring the manner in which photography is used on a daily basis, and not necessarily as something confined to the museum and gallery.

have too often been treated as the subordinate subject of "linguistic imperialism" (261); and, certainly, articulating a role for visual literacy within academe requires a radical rethinking of long-held presuppositions and prejudices. But, as Radcliffe asks rhetorically, "[r]ather than disputing priority, wouldn't it be more valuable to inquire into the various ways in which linguistic and non-linguistic modes…combine, intersect, and resist one another?" (261). By attending to those artists and authors who are working to unify "otherwise antagonistic epistemes" (Esrock, "A Proposal" 120), we can as teachers and researchers offer our students and others a unique critical vantage point on an important cultural contact zone.

⊞ ⊞ ⊞ ⊞ ⊞ ⊞ ⊞ ⊞ ⊞

Stanley Aronowitz, Henry Giroux, and others have already called for a new approach to education, one informed by the same border-crossing impulses that advocate the convergence of literature and so-called "sister disciplines." Giroux argues against a curriculum "locked within disciplinary boundaries and recycling old orthodoxies" (1); instead he champions an interdisciplinary, postmodern pedagogy based on "a new discourse that proposes radically new questions, analyses, and forms of ethical address" (3). This pedagogy advocates an integration of specialist knowledge and thus constitutes an appeal for educators to combine their disciplinary expertise and collaborate on research and teaching that speaks to issues of more than specialized significance. Aronowitz and Giroux argue for a "border pedagogy" as a "counter-text" (118), an approach to teaching that places the analysis of cultural codes, the excavation of contending literacies, and a radical interdisciplinary dialogue at the centre of the curriculum.

As exciting as such theoretical and pedagogical speculation may be, the implementation of a border pedagogy requires more than the drafting of academic articles or the writing of new lesson plans; we need, in addition, a clearer understanding of (1) what the "new discourse" entails, (2) how we should approach or otherwise involve ourselves in this new discourse, and (3) what may be gained by such involvement.

Our point of entrance into the question of integrating literacies began several years ago when we team-taught a senior-level Visual Arts course, "Photography and Literature: A Canadian Perspective." The course examined questions of cultural conflict sure to confound a specialist approach. These questions, the basis for our border pedagogy, quickly established terms of reference as we, along

with our students, made public the generally private or "understood" preconceptions that inform our respective disciplines. Garrett-Petts's "literary" reading of an artwork, or his sense of the work's aesthetic and social significance, often differed from Lawrence's "Visual Arts" response—and, not surprisingly, it was the public discussion of those differences that provoked the most interesting and lively inquiry in class. We became interested not only in *what* a work meant and *how* it meant, but also *why* it meant. This was particularly true of works which combined visual and verbal elements—hybrid art forms that, in a sense, seemed ready-made for a course like ours. Image/text art, we found, embodied, incorporated, dramatized, or contested the same constellation of issues that gave border pedagogy its sense of purpose and urgency.

Some of the works that initially took our interest came to be understood as rather simple explications, even illustrations, of these issues: too often we found, even with respect to some of the more celebrated works, that they seemed designed to be eminently decodable in terms of their meaning, ironies, embedded theories, etc. Instead we found ourselves drawn to image/text constructions that demanded new ways of reading and seeing, ones that rewarded us with new ways of relating to the narratives and called for *both* a spectator and a participant stance. The photographic again seemed an especially charged site for our inquiry. Always we came back to the question of how to "read" the work: were seeing and reading the same process? Did the written text, in the form of a juxtaposed narrative or caption, always guide or contextualize our reading? Was there a hierarchy of visual and verbal codes? How did photography's "in-between" status complicate this hierarchy? Did the process of reading image/text works affect the way we read more conventional artforms?

The first part of this book, worked out by Garrett-Petts first as a doctoral dissertation and then in a series of journal articles and conference papers, looks at the rhetoric of reading literacy narratives, an emerging literary and visual genre that, like Shaw's *Pygmalion*, "foregrounds issues of language acquisition and literacy." According to Janet Eldred and Peter Mortensen, the two critics who first coined the term "literacy narrative," the genre is structured by "learned, internalized 'literacy tropes,'…by 'prefigured' ideas and images…; they include texts that both challenge and affirm culturally scripted ideas about literacy" (513). These literacy narratives are both subtle and overt, successful and unsuccessful. Some seem hopelessly didactic or directorial, leaving the reader/viewer little to do but "get the point." As Robert Kroetsch

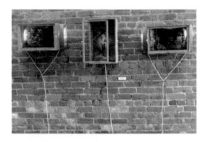

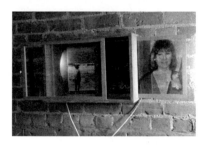

Student exhibition of photo-based works, showing a collaborative project by Bernice Machuk, Patricia Schneider and Debbie Simoneau; with a detail of Debora Simoneau's construction, Kamloops, B.C.

observes, "The minute there's a point, you've lost the art. Art may well be instructive as well as entertaining. But the instruction is not prescriptive. *It is perceptual.* And that takes us into the dread realms of language and imagination, or the possibilities of art" ("Contemporary Standards" 8; emphasis added). More particularly, it takes us into the realm of reading, of how we perceive. As an introduction to this topic, we focus initially on *reading* as trope and process in the work of Margaret Atwood and George Bowering, two authors whose writing does indeed challenge sanctioned modes of literacy formation and teaches new modes of verbal and visual response.

The argument for developing a rhetoric of reading, presented initially as a problem for literary studies, becomes still more urgent when we turn jointly to the question of reading "PhotoGraphic" narratives, especially those that inform or otherwise complicate our understanding of a new visual/verbal vernacular in Canadian literary and artistic practice. The vernacular literacies we explore tend to position themselves outside the dominant discourses of literary and high art cultures; they create a space where visual and verbal and oral modes converge, often confounding conventional response. Part of our interest in this area of convergence is how the issues we raise intersect new scholarship on postcolonial representation. We see our discussion of colonization, linguistic imperialism, vernacularism, marginalization, and so on, rehearsing the rhetoric of the "contact zone," Mary Louise Pratt's congenial metaphor for the social space "where disparate cultures meet, clash, and grapple with each other, often in highly asymmetrical relations of domination and subordination" (4).

Pratt introduces the concept with her own literacy narrative, a story about the initial suppression and eventual liberation of vernacular literacies long ignored. Her point of departure is a twelve-hundred-page letter written by an Amerindian, Andean author (Felipe Guaman Poma de Ayala) and dated in the year 1613. According to Pratt, there were "nearly eight hundred pages of written text and four hundred elaborate line drawings with explanatory captions" (2). What fascinates (and appalls) Pratt is how this extraordinary manuscript, ostensibly addressed to King Philip III of Spain but more likely a personal narrative of indigenous response to Spanish colonization, sat unexamined in a Copenhagen library for nearly three hundred years: "No one, it appeared, had ever bothered to read it, or even figured out how to read it." (2). Not until the late 1970s, says Pratt, did Eurocentric and "positivist reading habits" give way to interpretive studies sensitive to "postcolonial pluralisms"; only at this point could Guaman Poma's text be

Line drawing from Felipe Guaman Poma de Ayala's *Letter* (1613).

"read as the extraordinary intercultural *tour de force* that it was" (4). Pratt's account is as much a story of reading as it is a story of writing and drawing: the challenge for the arts of the contact zone, including photo/graphic literacy narratives, is "to be read, *and to be readable*" (4).

Although the entire book has benefited from many hours of collaboration (discussion, argument, revision, joint archival research, teaching, etc.) we have endeavoured to speak out of our personal and disciplinary orientations (and in both verbal and visual media)—to situate the rhetoric of reading visual and verbal narratives as a site of contesting literacies. Indeed, in composing this book we became even more committed to the notion of collaborative research. No single author, no matter how eclectic and learned, can speak authentically the language of more than one discipline. The inferences, nuances, and presuppositions that help define an academic community are learned and felt within that community, not picked up second hand from without. Individual attempts at interdisciplinary work are, to some degree, invariably eccentric exercises. Similarly, we are aware that interdisciplinary inquiries must be negotiated among multiple and largely discipline-specific audiences. Throughout the writing process we have endeavoured to keep our conjectural audiences in mind: we are aware that though interdisciplinary topics may have wide appeal, they must be discussed in terms accessible and relevant to disciplinary pursuits. Toward that end, in the opening sections of this book, we spend much of our time defining the relevance of reading, rhetoric, and visual literacy for an audience of literary critics and theorists. Gradually, we shift the focus to the visual medium, primarily photography, in an attempt to show how a rhetoric of reading can help us respond to visual narratives. Those readers who wish to hear less about reading theory and more about reader response to visual/verbal texts may wish to jump from Chapter 1 directly to sections on artists' books or on the individual works discussed. We can imagine those with strong visual arts backgrounds or interests beginning with the latter sections and working backwards. It is our hope, however, that the book's overall organization and argument will introduce all readers to new angles of inquiry—and that it will provoke other collaborative and interdisciplinary responses.

Our first goal is to establish a multidisciplinary frame for the discussion of reading and viewing: here we probe and juxtapose a number of ostensibly incongruous discourses, including the work of philosophers, cognitive psychologists, educators, as well as rhetoricians, critics, and artists. Within this frame we arrange our dialogue

and test it, as mentioned, against the work of Margaret Atwood and George Bowering, two writers whose narratives explore the thematic implications of combining and contesting oral, verbal, and visual modes of discourse. Later we turn to the work of writers and photographic artists such as William Notman, Hannah Maynard, Brenda Pelkey, Carol Condé and Karl Beveridge, Michael Ondaatje, Fred Douglas, Michael Snow, Robert Kroetsch, Ernie Kroeger, Roy Kiyooka, Iain Baxter and the N.E. THING Co., Sharyn Yuen, Daphne Marlatt and Robert Minden, and others who have begun to explore aspects of a new cultural literacy, one that combines visual and verbal codes.

Mixing the visual and verbal, of course, is not new; it is featured in works and periods as diverse as illuminated manuscripts, medieval and early Renaissance paintings, seventeenth-century Emblem books, shaped verse from George Herbert to bill bissett, and mixed media works from Blake to Cubist collage and the recent visual narratives that have emerged out of conceptual art. Still, "[a]lthough the breaching of artistic boundaries is not confined to any historical period," as Jessica Prinz points out, "it *has* surfaced with tremendous force and great variety in our own time" (7). And like Norman Bryson, we see image/text works as historical reference points, indices of aesthetic and disciplinary change: "in some periods there is overlap, in other periods there is opposition, between verbal and non-verbal elements in representation" ("The Politics" 97). In our present period, the renewed emphasis on visual modes of communication and artistic representation is challenging traditional notions of literacy, forcing us instead to confront the notion of "literacies."

⊕ ⊕ ⊕ ⊕ ⊕ ⊕ ⊕ ⊕ ⊕

Cultural critics, literacy theorists, authors and artists, should have something to say about the theory and practice of "interdisciplinary" composition—and to their credit, many have begun to explore the thematic and formal implications of border-crossing literacies, defined variously as "imagetexts" (Mitchell), "interrogative texts" (Belsey), "historiographic metafictions" (Hutcheon), "ekphrastic objects" (Kreiger), "borderblur art" (Sinclair), "contact zone narratives" (Pratt), "border writing" and "multidimensional texts" (Hicks).[1] To varying degrees, each of these forms stresses what Eva-Marie Kröller and, more recently, Jessica Prinz and Manina Jones have identified as the collage and "documentary-collage" impulses in recent fiction and poetry. Generally speaking, the notion of collage has been imported into literary studies as an

1　　According to Belsey, texts do three things: they declare themselves, they argue, and they question. The imperative mode ("the sermon, party political broadcast or [in some cases] documentary film") seeks to align the reader, viewer, or listener by encouraging identification with a unified discourse; the imperative mode convinces the reader, viewer, or listener that it is safe to seek (and find) coherence. The interrogative mode puts coherence into question, discourages identification with any unified discourse, draws attention to its own textuality, and thus distances the reader, "at least from time to time, rather than wholly interpolat[ing him or her] into a fictional world" (91-92). Belsey notes that "it is possible to locate elements of one modality in a text characterized predominantly by another," and that, we feel, is precisely the way literacy narratives work. These literacy narratives, at least the ones that interest us here, represent a cross between the imperative and the interrogative. Where we differ from Belsey is in our sense of how the rhetorical situation of reading is constructed. Belsey—like most other theorists—places the weight of responsibility on the text; yet, as Pratt's narrative of Guaman Poma's "interrogative text" makes clear, the formal features do not determine absolutely reader/viewer response. Such texts need a ready audience.

equivalent term for "intertextuality": as a form of allusion, citation, or echoing. Interest among members of the Canadian literary community has tended to focus on collage as a formal strategy rather than as part of a larger rhetorical enterprise. Kröller writes of collage as a means of unsettling the prosaic: it deconstructs "hegemonies, definitions, and unities" (*Bright Circles* 11). Similarly, Jones sees collage as affiliated with "a group of writings Mikhail Bakhtin refers to as the 'seriocomical genres,' which bring a muliplicity of disparate styles and voices into a single contextual space" (14). In their most overt manifestation literary collages make extensive use of "'inserted genres,' such as letters, found manuscripts, parodies of high genres, and parodically reinterpreted citations. . ." (Jones 14). This dual process of insertion and ironic citation emphasizes the reader/viewer's sense of mediation and materiality.

Artists such as Fred Douglas and Ernie Kroeger, and theorists such as Rosalind Krauss and Donald Kuspit, who have come to these interests by way of the visual arts, display in their works and writings an understanding of collage more closely aligned with issues of production and process. Kuspit, for example, sees collage as providing an opportunity for a reinvestment of personal involvement in the creative process: collage provides an antidote to art-making practices that set aesthetic experience apart from the dailiness of being. For Kuspit, and we suspect for many of the authors and artists discussed here, the aestheticization of lived experience (in both art-making and art criticism) is losing its appeal. Art and literature, even postmodern art and literature, must do more than parade ironies, paradoxes, or parodies:

> The collage is a relative state of artistic affairs, where relativity indicates the restlessness of individuality in the process of becoming. As such, the collage becomes emblematic of the task of art at least since Baudelaire: the redemption of individuality in mass society, with its standardizations or categorizations—its banalization or deindividualizing of belief. Collage makes poetry with the prosaic fragments of dailiness. The poetry is a matter not just of recognizing the legitimacy of choosing one's own context of life from the universal dailiness and thereby in some sense escaping it, but of not getting locked into or trapped by this context....The essential playfulness of the collage is a direct acknowledgment of the relativity of individuality in the world, as well as a way of expanding that world to include it, and of expanding individuality to include the world. One can view this ironically, but to do so implies a serious

dedication to irony as the only way of individualizing in a world of standard categories. (48)

In theory, of course, all texts can be regarded as intertexts, as intersections of multiple genres, borders, influences, ideologies, and social agendas; and critics have generally regarded so-called collage texts as differing more in degree than in kind. The collage text as literacy narrative—one that foregrounds "the relativity of individuality" as a condition of reciprocal interaction among multiple discourses—puts the greatest demands on reader and viewer response. As noted already, these demands may look more like challenges, especially to those who see themselves as defenders of print literacy—but an exclusive, academic definition of "literacy" has increasingly less in common with lived experience, and it is hard-pressed to accommodate the intertextual modes of reading that literacy narratives teach. As Richard Johnson notes,

> The isolation of a text for academic scrutiny is a very specific form of reading. More commonly texts are encountered promiscuously; they pour in on us from all directions in diverse, coexisting media, and differently-paced flows. In everyday life, textual materials are complex, multiple, overlapping, coexistent, juxtaposed, in a word, "inter-textual." (67)

Of late, rather large claims have been made about revolutionary changes in the production and reception of both literature and visual art. W.J.T. Mitchell maintains that our conception of textuality is moving from the linguistic to the pictorial, that our "need to defend 'our speech' against 'the visual' is…a sure sign that a pictorial turn is taking place" (*Picture Theory* 13). According to Mitchell, "recent developments…make the notion of a purely verbal literacy increasingly problematic" (6). Marshall McLuhan set out many of the terms of reference for a discussion of communication revolutions more than three decades ago, and, despite the difficulty that early readers noted in their response to McLuhan's "mosaic" method of composition, his contention that new systems of communication are retribalizing us within orality offers a salutary reminder that revolutions often recontextualize and thus recycle the old in the name of the new. For those of us interested in blurring formal and disciplinary boundaries, recent urgent appeals "that we can no longer separate visual literacy from verbal literacy, that we must treat word and image equally and simultaneously" (Fox, from the dust jacket copy) strike an attractively democratic

"Whatever the pictorial turn is,…it should be clear that it is not a return to naïve mimesis, copy or correspondence theories of representation, or a renewed metaphysics of pictorial 'presence': it is rather a postlinguistic, postsemiotic rediscovery of the picture as a complex interplay between visuality, apparatus, institutions, discourse, bodies, and figurality. It is the realization that spectatorship (the look, the gaze, the glance, the practices of observation, surveillance, and visual pleasure) may be as deep a problem as various forms of reading (decipherment, decoding, interpretation, etc.) and that visual experience or 'visual literacy' might not be fully explicable on the model of textuality." *W.J.T. Mitchell—Picture Theory.*

chord; but such appeals also tend to ignore the social and disciplinary contexts that have long separated verbal, visual, and oral modes of communication. It would be a mistake to conflate word and image as equal and simultaneous, for to do so only glosses over important social and disciplinary differences of purpose and form. Instead, we need to come to terms with Mitchell's recognition that teaching a purely verbal literacy has become "increasingly problematic."

What we believe the new emphasis on the visual does signify is a willingness (among some contemporary critics, authors, and artists) to acknowledge and accommodate competing modes of representation; what the new interest in how these modes compete reflects is a conviction that by better understanding the give and take among discourses we can better understand the rhetorical processes that underlie all human communication practices.

Emily Hicks, in *Border Writing: The Multidimensional Text*, argues that "to read a border text is to cross over into another set of referential codes" and, in terms of response, border texts require us "to look in two directions simultaneously" (xxvi-xxix). It requires both seeing and reading—or, eventually, an understanding of reading *as seeing*. Significantly, Hicks turns to photography, to holography, as a "multdimensional model for visualizing" how competing referential codes might be read:

> A holographic image is created when light from a laser beam is split into two beams and reflected off an object. The interaction between the two resulting patterns of light is called an "interference pattern," which can be recorded on a holographic plate. The holographic plate can be reilluminated by a laser positioned at the same angle as one of the two beams, the object beam. This will produce a holographic image of the original object. A border person [or a reader of border art] records the interference patterns produced by two (rather than one) referential codes, and therefore experiences a double vision thanks to perceiving reality through two different interference patterns. (xxix)

Later in the same work Hicks extends her metaphor, claiming that "[o]nly readers who are able to negate their assumptions about...these codes until they can hold both strands of the double code simultaneously will be able to 'see' the text in its full dimensionality. This can be imagined by remembering the experience of wearing 3-D glasses. The image is printed twice, in two colors of ink. The glasses make it possible to see both at once, to perceive

depth" (68-69). Among theorists such as Hicks, the process of reader or viewer response has thus become a central subject of both creative and critical inquiry—and this book advocates that the politics, pedagogy, and practice of intertextuality, in turn, must become a topic of central concern for those of us teaching and studying literacies.

Locating "literacy" at the intersection of visual and verbal systems yields significant insight, helping foster the kind of "double vision" that Hicks describes. It leads to a comprehensive and sophisticated appreciation of textuality and intertextuality in all media. In particular, it helps us refine our critical appreciation for, and interpretations of, works that combine forms of visual and verbal discourse, allowing us to avoid the kind of blindspots that in the past have provoked injunctions against visualization in reading— or have treated the visual elements of a text as mere illustrations of marginal critical relevance.

Anthologies and new editions that reprint the writing but leave out the original accompanying visual images suggest a revealing attitude—the same kind of attitude that allows Dennis Cooley to reflect "ironically," in footnote 12 of his article on Micheal Ondaatje's *The Collected Works of Billy the Kid*, "my argument about photography doesn't take account of the actual photographs [in the book]" ("I am" 237). We need to recognize, with Douglas Barbour, that a work like Marlatt's *Steveston* "is a collaboration [between a poet and a photographer], and that reading the poem apart from [Robert] Minden's series of photographs makes for an incomplete reading of the work" (225). We also need to understand (and question) the critical presuppositions that in the same article allow Barbour to present just such an "incomplete reading," ignoring Minden's photographs with the confident declaration, "Nevertheless, it is Marlatt's writing which interests us here" (226). As Stephen Melville notes, there is "something funny" about this kind of critical "chiasmus"—"something funny that seems to go on with some regularity between criticism, literature and [visual art], and something the diagnosis of which might powerfully inform our thinking about the extension of literary theory into the visual domain" (78).

Reading image and text together, like viewing a collage, requires a reorientation to textual space: it challenges us to think about reading in spatial terms. In his "Notes on Post-Realistic Fiction," George Bowering reaches a similar conclusion; significantly, he reaches this conclusion via an intriguing if undeveloped comparison between the plastic arts and the book:

2 Murray Kreiger complains that "[t]he borrowing by literary critics of descriptions of response conventionally assumed to be appropriate to the plastic arts is so common that we often fail to observe it and to be concerned about its inappropriateness." For Kreiger, "such borrowing is a crossing over of...language" (31); but we would argue that such border crossing is an inevitable consequence of border writing, literacy narratives, and a developing rhetoric of perceptual response.

Architecture asks you to walk through it & notice the changes in configuration as you do. Sculpture generally invites a walk around it. Even paintings are so hung that you move your body toward them. These are spatial in structure. Whether we are talking about the turning page, opened on the lap, or the movement of the reader's eye at his [or her] chosen moments, the book is primarily spatial in structure. ("The Painted Window" 119)

Aspects of Bowering's rather literal take on the space of reading show up regularly in the rhetoric of recent literary theory, especially in the use of spatial metaphors: "site of struggle," notions of "discursive space," "cultural text," and of reading as "located in the space of politics and ideology."[2] The visual arts community too is beginning to reconsider notions of textual space. In a provocative statement on art history, Shelley Errington maintains that

> Most art historians tend to look within the frame for meaning (hence their preoccupation with iconicity, which takes one a long way for several centuries of Western Art). A few—very few...look behind the frame, so to speak, elucidating the kinds of optical habits, metaphysical theories, and daily practices that were poured into the object. And a few more, but still very few, look in front of the frame, to see the performative context, the practices and categories of the people who handle it, within which the object, art or otherwise, is constituted as the kind of object it is. David Summers calls this the 'subjunctive space'—not really in front of the object but surrounding it, constituting it. (272)

Both Bowering and Errington call for an inclusive mode of response, one that looks within, behind, and in front of the text. We can hear echoed in this call the competing voices of New Historicism, feminist criticism, deconstruction, rhetorical criticism, and the iconoclastic gestures that have resulted from the meeting of social constructivist theory and postmodern critique.

According to some, old ways of reading have irrevocably changed. Donald Morton argues that, within literary studies, the "situation" of reading has shifted from a seemingly objective view of the text as verbal icon, to the psychological, reader-response space of the immediate reading experience, to the social space of reading as socially constructed and inhabited by multiple (and often competing) voices. "There is less talk today," says Morton, "about the relations between 'story and discourse' and more talk

about the relations between 'story and situation.'" "[T]he turn to situation," he adds, "means giving increasing attention to the 'ideological' and 'political' dimensions of narrative"(408).

But, like Pratt's literacy narrative of suppression and liberation, Morton's account both narrates *and* advocates: English Studies has hardly embraced the social constructivist thesis, and shifts in the situation of reading occur in a much less linear order than either Pratt or Morton allows. Talk about the "turn to situation," or about "the pictorial turn," reflects a rhetorical strategy: an attempt to define and promote an appropriate rhetorical situation for reading contemporary modes of discourse. The notion of "turning" away from positivist or realist aesthetics, or from a linguistic to a pictorial orientation, tends to obscure the ubiquitous presence and power of earlier critical perspectives. Clearly, someone who views reading as a matter of distinguishing decoys from "true ducks" will be frustrated by a visual/verbal discourse that invokes "multistable" images (images such as Hicks's hologram, Holbein's *The Ambassadors*, Ondaatje's Billy the Kid, or Wittgenstein's famous "Duck-Rabbit") as its models. Reading, we maintain, and the ways we conceptualize reading, are recursive processes—a matter of turning and returning. Whether represented in Bakhtinian terms as dialogic, or in visual terms as photographic or "multistable" images, reading is best conceived as a dialectical process. Like intertextual compositions, and like developing notions of individuality, reading is becoming aptly defined as an act "constituted in the argument or dialogue" among competing literacies (Mitchell 45). The phrase "argument or dialogue" perhaps equivocates unnecessarily, for as we shall urge in detail, like literacy narratives, all interpretive readings advocate and thus argue for a particular world view. Reading is a rhetorical process: readers do not and cannot separate meaning from rhetorical context. Reading is epistemic (Brent): readings are always conditioned by world view, by the way readers know the world.

"Struggle," "dialogue," "dialectic," "conversation"—these are the current metaphors that help articulate our sense of how readers *know*. Both readers and readings alike are seen by many as constructed amidst the give and take of multiple social forces (politics, gender, class, race, etc.); thus, if we are going to understand how we read, we need to understand the context of reading: we need to look within, behind, and in front of the frame—and at the conditions that make the frame visible. The principal challenge in an age of multiple and competing literacies is the need for a clear understanding of how oppositional representations affect or indeed define the reading process. It is one thing to claim that reading is

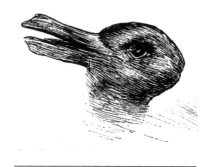

Wittgenstein's Duck-Rabbit.
Reproduced from *Fliegende Blätter* (1892).

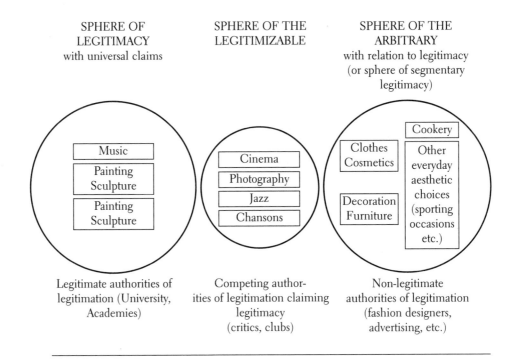

SPHERE OF
LEGITIMACY
with universal claims

SPHERE OF THE
LEGITIMIZABLE

SPHERE OF THE
ARBITRARY
with relation to legitimacy
(or sphere of segmentary
legitimacy)

Music

Painting
Sculpture

Painting
Sculpture

Cinema

Photography

Jazz

Chansons

Cookery

Clothes
Cosmetics

Other
everyday
aesthetic
choices
(sporting
occasions
etc.)

Decoration
Furniture

Legitimate authorities of
legitimation (University,
Academies)

Competing author-
ities of legitimation claiming
legitimacy
(critics, clubs)

Non-legitimate
authorities of legitimation
(fashion designers,
advertising, etc.)

Diagram from *Photography: A Middle-brow Art*, p. 96.

a site of struggle; it is more difficult but more crucial that we develop a theory of how that struggle works to produce meaning. Significantly, although Morton does not consider the integration of visual and verbal literacies specifically, he nonetheless finds that "the most socially productive reading/writing involves the act of inserting oppositional representations into the texts of culture as a mode of political practice"(410). Works that combine image and text provide graphic, highly accessible, examples of "oppositional representation."

But not all modes of representation are created equal; the clash of cultures articulated by Pratt's notion of the contact zone plays itself out "locally" each time we respond to works of vernacular composition. As Bourdieu has taught us, "the various systems of expression [theatrical presentations, sporting events, recitals of songs, poetry or chamber music, operettas or operas, etc.] are objectively organized according to a hierarchy independent of individual opinions, which defines *cultural legitimacy* and its gradations" (95; emphasis in the original). Bourdieu's diagram (above) offers a concise visual representation of his thesis.

In terms of our present discussion, some modes of expression appear more "legitimate," and thus more *literate*, than others.

Highly literate modes, as opposed to popular, less literate modes of expression, evoke a specialized, learned response:

> Faced with meanings situated outside the sphere of legitimate culture, consumers feel they have the right to remain pure consumers and judge freely; on the other hand, within the field of consecrated [high] culture, they feel measured according to the objective norms, and forced to adopt a dedicated, ceremonial and ritualized attitude. Thus jazz, cinema and photography do not give rise—because they do not claim it with the same urgency—to the attitude of dedication, which is common coin when dealing with works of scholarly culture. (95-96)

When these same modes are integrated, a kind of class warfare is initiated—one that provokes the ambiguous (or hostile) responses we see featured in the various defenses of print-literacy.

Academic treatment of the "spheres of legitimacy," as Bourdieu calls them, is commonly framed in terms of the spectator-participant model first introduced by D.W. Harding and developed most tellingly by James Britton. Legitimate cultural modes (especially works of literary or high art merit) are said to call for a spectator stance; other modes of discourse—those that transact, inform, or persuade—call for a participant stance. Of the two stances, Britton advocates the role of spectator, where experience can be viewed and shaped from a detached, evaluative perspective. In essence, Britton seeks to "legitimize" a hierarchy of expression, for, as he states, "[t]here is an important implication here: when we move into the spectator role, our utterance itself moves into the focus of attention, becoming an end rather than a means to something outside itself. As such an utterance moves up the scales from expressive to poetic, there is an increasing stress upon the forms of language itself and upon the formal disposition of whatever the language portrays…(19). Britton balances the scales in favour of poetic discourse, but, interestingly enough, in order to schematize the process of cultural exchange (and the reader or writer's involvement in that exchange), he compresses Harding's four roles of response (operative, intellectual, perceptual, and evaluative) into three: he leaves out the perceptual, claiming that "there was no obvious way in which language could serve its purposes" (18).

The distrust of sensation as a vehicle for knowing dates back to Plato's argument against the Sophists, where "base," common senses and "high" intellectual inquiry are clearly segregated. What

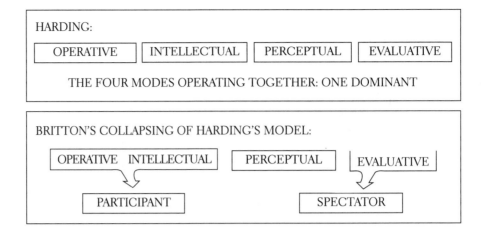

Britton's Marginalization of the Perceptual.

we need to remember here, though, is that such resistance to legitimizing perceptual experience is always tied to a range of historical, social, and political purposes. When integrated modes of visual/verbal expression (and integrated approaches to learning) gain currency, an understanding of the perceptual realm gains urgency. Further, as Barbara Maria Stafford reminds us in her history of visual education,

> [r]ecent scientific discoveries that early stimulation is crucial for brain development have led to the reassessment of the role played by sensory experience in knowledge formation. The brain uses the outside world to shape itself and to hone such crucial powers as vision, reasoning, and language. Not hard wiring but continual interaction with the external environment is now thought to produce even the most abstract kinds of cognition. (xxi)

The experiencing and organizing of perception *does* seem to play an increasingly important role in our responses to image/text compositions. And the pedagogical implications of ignoring or marginalizing the experiential (a process most frequently linked to otherwise "illegitimate" cultural spheres) should give us pause. At the very least we might speculate that the presence of visual/verbal compositions complicates our locus of response, ensuring some degree of oscillation between the spectator and participant roles. Moreover—and this is especially true for print-oriented readers— the presence of visual elements refocuses attention on the perceptual mode.

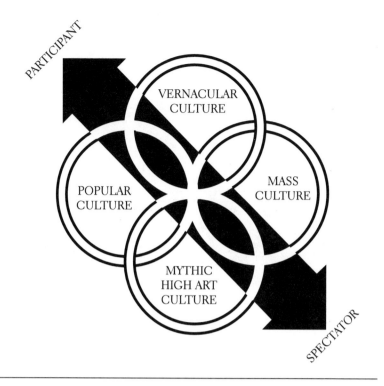

The Four Cultural Domains.

Bourdieu's three spheres of legitimacy and Britton's spectator-participant poles need further complication, for, as presented, they appear too static to accommodate interarts practices. In their stead are offered the following pair of elaborations. The diagram above represents the spheres in terms of their cultural domains, seeking to show how the four domains intersect and overlap. By distinguishing "vernacular culture" (or indigenous expression) from the more commonplace categories of "popular," and "mass" cultures, the model suggests a place for perceptual response and practice.

In addition the model is offered as a heuristic for cultural analysis. If we take Rutledge's "Duck," for instance, we can trace its migration across the four domains, thus facilitating a more precise discussion of how meaning and significance changes than the usual metaphors of conversation and struggle allow. In short, we can visualize the process of meaning-construction and legitimization (see the following page).

Such a flow chart of cultural exchange helps sensitize us to the aesthetic potential of vernacular expression. As Andy Warhol made clear, yesterday's soup can may become tomorrow's cultural icon. The boundaries between the cultural domains are overlapping and permeable: the duck decoy begins, in its original context, as a

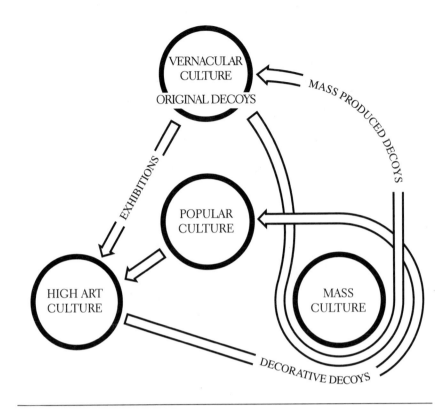

The Pattern of Cultural Exchange.

product of vernacular expression—a crafted, perceptual response to an environmental need. With industrialization, however, the duck decoy becomes increasingly less tied to individual response: it becomes more of a mass-produced item. Such an exchange back and forth between indigenous communities and the marketplace seems common enough. But then the duck decoy moves into the sphere of high art—as the object of "folk art" exhibited in museums and art galleries during the last two decades or so. Sanctioned (or legitimated) in this manner by the institutions of high art, the duck decoy has gathered popular appeal, now crafted in large and small industries as decorator items such as the "duck telephone" illustrated on page 23.

Throughout this book we hope to trace this cultural flow, showing how literary and visual forms, vernacular modes and objects, cultural icons, and, most importantly, verbal and visual responses migrate and adjust to the shifting rhetorical situation of each cultural domain. The vernacular is our starting point, for it is, by definition, set apart from the conventions, values, and expectations imposed by high art culture. Moreover, the vernacular invites us to reconsider notions of indigenous and personal expression, coherence, perception, and authenticity. We are interested in those nar-

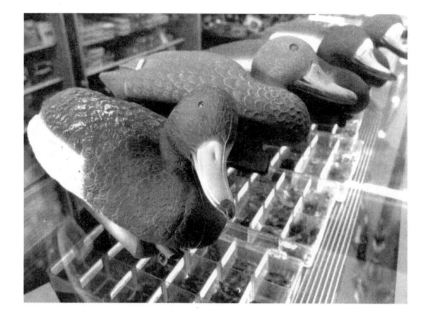

The duck decoy as mass-produced item. Photograph by Donald Lawrence.

rative constructions, generally forms of verbal and visual collage, which seem to call for perceptual responses, constructions which, as Kuspit suggests, draw upon a "uncertainty" as a "method of creation" (43). Collage is itself, or at least originated as, a vernacular mode that has today taken on high art significance; "[o]nce considered a folk art, collage in the twentieth century has emerged as both medium and an idea, and has led to some of the most significant developments in art and criticism in our time" (Hoffman 1). And although they are often informed by contemporary theory, these twentieth-century collage constructions do more than illustrate or embody theory; works by such artists and authors as Fred Douglas, Brenda Pelkey, Ernie Kroeger, Sharyn Yuen, Michael Ondaatje, and Robert Kroetsch, in particular, help establish a rhetorical situation for what we see as a new kind of imaginative and intellectual engagement—one that employs the photographic to extend beyond the realm of visual and verbal identification invoked by image or text alone.

In summary, then, to successfully read multiple and vernacular literacies we must also consider (1) how those literacies are constructed, (2) what is at stake (culturally, historically, and personally) when such literacies develop, and (3) how we might best respond to this new rhetorical situation.

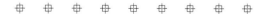

The chapters presented in this book suggest some ideas on how teachers and researchers can go beyond the traditional "sister arts"

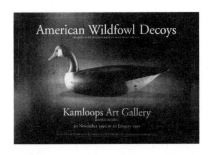

Kamloops Art Gallery exhibition poster, *American Wildfowl Decoys* (1990). Collection of the Museum of American Folk Art, New York. Poster Design: LeftBankDesign, Kamloops.

3 One of the best descriptions of Project Zero, a research program founded by the Harvard Graduate School of Education in 1967, is offered by David Perkins and Howard Gardner in a special issue of the *Journal of Aesthetic Education*:

A number of core convictions mark and unify our enterprise. We share a belief that the arts, usually celebrated as the dominion of the emotions, are profoundly cognitive activities; a belief that human intelligence is symbolically mediated through and through and must be understood from the perspective of symbolic development; a belief that creative and critical thinking in the arts and the sciences have far more in common than is often thought; a concern to study and understand the psychological processes and resources underlying some of the peak achievements of humankind. (ix-x)

vision that has typically characterized interarts studies: instead of invoking analogies between the visual and the verbal, and instead of teaching the arts as comparable but essentially discrete forms, these chapters explore strategies for, and the consequences of, integrating literacies. For when different processes of perception and cognition are combined, as they are in our responses to artists' books, PhotoGraphic compositions, visual narratives, mixed-media art, etc., the perceived "text" that results becomes, in Stephen Behrendt's terms, a "third text"—a metatext that draws upon the visual and the verbal. Coming to terms with that third text is what this book is all about.

We hope that, for the most part, these chapters can speak for themselves, but we would be remiss in not saying a word about the strong pedagogical theme that informs both our general interest in image/text composition and our specific interest in the "PhotoGraphic" as literacy narrative. Our joint fascination with this topic began in the classroom, and the disciplinary discourses that shape what can and cannot be said about such topics have their greatest impact on academic readers and in school and university classrooms. It seems a curious anomaly that while the inherent value of an integrated curriculum is taken for granted in the early grades (thanks to the work of programs like Harvard's Project Zero and Italy's Reggio Emilia),[3] opportunities for integrating literacies become increasingly rare when students move up through the educational system. By the time we reach university, the objective of producing "a reintegrated child who is capable of constructing his or her own powers of thinking and selecting through the re-animation and integration of all the expressive, communicative, and cognitive languages" (Malauzzi, qtd. in Edwards 22) becomes replaced by the demands of highly specialized, disciplinary discourse. The promotion of rich perceptual experiences as vehicles for academic inquiry becomes, at the very least, suspect; creative play and risk-taking have little "legitimate" place in higher learning.

Part of the problem involves the social values imparted during teaching: very early on children learn "that books with pictures are for 'little kids' and are to be put aside when the young readers can 'really' read"(Day 69). We need to ask, with Brenda Daly, "Who benefits from this failure of schools to teach an integrated approach to the visual and verbal arts?" Daly argues that the fault lies with an institutional structure still informed by male-dominated hierarchies: "mother-dominated, multi-subject classrooms," she says, "are considered appropriate for children, while father-domi-

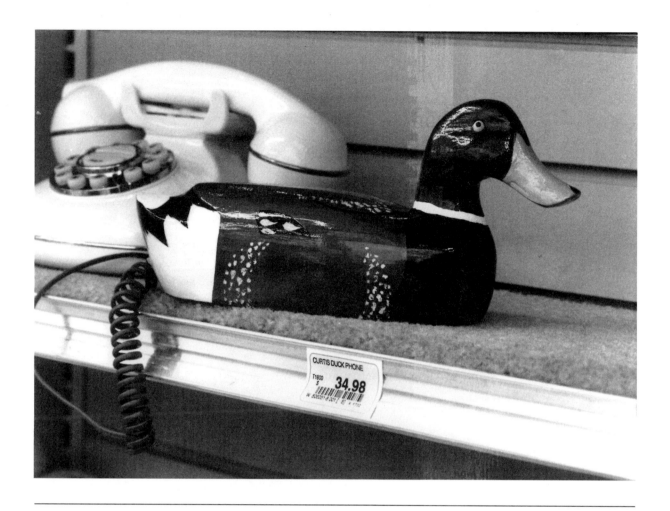

The duck decoy in popular culture. Photograph by Donald Lawrence.

nated education, with its specialized categories of knowledge, begins at puberty" (109-10).

Others who have influenced our view on this topic, scholars and teachers such as Behrendt, echo Daly's critique, noting that "whatever lip service may historically have been paid to egalitarian notions of the 'sister arts,' the literary sister has tended to be not just the dominant, but also the colonizing, sibling…"(46). That said, we feel it would be a mistake to re-enact this pattern of colonization and, in the name of some interdisciplinary ideal, render all disciplinary boundaries irrelevant: by foregrounding and contextualizing the academic "turf wars," and by featuring literacy narratives that question how and what we read, we hope to provide an informed, productive, and multidisciplinary dialogue about the rhetoric of reading and viewing integrated literacies. We hope to

map, then, not only an intriguing area of Canadian academic and artistic inquiry, but also what we see as a new pedagogical space of increasing significance as we enter an age where changes in media do indeed affect the messages we communicate—and the artforms we value. This is a study of reading and *readability*.

One thing seems certain: our notions of what constitutes art—and of what separates high, mass, popular, and vernacular cultures—are under review. As the technology for combining image, text, and other media becomes more sophisticated and accessible, the gap between production and reception of multimedia communication will diminish. Spectator and participant roles will become functionally interchangeable; and what was once the subject of literary and visual tropes will become increasingly a pragmatic commonplace. Literacy narratives anticipate and dramatize those changes, but the best of these narratives do more than teach: they move us toward a new vocabulary of personal and perceptual response, and, ironically in an age of mass communications, toward a renewed appreciation for the idiosyncratic, the local, the vernacular.

The Location of Reading

2

In the first part of this chapter, we explore how linking reading and seeing to rhetoric rather than poetics establishes a theoretical framework, a "Third Space," for exploring PhotoGraphic composition and reception. We look especially at Margaret Atwood's novel The Handmaid's Tale *as an allegory of reading in the Third Space, noting how rhetorical reading practices imbricate the drama of personal choice. The chapter ends with a more in-depth exploration of vertical and horizontal allegory: we argue that these spatial metaphors describe the tension of double exposure in postmodern reading practices, where a vertical response orientation (a reading suspended in memory) is overlaid by a horizontal linking of images and texts (a reading unfolding in real time).*

Bridging the Aesthetic-Material Divide

Coming to terms with the arts of the contact zone, and the quest for readability: these are shared goals for those interested in the border pedagogy of literacy narratives. Rhetoric is crucial to this mix of concerns, for reading the PhotoGraphic requires a double take, a metacognitive process dependent upon our sympathetic identification with an advocated world view. How to negotiate epistemological assumptions is what literacy narratives teach. They teach us the benefits of seeing double; they remind us that reading and seeing involve us in a double bind, where we must both distance our selves from yet work within the dominant discourse. George Bowering puts it this way: one "does not want to create and write a new language; rather one wants to work out a new relationship with language. One wants to speak [or read] inside the dominant discourse, but if one is thinking at all, one is perforce bilingual" (*Errata* 96). As readers, we can submit to the ruling discourse (let the discourse write our reading), or we can resist by reading the work and our own initial responses as products of their social context. To do so is to acknowledge reading as situational and dependent upon a rhetorical interaction; and meaning so viewed does not exist apart from the dialectical process of sorting out alternative interpretations.

It is just this sort of ironic relationship between and among interpreter, interpretation, and the dominant discourse that describes

Ernie Kroeger, *Crossing the Great Divide* (1988). Photographed in collaboration with Kate O'Neil. Reproduced courtesy of Ernie Kroeger.

the narrator's discomfort in a novel like Margaret Atwood's *The Handmaid's Tale.* The novel is set in a near-future world where a religious theocracy now rules, where reading and writing are forbidden. The narrator, Offred, finds that, in such a world, the truth lies with those who have the power to tell the story; and finding herself without access to such power, the narrator interprets her situation by relying as much upon belief as she does upon critical acumen. To write a novel, or to compose a taped message for future generations, celebrates a belief in the power of the word; it is a reaching out to an audience, in the hope that there will be a ready and sympathetic audience there. As the narrator puts it, "By telling you anything at all I'm at least believing in you, I believe you're there, I believe you into being" (251). Belief is, in essence, an assertion of epistemology; in this case, it is a creative impulse that rejects the state's power to define and restrict identity. For Offred, narration and appropriate audience response are cast as political acts of self-preservation.

Belief, though, is never ideologically neutral: to assert belief in a world without absolute truth becomes, "if one is thinking at all," a problem of ethics. Reading too is a matter of belief and ethics, for we can no longer innocently test our readings against an objective text. A work of art's meaning is always already inhabited by our presuppositions. We become more responsible—not less responsible—for both what we believe and how we persuade others of our beliefs. Thus, as Richard Rorty says of critical theorizing in general, reading in the postmodern (or postcolonial) condition becomes a matter of "playing off alternatives against one another, rather than playing them off against criteria of rationality, much less against eternal verities" ("Hermeneutics" 11). The focus shifts from "knowledge" (as a matter of justified true belief) to the process of "knowing" (as a matter of probability and the rhetorical shaping of beliefs).

As noted in our opening chapter, and as illustrated by Atwood's *Tale,* the contending literacy narratives argue for a renewed emphasis on "situation," on reading as a social space for resistance, negotiation, dialogue, visualization, and multiple border-crossing maneuvres. This convergence of metaphors and interests has preoccupied us while working on our research into the PhotoGraphic. For some years we did little more than catalogue the increasing cluster of metaphors that seek to describe the space of critical response. Only recently, however, have we begun to understand that we were (and still are) witnessing the progressive articulation of a new rhetoric—certainly a new array of rhetorical *topoi,* or places in the mind where critics go to interpret artistic works.

Traditionally, as Jeanne Fahnestock and Marie Secor have documented in their "Rhetoric of Literary Criticism," critics have looked to six *places* to work out their readings. These are places tied to a print-literacy orientation. The first two *topoi, Complexity* and *Contemptus Mundi*, are attitudinal, where critics look to the text for structural and thematic complexity while alert for signs of decay or despair; the remaining four describe a recipe for critical practice:

Appearance/Reality, where critics look for patterns of duality, for meaning below the surface;

Paradox, where critics find and reconcile textual contraries;

Everywhereness, where critics identify a pattern that others have overlooked, and then find that pattern "everywhere" in the text; and

Paradigm, where critics find that a key pattern "in" the text acts as a guide for reader response—or where that key pattern is seen to reflect some pattern in the "real" world.

The PhotoGraphic invites a more spatial, more overtly paradigmatic, orientation. The shock of the new or "low" becomes cause for delight, not despair; duality becomes as much a condition of reading as it is a pattern found *in* the text; and paradoxes become sites for exploration and dilation, not reconciliation. Instead of a principal focus on such areas as structural cohesion, tension, iterative imagery, form, characterization, realism, mimesis, and interpretive authority, the literacy narratives discussed in *PhotoGraphic Encounters* introduce a new lexicon: a focus on *authenticity, allegory, the space between, horizontal* and *vertical* reading orientations, *interaction*, the *moment, orality, photography, process, reading, stasis* and *motion*, the *vernacular*, and the *visual*.

These new points of critical focus are, we believe, part of the pictorial turn in the narrative arts—a turn that has given increased emphasis to the role, even the "logic," of the photographic paradigm. Paul Virilio details a rather too tidy but nonetheless provocative narrative of the image, what he terms a "logistics of the image":

The age of the image's *formal logic* was the age of painting, engraving and etching, architecture; it ended with the

"Certainly there have been historical periods when words and images have been felt to be fundamentally different kinds of representation. In the eighteenth century Lessing's *Laocoön* for example, argued that painting and poetry are domains so far apart that attempts to bring them together produce disaster... And from the standpoint of eighteenth-century aesthetics, this view was, doubtless, locally true. Lessing's discussion was keyed to the specific pictorial practices and expectations of the eighteenth century. Medieval or early Renaissance paintings that represented several episodes in a saint's life together in a single panel were beyond the pale of art; there were as yet no cubist collages that inserted letters and words directly into the pictorial space.... Only by fiat can these kinds of art be declared 'not art.' So one's first observation, on the idea that words and images inhabit different and exclusive domains, is that the evidence suggests otherwise..."
Norman Bryson—Visual Theory.

THE "AGFA" BOOK. 43

"Agfa"-Flash Lamp
(PATENTED.)
Improved Model

This is marketed in place of the uncertain striking safety

Agfa Book of Photographic Formulae
(1910).

eighteenth century. The age of *dialectic logic* is the age of photography and film or, if you like, the frame of the nineteenth century. The age of *paradoxical logic* begins with the invention of video recording, holography and computer graphics. (63)

This three-stage progression seems far too rigid, but it does highlight a number of key issues, and it does acknowledge photography as crucial to any discussion of the image's evolution and narrative potential.

A more recursive model, but one based on Virilio's logistics, might better represent the interplay of the formal, the dialectical, and the paradoxical. Indeed, we might well argue that, in the present moment, all three logics are always in play, and that the aware artist (and reader) must continually look to the space between to create meaning. We might also consider the potential rhetorical value of paradoxical logic, for, as Emily Hicks's discussion of holography suggests, new conceptual frameworks need not provoke what Virilio calls "frantic interpretosis" (63). The double (or triple) vision encourages heightened awareness—and an opportunity to reflect on the conditions of artistic production and reception.

Virilio's view is more negative. He sees paradoxical logic "resolving itself" as "real time presence," an over-involvement or entrapment in the high definition moment that, in effect, mesmerizes us and precludes critical reflection. We certainly do not want to dismiss this darker view. On the contrary, we see potential intoxication *in the moment* as an important topic for a rhetoric of reading—but we link such a tendency to a naïve modernism rather than to the paradoxical logics of postmodernism, as Virilio seems to do.

PhotoGraphic artforms, for example, invite a dialogue between Virilio's logistics. The space between, the gaps and seams opened through both careful arrangement and accidental juxtaposition, asserts its own logic of rhetorical interruption. According to Homi Bhabha, these interruptions are emblematic of a larger "real world" Third Space, where cultures intersect. Bhabha sees the space between "different art practices, and between different theories" as "a very interesting place of enunciation, because it's also the place 'in the midst of.'… One of the characteristics of this place 'in between' is that there is always that moment of surprise, that moment of interrupting something…. But from that moment of interruption emerges something new, something different, a displacement" ("Visualizing Theory" 454). The moment of interruption is also an invitation for something new or different in reader

response, usually an opportunity to deconstruct or read against the perceived grain of the text. We also see the Third Space as an opportunity to explore new topics of the sort listed above.

The new *topoi* seem heavily freighted with a concern for reading as a "political" activity. The notion of reading against the grain, for example, draws upon a rhetoric of resistance and emancipation that positions realist and modernist practice as variously limited, restrained, monologic, or closed; postmodern and postcolonial reading practices as free, dialogic, and open. The modernist reader/viewer remains a spectator, while the postmodernist becomes a participant in the co-creation of meaning. Although many of these emancipatory terms of reference come from the political sphere—where, historically and socially, marginalized groups work to articulate new forms that rival, even contest, the dominant discourse—many Canadian PhotoGraphic works tend to be more closely tied to the academy (to questions of representational strategy rather than necessity, to issues of disciplinary power, institutional habit, and theoretical debate). PhotoGraphic art may draw upon forms of everyday resistance and social change—the readymade, hybrid texts, marginalia, graffiti, pamphlets, folk art, posters, protest rallies, oral performances, political demonstrations, rap, reggae, break-dancing, underground publications, e-zines, and so on; and it may well speak about issues relevant to everyday resistance. But it is equally well informed by the give and take of high art culture. Why, though, turn to words and images drawn from popular, mass, and vernacular cultures? Is this yet another example of cultural appropriation?

Whether they are working inside or outside the academies and galleries, those involved in such debates remain no doubt passionate of purpose. It must be said, however, that some of the less impressive hybrid art may reference, even embrace, other cultures but end up simply raiding them for elements of their formal design and novelty. In our experience such art turns to classical high art icons, or to images from popular culture, mass culture, and the vernacular, as a way of illustrating high art theory. The more interesting work involves some element of authentic engagement with those cultural domains, especially with vernacular materials. This kind of work substitutes authenticity for authority, supplements high art aspiration with vernacular inspiration, reorients notions of margin and centre, and generally opens a meeting place (Bhabha's "Third Space") for creative and critical inquiry.

For inside workers, that is, those of us engaged in the discourse of academic and high art cultures, what is at stake is nothing less than how we read and interpret. Acknowledging the "Third Space"

Richard Bolton, "The Modern Spectator and the Postmodern Participant." Reproduced from *Photo Communiqué*, Summer, 1986. Courtesy of the author.

The direction of his gaze
revealed the future.

Every fiction is supported
by a social jargon, a sociolect
with which it identifies.

Geoff Miles, *The Trapper's Pleasure of the Text* (1985). Reproduced courtesy of the artist.

establishes grounds for questioning seemingly fixed and naturalized habits of critical response; the Third Space provides grounds for epistemological rebellion.

The stakes are high, both inside and outside the academy; and critics are right to see theoretical debate as both politically charged and relevant to understanding new artistic trends and movements. Just as cultural texts generally are constructed in terms of often conflicting words and images, so institutional contexts are constructed in and through conflict. As a kind of preface to our main argument, we offer a brief review of one important academic context in action: English studies in Canada. Although we make no

pretense that the following introductory observations do more than supplement the more extensive institutional histories of Heather Murray and Henry Hubert (in Canada), Gerald Graff (in the United States), and Terry Eagleton (in Great Britain), we nonetheless want to highlight a key literary debate—what we call the aesthetic/material divide—that provides a primer on why Canadian literary studies, as an academic discipline, has shied away from considering the visual aspects of reading and writing. Understanding, much less bridging, the distance "between" the textual and the material is no easy task—especially for a literary and critical culture that has consistently privileged reading as an aesthetic pursuit. Still, the nature of that divide, that Third Space, deserves more attention than it has received.

Traditionally, English departments have had a difficult time relating the teaching of literature and critical practice to the more pragmatic concerns of literacy instruction. Where the discipline has treated literacy, it has done so to emphasize reading rather than writing. (A recent study of writing programmes across Canada reveals that most formal writing instruction is delivered outside the English classroom—by faculty in Engineering, Law, and a host of professional programmes.) Attention to questions of visual literacy remains sparse, falling into marginal categories of literary specialty such as "literature and the other arts," or "literature and film."

Our stories of reading, especially discipline-based literacy narratives, repeatedly cast word and world as protagonist and antagonist—despite the general recognition that either/or positions seldom offer more than reductive assertions. One way out of this impasse, we feel, involves a move from the domain of poetics to that of poetics *and* rhetoric.

Just such a move has been taken recently by Mieke Bal, a European scholar who has begun to seek a convergence between narratology and rhetoric. In *Double Exposures*, Bal introduces the notion of reading as both spatial and situated; she explores how we read the museum space, finding narrative illustration a crucial component of the discourse, a linguistic substitution taking "the place of things museums use to make their arguments" (6). "In other words," says Bal, critical arguments depend upon a gesture toward the material: illustrations, examples, and narratives "cannot be deployed without the gesture of 'Look!'" (6). Echoing Hicks, Bhabha, and an increasing chorus of others, Bal points to the need for "double exposure," a rhetorical practice which exposes how "[t]he reading itself…becomes part of the meaning it yields" (7). Such rhetorical self-consciousness implies both a new focus on process and a new humanism, where human agency, though nei-

Aristotle's *Rhetoric*, the inspiration for later classical works by Cicero, Quintilian, Horace, and St. Augustine, begins with the powerful assertion that rhetoric "is the counterpart of dialectic" (1). Similarly, Aristotle offers the *Rhetoric* as a companion piece to his *Poetics*: readers of the *Poetics* are referred to the *Rhetoric* for discussion of *dianoia*, the art of framing speeches; "the *Rhetoric* refers us to the *Poetics* for a discussion of matters that are more fully dealt with" (Cooper, *Rhetoric* xviii), including discussion of grammar, diction, and style. The alliance of the two works, *Poetics* (with its focus on formal characteristics) and the *Rhetoric* (with its focus on the effect of form on audience), provides a comprehensive and influential program of study: "for many centuries to come the discussion of poetic diction was dominated by the criteria of good and bad style which Aristotle had established in the Rhetoric; as for…character sketches, we find them as early as Horace bodily transferred from *Rhetoric* to *Poetics*" (Solmsen, "Introduction" xiii). For Aristotle, rhetoric was above all a study of audience based upon "the faculty of observing in any given case the available means of persuasion" (1). If the *Poetics* presented a theory of structures, the *Rhetoric* provided the necessary supplement, a theory of processes (of "means").

Sharyn Yuen, a double exposure from the original slides taken in Namcheng, China. Images from the slides were reproduced in Yuen's *Jook Kaak* series (1986).

ther stable nor autonomous, nonetheless exists as an identifiable social force, an agency for "looking." It also encourages us to consider visual culture and visual modes of representation as something other than a pale or secondary version of print-literacy.

To assert a new humanism of rhetorical presence, one need not abandon the post-structuralist insight that subjectivity is multiple and constructed (like, say, English departments) within a polylogue of competing discourses. Rather, the challenge for postmodern authors, artists, and theorists becomes one of articulating the Third Space or cultural contact zone which mediates between the individual and the social, between image and text, between image/text and world. As Mariana Valverde argues for "social theory," we "might try to retain the freshness and political commitment of the new humanism while understanding that the wretched of the earth, be they women, Third World peoples, or workers, are after all unstable and fragmented subjects who exist as distinct groups largely through the social effectivity of discourses" (184). Literary theory that treats readers and writers as subject positions embedded in a text simply cannot respond to questions of social subjectivity and mediation, much less to the question of how we read literature *and* visual art.

A Discourse of Civility

Rather than seeking points of convergence among literary theory and the other disciplines (art history, visual literacy, media studies, communication theory, reading theory, composition, rhetoric) concerned with the politics and pragmatics of how we produce and respond to texts, English studies tends to avoid talking about processes and practices. Instead, intellectual detachment seems very much in fashion: theorists *identify* and *defuse* rather than *employ*. But an anti-utilitarian bias, no matter how muted, seems bound to confound discussion of politically and materially engaged reading practices. The reader ends up "defined in terms of a hypothetical state, which obfuscates and impedes a conception of an embodied reader that takes into account differences among actual readers" (Bogdan 212).

The role of the actual reader and of reading practices has long been either taken for granted as a cultural given or marginalized as an excluded concern—as a subject better taken up by, say, educators and sociologists than by literary critics. As professional readers, critics generally assume that they know what reading is: "an

undifferentiated and unproblematic activity, performed by some wholly abstract entity called 'the reader'" (Batsleer, Davies, et al. 140). Traditionally, literary critics offer readings that elide discussion of the process by which those readings are achieved. Comprehension is "unproblematically" equated with the formal structure of the text being read, and reading becomes an invisible activity. Literary criticism functions, then, as Deane Bogden argues, like "a kind of fail-safe for the deficiencies of the 'real' experience of participatory reading in that criticism can always refer the reader to the level of myth,…where presumably there is no conflict of interest, wounding of feeling, or inequity of power operating with respect to the act of reading as a lived activity" (213). Such aesthetic theory facilitates the idealization of reading practice; it implicitly advocates a model of reading that seems more compatible with nineteenth-century notions of political privilege than with twentieth-century notions of political contestation. Indeed, before moving to a consideration of how we read PhotoGraphic constructions, we want to argue here that, within the literary community, contemporary critical discussion of reading frequently collides with a latent, idealized narrative of moral development and aesthetic detachment.

For early Canadian literary scholars such as W.J. Alexander, James Cappon and A.S.P Woodhouse (1884-1950s), the critical mind was developed indirectly, through reading cultural masterpieces. If theory was to be learned, it was to be learned implicitly, and reading was celebrated "as a form of intelligent recreation" (Woodhouse, qtd. in Harris 126). Henry Hubert has documented in considerable detail how English studies, as it emerged from the nineteenth century, brought with it an elitist "emphasis on liberal culture unrelated to the practical exigencies of life" (124). Arnold's attack on the "philistinism" that he associated with secular materialism, Cappon's distaste for narrow materialism—such attitudes affirmed the "historic non-utilitarian philosophy of the English university system" (Hubert 123) and helped establish what Lorraine Weir has called "the discourse of civility" (24). Such a discourse focused literary (and literacy) instruction almost exclusively on what readers should learn from texts; the question of what readers might bring to texts, or even the notion of "non-verbal texts," would have been, if not inconceivable, then at least irrelevant.

During this period, reading theory (consideration of how we interpret meaning) was seldom explicitly stated. Readers and the process of reading, when mentioned at all, were cast as bit players in a national morality play wherein literature provided a mirror of Canadian reality and readers were exhorted to reflect upon its

Contemporary Canadian writers and artists are not immune from the influences of this tradition of close reading, or from the inherited epistemology and ideology it dramatizes. Frame conflict seems inevitable. "Like many people of my generation," says Robert Kroetsch, I was trained to be a New Critic before I knew I was being trained as a New Critic. It was only later that I realized that there was a kind of ideology operating in those teachers who were teaching me. I think that that's one of the things that made me uneasy when I recognized it, though I'm still as a teacher very much caught up in that and I think probably a lot of those reading strategies that I learned in New Criticism still influence me as a writer.
(*Labyrinths* 31)

Writing and reading converge as mutually dependent creative activities. As we have noted, writing, like reading, is a matter of learned "strategies," interpretive frames that while they enable coherent "readings" also necessarily restrict both creation and perception of new modes of discourse. To read and write postmodernist fiction, we must unlearn our conventional strategies of realist response and return to a rhetorical orientation. The shift in perspective, however, is not easily accommodated, and it would be unreasonable to assume that postmodernist writers and readers can transcend completely the inherited formalist bias we associate with the realist tradition. Indeed, the developing postmodernist rhetoric of reading dramatizes the problems inherent in shifting from a product-orientation to a process-orientation.

In this context it seems worth remembering Etienne Balibar and Pierre Macherey's salutary reminders about the liberal humanist ideal of individual freedom and consciousness—reminders that speak to the issues raised by the notions of horizontal reading as a "free play of signifiers." Balibar and Macherey define the status of the text in terms of its social reception, arguing that we consider "all the historic dissimilar modes of reading texts":

the 'free' reading, reading for the pure 'pleasure' of letters, the critical reading giving a more or less theorised, more or less 'scientific' commentary on form and content, meaning, 'style', 'textuality' (revealing neologism!)—and behind all readings, the explication of texts by academics which conditions all the rest. (11)

Georg Brander, "Table Camera Obscura" (1769). Reproduced courtesy of the Gernsheim Collection, Harry Ransom Humanities Research Center, The University of Texas at Austin.

embodied truth. As Margery Fee puts it, nineteenth-century criticism offered a remarkably tidy version of reception aesthetics: "the national literature reflect[ed] the people to themselves; through reading it they recogniz[ed] what they truly [were] most clearly" (39). The mimetic premise informs most nineteenth-century notions of reading, offering a newly literate population a program of reading that would ensure acculturation. Mary Lu Macdonald explains the dominant literacy narrative of the age:

When reading and writing were skills possessed only by the upper and middle classes, who could be relied on to understand and obey both literary and social rules, the effect of literature on individuals did not pose any threat to society. However, as literacy expanded in the nineteenth century the moral and intellectual instruction of a new class of readers was perceived to be of urgent social importance. Literature was now expected to enlighten and indoctrinate the newly-literate agricultural and industrial working classes. (86)

The discourse *of* civility was also a discourse *for* civility. Literacy, like gardening, was a matter of cultivation, and vernacular literacies were not allowed to develop untended.

In an age where culture could be idealized in terms of Arnold's "sweetness and light," and where, more generally, the Canadian moral rhetoric privileged metaphors of "light, soap, and water" (Valverde), notions of reading remained subject to a cultural preoccupation with moral improvement. Literature, according to the early critics, "did not merely convey the author's meaning or message; it altered the mental and spiritual state of receptive readers and elevated them to the realm of a superior reality" (Jansen 557-58). Patricia Jansen's review of "Arnoldian Humanism, English Studies, and the Canadian University" notes in passing the visual metaphors embedded in the late Victorian epistemology. W.J. Alexander, first professor of English exclusively in 1884, W.M. Tweedie, Mount Allison's professor of English in 1888, and Mathew Arnold: these professors enjoined readers to "make sure that we use our own eyes," to "see things as they really are" (qtd. in Jansen 552, 554). Readers were warned to keep their eyes open. Ironically, while the metaphors of sight, light, gardening, and so on, imply a materialist orientation, the early critics advocate, to paraphrase W.S. Milner, that we "rescue [reading] from the spirit of the crowd" (qtd. in Jansen 557). Thus, although reading had a clear social mission, theories of the reading process shared only a

metaphorical connection with the social realities of class, gender, race, education.

Just as contemporary critics do not speak with one voice, however, nineteenth-century pronouncements on reading were similarly inhabited by a variety of discourses and rhetorical motives. Their shared idealist stance, after all, does not ignore (or dismiss outright) the material world. Poetry, says E.W. Dewart in 1864, "may be regarded as occupying in the world of the mind, a place and a purpose analogous to scenes of beauty or grandeur in the material world" (qtd. in McCarthy 34). As Dermot McCarthy explains, Dewart mounts a defense of the aesthetic and introduces the concept of "ideological cohesion based on the 'complementary' relations of the aesthetic and the practical…"(34). Dewart's position, and the epistemology it supports, offered nineteenth-century and early twentieth-century scholars a convincing rationale for critical practice. By focusing on the aesthetic, and by advocating an appreciation of the ideal, they hoped to affect *indirectly* the practical world. Complementary relations are not, however, direct correspondences, and a system of critical coherence founded on analogy ensures the privileging of the aesthetic over the social. Verbal/visual relations may also be viewed in light of the correspondence model, fostering the prevailing "sister arts" approach that has, until fairly recently, dominated literary attitudes toward visual culture and kept visual literacy in its place.

The Problematics of Mediation

The advent of post-structuralist and postmodern theories has made us all more self-conscious about disciplinary assumptions and practices; yet, curiously enough, the marginalization of both theory and rival textualities remains a stable feature of English studies discourse. Even among contemporary theorists there is a tendency to elide modal differences or otherwise domesticate the visual by regarding it as just one more form of language, as "text." After all, the intentional fallacy and the affective fallacy are still frequently invoked as examples of naïve reading practice; and among post-structuralists questions of intention, authenticity, personal investment, and reception are treated as written by (and thus inextricable from) the dominant print-centred discourse. Where naturalist and modernist notions of reading were primarily expressions of ideology tied to concepts of nationalism, morality, and humanist ideals, contemporary notions of reading are often expressions of an ideology tied to models of language. The rhetoric of

The important contribution to reading theory made by critics such as Balibar and Macherey (and Althusser before them) centres on the insight that any reading—what they term a "literary effect"—"is not produced by a [single] determinate process, but actively inserts itself within the reproduction of other ideological effects" (11). As the limited applicability of early (data-driven) pedagogical models to literary interpretation suggests, however impressive an empirical account of the reading process may be, by neglecting the larger social process ("the rituals of literary consumption and 'cultural' practice" [11]) its relevance may be justifiably viewed as of only marginal interest to literary scholars. For, as Balibar and Macherey point out, there is a significant difference between "the discourse of those who 'write' (books) and 'read' them, and the discourse of those who do not know how to do it although quite simply they 'know how to read and write'" (12).

Reading the landscape in the twentieth century necessitates a more complex set of strategies than the "discourse of civility" allowed:

> When my older brother went hitchhiking across Canada, he would send me back postcards. I was living in Toronto at the time and hadn't experienced the western landscape first hand. But I would receive postcards. One shows two deer in a forest setting. The image, at first glance, looked convincing enough, until I found other postcards featuring the same deer set into different landscapes. It became clear that the deer weren't real, and this recognition made me rethink how nature is both represented and misrepresented.

Donald Lawrence — "Artist's Talk."
Stride Gallery, Calgary, July 10, 1993.

contemporary literary theory typically employs post-Saussurean means only to achieve late-Victorian ends, rehearsing, that is, one more idealist narrative. Surely Leonard Jackson has a point when he maintains that what poststructuralist "philosophy does is to replay many of the claims of nineteenth-century idealism—that the world is a mental or ideal construct—replacing the notions of 'the mind' and 'ideas' with the notions of 'language' and 'discourse.'" "[T]he same arguments that hold against traditional idealism," he says, "hold against the new linguistic or discursive form of idealism" (11). Jackson probably goes too far in indicting all poststructuralist (and, by implication, postmodernist) theory, for, as Valverde argues from her sociological perspective, a commitment to literary methods "need not imply a commitment to philosophical idealism" (174). Still, the promptings of Jackson require some

reconsideration of how far recent theory has taken us. We need to wonder aloud, with Valverde, "isn't discourse a fancy word for ideology? Aren't these poststructuralists just Hegelians in disguise?" (174).

The appeal to tradition remains strong. In a sense, too much self-consciousness or awareness (too much theory) works against the necessary fiction of aesthetic detachment. The metafictional, especially that which juxtaposes multiple modes of representation, complicates conventional reading practices, encouraging reflection on questions of process, power, and context—questions which implicate the reader in the construction of meaning. Traditionally, such questions have been ruled out of court as improper, out of place. As we suggested in Chapter 1, the distrust of the visual has a long history, one tied to notions of literary propriety. Joseph Campbell's review of "proper" and "improper" art is instructive here.

Taking his cue from James Joyce's A *Portrait of the Artist as a Young Man*, Campbell invokes Stephen Dedalus's definition of art as "the human disposition of sensible or intelligible matter for an esthetic end" (122). Campbell notes that "esthetic" is from "the Greek *aisthētikos* ('perceptive'; *aisthanesthai*, 'to perceive, to feel') and so has to do with sense experience, but also with feeling." He concludes that 'proper' art, in Joyce's view, whether of sensible or of intelligible matter, rests in esthetical, disinterested perception, apprehension, and feeling, whereas 'improper' art is in the service of interests other than the esthetic—for example, ethics, economics, sociology, or politics" (123). The distinction is a familiar one: proper art appeals to universal ideals of beauty and encourages a disinterested response; improper art excites desire, reveals didactic intent, conveys social criticism—and thus may be characterized as "popular, local, provincial" and "regarded as esthetically insignificant." This is the traditional distinction that for nearly two thousand years has separated poetics (the philosophy of aesthetic form) from rhetoric (the art of persuasion):

> All "improper" art, whether pornographic or didactic, thus moves one, or at least is meant to move one, to action, either with desire toward the object, or with fear or loathing away from it. It is therefore, as Joyce says, kinetic (Greek, *kinētikos*, from *kinein*, "to move"), whereas "proper" art is static (Greek, *statikos*, "causing to stand"). We speak of esthetic arrest. One is not moved to physical action of any kind, but held in sensational (esthetic) contemplation and enjoyment. (123)

"[C]ertain paradigms of social power (rooted in questions of received propriety and control or property) came to be associated with certain modes of aesthetic expression (written books, heroic adventures, epic proportions).... Clearly the systems and expectations of polite literature did differ in some respects from the terms and definitions of vernacular speech—though the distinction is not absolute, and though critical generalizations sometimes make it sound as if it were." *W.H. New— Land Sliding.*

theory of an idea

 of construction

the displacement of text

shifting around
 the notion of its image

 its place in the image itself

more specific than its proximity
 to the real sign

 this page
is the real table the
 plane of language

with no shape

 perhaps to be jettissoned
 or not thought

until much later

 when it is written in the mind

Ian Wallace, from *image/text* (1979). Reproduced courtesy of the artist.

Proper art (i.e., "high art") is said to elevate the mind; improper art (i.e., popular and vernacular works) is regarded as merely rhetorical, decorative and/or social.

For most of the twentieth century, this classical distinction effectively marginalized much otherwise interesting art (and critical reflection). But ours is an interrogative age, where critics and artists alike seem intent on questioning past ideologies, tastes, assumptions, and traditions. Taking *our* cue from the work of Mieke Bal, we "prefer to take issue with the notion that rhetoric is just the 'waste' or 'noise' of…writing; the excess stuff a good academic [or a good artist] ought to avoid, or reduce to an acceptable minimum" (6). Art in the postmodern period seems hopelessly rhetorical—just as attempts to legislate aesthetic propriety seem, at root, rhetorical. To understand and discuss the PhotoGraphic, we must

move beyond inherited prohibitions against the hybrid or the experimental. We need to come face-to-face with the proposition that some of the very best art may have designs on us; may be kinetic (aspiring toward, and focusing on, motion and process rather than stasis and product); may make use of local, popular, "low" materials; may demand a double response, one in touch with material realities yet aware of their aesthetic potential. The PhotoGraphic asks for a special kind of awareness, one that attends to artistic form but simultaneously reflects on the material, social, personal, historical, and political conditions that mediate our perception of that form. To accommodate and better understand such a double vision, we propose an integration of and renewed attention to rhetoric as a crucial mediating element in critical reading and viewing.

More and more, the discipline of rhetoric is becoming recognized as an important mediating discourse, "a useful conceptual bridge from the linguistic and philosophical topics of post-structuralism to the material and political concerns of cultural criticism" (Mailloux 38). Valverde's importation of rhetorical analysis in *The Age of Light, Soap, and Water*; Steven Mailloux's rehabilitation of rhetoric as cultural critique in his *Rhetorical Power*; James Berlin's *Rhetoric and Reality*, where he uses epistemic rhetoric to critique the teaching of composition in American universities; Lynette Hunter's discussion of the rhetorical stance in *Modern Allegory and Fantasy*; Stanley Fish's recent work with rhetoric in *Doing What Comes Naturally: Change, Rhetoric, and the Practice of Theory in Literary and Legal Studies*; Maurice Charland and Martin Allor's recent celebration of rhetorical theory's relevance to Canadian communication studies—these and numerous other interventions attest to the significant role rhetoric can play.

Allor outlines what might be gained:

> The potential dialogue between rhetoric and cultural studies should be sited precisely on the terrain of their conceptions which compete for similar purchase on the real world of politics.... In order to question and compare the objects of disciplines it is necessary first of all to position the implicit telos of their projects.... That is to say how do particular conceptions or interpretations fit into projects of description, interpretation, understanding, prediction or intervention? And, more importantly, what are the particular characteristics of the political field that a discipline necessarily constructs in order to intervene in the wider scope of social institutions and practices? (68)

As C.S. Baldwin observes, the status of rhetoric was affected by changes in relations among the *trivium* of liberal arts—rhetoric, grammar, and logic (Baldwin 151-53). The history of rhetoric may be thought of as a story of misapplications and extensions: in the middle ages, poetics constitutes a misapplication of rhetoric to style, while *ars dictaminis* (the art of letter writing) and *artes praedicandi* (the arts of preaching) constitute pragmatic extensions of rhetorical theory (Baldwin 191-95). After the twelfth century, rhetoric's theoretical relevance deteriorated even further. It ceased to be taught as a liberal art, and it retained practical relevance only in the form of epideictic oratory. Classically, of course, rhetoric consisted of five related departments: invention, disposition, style, memory, and delivery. By the sixteenth century, and with the publication of Peter Ramus's influential *Rhetorica*, rhetoric was divorced from dialectic and the province of rhetoric was accordingly reduced to *elocutio* and *pronunciatio*, style and delivery.

These are big questions. But they are ones that need addressing, especially for those of us who regard reading, writing, and seeing as social, even political, acts. With these questions in mind, a rhetorical focus on reading seems long overdue in both literary studies and the visual arts generally, and crucial to a full understanding of PhotoGraphic encounters. A consideration of how reading and readers are represented metaphorically, pragmatically, and theoretically should yield valuable insights concerning the nature of meaning, reality, and knowledge.

What has been called "epistemic rhetoric," which unites a decidedly postmodern focus on epistemology and process with a pragmatic insistence that humans *act*, seems the most likely candidate to facilitate a coherent conversation among the disciplines. An epistemic focus may not uncover eternal truths or ideal forms, but it can direct critical attention to the interpretive systems that inform our perception of things: an epistemic focus can treat theoretical inconsistencies not as examples of failed logic or morality, but as an opportunity to explore the inevitable clash of pressures and counterpressures that shape critical assumptions and frame our readings. We can begin to treat reading as "the problematics of mediation," Allor's phrase for "the underlying model of mediation that determines the terms of internal and external debate" (68-69):

> Problematics of mediation attempt to resolve a fundamental contradiction facing the human sciences: the simultaneous "existence" of individuality and society. Unlike approaches that restrict themselves to a conceptual structure of individuation (psychology, psychoanalysis) or sociality (structural functionalism, structural anthropology), or textuality (poetics, literary criticism), problematics of mediation entail (explicit or implicit) attempts to analyze individual action in relation to a social field. (69)

Allor is here intent on specifying a "domain of mediation"; such terms as "public" and "culture," he argues, "specify an intermediate abstraction that functions to mediate between the individual and the social." And since these "intermediate abstractions" foster "generative conceptions of both the human individual and the domain of the social," disciplinary contestations "are productions of fundamental differences in conceptions of mediation; they are not the direct result of different conceptions of language or tools for the analysis of texts ..." (69). In other words, what we say about reading or seeing, and how we conceptualize these processes, has

profound implications for how we actually read the world around us. For an area like literary studies, as the "colonization" of visual culture suggests, separating "conceptions of mediation" from "conceptions of language" seems more problematic than Allor allows. Nonetheless, the definition of mediation helps explain why perception (reading, in particular) should be (has already become) regarded as so crucial a critical and thematic concern.

The domain of mediation suggests, as Bhabha speculates, "a very interesting place of enunciation," because it's an occasion for interruption and displacement—for rhetorical adjustment. The zone of mediation, according to Bhabha, may be theorized as the process of "cultural hybridity" giving rise to something "new" and initially unrecognizable, a new area of "negotiation" of meaning and representation" (*The Location* 1-39).

Casting reading as a rhetorical topic has numerous advantages: contemporary rhetoric is by definition transdisciplinary, having roots in oral culture yet attuned to the changing modes of communication initiated by social and technological change. Ostensibly, it might seem clearer to speak of a "theory of reading" or the "semiotics of reception": certainly such terms have greater currency within the discourse of literary criticism. Semiotics and theory, after all, carry with them the caché of scientific discourse. But one of the problems with reading theory and communications theory has been a doggedly "scientific" attitude toward the number of variables at play. Accounting for the *context* of reading remains the recurring impasse: how can any theory or model account for all the possible variations of personal, social, national, political, or modal motives and contexts that affect what we read and see? Whether debated or otherwise articulated in the schools, the uni-

Similarly, rhetoric and poetics parted company. As Rosemond Tuve notes, "in so far as they were arts of thought, poetry [the focus of poetics] and rhetoric had not been divided prior to Ramus" (*Elizabethan* 339); after the sixteenth century, the increasing propensity to Balkanize the three liberal arts laid the groundwork for our modern notion of rhetoric and poetics as discrete branches of inquiry. Rhetorical definitions of discourse were soon relegated to handbooks on style as, more and more, words became objectified "ornaments" to be arranged and admired. Language became regarded less as a vehicle of human communication and more as an object of aesthetic contemplation.

Late-Victorian stereoscopic viewer and stereograph. Collection of Donald Lawrence.

Twentieth-century notions of rhetoric are significantly different from Aristotle's formulation. Though the importance of persuasion remains central, the field of rhetoric has recently held that a text cannot be read or understood in isolation from a context of audience response. The "New Rhetoric" rejects notions of textual autonomy, considering it the hypothetical construct of a naïve poetics that threatens to separate discourse (especially literary discourse) from the world of human interaction, motives, and fallibility. I.A. Richards argues that meaning "floats upon a primitive raft of consents" (*Speculative* 4) and declares in his *Philosophy of Rhetoric* that rhetoric "should be a study of misunderstanding and its remedies" (3); Donald Bryant argues that rhetoric "is primarily concerned with the relations of ideas to the thoughts, feeling, motives, and behavior of men" ("Function" 412). In "Rhetoric—Old and New," published in 1951, Kenneth Burke characterizes the shift in the conception of rhetoric in the following terms:

> If I had to sum up in one word the difference between the 'old' rhetoric and a 'new' (a rhetoric re-invigorated by fresh insights which the 'New Science' contributed to the subject), I would reduce it to this: The key term for the old rhetoric was 'persuasion' and its stress upon deliberate design. The key term for the new rhetoric would be '*identification*,' which can include a partially 'unconscious' factor in appeal. (203)

versities, or in the novels we read and the artworks we view, our understanding of reading and viewing remains subject to the rhetorical exigencies of the moment. No single theory can anticipate, much less accommodate, all the possible interactions among and between reader, viewer, image, text, and world. In rhetorical terms, then, the significance of "reading theory" lies not only in its truth value but in its ability to persuade—its ability to *advocate a context* wherein new and old artforms gain meaning. In short, the readability level of much contemporary art depends upon well articulated and sympathetic rhetorics of reading.

Entrances and Exits in *The Handmaid's Tale*

Margaret Atwood's *The Handmaid's Tale* depends upon advocating and enacting just such a sympathetic rhetoric of reading. It is a story told from the perspective of a young woman trapped in a dystopian future, a nightmare world, Gilead, where women become walking wombs in the service of the state. But this is more than a work of science fiction: this is a literacy narrative about the process of reading and the nature of narrative (of story). More important still, Atwood's novel presents a literary appositive to our own critical narrative on rhetoric and reading. In part an allegory of critical reading practices, *The Handmaid's Tale* dramatizes the difficulties of reading and of being read in the Third Space.

Atwood's literacy narrative teaches us the importance of allegory as a rhetorical stance, a position which, according to Lynette Hunter, imbricates a drama of personal choice. The allegorical stance, says Hunter, is that which "recognizes the world external to human beings, the material world...and hence recognizes the need for a discussion of relations of power when considering the use of language...." Hunter positions allegory as a kind of self-conscious bridge between the aesthetic and the material; she argues convincingly that in the modern age the terms allegory and rhetoric may be used interchangeably. When reading allegorically, "the reader is always aware of that materiality and of the interaction with language that texts engage us in. It is as if once you make a decision to read actively you enter the allegorical, but if you make no decision, you enter fantasy by default" (140).

For Atwood's narrator, the process of telling her tale (and the possibility that a future audience will hear her story) provides her with a measure of control in the otherwise oppressive silence induced by Gilead's totalitarian regime. "If it's a story I'm telling," says Offred early in the novel,

I have control over the ending. Then there will be an ending, to the story, and real life will come after it. I can pick up where I left off.

It isn't a story I'm telling.

It's also a story I'm telling, in my head, as I go along…

A story is like a letter. *Dear You*, I'll say. Just *you* without a name. Attaching a name attaches you to the world of fact, which is riskier, more hazardous: who knows what the chances are out there, of survival, yours? I will say *you*, *you* like an old love song. *You* can mean more than one. (37)

We learn late in the novel that Offred records her life story on some thirty cassette tapes; she works out her story "in conversation" with an implied audience, by attaching a "name" to that audience. Similarly, "the world of fact," so-called "real life," is described as the place signified by "[a]ttaching a name": life is made real through naming, through public address. But if Offred's tale represents, as we shall argue, an act of self-definition for the narrator, it also reaches out and, in the process, gives definition to the necessary "other," the reader invoked and addressed.

Atwood's desire to teach has always been an important element in her work; we share Frank Davey's sense that "[m]ost of Atwood's fiction…seems written at least in part to render a commentary on contemporary society" (*Feminist* 165). Indeed, in *Second Words*, Atwood echoes Hunter's view of allegory, defining the "novel proper, as distinguished from the romance and its variants, [as] one of the points in human civilization at which the human world as it is collides with language and imagination" (417). Language, especially the politics of language, becomes, naturally enough, Atwood's primary focus.

Though the language-centred focus in the novel might suggest a privileging of the aesthetic over the pragmatic, we shall argue that *The Handmaid's Tale* conforms to a consistent rhetorical purpose (didactic in nature) that informs all of Atwood's novels: her desire to teach her audience how to read the world. She sees her writing as a way of communicating rhetorical and political realities; and she is generally critical of those experimental authors who "stop writing for readers *out there* and write for readers *in here*, cosy members of an in-group composed largely of other writers and split into factions or 'schools' depending on who your friends are and whether you spell I with a capital I or a small one" ("End" 431). The reader "*in here*," whether the member of an in-group or a conjectural projection of the group's theoretical preoccupations, seems considerably easier to identify than the reader "*out there*,"

Rhetorical discourse thus defined becomes more than inducement to action; rhetoric becomes the study of human relations, of the means of identification and consubstantiation. As Burke explains in *A Rhetoric of Motives*, "You persuade [others]…only insofar as you talk [their] language by speech, gesture, tonality, order, image, attitude, idea, *identifying* your ways with [theirs]" (55). The New Rhetoric, then, accentuates the dynamics of human relations as we reach out, attempting to communicate, interpret, understand, and identify in an ever-shifting social, ideological, and linguistic environment.

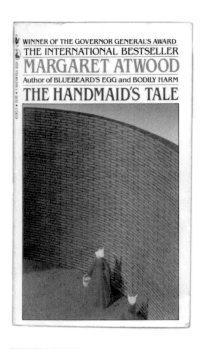

Book cover of Atwood's *The Handmaid's Tale* (1985). Reproduced courtesy of McLelland and Stewart and the author.

Just as New Critical inquiry could not in practice avoid (however parenthetically) discussion of the reader, so the potential for reconciliation between rhetoric and poetics has always been imminent. As Donald Bryant notes, though "sporadically the effect of critics and theorists has been to keep *rhetoric* and *poetic* apart, the two rationales have had an irresistible tendency to come together, and their similarities may well be more important than their differences" (424). The rising interest in reader aesthetics, a phenomenon Elizabeth Freund has called "the return of the reader" (13), changes the dynamics of literary criticism and makes the division between poetics and rhetoric all the more difficult to maintain. As long as the focus remains on the structure of the text, rather than on the dynamics of its production and reception, literary analysis can focus on poetics alone. But the "more we speculate about the effect of a...literary work on an audience the more we become involved in metaphysical questions in which rhetoric must be involved" (Bryant, "Rhetoric" 423). In many ways the reading of postmodernist texts provides the ideal occasion for the re-involvement of rhetoric.

the actual reader of narratives. Atwood's invocation of the reader always implicates the reading practices of the reader addressed outside the novel.

While she may have more in common with writers such as Bowering, Kroetsch, Ondaatje, and bpNichol than she believes, Atwood is nonetheless openly hostile to the cultivation of a private aesthetics divorced from the form and responsibilities of public discourse. Accordingly, *The Handmaid's Tale* invokes the conventions and themes of postmodernism (especially those conventions common to Canadian postmodernist texts) in order to reinsert them back into the narrative of daily experience. Atwood's *Tale* invites a reevaluation of reading, interpretation, and the postmodern condition.

The Handmaid's Tale provides an intriguing point of reference for anyone interested in defining the "narrative" of Canadian postmodernism. Though it shares a decidedly postmodernist view of narrative and history, and though it does encourage the reader to share in the "performance" of the text, Atwood's novel may not seem of a piece with works such as *The Collected Works of Billy the Kid*, *Steveston*, *Burning Water*, *Caprice* or *Shoot!* The main difference lies in the novel's rhetorical intent: questions of epistemology, though crucial, are often overshadowed by the drama of ideology. *The Handmaid's Tale* seems to be primarily about politics rather than perception; but, for Atwood, politics and ideology become rhetorically significant in terms of their ability to shape how and what we know.

The themes of postmodernism are naturally attractive to a politically and aesthetically self-conscious writer such as Margaret Atwood. In *The Handmaid's Tale*, she adopts the theory of history as narrative, making it a *leitmotif* in her examination of the relationship between political power and individual identity. But, in Atwood's fiction, aesthetic concerns are always tempered by didactic intent. For Atwood, after all, fiction writing is "the guardian of the moral and ethical sense of the community" ("End" 424). As an author, she wants her reader engaged in interpretation, not lost in the funhouse of perceptual confusion; and, thus, in *The Handmaid's Tale*, Atwood encourages her reader to treat the near-future setting as an extension of our existing world. The narrator consistently filters her perception of the futuristic Gileadean society through a decidedly contemporary frame of reference.

Early in her story, the narrator, Offred, establishes an intimate, confessional tone. The situation is new, but the shared frame of reference—memories of mini-skirts, punk-rock hairdos, dances in high school gymnasiums—mediates against the initially obscure

FRED DOUGLAS

October 15 - November 1, 1986
opening October 14 at 8 p.m.

COBURG **GALLERY**
314 W. Cordova **Vancouver**
604/688-0866 **V6B 1E8**

"Wounded Leg" 1986

Fred Douglas, exhibition invitation. Reproduced courtesy of the artist.

comments regarding "Aunts" and "Angels." Offred's desire to reach across the space of cots set up in rows establishes a desire to communicate that dilates into her larger rhetorical purpose: to make meaning out of her life and to communicate her story to a future audience.

Offred is very much the self-conscious storyteller in search of an audience:

> Tell, rather than write, because I have nothing to write with and writing is in any case forbidden. But if its a story, even in my head, I must be telling it to someone. You don't tell a story only to yourself. There's always someone else. (37)

The reader is clearly implicated in the narrative process, and the direct address draws us closer to the narrator. We are confidants, participants even, in a love song. Pragmatically, our job is to listen, sympathize, and learn from Offred's testimony.

In the final section of the novel, however, Offred is no longer the narrator. Her role is replaced by the "Historical Notes" of a future academic audience looking back at Offred's narrative as documentary evidence of a past culture. The reader's role too is

Contemporary authors, especially Canadian writers such as Robert Kroetsch, seem to demand such a rhetorical response as a way of over-throwing the reading conventions of realism. "I'm interested in sharing with the reader the fact that I'm making a fiction," says Kroetsch:

> One of the assumptions of old-style realism is that the novel isn't a fiction. Verisimilitude, the text-books demand. And I'm no longer interested in that. I want the reader to be engaged with me in fiction making. I work a reader pretty hard...in that I want him to enter the process with me. Some writers fill in all the spaces, or they use all the conventions. They give all the details. I like the sense of process being fluid and open. (Hancock 42)

Kroetsch's rhetorical position asks a great deal of his readers: he asks us to divest ourselves of old reading habits and to enter the process of fiction making. The "new" reading conventions promise a collaborative, dialogic experience; and, perhaps more importantly, they promise to shift critical attention from form to process—from the domain of poetics to the domain of rhetoric.

usurped, embedded in the subsequent narrative of Professor Pieixoto, an academic reader of Offred's taped testimony. At this moment, for the reader of Atwood's novel, the whole pragmatic structure of the once intimate fictional communication situation is shattered. The narrative frame shifts; the "Historical Notes" chime the unmistakable ring of closure upon a hitherto open-ended narrative process; and the reader seems encouraged to slip from the role of tacit participant to that of detached observer—and, to paraphrase Lynette Hunter, "enter the rhetorical by default."

In the hands of a "more" postmodernist writer, the narrative shift might be an occasion for *aporia*, leaving the reader "without passage" to determinate meaning. Atwood, though, is too didactic an author to leave her reader lost for very long. What is disrupted is not meaning, but the pragmatic aspect of storytelling as a performance between teller and listener. We say "between" because traditionally the oral tale—Offred speaks, not writes, her narrative—constitutes a community event, a speech act in which the listener, through his or her reactions, helps shape the tale. The oral narrative does not exist as text, but only as the shared space of performance between teller and listener.

J.L. Austin's Speech Act theory (outlined in *How To Do Things With Words*) calls such shared space the result of the "illocutionary rules" of discourse. According to Austin, every utterance possesses an illocutionary force, a rhetorical cue as to how the utterance is to be received (as a command, a request, a promise, a threat, etc.). No utterance exists meaningfully as pure discourse abstracted from contextual constraints. By introducing the context of a future audience at the end of Offred's narrative, the "Historical Notes" section breaks the illusion of performance and reminds the reader that we have been reading a fictional narrative, which, like all literary works are, "discourses with the usual illocutionary rules suspended" (Ohmann, "Speech" 53). This seems fair enough. Despite the psychological realism of Offred's perceptions, we are unlikely to confuse her with an historical character; and even though the narratives of literature and history share a fictional impulse, they are not quite identical. We may not "know" George Vancouver, the McLean brothers, Billy the Kid et al., except through texts, but few would argue that our ethical commitment to the characters of history (or of "a real historical fiction") matches our commitment to "Offred." For the fictional audience dramatized within the final section of the novel, however, Offred should not be perceived as a fictional character but as a witness to history.

It comes as something of a shock, therefore, to read the International Historical Association Convention of 2195 treating

Offred's "Tale" as "acts without consequences of the usual sort, say-ings liberated from the usual burden of social bond and responsi-bility" (Ohmann 53). Richard Ohmann argues that when the illocutionary force of discourse is suspended, as it is in literature, the reader "is neither contractually nor morally implicated, nor in any way bound by the act in which he participates" (56); and from a realist perspective, this is surely true. But Atwood's *Tale* (and post-modernism generally) seems determined to confront such notions of the reader's role in the construction of meaning, for, in rhetori-cal terms, the break with the illusion of performance implicates a new "burden of social bond and responsibility": the reader now becomes aware of her own complicity as part of a community of interpreters whose presence, and shared conceptual bases, frame what can and cannot be read. The "Historical Notes," then, free readers from their "realist" roles as collaborators and confidants, and prompt a metacognitively aware "rereading" of the "Tale" held in the memory.

The Handmaid's Tale heightens reader awareness about the read-ing process itself. It offers a narrative of reading strikingly similar to those detailed as a preferred pedagogical and/or political strategy by such critics as Bal, Bhabha, Behrendt, Hicks, and Pratt, whose various theories converge on the notion of metacognitive aware-ness. Each argues that a bottom-up preoccupation with decoding surface-level meaning must give way to a "top-down," highly self-conscious re-reading, where readers theorize the rhetorical situa-tion and situate themselves as motivated participants in the construction of meaning. Before we can claim that we "know" what the text means, we need to inquire into the conditions of knowledge—whether those conditions are visualized as a double exposure, a Third Space, a third text, a border text, or a contact zone.

These rhetorical constructs describe a site for exploring how we understand and "see" our world—an emphasis on exploration and awareness not restricted to literary criticism. As Lorna Irvine has pointed out in *Sub/Version*, others, such as art historian John Berger, regard "self-consciousness about various 'ways of seeing' [as] a necessary approach to the interpretation of art" (5). Irvine herself sees the dual role of participant and observer as a charac-teristic quality of Canadian literature and women, arguing that to "teach the reading [the subversion] of covert stories seems…a major task of feminist theory" (13). And in "Reading Ourselves: Toward a Feminist Theory of Reading," Patrocinio Schweickart concludes her article with a three-stage strategy that outlines in remarkably concise terms the process of reading in this Third Space.

We argue that recent interest in nar-rative theory and recent develop-ments in image/text composition point toward the kind of *rapproach-ment* between poetics and rhetoric that must occur if we are to achieve a fuller understanding of how we "read" postmodernist texts and images. As we hope to show in the course of this study, the considerable challenges presented by the PhotoGraphic narratives of writers and artists such as Margaret Atwood, George Bowering, Micheal Ondaatje, Brenda Pelkey, Daphne Marlatt, Roy Kiyooka, Robert Kroetsch, Fred Douglas, and others, require a col-laborative rhetorical response from their readers/viewers. These Canadian artists reach out, seeking to engage us in a dialogue about the interrelated nature of authors, texts, images, and readers. bpNichol calls this new rhetorical dimension of reading part of a "new humanism" that, as Stephen Scobie notes so elo-quently, "is simultaneously a celebra-tion of the 'human community' in its most personal form, and a linguistic manifesto, in which linguistic inabili-ty is seen as the condition of our lives" (*bp Nichol* 28).

Cover design and collage by
Margaret Atwood (1970). Reproduced
by permission of Oxford University
Press Canada and the author.

Schweickart casts reading as a dialectic, "a matter of 'trying to connect' with the existence behind the text" (53). The dialectic has three moments:

> The first involves the recognition that genuine intersubjective communication demands the duality of reader and author (the subject of the work). Because reading removes the barrier between subject and object, the division takes place *within* the reader. (53)

At first, then, reading "induces a doubling of the reader's subjectivity" (53), with one aspect attributable to the author, and the other to the reader. The feeling here is that failure to equate reading with "intersubjective communication" inevitably leads back to realist notions of reading as a bottom-up decoding activity. The second moment of the dialectic is reached when the necessary fiction of authorial intention becomes recognizable as a projection of the reader's subjectivity—and thus when the reader is recognized as sharing a primary responsibility for co-creating the text. Finally, the third moment strikes the now familiar chord of metacognitive awareness: "In the feminist story [of reading]," says Schweickart, "the key to the problem [of keeping reading from being totally subjective] is the awareness of the double context of reading and writing" (53). The third moment involves an informed assessment of both rhetorical contexts, of the social forces which impinge upon the production and reception of meaning. What we achieve through such projection, introspection, and metacognitive awareness is an interpretation of two subjectivities, of two epistemological hypotheses that shape how we know the text.

Discussion of duality and double vision as a thematic focus in Atwood's work has become commonplace since the publication of Sherrill Grace's book-length study, *Violent Duality*. What Atwood seems to have created in *The Handmaid's Tale* is an imaginative Third Space where the reader encounters the double vision as both a thematic focus and an experiential condition of reading. In an early critical article, for example, John Moss provides a revealing narrative description (almost a protocol) of his "subjective" response:

> Reading *The Handmaid's Tale* is in itself a moral experience. We do not learn through the novel that morality can be confusing. We are genuinely confused. What Atwood gives the reader to think about is often at odds with what the narrative demands we feel. We find ourselves within

the text, unable to sort out the contraries. And outside the text we find ourselves reading. The relationship between reading, morality, and individual presence in the world is a major concern of the novel and, obviously, of the author whose personality informs the work, inhabits the text, and shares with us her deepest and most whimsical fears. ("Life/Story" 87)

Reflection on our roles as readers inside and outside the text, and upon the projected subjectivity of the author, seem connected to the initially disjunctive effect that many readers associate with reading the "Historical Notes" section of the novel, the brief epilogue, set in the future, that reflects upon the action of the main narrative. Atwood enacts a narrative double vision.

When reading the "Historical Notes," the reader's sudden shift in orientation is matched by an equally disturbing realignment of relative power: reading the "Tale," we assume a role of equal partnership as we participate with the narrator (at least imaginatively) in the construction of her story; suddenly, though, when the "Historical Notes" subsume and thus subvert Offred's narrative, the relative power positions of narrator and audience shift, both pragmatically and thematically. The status of Offred's "Tale" diminishes when it is effectively rewritten by the official discourse of History. Such a reconstruction is disturbing for most readers of Atwood's novel. It is meant to be.

Consider Pieixoto's treatment of Offred's narrative:

> Strictly speaking, it [the "Tale"] was not a manuscript at all when first discovered, and bore no title. The superscription "The Handmaid's Tale" was appended to it by Professor Wade, partly in homage to the great Geoffrey Chaucer; but those of you who know Professor Wade informally, as I do, will understand when I say that I am sure all puns were intentional, particularly that having to do with the archaic vulgar signification of the word *tail*; that being, to some extent, the bone, as it were, of contention, in that phase of Gileadean society of which our saga treats. (*Laughter, applause.*)
> (282-83)

Professor Pieixoto, Knotly Wade and the Historical Association are clearly not what Offred had in mind as her implied audience. The whole tone of their response is wrong. Pieixoto's sophomoric, smut-

ty puns and jokes at the expense of those women, like Offred, who endured the religious extremism of Gilead strike the reader as ominous signs that little has really changed: Offred is still a victim of an oppressive patriarchal world view. Worse still, Offred's narrative warning against moral dictatorship, dehumanization, and atrocity in the name of the oppressive Gileadean theocracy is summarily dismissed in an "editorial aside" by the official voice of History:

> If I may be permitted an editorial aside, allow me to say that in my opinion we must be cautious about passing moral judgement upon the Gileadeans. Surely we have learned by now that such judgements are of necessity culture-specific. Also, Gileadean society was under a good deal of pressure, demographic and otherwise, and was subject to factors from which we ourselves are happily more free. Our job is not to censure but to understand. (284)

By arbitrarily framing Offred's oral tale, and by treating her experiences as an artifact, the "Historical Notes" simultaneously diminish the vitality of the fictional "dialogue" and increase the reader's awareness of his or her own interpretive responsibilities. Implicitly we are reminded that, as members of an interpretive community, readers bring meaning to texts and thus influence the performance. Arnold Davidson sees the "Notes" as a metacritical commentary on scholarly reading practices, and asks the rhetorical question, "Do we, as scholars, contribute to the dehumanization of society by our own critical work, especially when, as according to the distinguished professor of the novel, 'our job is not to censure but to understand'?" ("Future Tense" 115). The question focuses squarely on the nature of knowledge and our ethical responsibility for the creation of knowledge. For the rhetorically aware reader, questions of epistemology and ethics are unavoidable.

When cultural anthropologists or folklorists, for example, fix an oral performance in print, when they transcribe narration into narrative, they change it. Listen to the following discussion of methodology in folklore field research:

> Like butterflies, human behavior can serve the needs of science [and literature] only when it is preserved as "the remains" after the life and the moment are gone. Stories in a documentary key—stories framed by the expectations of pedagogy and academic inquiry—are at best simple reminders that each recorded text represents a once vital interaction. (Dolby-Stahl, "A Literary" 51)

DAGUERROTYPE TAKEN IN OLD AGE

I know I change
have changed

but whose is this vapid face
pitted and vast, rotund
suspended in empty paper
as though in a telescope

the granular moon

I rise from my chair
pulling against gravity
I turn away
and go out into the garden

I revolve among the vegetables,
my head ponderous
reflecting the sun
in shadows from the pocked ravines
cut in my cheeks, my eye-
sockets 2 craters

along the paths
I orbit
the apple trees
white white spinning
stars around me

I am being
eaten away by light

Journals of Susanna Moodie (1997). Reproduced courtesy of Charles Pachter and Margaret Atwood.

The approach taken by the literary critic treating the experience of reading is not so dissimilar. The presence of the critical eye may change the nature of the "once vital" initial reading experience. Certainly, in Atwood's *Tale*, the proxy academic community of the "Historical Notes" presents academic inquiry at its "unself-conscious" worst.

In *The Handmaid's Tale*, Atwood seems interested in promoting a very different, a very pragmatic, kind of interpretive strategy. The "Historical Notes" demonstrate how systems of discourse are synonymous with systems of power. Elsewhere Atwood notes that interpretation in general implicates systems of value and power:

> We are all organisms within environments, and we interpret what we read in the light of how we live and how we would like to live, which are almost never the same thing, at least for most novel readers. (*Second Words* 419)

The process of interpretation depends upon who we are and how we relate to our environment. That view informs the political theme of Atwood's novel and gives dramatic focus to many of the issues discussed thus far.

Atwood's novel (indeed all her novels) concerns power structures and how they work to confine and determine the individual's ability to communicate and interpret. Power determines freedom, or the absence of freedom; it is, according to Wayne Booth in "Freedom of Interpretation: Bakhtin and the Challenge of Feminist Criticism," a matter of *freedom from* and *freedom to*:

> All the *freedom from* [external restraints and the power of others to control thought and actions] in the world will not free me to make an intellectual discovery or to paint a picture unless I have somehow freed myself *to* perform certain tasks. Such freedoms are gained only by those who surrender to disciplines and codes invented by others, giving up certain *freedoms from*. (47)

Paradoxically, total *freedom from* is no freedom at all; it is merely a condition of powerlessness. Consider Aunt Lydia's reductive analysis of freedom, an ideologically-bound interpretation offered as an instructive anodyne to the Handmaids and to a society supposedly dying of "too much choice" (24). Aunt Lydia's role is to retrain young women of child-bearing age; she must tutor them in the ways of the new world:

> There is more than one kind of freedom, said Aunt Lydia. Freedom to and freedom from. In the days of anarchy, it was freedom to. Now you are being given freedom from. (24)

The Gileadean regime's version of freedom constitutes a political, deceptively seductive formula that effectively subverts the liberal humanist distinctions of thinkers such as Wayne Booth. The negotiated compromise characterized by Booth becomes not a limited ideological surrender in order to learn the code and discipline of society, but a complete surrender of all personal liberty. The absence of freedom, the subservience to a puritanical system of belief, is proffered by Aunt Lydia as its own reward. The true believer clears her mind: "What we prayed for," says Offred, "was emptiness, so we would be worthy to be filled..." (182). Ironically, the luxury of "freedom" from entering the discourse of human events, a luxury shared by those who have (or who regard them-

Carole Condé and Karl Beveridge, "Political Landscapes" (1998). From *Days of Action*. Reproduced courtesy of the artists.

selves as having) little place in the narrative of daily history, helps to prepare the way for the establishment of Gilead. Before the onset of the Gileadean regime, Offred chose not to participate, not to enter the narrative:

> We were the people who were not in the papers. We lived in the blank white spaces at the edges of print. It gave us more freedom. (53)

If there is a lesson here, it is that the freedom of living in "the gaps between the stories" (53) is illusory. White spaces, like "Third Spaces," are meaningful for those who have learned the code. Atwood's novel invokes the postmodernist notions of narrative, indeterminacy, and *aporia* and then reconsiders their aesthetic significance by subtly reminding her readers (by way of Offred's

example) of their own political responsibilities: Offred's initial free-dom from the narrative impedes her freedom to write, revise, and shape her own life story; one cannot withdraw from the discourse without serious consequences.

Despite Aunt Lydia's sophistry, learning and interpreting the language of the environment is a necessary first step toward *freedom to*. In a world where reading and writing have been outlawed, Offred's tale, her recorded interpretation of events surrounding the Early Gileadean Period, represents more than a documentary account; it is clear testimony of her refusal to surrender her freedom to interpret and communicate. Like the Handmaid who occupies the room before Offred's arrival, Offred communicates a message in defiance of political authority.

For Offred, the words *Nolite te bastardes carborundorum*, scratched into the corner of her cupboard by her predecessor, offer a message to be interpreted. "It pleases me to ponder this message," she says. "It pleases me to think I'm communing with her, this unknown woman" (49). The words become a prayer, a distraction from the prayers and blessings that permeate the Commander's household. The words are also subversive, an act of rebellion against the will of the Republic. When Offred first encounters the mock-Latin phrase, it holds no referential meaning: the words cannot be read—not literally, at least. Offred discovers later that the "unknown woman," her predecessor, learned the phrase when she found it scribbled in the Commander's schoolboy primer. One commentator, Harriet Bergmann, claims that this discovery and the words' connection with the Commander diminish the text's power to comfort and communicate. Bergmann says that

> the piece of *text loses its status as message* and therefore its potential to comfort Offred. Not a message of sisterhood at all, it is, at least probably, a male text, in a language as debased as the photo of the Venus de Milo ["with a moustache and a black brassiere and armpit hair drawn clumsily on her" (175)]. ("Fishing" 849)

But while it is certainly true that the meaning of the words change for Offred, we are not convinced that it *"loses its status as message."* Instead, the message of sisterhood would seem to *gain* significance. The issue is not really one of the words' literal translation, or of their contamination as a "male text": the words gain significance as Offred learns of their social function. Her knowledge of the text forges an intertextual link with all those (Handmaids or school-

boys) who seek to establish a rhetoric of resistance to authority. Offred enters "intertextually" into a subversive conversation. As Michèle Lacombe says of the message, the "notion of palimpsest…applies to the reading and writing of this phrase: [the Commander] is its immediate but not original male author, and his use of it has been reappropriated by the previous and current handmaids with subversive if ironic intent" ("The Writing" 13). The reading lesson Offred learns directly (and her audience learns indirectly) is not simply to translate (or decode from the "bottom up"), but to position oneself (to "compose" oneself) within the cultural conversation.

At first, Offred has only herself to compose: "I compose myself. My self is a thing I must now compose, as one composes a speech" (62). Language becomes both her refuge and a way to preserve sanity. She chooses to read allegorically:

> I sit in the chair and think about the word *chair*. It can also mean the leader of a meeting. It can also mean a mode of execution. It is the first syllable in *charity*. It is French for flesh. None of these facts has any connection with the others.
>
> These are the kinds of litanies I use, to compose myself. (104)

Salvador Dali, *Venus de Milo with Drawers* (1936). Photograph by Jackie Sheckler.

She interprets her world as one might solve a linguistic puzzle; like the message scratched in her closet, her world presents a "hieroglyph to which the key's been lost" (138). Constance Rooke quite rightly points out that, for the reader, "'these facts' are indeed connected[,]" and that the "statement that they are *not* operates as an invitation to the reader to discern their connection…" and "to do a better job of interpretation…" (183-4). At this point in Offred's story, however, it is not the validity of interpretation that is important; it is the process, the act of keeping both her intellectual skills and her political will alive. Offred's plans to press a dried flower under her mattress, to "[l]eave it there, for the next woman, the one who comes after" (92) represents an act of self-expression that presupposes a "self" to express. Communication and social identity are inextricable. Like her condition, Offred's sense of self is not unique—and her symbolic reaching out to another, "the one who comes after," may be read as a gesture of sisterhood akin to the scratching of words in a cupboard.

To communicate is to hold power. Words like those on the petit-point "FAITH" (54) cushion she finds in her room, or contained in

my name is someone and no one...
I have borne witness to the world:
I have confessed the strangeness
of the world

Claudia Sbrissa, *Little Pillow* (c. 1998). Front and back views. Reproduced courtesy of the artist.

the lyrics of songs, "especially ones that use words like *free*...are considered [by the powers that be] too dangerous" (51). Only those with political power are singled out to enjoy the company of words: Aunt Lydia flaunts her prerogative to read during the district Salvaging, a public ceremony, by taking "an undue length of time to unfold and scan [a written notice,] rubbing [the handmaids'] noses in it...(258); the Commander's office is an "oasis of the forbidden" (129), filled with books—"[b]ooks and books and books, right out in plain view, no locks no boxes" (129; and Offred's forbidden evening visits with the Commander revolve around playing games of Scrabble. The language games further revitalize Offred's "nearly forgotten" (145) link to her past self and "customs that had long before passed out of the world..." (145). A pen between her fingers "is sensuous, alive almost, [she] can feel its power, the

PhotoGraphic Encounters

power of words it contains" (174). As Offred's power over language increases, so too does her sense of social identity and purpose.

The impulse to communicate symbolically via a dried flower, or the silent semaphore of "infinitesimal nods" (265) among the Handmaids, or the exchange of passwords among the resistance movement, or the thirty tape cassettes that constitute Offred's narrative—each act affirms the existence of the collective will to resist: "We show each other we are known, at least to someone, we still exist" (265). The alternative, an emptying of self and an obliteration of personality, suggests the truly insidious nature of *freedom from*. Janine, the frightened, obedient Handmaid, exemplifies one who withdraws from all attempts to communicate and interpret. After the Particicution, a public execution, Janine has a smear of blood across her face and a clump of blond hair in her hand. The brutal murder of a Guardian, a murder in which she was an active participant, makes no discernible impact upon her. "You have a nice day," (263) she says, echoing an insipid, empty phrase that, given the context, seems all the more meaningless. Janine has no message to communicate, no socially aware consciousness left to express. "[S]he's let go, totally now, she's in free fall," says the narrator, "[S]he's in withdrawal" (263). Janine enjoys freedom from all care and responsibility; she is an empty vessel to be filled and used by the Republic.

Similarly, following her friend Ofglen's suicide, the narrator feels a sudden surge of submission. Wishing she were safe from discovery now that Ofglen is dead, she contemplates emptying herself, becoming "a chalice. I'll give up Nick, I'll forget about the others, I'll stop complaining. I'll accept my lot" (268). Although such thoughts are only momentary, "for the first time" she feels "their [the regime's] true power" (268). The power of the regime lies not in its authority but in its ability to usurp a person's *freedom to*. What is at stake here, if we interpret Atwood correctly, is the freedom of self-expression: Gilead is interested in more than sociopolitical power through the control of information and the dissemination of the party line; the genius of the Gileadean power structure lies in its ability to replace personal experience and awareness with a master narrative that makes personal self-expression and interpretation redundant.

In the Republic of Gilead, the "true believer" is one who no longer has any beliefs—if we take the word belief to imply a volitional act. To write a novel, or to compose a taped message for future generations, celebrates a belief in the power of one's personal consciousness to communicate beyond the self; it is a reaching out to an other. As the narrator puts it, "By telling you anything

at all I'm at least believing in you, I believe you're there, I believe you into being" (251) "Belief" is, in essence, an assertion of epistemology; in this case, it is a creative impulse that rejects the negation of an historically and socially situated self and denies the absence of possible audiences. Narration and appropriate audience response are cast as political acts of self-preservation.

⊕ ⊕ ⊕ ⊕ ⊕ ⊕ ⊕ ⊕ ⊕

From Vertical to Horizontal Reading

What we have been looking at throughout our discussion of *The Handmaid's Tale* is the effect of rhetorical intention on artistic form. Atwood is an author of pronounced moral and didactic sensibilities working within a predominantly modernist and postmodernist discourse. Like her protagonist, the author must enter the discourse, surrender herself to "codes invented by others" in order to reinsert them into her own narrative. Rather than seeking to argue against (or ignore) the developing "narrative" of Canadian postmodernist authors, Atwood chooses to tap into the narrative and establish an integrated relationship with her audience; in the process she offers her readers a reading experience subtly different from that offered by other postmodernists such as George Bowering and Robert Kroetsch. The postmodernist author is thought to toy with the reader through a medium of expression that is antagonistic toward realist interpretative practices and offers, in its place, a playful reading, to be enjoyed at the moment of perception. Bowering speaks often about drawing "the reader's attention to the surface" (*Mask* 120) of literature, to visualizing "sharp imagery & language that is interesting prior to reference, or interesting because the reference is so difficult to ascertain" (114). Bowering's concern, as we understand it, is twofold: that "the literal prose...be more interesting & [that] the reader...be called upon to actualize the work" (120). These interests do not compromise his work's political intent. It is simply that Bowering wishes his readers to linger over the sounds and shapes of the words as they are being read. Accordingly, in an essay such as "The Painted Window," when he argues that postmodernist reading involves a suspension of critical judgment and an engagement in the surface-level delights of language, he is not counselling against interpretation. He is counselling against conventional realist reading, which overlooks more than it sees. Atwood, on the other hand, is unambiguous on this issue: she sees interpretation as a political imperative; she wants her reader aware of the significant allegorical correspondence between reading a work of fiction and making sense out of

life. Neither reading nor life can ever be considered ideologically or epistemologically innocent—and every act of reading constitutes an act of self-definition in "conversation" with author, text, image, and context.

In the final analysis, flirtation with the extreme postmodern condition of total participation in an indeterminate semiotic landscape is anathema to Atwood. "Perspective is necessary," (135) says Offred; and that is what Atwood gives her readers, the "illusion of depth, created by a frame, the arrangement of shapes on a flat surface" (135) that makes interpretation possible. The extreme postmodernist alternative traps the uninitiated reader, like Offred, in a "bottom-up," primary reading experience that precedes interpretation,

> your face squashed against a wall, everything a huge foreground, of details, close-ups…a diagram of futility, crisscrossed with tiny roads that lead nowhere. (135)

That Atwood is ethically and aesthetically concerned with questions of perspective seems obvious: her novels and short stories are full of examples of characters fixated by surfaces, trapped into a close-up view of reality ostensibly unmediated by a theoretical perspective. This is a view akin to Paul Virilio's nightmare vision, where high definition images of real time events induce "virtual" stasis. Joan Foster, in *Lady Oracle*, writes her gothic novels "with [her] eyes closed" (131), not wishing to take responsibility for what she commits to paper; she is someone who finds it "so hard to read theories" (212), and yet, ironically, she "always found other people's versions of reality very influential" (161). Similarly, Sarah in "The Resplendent Quetzel" does not believe in reading about places before visiting on vacation, and her story dramatizes how prior knowledge affects what we see (or don't see). And, to take one more example, Rennie Wilford laments early in *Bodily Harm*, "I see into the present, that's all. Surfaces. There's not a whole lot to it" (26); only later does Rennie's superficial vision of life give way, when her world is turned "inside out" and she discovers that there is no refuge from political commitment, from living life "in depth." The postmodern condition of pre-critical perception does not hold the attraction for Atwood that it does for Bowering: to "live in the moment," says Offred—and Atwood—"is not where I want to be" (135). Atwood's characters and readers learn to recognize the limitations of the immediate moment and to become aware that perception depends upon perspective, upon the assumption of an allegorical stance and rhetorical self-awareness.

"The post-modernist novelist admits the power of the reader. He is sitting with the book before him, and may if he feels like it, skip twenty pages, or rip the last chapter out on his way from the book store. The movie-goer has no such power. He can stay or go. The reader can go back to his favourite scene a hundred times. His literal experience is spatial." *George Bowering—"The Painted Window."*

"The *phatic image*—the targeted image that forces you to look and holds your attention—is not only a pure product of photographic and cinematic focusing. More importantly it is the result of an ever-brighter illumination, of the intensity of its definition, singling out only specific areas, the context mostly disappearing into a blur." *Paul Virilio—The Vision Machine.*

1 Citing a number of feminist writers (including Nancy Hartsock, Elaine Showalter, and Gracie Lyons), Chris Bullock calls this tendency toward wholeness typical of a "female mode" of writing:

> This female mode is indirect, informal, additive; it is non-adversarial and non-combative; it attempts to achieve an integrated and supportive relationship with its audience.... (2)

Atwood's novel at once embraces the current Canadian postmodernist aesthetic—in particular, the theory that life, like the novel that seeks to represent life, is shaped by a narrative process—and counsels against postmodernism's perceived apolitical tendencies. It is only through narration, she implies, through communicating our story to others, that we establish individual and collective identities. Where some contemporary authors seek to divorce theory from everyday life, Atwood pushes toward a reconciliation, a linking of theory to experience, of ideas to life.[1] To eschew interpretation and to retreat into an exclusive focus on the process of narration means risking the rhetorical distance needed to understand who we are and how we relate to the world around us. For some postmodernists, the medium may be regarded as the message, but as Atwood makes clear, it is not the whole story.

⊞ ⊞ ⊞ ⊞ ⊞ ⊞ ⊞ ⊞ ⊞

From Vertical to Horizontal Reading

A key critical document, a seminal statement on the role of allegory in the rhetoric of reading postmodern narrative, is Craig Owens's 1980 essay "The Allegorical Impulse: Toward a Theory of Postmodernism." Owens's essay, which we are convinced has directly or indirectly influenced many of the artists, authors, and critics referenced in this book, posits a renewed interest in allegory as the principal distinguishing feature of contemporary (postmodern) art. The allegorical impulse, argues Owens, "is an attitude as well as a technique, a perception as well as a procedure" (204). In other words—or, at least, in the words we think Owens would endorse—the allegorical impulse, by bringing attitude and perception into play, stresses reading and viewing as rhetorical activities. Owens says as much when he takes up the role of allegory in so-called vertical and horizontal reading practices.

Before the postmodern period, allegory, like rhetoric, was regarded by most critics and artists as something added onto (and thus separable from) the work itself: "allegory *is* extravagant, an expenditure of surplus value; it is always *in excess*." Poetics, which tends to separate form from content (and the work from its reception), seems right at home with a modernist/realist aesthetic, for, by viewing rhetoric (including allegory) as something detachable, "modernism can recuperate allegorical works for itself, on the condition that what makes them allegorical be overlooked or ignored" (215). For the postmodernist, however, allegory is but one of an array of potentialities, structural possibilities, "inherent in every work"; moreover, according to Owens, "allegory remains *in potentia* and

is actualized only in the activity of reading, which suggests that the allegorical impulse that characterizes postmodernism *is a direct consequence of its preoccupation with reading*" (223, emphasis ours). "And with the reader," we might add, for, again according to Owens, allegory has designs upon the reader: "it should be remembered that allegories are frequently exhortive, addressed to the reader in an attempt to manipulate him [or her] or to modify…behavior" (225). If Owens is right—and we think he is—the allegorical impulse pushes all contemporary art toward the literacy narrative form we outlined in our introduction.

When we recognize allegory, we are encouraged to see a doubling of one text by another, whether that "other" be in the form of an embedded commentary, an associated story, a visual illustration or complement, or whatever: "In allegorical structure, then, one text is *read through* another, however fragmentary, intermittent, or chaotic their relationship may be" (204). Allegorical reading is "palimpsestic," where the doubling of texts destabilizes any easy attempt to find or impose meaning. The doubling effect, as the palimpsest metaphor suggests, asserts a vertical stacking of images and/or narrative associations. Or, to co-opt a term from photography, the allegorical way of seeing emphasizes the narrative *depth of field*. Lingering over perceptions of depth tends to slow down the reading process, effecting a static, predominantly spatial, relationship with the work. Allegory takes on the role of the arrested moment, "the epitome of counter-narrative, for it arrests narrative in place…[superinducing] a vertical or paradigmatic reading of correspondences upon a horizontal or syntagmatic chain of events" (208). Allegory functions, then, as part of a rhetoric of interruption—of baffles, citations, ironic asides, counter-narratives, anecdotes, etc.—that postmodern authors and artists draw upon to co-ordinate the ebb and flow of their narratives. But, as Owens allows in a footnote to Joel Fineman's work on "The Structure of Allegorical Desire,"

> there is allegory that is primarily horizontal…[and] there are allegories that blend both axes together in relatively equal proportions. (qtd. in Owens, 208)

It is this notion of horizontal and blended allegory that we find especially intriguing. The postmodern imperative, as we see it, pushes the reader toward a horizontal orientation—one emphasizing narrative flow over stasis, metonymy over metaphor. Indeed, we would risk the following: that the most successful postmodern narratives feature, in some measure, the paradoxical rhetoric of horizontal allegory.

The rhetoric of reading the postmodern seems to require readers to take up an anti-realist or post-realist stance. Realist reading practices are tied to metaphors of closure, verticality, and a close-up view of the text; postmodern reading emphasizes openness, horizontal associations, and a decidedly contextual focus.

In her preface to *Reading Frames in Modern Fiction*, Mary Ann Caws offers a clear picture of a critical tendency to spatialize, to freeze and frame the signifier:

> in the most widely read and enduring narratives, certain passages stand out in relief from the flow of the prose and create, in so standing, different expectations and different effects. We perceive borders as if signaled by alterations of pattern and architectural, verbal, or diegetic clues. (xi)

These framed sequences create "a privileged space and a remarkable moment, brief or prolonged, which remains in the mind thereafter" (Caws xi). For Caws, the text becomes a hypothetical construct frozen in time and insulated from the shifting horizon of audience expectations.

Henri Cartier-Bresson, *Man Jumping a Puddle* (1932). Gare St. Lazare, Paris. Reproduced by permission of Magnum Photos.

The kind of interdisciplinary exploration necessitated by a joint focus on reading and rhetoric repeatedly returns to questions of process and power (especially pedagogical power and interpretive freedom), to tropological aspects of language, and to epistemology. We can hardly ignore the fact that the creation of a new discourse—one that treats reading as a rhetorical practice—establishes its own way of "seeing" the subject, establishes (or valorizes) particular metaphors that enable new ways of thinking and talking about reading; thus it seems fair to speak about "the rhetoric of reading theory" and how that rhetoric influences (or has the potential to influence) the problems we see, the questions we ask, and the language we use.

A vertical orientation embraces, as natural, a fixation upon the arrested moment, a doctrine that "dominated artistic practice during the first half of the nineteenth century" (Owens 210) and has influenced narrative composition through at least the first half of the twentieth century. A horizontal orientation calls for a different kind of associative practice, one that has more in common with putting together the frames of a film, the images in a dream, or the hyperlinks in the World Wide Web. Instead of framing and reinforcing the symbolic or aesthetic unity of a single image or scene, the horizontal orientation promises a more promiscuous, aleatory mix of possible associations. The rhetoric of horizontal allegory

casts reading and viewing as forms of invention, encouraging us to see the act of reading as involving something other than the traditionally detached, spectator role of modernist practice. Reading horizontally means learning to read *through* the text, to delight in both surface texture (what Gregory Ulmer calls the "literal/letteral play" of word and image) and depth of field (the array of lateral associations invoked by our interaction with the text). The textual or visual work read horizontally is a site to be explored, not a framed moment to be admired or decoded.

What we are talking about here, though, is not some special attribute of postmodern texts; we are talking about rhetorical attitudes toward reading and viewing. How we read and see is largely a matter of how think we read and see. In terms of literary and visual arts criticism, for example, interpretation is inevitably guided by the critic's vertical or horizontal orientation. Modernist critics tend to look for aesthetic coherence in terms of the work's unity of effect; they hold up a mimetic ideal which prizes realism as an aesthetic category and practice. Postmodernist critics quite simply

Darlene Kalynka, "What should I do with the farm?" (1995). Earthbox from *Summer Fallow*.
Kalynka's earthbox forms a palimpsest where the dark earth shows shadow-like through a white screened image on plexiglass.

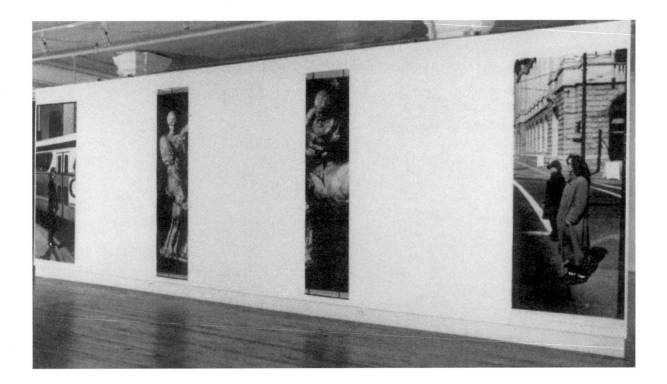

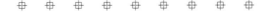

Ian Wallace, *Heavenly Embrace* (1987). Installation view. Reproduced courtesy of the artist.

Just as at the lexical level the meaning of language changes with time and context, so more complex arrangements of signifiers change. A catalogue of distinctive features (a poetics) is only meaningful (1) within a specified context, and (2) for those who consent to its authority as an enabling schema. At a social level, of course, we need such reference points if critics hope to engage in anything but discussion of theoretical abstractions. However, it is becoming, we suggest, increasingly difficult to cite "textual evidence" as if that evidence constitutes an ideologically innocent and objectively verifiable entity. We cannot—and should not—avoid talking about the text, but, as the principles of the New Rhetoric suggest, the significance of textual features is always contingent upon our sense of the text's rhetorical context (a sense guided by our epistemological assumptions).

employ a different orientation to the text; they look through the text to other possible competing interpretations and associations.

⊕　⊕　⊕　⊕　⊕　⊕　⊕　⊕　⊕

Reading as Critical Performance

By changing the rhetorical situation in which texts are read, postmodernist literacy narratives variously seek to overturn any conventional vertical conception of oral, visual, and written communication. Theory takes on the didactic function of a critical interlocutor, guiding audience response by extending to visual and verbal texts the dynamics of production and response that have been traditionally limited to public speaking alone. As a result, the formal texts of modernist fiction and the "performance texts" of postmodernism seem to reflect two very different kinds of reading experiences; they certainly imply two very different world views.

The reader's self-consciousness, then, is not simply prompted by thematic references to the construction of meaning; the primary reading experience (the perception of the text that precedes formal

interpretation) is likely to be more pronounced for those encountering postmodernist/metafictional texts for the first time. As the reader begins to anticipate the rhetoric of postmodernism, attention to surface details (that is, the process of bottom-up decoding) gives way to a new rhetorical orientation wherein we set aside our conventional expectations and begin to experience and reflect upon our responsibilities for the co-creation of meaning. The process, as we have described it, echoes the pedagogical impulse alluded to in Chapter 1—and for good reason. Canadian postmodernists share a central concern for the reader, and for teaching the reader new ways of knowing. Once again, the rhetorical conception of reading and writing as part of a collaborative communication model foregrounds epistemology as an ideological concern: the social dynamics and politics of our ostensibly innocent ways of knowing are shown contaminated by competing cultural forces; and the rhetorical acknowledgement of the artist and audience as participating agencies roots postmodern discourse in a particular situation, thus further implicating the discourse's allegorical, historical, and political dimensions.

The "new rhetoricians" (especially, we would argue, those exploring the borderblur of PhotoGraphic composition) ask us to reconsider our traditional (epistemological) assumptions about story, genre, point of view, epistemology, character, and the process of interpretive reading. Their works question the traditional borders of verisimilitude, modulating the referent for "reader" and "viewer" between the figure invoked and the figure addressed.[2] Each of these authors and artists creates works that dramatize the notion of art as both transaction and event: they help us understand and resolve questions regarding the nature of, and possibilities for, collaboration; the ethical and political responsibilities of defining oneself in the process of reading, seeing, and writing; and the new consciousness of oral discourse and of reading and seeing as a kind of ongoing conversation. Generalizations, of course, tend to leave out a good deal: while it is fair to say that all the artists and authors discussed in this book share a common view of reality as a narrative process, each's individual sense of the aesthetic, social, and political implications of this new world view differs significantly. And it is to an exploration of these commonalities and differences that we now turn.

2 Our terms "reader addressed" and "reader invoked" are based upon the categories Lisa Ede and Andrea Lunsford establish in their fine essay "Audience Addressed/Audience Invoked: The Role of Audience in Composition Theory and Pedagogy."

In postmodernist Canadian literature, the notion of fiction creating, rather than representing, life has gained currency as both a controlling aesthetic and a central theme. Books such as George Bowering's B*urning Water*, Robert Kroetsch's *What The Crow Said*, and Michael Ondaatje's *The Collected Works of Billy the Kid* and *Coming Through Slaughter* foreground the fictionality of history and the importance of individual perception by deliberately disrupting expectations of what and how the reader reads. Kroetsch says that "the fiction makes us real" (*Creation* 63); Ondaatje refers to the arrangement of facts in *Coming Through Slaughter* as "expanded or polished to suit the truth of fiction" (*Coming* 158); and Bowering calls *Burning Water* "a real historical fiction" (*Burning* 9). What is being stressed is the construction and reconstruction of narrative as a cooperative act between writer and reader. What is being interrogated is the nature of authenticity and truth.

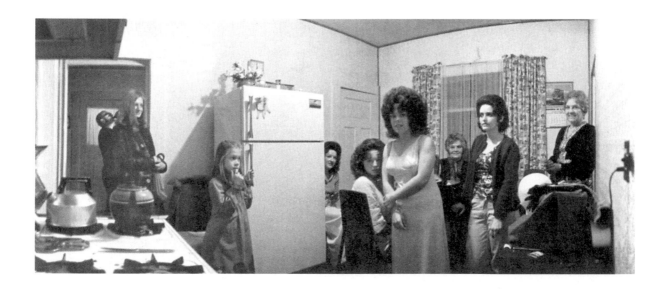

Fred Douglas, "My Sister Jo Getting Ready for her Wedding" (1975). From *Durations*, taken with a Widelux panoramic camera.

Authors and artists such as
Bowering, Douglas, Kroetsch,
Marlatt, Minden, and Pelkey
would argue that the truly extraordi-
nary response is one which
continues to valorize the atrophied
narrative conventions of an increas-
ingly obsolete world view. The
authors and artists that interest us in
this study are self-conscious rhetori-
cians narrating what they see in
terms of how they believe humanity
constructs reality. Or, in Bowering's
"other words, the novel is now
saying, 'Hey, I'm human, too!'"
("Painted Window" 36).

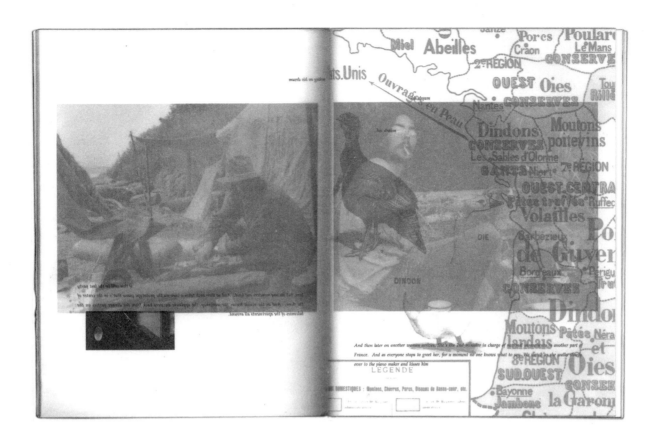

Reading in the postmodern condition. Page spread and overlays from *How to Avoid the Future Tense* (1991), a bookwork by Liz Magor and Joey Morgan. Reproduced courtesy of the artists.

Novelist as Radical Pedagogue: Reading George Bowering and Postmodern Literacy Narrative

3

Interarts studies typically focus on correspondences between literature and the visual arts, especially painting. The whole tradition of Ut Pictura Poesis is founded upon a faith in such correspondence. It seems natural enough for authors and artists to borrow from one another, for visual artists to write and literary authors to paint, sketch, or take photographs. Margaret Atwood is famous for her naïve watercolours and collages; Roy Kiyooka for his photo-textual compositions—"dazzling...forays into diverse artistic media," which, as Roy Miki speculates, "may have made him a slippery writer to comprehend..." ("Inter-Face" 52); Michael Ondaatje for his own photographs and his interest in photography as literary trope; Diane Schoemperlen for her inclusion of the photographic as what Robert Wilson calls "dirty realism" in Double Exposures *and* Forms of Devotion: Stories and Pictures—*and the list goes on. We turn here, though, to the prolific but marginal literary figure of George Bowering, not because he has been a major practitioner of PhotoGraphic composition, but because his body of work (creative and critical) provides a wonderfully articulate literacy narrative on the rhetoric of reading visual and verbal texts.*

Photographs and Pedagogy

Eva-Marie Kröller's study *Bright Circles of Colour* has established George Bowering's reputation as a literary figure attuned to the strategies of visual culture. Though not well known as a visual artist himself, Bowering started off his military career as a photographer for the RCAF—and as an author he has retained an abiding interest in vision and photographic representation.

Bowering has nurtured life-long friendships with such visual artists as Greg Curnoe and Roy Kiyooka, sometimes engaging in collaborative work. *The Man in Yellow Boots*, co-authored with Kiyooka, suggests one early form of collaboration; Bowering's artist's book, *Baseball: A Poem in the Magic Number 9*, suggests another. Both are concerned with the everyday, with transforming vernacular experiences and pastimes into art.

Elsewhere, Bowering has taken an active interest in the choice of photographs to illustrate his books: "I like photographs rather than paintings or drawings, rather than art," he says, "to decorate my books. On the cover or inside, I prefer photographs.

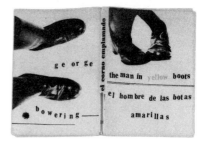

George Bowering and Roy Kiyooka, *The Man in Yellow Boots*. Cover image. Reproduced with permission from George Bowering and the estate of Roy Kiyooka.

George Bowering. Selection of book cover images. Reproduced courtesy of the author. Photograph by Donald Lawrence.

"A good illustration of Bowering's concept of self are the photographs on some of his books.... [H]ere, the authorial mystique is often ironized, even self-destructive." *Eva-Marie Kröller—Bright Circles of Colour.*

Photographs happen now, and then, now and then. But art always happens when. No matter how active, art comes from somewhere like eternity and is pointing its nose, and ours, toward eternity" (*Errata* 27). A sense of visual decorum linked to a distaste for high art pretensions informs his aesthetic position.

In this chapter, though, we are less interested in Bowering's own visual explorations than in the ways those explorations have helped shape his rhetoric of reading and seeing. With Kröller, we want to argue that Bowering's attention "to visual strategies is at the centre of an uncompromising commitment to his art" (12)—to a celebration of vernacular expression and representation. We approach his

WESTERN: Caprice?

(a) heroine: Caprice

1. attractive freckles (from Trish)

2. has my copy of _Faust_ (including stamp of
 Sask. Theatre). (and other books)

3. name is Caprice (only one name?)
 ⟶ maybe book's title.

4. she's a poet.
 See _Portrait of an Artist_
 p. 217.

5. she loves one of those ballplayers.

George Bowering. First page of Bowering's *Caprice* notebook (rough notes for the novel *Caprice*). Bowering Papers. National Library of Canada. Reproduced courtesy of the author.

recent writing, then, as an extended literacy narrative, one intent on teaching his readers a postmodern mode of visual and verbal response.

In "Extra Basis: An Interview with George Bowering," Laurie Ricou asks Bowering to talk about pedagogy, about teaching in your books, if you do" (Quartermain and Ricou 52). It is a question to which Bowering never responds directly. Instead, he reveals that he sees himself as a "good, but not devoted" teacher, and he recalls how *Caprice* "probably began with a graduate course [he] gave on the Western ten years ago" (52). The response is not so much an evasion as it is a characteristic omission—and probably a reaction

against what he sees as the pronounced moral didacticism of other contemporary Canadian writers, such as Margaret Atwood. Nonetheless, Bowering remains intellectually and emotionally concerned about "teaching" the reader how to respond. Perhaps more than any other Canadian writer, he has attempted to theorize away the boundaries between critical and creative discourse; and, in the process, he has explored the area of overlap between the postcolonial and the postmodern. As Kröller says on the back cover of *Imaginary Hand*, Bowering's own critical and creative idiom, though typically iconoclastic and flippant, "only serves to disguise the committed, even stern, voice he assumes in his role as teacher and critic."

Not all critical readers are as convinced as Kröller that Bowering's work contains evidence of serious commitment. Some see Bowering's writing, and the Canadian postmodern generally, as both frivolous and a threat to Canadian culture; and, significantly, such critics as T.D. MacLulich identify postmodernism and the reading practices associated with postmodernism as pedagogical problems. Fearing a decline of interest in the Canadian canon, in such realist authors as Frederick Philip Grove, Morley Callaghan, Hugh MacLennan, Sinclair Ross, Margaret Laurence, and Robertson Davies, MacLulich argues that

> [o]ur universities should be encouraging such writing, rather than calling for experimental or language-centred fiction. After all, what will we get if Canadian fiction wholeheartedly adopts the international style? At best, we will see more incarnations of *The Studhorse Man* (1969). At worst—and this a more likely result—we will get more works like Chris Scott's *Bartleby* (1971) or George Bowering's *A Short Sad Book* (1977) and *Burning Water* (1980). The games that these works play with Canadian themes may not announce the health of a national tradition, but may predict its death, crushed by the weight of excessive self-consciousness. (252–53)

For MacLulich, the realist paradigm inherited from the dominant founding cultures remains an unquestioned (and seemingly unquestionable) presupposition: "When there is an emphasis on technical innovation in fiction—and a concurrent denigration of the straightforward mimetic possibilities of fiction—then our fiction may lose its capacity to mirror the particularities of culture and personality" (250). The indictment is a serious one. MacLulich implies that, by reading the Canadian postmodern, we

are forsaking issues of social import. Moreover, he argues that since "Formal instruction in Canadian literature is now the single most important factor in shaping the future readership for Canadian writing" (248), what we teach has serious social consequences. MacLulich is surely right to draw attention to questions of curriculum and the role of instruction in the development of a readership, but he goes too far when he suggests that enthusiasm for teaching and reading the postmodern is simply a matter of satisfying "the latest dictates of literary fashion" (249). If, contrary to MacLulich, we start with the assumption that there may be a serious social purpose to Canadian postmodernism, then we are obliged to reconsider the ethics of reading Bowering and what his work teaches.

Taking Bowering Seriously

In this chapter we shall attempt to highlight the serious side to Bowering's view of reading: first, by focusing on *Burning Water* and *Caprice*, two-thirds of an as yet unfinished trilogy very much concerned with the subject of reading, seeing, interpreting, and postcolonial discourse; and second, by turning to his most politically aware work to date, *Shoot!* All three novels suggest a complex set of literacy narratives, each intent on tuning both eye and ear. "I believe that reading comes before writing and speech," says Bowering, reflecting on the composition of *Burning Water* and *Caprice*.

> Reading involves, say, reading the sky to see what the weather is going to be like tomorrow. And then eventually people say, hey, I could actually put up something for somebody to read, like a little pile of stones, or blaze a tree. (Quartermain and Ricou 65)

Burning Water, a novel tracing Captain George Vancouver's colonial explorations in western British Columbia, treats the theme of reading as inner vision—"the difference between fact and fancy and imagination"; *Caprice*, a Western tale of frontier development, is much more interested in reading as perception—"*Caprice* is all about seeing things, and it keeps talking about various kinds of eyes and language" (Quartermain and Ricou 65). But in both novels, the author depicts writing and reading as communal and consensual processes; he seems very aware that, in practice, readers use what writers say to construct and consolidate their own meanings.

Writer, text, and reader collaborate, through the text and the space it brings into focus, to make meanings—meanings that take shape "beyond" the text. The question of how we read our world marks a significant area of overlap between postcolonialism and postmodernism, for both discourses challenge the dominant order and both engage in what Linda Hutcheon calls "debates and dialogues with the past." She sees this overlap as a "conjunction of concerns" and asserts that "it is not just the relation to history that brings the two 'posts' together; there is also a strong shared concern with the notion of marginalization, with [the] state of ex-centricity" (72). Postmodernism offers a critique of the conventions of realism; postcolonialism seeks to counter the imported narratives of an imperial culture, for, as Kröller points out, postmodernists and postcolonialists alike consider realism "an instrument placed at the service of the conqueror to perpetuate the reflection of his world image as the only one possible" ("Postmodernism" 53). Both discourses show an almost irresistible tendency to converge on topics of perception and interpretation, on reading, especially for a postmodern author dealing with postcolonial themes.

Bowering writes historical narratives about colonial conquest and postcolonial resistance to imported tradition; thus he initiates a double vision that enables an ongoing dialectical struggle between conventions of realism and postmodernism (or what Bowering calls "post-realism"). In his fiction, narratives of imperial history are subverted by a metanarrative that continually foregrounds the processes through which histories are constructed and reconstructed. The focus shifts from the historical record, as documented and sanctioned by colonial culture and its discursive practices, to a fascination with how history gets written and read. As Kröller says of *Burning Water*, "postmodernist scepticism toward the ability of language to capture truth [is] placed at the service of defining the role of fiction in a post-colonial context" ("Postmodernism" 60). Bowering in particular is committed to teaching his audience a rhetoric of response that will make sense of this postmodern/postcolonial overlap.

In his remarkable prologue to *Burning Water*, Bowering offers a preface to reading in which he frames a rhetorical space for the composition and reception of narrative. "When I was a boy," he begins in what first appears to be a conventional enough opening, "I was the only person I knew who was named George, but I did have the same first name as the king. That made me feel as if current history and self were bound together, from the beginning" (9). The apparently innocent coincidence of names provokes a wider recognition that the narratives of history have consequence for

Bowering's developing sense of identity. Living in Vancouver prompts yet another series of highly personal associations: Vancouver, George Vancouver, George the Third, and Bowering's own geographical and historical "involvement." "What could I do," he asks rhetorically, "but write a book filled with history and myself, about these people and this place?" (9). Both Georges, Bowering and Vancouver, depend on narrative, are constructed in narrative; and any attempt to pretend objectivity by hiding behind the conventions of realism would only compromise Bowering's sense of narrative's potential authenticity.

Storyteller, subject, and, as Bowering makes clear in the conclusion of his prologue, audience are all implicated in a complex narrative interrelationship that collapses conventional distinctions between oral and written discourse, history and fiction, writing and reading:

> We cannot tell a story that leaves us outside, and when I say we, I include you. But in order to include you, I feel that I cannot spend these pages saying *I* to a second person. Therefore let us say *he*, and stand together looking at them. We are making a story, after all, as we always have been, standing and speaking together to make up a history, a real historical fiction. (10)

By conflating the historical record of colonization and the metafictional reflections of a contemporary narrator, Bowering constructs his "real historical fiction," a simulacrum foregrounding postcolonial concerns. We are, in effect, asked to view the traditional, realist narrative of discovery and colonial exploration through a postmodern lens.

The new rhetorical situation for reading depends, in part, upon what we perceive to be the status of the prologue and its relation to the text that follows— an issue and a relationship problematized by Derrida. In *Dissemination*, Derrida reminds us that "[p]refaces, along with forewords, introductions, preludes, preliminaries, preambles, prologues, and prolegomena, have always been written, it seems, in view of their own self-effacement" (9). The prologue introduces the text but traditionally "remains anterior and exterior to the development of the content it announces" (9). Derrida asks, "Couldn't it be read otherwise than as the excrement of philosophical [or narrative] essentiality—not in order to sublate it back into the latter, of course, but in order to learn to take it differently into account?" (11). Bowering's prologue, we suggest, needs to be read "otherwise."

If *Burning Water* centres on the author's presence, it simultaneously involves the presence of the reader, the other maker of meaning without whom the narrative would cease to exist as a process of communication. Vancouver and Bowering both rely on the reader, for

> as the voyage grew longer and the book got thicker he felt himself resting more and more on his faith in the readers: would they carry him, keep him afloat? (173)

Without the reader, the process of narration congeals into the product of narrative; but the rhetoric of the prologue, if accepted as an enabling circumstance for reading, creates a shared space that privileges communication and collaboration between writer and reader as both a controlling metaphor and a guide for reading postmodernist narrative. There is, as MacLulich and others repeatedly insist, a postmodern playfulness about Bowering's work, his wordplay, his *roman à clef* references, his provocative public statements on reading. But if we are going to read *Burning Water* (or any novel by Bowering) in the spirit in which it is offered, we need to take the notion of "collaboration" seriously, for it is only through collaborative reading and writing that a postcolonial discourse can emerge.

This is no easy task for readers who operate with romantic (and Eurocentric) notions of "belief" and "suspended disbelief." Many readers have responded with irritation to what they see as a dual narrative: Carla Visser sees Bowering's story about the process of literary production and reception as intruding on the narrative of Vancouver's voyage; and Edward Lobb finds that the author's presence "spoils the reader's fun—the traditional fun, that is, of absorption in narrative" (123). Another reader, Janet Giltrow, in an early review of *Burning Water*, complains about what she calls "the interpolated narrative":

> conveying some very ordinary details of the writer's life, the interpolated narrative embarrasses the text, lingering like an unnecessary excuse....Chapters beginning "He..." are no doubt deliberately ambiguous in reference; but when the antecedent George turns out to be Bowering rather than Vancouver, the reader is disappointed, for this version of the life of Vancouver is interesting, and the delays in advancing the story are exasperating. (118)

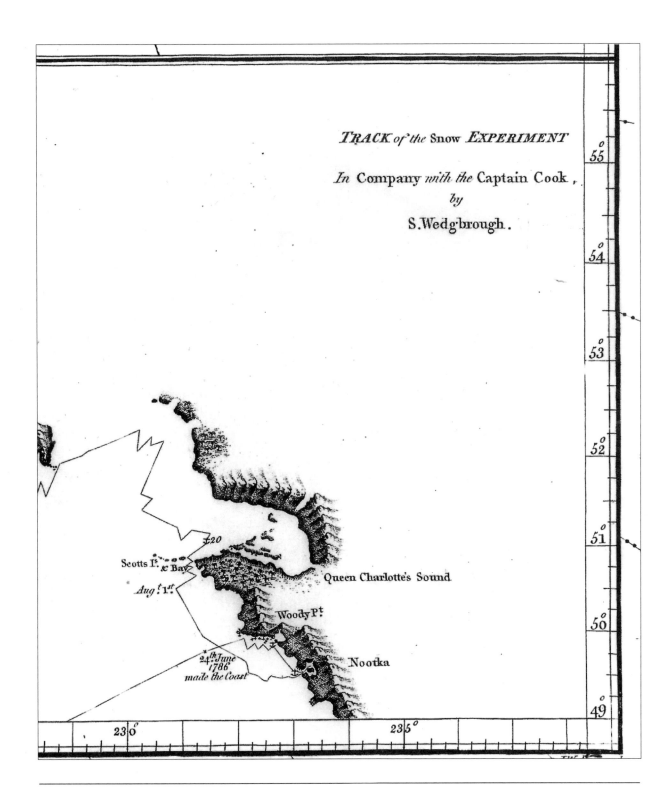

S. Wedgbrough, "Track of the Snow Experiment: In Company with the Captain Cook" (1789). Engraving.

Giltrow compares the novel to a "projected," ideal text—one that is comfortably coherent, plain-spoken, and referential. "The structural commotion of flashbacks and fast-forward leaps," she says,

> pesters this plain-speaking [that she finds in the travel sections] with stops and starts and recursiveness, making the narrative spasmodic just where the logic of travel demands that the story be advanced. (120)

Giltrow is by no means unaware of Bowering's probable intent in writing *Burning Water*; on the contrary, she acknowledges that "Bowering may see this as a contest between traditional and modern fiction" (120). She simply feels, however, that authorial intention is irrelevant here. The important issue is one of genre and the schema it demands: "Voyage narrative is neither realistic nor novelistic: it is documentary and compellingly linear" (120). For this reader, taxonomy takes on an imperialist role, which in turn takes us some distance from the initial reading process. Ironically, the description of the narrative "with stops and starts and recursiveness" sounds very much like a psycholinguist's version of how we do "in fact" read. Giltrow, though, has little interest in reflecting on process; she wants to get on with the story. These critical readers have little time for talk of epistemic rhetoric and the aesthetic of double exposure.

However, there are signs that the kind of rhetorical situation invoked in the prologue to *Burning Water* may yet find a more sympathetic, more collaborative, response; published readings are beginning to address the problems and responsibilities of reading itself. In a brief essay in the second edition of his *Reader's Guide to the Canadian Novel*, John Moss articulates what might be a common experience for those seeking to respond to the novel "on its own terms":

> In the first edition of this book, I wrote a fair acknowledgement of what happens within the text of *Burning Water*, without showing much awareness of its significance. That was five years ago. My essay was analytic and descriptive. My attention was directed somewhat myopically toward the fictional reality, as if it existed apart from the surrounding world and took precedence over it. This, in spite of Bowering's insistence, within the novel, that I as a reader do otherwise! The whole thrust of his work, at this stage, is against barriers between life and art. *Burning*

Water insists that there is a world beyond the text. It does so, perhaps paradoxically, by repeatedly collapsing the illusion of reality within the text, so that we are thrown, again and again, back upon ourselves, reading. In attending to the collapse, I seem to have ignored myself—although my presence is crucial to Bowering's achievement. *Mea Culpa.* (32)

Moss's confessional tone and highly personal admission of guilt over earlier, less aware readings suggest the enthusiasm of a convert to a revolutionary world view. Instead of shifting the responsibility for determining meaning from the text to genre, as Giltrow does, Moss speaks of the reality of the text "collapsing," and of the need to confront the reader's role as a co-creator of meaning. The difference in these two responses suggests that we need a better understanding of Bowering's view of readers, reading, and the interrelationship between life and art. We need to ask, then, "How serious is Bowering?" Does he "lack...genuine concern for his readers" (Whalen 34)? And to what extent does his conception of reading and seeing influence the rhetorical direction of his art?

Cover of George Bowering's *Errata* (1988). Red Deer College Press. Reproduced courtesy of the author.

Particular Accidents

The question of Bowering's seriousness is complicated by his abiding love of (and faith in) the aleatory aspects of life and language. There is certainly an element of whimsy to Bowering's rhetorical stance, but there is also a serious epistemological point at stake, and we need not become so distracted by what we perceive as a frivolous tone that we miss a serious message. Bowering, after all, has "always favoured tapinosis," which he defines as "a sneaky kind of rhetoric—it means the saying of very serious things in offhand language, in vernacular, even in slang" (*Errata* 61). Take Bowering's frequent references to things accidental. On a superficial level, an accident refers to a mishap often caused by inadequate planning or perception. For Bowering, however, the accidental illustrates the very nature of how we read and write narrative. He is fascinated by those moments when the discovery of meaning occurs "accidentally," for the accidental tends to prompt both a sudden recognition of interpretive processes and an invitation to integrate accidental meaning into a narrative of origins and causes. In *Errata*, for example, Bowering links the accidental to the concept of "intertexuality," the concept that every text quotes,

Cover of George Bowering's
Particular Accidents: Selected Poems
(1980). Talonbooks. Reproduced
courtesy of the author.

alludes to, revises, parodies, and otherwise echoes other texts. Intertextuality, he says, works best "as a series that looks accidental, that makes an order by apparent coincidence, synchronicity, let us say" (6). In the same collection of brief essays, he tells an anecdote that illustrates his sense of writing and reading as intertextual, social, collaborative, horizontal, and accidental:

> One morning I walked along Inglis Street in Halifax with Ted Blodgett, the poet. We saw a sign in a shop window: "Words." Then next door we saw a pizza oven with this word on it: "Blodgett." In moments such as that, literate people start looking for meaning. Or they pretend to, and often that pretense is made in fiction or poetry or conversation. Actually Blodgett and I knew that there was no meaning in the coincidence on Inglis Street. In fact, the lack of meaning is what made the event delightful. There is a lesson for the reader of contemporary poetry in this. A poem such as Robert Kroetsch's "Sketches of a Lemon" is delightful because the connections between parts of the poem are accidental, and devoid of systematic meaning trails. The walk along Inglis Street is metonymic. It is also highly readerly. Its meaningless conjunction of words has stayed with me, as Kroetsch's poem has, while other walks in Halifax, and other poems about fruit have faded. (65)

By reading such "signs," says Bowering, the reader becomes aware of his or her role as a maker of meaning. These aleatory moments constitute the brief epiphanies of Bowering's art: they point toward the necessity of a shaping consciousness to borrow and intertwine texts in new, meaningful arrangements and contexts. The "truly" accidental occurrence, like all texts, remains literally "meaningless" until the reader activates its significance. Meaning resides in reading, not in texts. For Bowering, the accidental thus becomes a postmodern aesthetic principle asserting the ascendancy of process over product, horizontal association over vertical dominance. It also becomes a postcolonial topic insofar as a commitment to the accidental subverts the supposedly seamless authority we grant the historical narratives within which cultural imperialism flourishes and gains definition. Accordingly, Bowering's *Selected Poems* are subtitled "Particular Accidents," collisions between words and world, where both author and reader collaborate as accessories before, during, and after the fact. One may distinguish, of course, between the truly capricious and that which merely "looks" unplanned. But Bowering seems to be say-

ing that, since all language acts are socially constructed and therefore essentially collaborative, and since we do not have absolute control over the dynamics of that collaboration, some element of chance influences how we construct meaning at any given moment. We never perceive the text the same way twice—not because the text changes, but because we are not the same people we were a moment ago.

If the accidental informs interpretation, it also informs composition; more particularly, it informs the writing of a work such as *Burning Water*. Bowering, indeed, sees the whole inspiration for his novel as accidental:

> With *Burning Water* it started by accident when I was in London, Ontario and I couldn't write about that place. I don't know how it happened, or why it happened, but I was in the library and I found Menzies' journal [the journal of a botanist assigned to Vancouver's ship], which had been published by the B.C. Government in 1933, or something like that. I don't know why I picked it up, but I took it home and I read it. (Quartermain and Ricou 59-60; emphasis added)

Aleatory moments insinuate themselves into all of Bowering's recent narratives, and they constitute a primary motivation for his writing and reading. "What I really like in a story," says Bowering,

> is that sometimes you have an experience when you are writing fiction, that something just happens nicely and you didn't think it was going to happen and it works and you say, "Whoopee!" As if you were an outsider reading it and saying, "Whoopee!" I love it when I find in somebody, or even in myself, a passage in a story that makes references to twenty other things that have happened in that book. Not necessarily logical ones, like repetitive colour, or an object, or something like that. (Quartermain and Ricou 61)

Bowering likens such moments of perception (of horizontal association) to "reading a system that you don't know, but are beginning to know" (61).

In *Burning Water* such moments are dramatized. While composing Vancouver's search for the Straits of Anian, the narrator notes that he took a break from his writing, walked around "the Tuscan capital" as a sightseer, and discovered by accident a paint-

Zachary Mudge, "The 'Discovery' on the Rocks in Queen Charlotte's Sound" (1792). Engraving. Reproduced by permission of the Special Collections Division, University of Washington Libraries. Photo Credit: University of Washington, negative No. 8188.

ing depicting a sea called the "Strette di Annian" (36). In a similar vein, the narrator notes that Vancouver fixed his sailing date for All Fools' Day and that "he [Bowering] had landed in Trieste and begun writing on All Saints' Day" (81). The narrator remarks, "It was all coming together in the way he loved—this had happened other times, and when it did he flew before the wind" (80).

This metaphor of flying before the wind, frequently reiterated in the novel, becomes a motif that links together a romantic faith in the importance of fancy and imagination and a postmodernist fascination with the accidental. Later, in Chapter 33, for example, we learn that the author

had, this is true, dipped into Vancouver's journal for Johnstone's Straits, and come up with the word "fancy." It was like finding the Strait of Anian in Florence, and it was

PhotoGraphic Encounters

also like several other things, found. When he found these things he knew a book was going well, that is without oars, before a good wind. (145)

The aleatory alerts us to a system that we don't know, but are beginning to know. Accidents suggest small tears in the ostensibly seamless fabric of patterns that make interpretation predictable, comfortable, and seemingly objective. To understand the accidental in narrative we need to take note of perception—of how we perceive, of how we read. "I'm more interested in perception than structure," says Bowering in *Craft Slices* (29); and elsewhere he muses about reading in explicitly visual terms:

> I would like to write a book, let us say a novel, an historical novel, in which once in a while a page is an actual mirror. If the reader has been deluded into thinking that the book "mirrors reality" or "holds the mirror up to history," the appearance of her own reading face might serve to shock her out of that error. (*Errata* 62)

The small shocks that Bowering sends his unwary readers argue for a renewed focus on epistemology; he has suggested that "modernism was ontological in purpose, & post-modernism is epistemological" (*Mask* 82). He repeatedly reminds us that we are at least partly responsible for what we know and see: "Reality is in the I of the beholder" (*Craft Slices* 28). As participants in, and co-creators of, the discourse, we need to recognize that simple inside/outside divisions will not hold:

> The place, the "out there," is not prior to human perception or activity; it is a result of someone's being in the world. "Environment" is not possible, because one cannot be surrounded by something he is a part of. (*Errata* 38)

Thus we do not so much "enter" the discourse; we become aware that we are already inscribed in (and by) discourse.

Only by refocusing his reader's attention on discourse as process rather than as product can Bowering establish a rhetorically aware audience. He is profoundly concerned with the ethics of reading and writing, with teaching appropriate modes of response. "Here is what one wants his reader to learn and know," he states explicitly in *Errata*: "that writing and imagining can be done, can still be done. One wants them to notice thinking, not buy thought. That's thinking, not thinking about" (18). He wants his readers to accept

the proposition that perception is a political act, that "we change the world by the manners in which we *perceive*" (*Craft Slices* 91). Bowering's rhetorical purpose, then, is not simply a self-serving search for a postmodernist audience; his sense of the political significance of language informs the shape of his postcolonial vision.

We get some sense of this commitment to the political in an essay called "A Great Northward Darkness," where Bowering takes the position that, by flouting the conventions of realist fiction, writers such as Leonard Cohen (and George Bowering) offer an ethical and thus responsible aesthetic position. Of Cohen he says:

> Despite the argument by naturalist writers that non-realists preach individualist escapism, it is easy to see that Cohen's concern is for a revolution of health in terms literary, physical, moral and political. Unlike the social realists, he knows that it is at best hypocritical to espouse social revolution through conventional and authoritarian aesthetic means. (*Imaginary Hand* 6)

Surely this kind of political commitment informs *Burning Water's* discourse on fact, fancy, imagination, and the shape of belief.

Politics, Language, and Epistemology

On one level, as Edward Lobb has discussed in some detail, *Burning Water* serves as a dramatic exploration of Coleridge's concept of imagination. In these terms, the various references to competing ideologies and cultures might be seen as little more than an amusing if elaborate treatise exploiting such contemporary theoretical concerns as historiography, intertextuality, and imaginative perception. Much of the "theory" in the novel comes in the form of a series of amusing dialogues between two natives identified, like characters in a Hollywood film script, as "the first Indian" and "the second Indian." Lobb suggests that this is enough, that the novel "succeeds because it is interesting and funny," and because it "avoids easy answers" (127). But the references to the collision of two worlds—European and Native—provoke more than an opportunity for "several funny dialogues between two Indians" (Lobb 113).

When, for example, the two Nootka first catch sight of Vancouver's ships, their dialogue sets in motion a complex chorus of multiple discourses that range far beyond the kind of language available to them on June 10, 1792. But then historical time is not

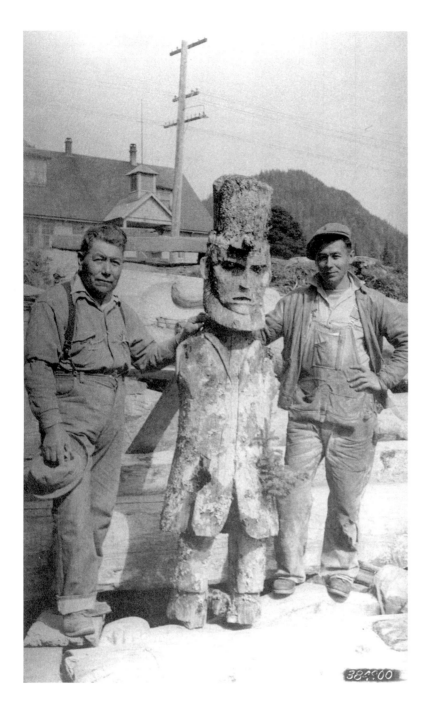

Anonymous, figure from the top of *The Lincoln Totem.* Tlingit carving of Abraham Lincoln, known variously as "The Proud Raven Totem" and "The First White Man Totem." Currently in the Alaska State Museum. Photograph reproduced courtesy of the United States National Archives Still Pictures Research Division.

in command here: as the narrator of *Burning Water* notes ironically, "It could have been June 20 for all the two men who watched from the shore could care" (13). The "first Indian" describes the ships as "two immense and frighteningly beautiful birds upon the water" (14), whereas the "second Indian" explains

that they are boats, "dugouts" with wings "made of thick cloth" (16). The first reading is coloured by the native's perception of himself as an artist (and by his desire to establish a place for himself among his tribe). A latter-day Caedmon, he says,

> "I will open my mind to the Great Spirit, and create a song, and the song will reveal the meaning of the vision, and I will take it back with me to the tribe, where I will be accepted and welcomed as…"
> "A full man of the tribe." (15)

Such an objective, however understandable, breaches an indigenous ethics of interpretation, for by allowing himself to become carried away by fancy, the artist has prevented his imagination from guiding his senses. The "second Indian" explains all this to his friend by treating the art of capturing meaning in terms of a fishing analogy:

> I am discrediting only your fancy. Your fancy would have the fish leap from the water into your bag. But the imagination, now that is another matter. Your imagination tells you where to drop your hooks. (16)

And a little later he advises that "you must allow your senses to play for your imagination"(16). In terms of a rhetoric of reading. the "first Indian's" interpretation offers little more than an unbridled and self-interested subjective response. His friend argues for critical reflection tied to an appreciation of both the context and the process of interpretation. He argues for an understanding of the contact zone where cultures meet. Significantly, what is at stake here is more than the credibility of a witness: the fanciful belief that the sailors must be gods, however innocent (even amusing) it may seem, constitutes an open invitation to political oppression. Only by remaining watchful and by reading the white signifier responsibly can the Nootka assert their power to understand their world and tell their own story. Historically, of course, the indigenous peoples did not always read carefully enough.

The wise native reader reappears in *Caprice*, looks back in time, and offers the following assessment:

> The people of my grandfather's grandfather's time paid the price for not watching everything the newcomers were doing. In our time the wise man will know everything that goes on in this valley. If we do not watch them carefully,

some day they will make us drink poison and lock us up inside big stone houses. That is what my father's father told me when I was younger than you are now. (129)

Explorers such as George Vancouver offer ample reason for watchfulness. For Vancouver, the world is an experimental text to be read according to the objectivist terms of his empirically-based discourse. To colonize, after all, means to control, categorize, and conquer. His vessel is a "fact factory" (186) measuring the serrated coastline, surveying the land, calculating the rainfall, documenting the vegetation, and assessing the native population—and life on board ship is little more than an "ineluctable daily sequence of facts": "The charts were covered with numbers and then rolled up and stacked in holes, waiting to be published at home. Vancouver even wanted to transform the Northwest Passage into a fact" (186). Language too is a mere fact to be mastered, and Vancouver's "trick of assuming the natives' tongue" (120) remains tied to an unshakable sense of mission: to chart, record, and claim both geography and inhabitants as wards of the Empire. "Learning a naked foreigner's tongue is the first step in creating some form of government," boasts Vancouver. He wants language, like everything else in his world, to be vertical, rolled up and stacked in neat, objective holes. There is no room here for an appreciation of "accidental" meaning or whimsy, and, as Menzies, the scientist, instructs his captain, the illusion of objectivity costs Vancouver dearly: "You learn [the natives'] language," lectures Menzies, "in order to practice your control over them, while you never get close enough to them to listen to that language for a while and find out what they want" (150). Vancouver, however, remains an unwilling pupil. Questions about historical and ideological contingency—questions that might trouble his adulation of facts and his abiding faith in a knowable universe—never shake his realist commitment that the new world can be objectively charted, understood, and explained. As a result, he reads life the way he reads maps, expecting in both an exact and unmediated correspondence between signifier and signified. As he sees things, "the coast is there, under California sun or behind New Norfolk mist. So his charts would be there as well, fact now by perseverance, equal to the real" (242).

What Vancouver fears is that other kind of reading: the kind practised by Menzies, the Scotchman who "could read [Vancouver's] skin and the colour of his eyeballs…[who] could look at the outside of his soul's vessel and make an estimation of the events transpiring inside" (73). Menzies's reading is not tied to language; it extends beyond the immediate signifier. When he sees

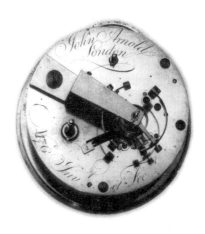

John Arnold's chronometer, No. 176 (1787). Photograph reproduced courtesy of the Vancouver Maritime Museum. The chronometer accompanied Vancouver's voyage. A similar instrument, Earnshaw's pocket chronometer, No. 1514, was also used by Vancouver, but, unlike the Arnold piece, became "unstable in performance." Alun Davies recounts how, on Friday, 19 April, 1793, "it stopped." Vancouver's own account is more detailed:

On winding it up it appeared that Earnshaw's had intirely (sic) stopped…I repeated my efforts to put it again in motion, but it did not succeed; and as its cases were secured by a screw, to which there was no corresponding lever in the box that contained it, I concluded that in the event of an accident, it was Mr Earnshaw's wish that no attempt should be made to remedy it …(qtd. in Davies). *Alun Davies—"Vancouver's Chronometers," in From Maps to Metaphors.*

himself through Menzies's eyes, Vancouver feels exposed to both others and himself, for Menzies "had read his soul...had read it before it had been fairly perceived by [Vancouver] himself" (73). Vancouver defines himself in terms of the social and emotional distance between what he perceives as his self and others. Thus, appropriately enough, he casts himself adrift from the company of others: "He had been at sea all his life, and all his life at sea he had been creating the distance between himself and others" (99). He lives "inside his head," keeping a distance from those others "out there" (99). The hard-won distance makes Vancouver "a young *ne plus ultra*" (21), but one condemned never to see beneath the surface of things. In contrast, the natives seek to understand their world through an exercise of the imagination that contextualizes people, places, and events in terms of stories based on community experience. Thus, for the natives, imagination (which yields insight) is more important than sight (which yields only fact). Indeed, according to the "second Indian," the tradition of cannibalism in his culture relates to his people's reverence for imagination:

> I cannot be dead certain, but I believe I remember hearing that one person would eat a second person in order to consume that second person's imagination....To transfer it from the person eaten to the person eating. (113)

The notion of identification of self and other through physical consumption offers a radical, even visceral, alternative to Vancouver's spiritual, emotional, and physical isolation. Where the natives eat words whole, Vancouver never develops a taste for more than their surface-level meaning. Vancouver prefers the company of boiled cabbage and vinegar: "This is the Communion I celebrate," he tells his young lieutenants, "in the true expectation that I will be safe in the companionship of the facts" (56).

Jeanette Lynes calls readers such as Vancouver "reader vandals," those who seek to "leave the text, having commodified or conquered its meaning" (73-74). Although the natives remain watchful, they nonetheless incorporate aspects of the invader's language into a sophisticated form of cultural conversation. Watchfulness does not mean withdrawal into social or linguistic isolation, for the range of discourse (especially the puns) that the two natives manage suggests a kind of polysemic defence against the white man's fixation with linear order, literal understanding, and historical accuracy. As we have already discussed, the first sighting of Vancouver's ships offers an initially dislocating heteroglossia; and

the story about the consumption of another's imagination illustrates the natives' rather literal-minded commitment to a heteroglossia of community imagination.

But it is in the second part of Bowering's unfinished trilogy that the role of language becomes even more pronounced. When in *Caprice*, for example, one of the natives talks of his people's time—of his "grandfather's grandfather's time" (128)—he characterizes history in terms of kinship relations, a temporal concept central to oral cultures. Cutting off the traditional catalogue of family references, his friend interrupts with the words "Et cetera," and the "first Indian" pointedly invokes a new discourse: "Very well, etcet-era"(128), he says. This is, as we are told, "not an Indian pun" (128); but, as Bowering argues, one cannot speak outside the dominant discourse—and "if one is thinking at all, one is perforce bilingual" (*Errata* 96). Puns and other language-play allow the natives a kind of linguistic high ground from which they can practice their bilingualism without suffering a loss of cultural identity through total assimilation. Thus this brief interlude of "Indian" and "non-Indian" puns offers a dramatic illustration of Bowering's concern for the definition of self and other through discourse; it points toward the political power of language, and perhaps more subtly, it argues that the notion of collaboration need not entail the loss of identity. As the native teacher advises, the trick is to "not assume all the invader's ways, but [to] make use of the particulars that will bring strength to the people" (*Caprice* 128).

George Bowering, original pocket book cover of *Caprice* (1987). Reproduced courtesy of Penguin Books Canada and the author.

Reading a Capricious World

Caprice offers the second installment of a three-part exploration of imagination, language, and the politics of interpretation. As Bowering explains,

> The first [novel] takes place in 1709, and the second one in 1890, so the third one should take place in 1990—about the time I'm writing it. The first one is on the sea…and the second one is on the land—so the third one will have to be in the air, right? (Quartermain and Ricou 56)

Caprice, set in British Columbia's Interior, in and around the town of Kamloops, plays with the narrative conventions of the traditional male-centred western: in place of the male gunslinger, Bowering introduces Caprice, a whip-cracking woman who reads *Faust* while tracking down her brother's murderer. Indeed, just

Photograph of Stuart Wood School, Kamloops school constructed c. 1890. Reproduced courtesy of the Kamloops Museum and Archives.

about everybody in the novel reads, and even more than *Burning Water*, *Caprice* explores the rhetoric of reading: it teems with poets, readers, and teachers and offers us a world where poems are tied to tumbleweeds and outlaws feign interest in Goethe; where "read[ing] sign" (129), whether in the form of books, laundry lists, people, or landscapes, becomes a principal preoccupation; and where virtually every character plays out the role of either teacher or student. The older native, for example, referred to as the "old teacher" (56), instructs his student in reading the ways of the world; Caprice, when young, announces "that she [is] going to become a schoolteacher" (21); Caprice's lover, Roy Smith, works as a teacher at the Kamloops Indian School; and even Loop Groulx is said to feel like Smith's "student or apprentice" (126).

Caprice thus presents a literacy narrative where life is a text to be written, taught, and, above all, read. As Stan Dragland notes, "Reading is a complex figure in *Caprice*...for the attempt to work out the way things are" (79). And the way things are is always a matter of interpretation: the older native laments the fact that he cannot read books the way he can read signs, while Roy Smith regards the enigmatic Caprice as one "living in a different alphabet" (76). What differentiates these readers from other less attractive figures is their capacity to reflect upon their interpretive processes, to worry words and attitudes into meaning. As Kröller observes, "The wittier characters in *Caprice* dismantle...words by punning, while the dimmer or more recalcitrant ones freely misunderstand them, confusing 'a patchy' [country] with 'Apache,' or 'motivation' with 'motive nation'" (*Bright Circles* 107). The wittier readers in *Caprice* accept the challenge to reflect upon their own habits of interpretation, and thus they differentiate themselves from those who accept colonial discourse without questioning it.

When Caprice misreads a passage from Goethe's *Faust* as "build words" rather than "build worlds"(21), she is, in effect, *reading in* meaning; and in the process she alerts her readers to the causal relationship between words and world interpreted. Words shape reality, and thus for good reason men such as Loop Groulx feel "affronted when they see someone else reading a book" (21). And when Frank Spencer smashes a pen under his spurred heel, he reacts, albeit instinctively, in fear of the power of language to shape his life story: "Throw that pen on the floor over here. Easy," he says to the journalist, Kesselring. "You aint putting me in history, damn you" (97). The point of focusing on this word/world relationship (in both *Caprice* and *Burning Water*) goes beyond mere postmodern highjinks or a literary nod to the Sapir-Whorf hypothesis, for, as we have tried to indicate, both novels speak directly and indirectly to issues of historical, political, epistemological, and ideological import. The point, ultimately, is to teach readers that successful interpretation often demands some level of self-consciousness about our terms of reference (our interpretive schemata). In particular, Bowering wants us to jettison the presuppositions of realism and come to terms with a new epistemic view. The shift to a postmodern, postcolonial, and, ultimately, rhetorical perspective is no easy matter, and like the parade of characters who track one another across the interior landscape near the end of *Caprice*, many of Bowering's readers are, we think, "late in understanding...what is happening" (248). The older native offers one explanation of the difficulty some have in "reading":

The Bill Miner exhibit (1999). Reproduced courtesy of the Kamloops Museum and Archives. Photograph by Donald Lawrence.

They have been late in understanding it [the narrative of their lives] because they have been trying to understand it in terms they are accustomed to. They have their peculiar notion that...actions can be explained by looking into the individual heart and head. (248)

Such humanist (realist) notions seem inadequate when compared to the everlasting narrative of the landscape and its people: "No single person's story could amount to much in comparison. No human being could walk or ride under that immense blue sky and remain a humanist" (198). Bowering, presumably, would be happy if his humanist readers underwent a similar transformation in the process of reading *his* narratives.

Reading and Writing in the Dark: George Bowering's *Shoot!*

The final scene of Bowering's *Caprice* shows the heroine riding off into the sunrise, "eastward through the west that was becoming nearly as narrow as her trail." Where *Caprice* seems more concerned with sending up the narrative conventions of the western, *Shoot!*, also set in the Thompson-Nicola valley of the late 1800s, focuses upon the social forces (the law, politics, racism, and economics) that delimit the lives of the "McLean Gang," brothers Allan, Archie, Charlie, and their friend Alex Hare. At first, the boys, like the landscape they inhabit, are "always moving" (45, 71): "Before the white people came the land was unsettled. It was always moving around, nervous. It could not sit still" (45). Ironically, the McLeans have become an unsettling influence, their racial mixture and criminal exploits provoking fears of an Indian uprising. White society wants the race problem "settled" (45), and opportunities for the likes of the McLeans become narrow indeed. Their movement becomes further and further restricted: like the natives, who "were assigned a little bit of land and encouraged to change their lives to fit into these enclosures" (156), the McLeans find themselves holed up in a besieged cabin, thrown into a New Westminster jail, and eventually "secured with heavy iron" (232) rings that would define the rest of their short lives.

The sons of Donald McLean (a Chief Trader for the Hudson's Bay Company in and around Kamloops) and their mother Sophie Grant (a Native woman of uncertain origin), the brothers are known as "breeds." Neither white nor Native, and accepted by neither community, the "Wild McLeans" seem inexorably driven into their roles as outlaws; as Archie puts it, "The onliest thing we were ever left with was gettin' famous" (89)—and they decide early in life that lasting fame can be achieved by following the example of outlaws to the south. What they fail to recognize is that the rhetoric of American-style violence does not play well in Canadian history books:

> Canadian history is mainly written by schoolteachers who know a lot about the Government. If an individual with a gun shows up, he had better be an American or else. In the Kamloops museum there's a display including pistols about Bill Miner the train robber. He was an American who snuck into Canadian history with a gun in his hand.

"The Shuswap people made imbricated red cedar-root baskets. You could fill them with water and drop rocks from the fire into the water and make the water hot enough to cook with. Families had baskets that lasted for years, and they made new baskets every year.
The white people began to buy these baskets, but they did not make hot water in them. They arranged them. Later they put them in their Indian museums. They said tribal people make baskets and white settlers make oil paintings. That is the difference between popular art and fine art." *George Bowering—Shoot!*

Alex Hare (BCARS, 3386)

Allen McLean (BCARS, 3387)

Archie McLean (BCARS, 3390)

Charlie McLean (BCARS, 3389)

The McLeans, New Westminster Jail. Images reproduced courtesy of the British Columbia Archives and Records Service.

People dont want to know about the McLeans. They werent Americans. They werent white people and they werent Indians. (59)

That the McLeans became famous in their day is not in dispute; but it is a fame carried by the hyperbole of newspaper men and frightened ranchers. Back then the "McLeans were history and news....They showed signs of becoming a legend" (246); today they have been all but erased from recent historical accounts of the period. As the narrator laments, "One hundred and twelve years...[after the McLeans were sentenced to death] two new histories of British Columbia were published to considerable acclaim. Neither mentioned the McLeans. The McLeans are not in history" (51). When people begin to stop telling stories about the boys, the McLeans disappear from history. Fame proves as difficult to hold onto as the boots and horses they steal, for history books are written and read by those in power, and, significantly, none of the brothers can either read or write. "Learn reading and arithmetic" (246), Archie's mother tells him, but, like his brothers, he too seems unable to decipher, much less control, the dominant language of white literacy and commerce. On his way to prison, Allan

PhotoGraphic Encounters

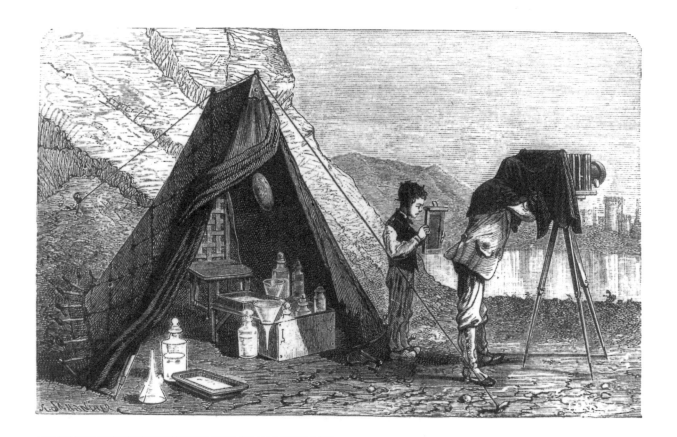

Anonymous, *Darkroom Tent in Wet Collodion Period* (c. 1875). Reproduced by permission of the Gernsheim Collection, Harry Ransom Humanities Research Center, The University of Texas at Austin.

is pulled feet first across ice and gravel and leaves "a pink line in the snow frozen to the surface of the ice." We are pointedly reminded that this is "the only writing Allan could read" (242).

Shoot! gets its title from a scene late in the novel: the McLeans find themselves in prison awaiting trial and an eventual sentence of death by hanging for the murder of two men. The oldest bother, Allan, challenges Warden Moresby and the guards, disdainful of both his immediate physical circumstances and the authority of several shotguns and a revolver pointed at his head:

> "I go where I want to go," said Allan, moving nothing, not even his lips. There was nothing now for anyone to say. It was dead silent inside the cell block. The rotting door was wide open, and late winter light showed dust particles in the cold air. A piece of pitchy wood snapped in the stove and the barrel of Moresby's revolver did not move. "Shoot!" said Allan, without moving his lips. Everyone was perfectly still, as if posing for a photographer. (253)

This scene offers one of many frozen moments, where Bowering complicates the metaphors and representational style of modernist photography (one thinks especially of Cartier-Bresson's notion of the "decisive moment" here). Action proceeds in a series of arrested moments, in stops and starts; figure and ground compete for the reader's attention; and key scenes are embedded among competing narratives so that past cause and future effect are always implied. When Allan McLean commands the warden to shoot, a narrative voice reminds us that he has unwittingly conflated the rhetoric of gunplay and photography, and at the same time rehearsed the faulty premise of his violent existence: a belief that history is a text shaped by force of will and individual action.

The narrator's reference to photography sets Allan's fatalistic bravado in sharp relief against a repertoire of self-conscious, sometimes earnestly didactic, observations. Here and throughout the novel Bowering effects a curious reading experience: the drama of the moment gives way to a sudden shift in perspective, for clearly the sensibility that would equate this futile stand-off with characters posing for a photographer does not belong to either Allan or the warden. The observation dissipates the dramatic immediacy of the scene and encourages us to reflect upon the absurd and ultimately impotent spectacle of a man with nowhere to go—an historical tableau framed by elements of oppression, racism, political expediency, and the economic imperatives of the white ruling class.

Bowering's principal subjects, four young men in search of their collective place in history, are threshold characters, occupying that liminal space between shadow and light, between relative obscurity and fame. Darkness is their element. But theirs, says the narrator, "was a darkness that would not stay down in the basement of history" (141). Like Archie Minjus, the character who first appears as the ship surgeon Menzies in *Burning Water* (1980) and then as the photographer in both *Caprice* and *Shoot!*, Bowering develops his figures in the dark, waiting for a public moment of recognition or insight:

> These four halfbreeds were dark shadows and white ones. They were the zone of translation. They were bad news of the future for the Indians, and bad news of the past for whites. They were trapped in a ghost life, like a high waterfall caught by a slow lens. They could never have participated in either community. (273)

"The eyes of Archie McLean." Detail of Archie McLean photograph, New Westminster Jail.

Appropriately, then, the novel ends with a startling image of Archie, the narrator, *and the reader* straining to see one another in the dark: standing with the hangman's hood over his head,

> Archie's eyes looked at nothing, at the chopped hair in front of him, at the hoof-prints of the horses in the snow, looked out of the photograph in the tray. I see them in the dark. You see them. The squinting eyes of little Archie McLean. (297)

The transition from the historical moment of Archie's execution to the squinting eyes staring out from the developing fluid of a photographer's tray captures the novel's theme—and its narrative method. The effect is not unlike that achieved by the ironic narrative asides, which, by interjecting a sudden shift in perspective, violate chronology and encourage the reader to see each scene as the product of multiple contexts. Here we are asked to bear witness not only to the execution, but to the photographic token which, like all narratives, is always in the process of developing. We are also reminded of Minjus's observation that "When they hanged these boys they were going to weigh shadows. They were going to hang images" (273).

This is a novel about the intercession of storytellers and language, about the need to translate the story across space, time, and the boundaries of genre and medium. Like the nineteenth-century photographer who "ducked under his black hood and transferred [the McLeans] to silver" (271), the narrator looks into the blackness of the McLeans's lives to reveal the forces that conspire to write the brief history of four Canadian outlaws. The success of the novel—and it is a wonderfully successful complement to Bowering's *Caprice*—depends upon the author's ability to tell multiple stories at the same time, like a juggler creating and sustaining a meaningful pattern by keeping the narratives moving—by keeping them in the air.

The story of the McLean Gang develops at the intersection of multiple plot lines and narrative perspectives. What we learn to read is not the "history" of the McLeans, but a story about the limitations and consequences of following one narrative too closely. The McLeans, for example, do not see a future for themselves except in terms of imported frontier myths; white society, in turn, cannot see the McLeans as anything but "breeds." Failure to see the whole picture leads to a kind of blindness involving prejudice and despair.

As readers, too, we are challenged to see things differently. Those looking to get to know the McLeans as fully realized characters may find themselves initially disappointed, for, according to traditional realist notions of character development, the brothers hardly exist. Such readers will almost certainly find themselves frustrated by the many narrative interruptions and interludes that disrupt the linear progress of the McLeans' story. If we look beyond the particulars of the characters and the drama of the moment, however, we discover a complex, collage-like narrative about the political, legal, racial, economic, and linguistic constraints that backed four young men into a small, obscure corner of Canadian history.

Bowering's Rhetoric of Reading

As these three literacy narratives teach, the difficulty in learning to read and see authentically lies in learning to leave the colonial of realism and realist response, truggled with an ongoing interest and it is this interest in the ludic ome commentators to dismiss his elf-indulgent, shallow. Smaro Bowering's playfulness, describes sness, an art of surfaces," and it is f the writer's and reader's con- urs," at least in part, "on the sur- o). That is, due to the novelty of the words on the page seemingly nventional reading strategies are are to continue reading, must onized habits of prediction (their lly, some of Bowering's early criti- bout "the potentialities in the sur- of "literal prose" (*Mask* 120), do otentially stable and unmediated. loping rhetoric of reading, terms and critical explorations of read- " (1978) and "Modernism Could nial conception of text no longer knowable text do not shape the rratives. Bowering's prose fiction as Kamboureli calls it, but those postmodernist aesthetics, between rse, should not be regarded as riting does exist, after all; what imply not inherently meaningful. n/postcolonial narrative acknowl- ifier: it does not ignore the words at their meaning must always be erience of reading.

iting as an "art of surfaces," or of ed with protecting "the signifier ptures only a partial view of his Lynes makes the case that, for or the author remains constant; and thus she concludes that "only the text holds a stable position"

(68). This assumption of "text as centre" leads Lynes to argue that "the signifier is always in danger. The signifier must be protected" (68). As she sees reader-text relations, the author must remain vigilant against bad readers who would "vandalize" his intended meaning. Lynes's metaphor captures something of the postmodern distrust of imposed authority, but, surely, to insist upon Bowering as an author preoccupied with protecting the text as centre is to place him in the company of George Vancouver and Frank Spencer.

Kamboureli and Lynes draw our attention to Bowering's concern for language, to his concern for getting the words right. But we see no evidence that Bowering believes it is possible to freeze the signifier's meaning. The notion of protecting the text may refer to an understandable impulse, but it cannot be considered the premise for a theory of reading.

We do not want to suggest, of course, that any movement from the product orientation of realism to the process-orientation of postmodernism and postcolonialism is likely to be made without experiencing some sense of confusion and contradiction. We would suggest, though, that Bowering's critical and creative narratives offer a coherent and thoughtful story of reading as a collaborative rhetorical process.

Bowering's notion of process is no simple matter, however, for he remains wary of the term. In conversation with Bowering, fellow postmodern author Robert Kroetsch argues that "we've overused the word 'process' beyond belief," and Bowering responds that he is "quite willing to let it go" (Miki, "Self" 135). "I'm much more interested in the 'random,' or chance, than I am in the 'processual,' I think," continues Bowering, though he acknowledges that the term "process" helps distinguish certain contemporary views of reading and writing from the view insisted upon by the New Criticism:

> I guess you'd have to write an essay about what "process" means to you, as opposed to what it means to somebody else. But when the word "process" came up in discussing poetry it was usually opposed to "product."….And product poetry, it seems to me, is what the New Criticism was interested in: a poem in which everything you can possibly find out about the poem is already there. So if there was any failure at understanding the poem, it wasn't that the poem didn't embrace that thing that you didn't find; it was that you didn't find the way into it. And, to me, the notion of "process poetry," for the reader, is that it's not necessarily

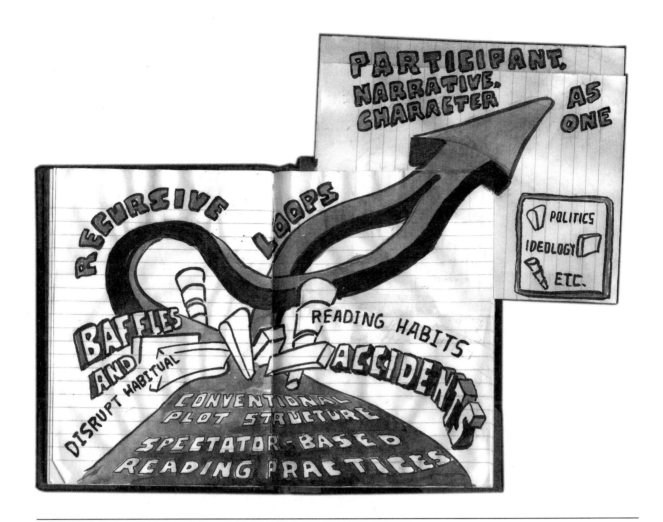

Donald Lawrence. Brush and pen diagram of alternative reading strategies.

inherent in the poem. Or needn't be understood as inher-
ent in the poem, unless somebody with a completely dif-
ferent matrix of experiences comes to the poem and finds
it in the work. (135)

Once again we see that Bowering's aesthetic position hinges upon
his sophisticated understanding of reading as a social interaction—
as an interpretive process of "coming to" the work and thus of sit-
uating that work within a "matrix of experiences." And what is true
for "process poetry," as we have seen, is true for *Burning Water*,
Caprice, and *Shoot!* His preference for "the random" or "chance"
over the "processual" remains of a piece with his commitment to
what we have called the accidental; moreover, when he moves

from poetry to prose narrative, the corresponding emphasis on plot allows him full range to explore notions of seeing and reading as particular accidents inevitably influenced by personal and cultural matrices of experiences.

As we have tried to show in this chapter, Bowering's view of reading as metaphor and process shapes both his fiction and his developing sense of interpretation as a political act. *Burning Water*, *Caprice*, and *Shoot!* do not represent a retreat from the world—from the social and ideological forces that shape our sense of how fact and fiction are constructed; as Bowering says, his writing simply offers readers "another way to make the connection" (personal communication, February 1990). The two conflicting world views (white and Native) dramatized in all three novels, for example, offer readers a clear sense of the political implications of interpretation. Despite the humour in the narratives, we are constantly reminded that the white invaders brought disease, alcoholism, and oppressive laws; that they murdered the natives "by the thousands, sacked their cities, defiled their holy places, erased their alphabets, melted down their gold, and brought half-breeds upon their women" (*Burning Water* 166-167). Like Peter Puget, the white explorers and settlers "felt the same way about commas that [they] felt about natives. The fewer the better" (207). Insensitive, wrongheaded, and otherwise obtuse readers such as Puget, Vancouver, and Spencer suggest clear examples of how we should not read Bowering's work.

To read the world through a filter of unexamined ideology ensures our participation in the maintenance of the dominant discourse. Only by reducing the distance between self and other, between reader and author, can we read collaboratively and responsibly. The only way in is to enter the conversation—to become perforce bilingual and conversational. With the narrator of *Burning Water*, we need to consider the woman who "had often been accused by herself and others of making novels out of what other people think is conversation" (80); and like the two natives in *Caprice*, whose "conversations [seem]...to threaten a kind of dispersal, to wander into byways that did not lead to the advance of education" (129), we are invited to engage with Bowering in the telling of story, in the making of meaning, and in our own education as readers. Bowering's novels too are "conversational," and Bowering seems to be saying that the postmodern artist with a postcolonial orientation has no other legitimate way to tell his story: all discourse is inherently dialogic, a matter of seeking to reach oneself and the other through language by creating as many exits and entrances as possible.

The New Vernacular and the Secret Victorian Aesthetic: A Rhetoric of Overt Falsification

4

The following chapter began as a panel presentation at the "Alternative Frontiers" Conference, Simon Fraser University in Vancouver, British Columbia. We staged the presentation as a critical/creative dialogue between artist and critic: Lawrence exhibited his own artwork and discussed its relationship to the conference's theme, "Is there a Canadian way to think about Canada?" Garrett-Petts offered a further analysis and commentary on the issues raised. We were, and are, interested in what we identified as a "new vernacular" of prose pictures and visual fictions. In Vancouver we argued that the inclusion of photographic images and techniques in contemporary Canadian literature constituted an importation of a visual vernacular—a way for individual artists to subvert the conventions of high art culture. Since that time we've worried about the word vernacular *more and more, seeing in it a way of conceptualizing both the intersection of competing cultural domains and the rhetorical presence of an "authentic" visual and verbal voice. We've come to understand much contemporary PhotoGraphic composition as either referencing or otherwise drawing upon the vernacular constructions of late-Victorian art. In the PhotoGraphic we see a postmodern rhetoric informed by a "decidedly turn-of-the-century turn of mind."*

Cultural Identity and Contested Space

More than a quarter century ago, critic and author Kildare Dobbs offered a portrait of Canada that was highly critical of the American presence:

> There is still a powerful myth of the North. Against all evidence, Canadians sometimes like to think of themselves as a hardy, frugal race of "hommes du nord." For the farther north one goes the farther one is from the United States and from supermarkets, superhighways, and advertising men in crew-cuts and two button suits. (68)

Commenting on this same passage, Stanley Fogel notes that "the tenor of Dobbs's remarks is by no means untypical of Canada's stance to American inroads" (1). However ingenuous the lingering image of a prelapsarian Canadian North might be, an anti-technological (anti-American) rhetoric continues to influence Canadian perceptions of nature and cultural identity.[1] Dobbs's aversion to

1 For a discussion of anti-American rhetoric in Canadian literary criticism, see Robert Thacker's "Gazing Through the One-Way Mirror"; see also Henry Hubert and W.F. Garrett-Petts's "Foreword: An Historical Narrative of Textual Studies in Canada."

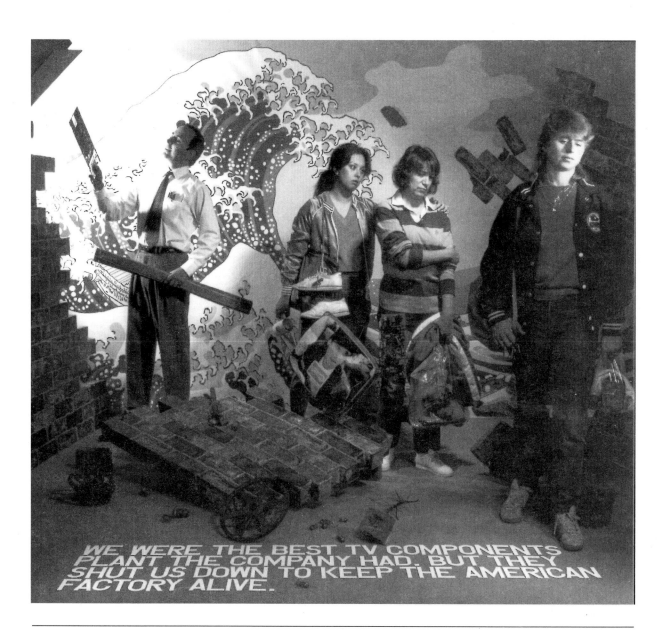

Carole Condé and Karl Beveridge, "The Wave" (1988). From *Class Work*. Reproduced courtesy of the artists.

advertising men, and to commercial culture generally, echoes the liberal humanist view that we should cultivate our best selves by rejecting the vain pursuits of the material world. What begins in the U.S. as a vernacular expression of commercial progress becomes, for Canadians, a threatening cliché, an irruption of mass culture. The question remains, however, how far north one must go to "purify" Canadian experience.

Dobbs's nationalist rhetoric offers a notion of identity based on absence rather than presence—Canada becomes what is left over

when America is filtered out of the picture. Such reactionary idealism has featured prominently in both academic and popular discourse on Canadian national identity since the late nineteenth century; since the early 1970s, the anti-American, anti-technology stance has been fashioned into a curious and contradictory critique, one suspicious of modernist ideology while still maintaining the modernist categories of purity, unity, transcendence, and realism. Robin Mathews, whose work typifies this stance, links the technical innovations of modernity to an American "individual anarchism"(120) and, like many nationalist critics, counsels writers and readers to embrace an extreme social realism.

What Mathews and others seem to want is what we might call a renewed emphasis on vernacular expression—a distinctly "Canadian" expression, artistic or otherwise, which is indigenous to a given community, and which operates outside the trends of high, mass, and popular cultures. Just what form this expression might take is not exactly clear, though there is some suspicion that cultural institutions (the museums, the arts organizations, the government departments, the universities, etc.) have not done enough to foster it. According to Susan Crean (writing in 1976), "although the arts are being made available to more Canadians, they seldom reflect the tastes of the people and the communities they purport to serve" (3). High art pulls us too much in the direction of imported European cultural norms; mass and popular culture pull us toward American taste. Significantly, Crean cites the American influence—primarily the visual media—as being the most pernicious. She writes that "in the cultural sphere we are only beginning to make the connection between U.S. domination of the media and the suppression of Canadian culture and independence" (5). Mathews, writing in 1995, goes even further, suggesting that many of us have given up on representing Canadian experience authentically; he accuses the Canadian intellectual community of "treason" (*Treason of the Intellectuals*).

We would be less than honest if we didn't note, at least in passing, our personal stake in this debate, for, as editors of the cultural literacy journal *Textual Studies in Canada*, we found ourselves on the receiving end of Mathews's criticism. *TSC* began publication in 1991; and from the outset we were dedicated to "reading" Canadian cultural texts in all media. Mathews saw us as yet another version of the *Tish* movement that, thirty years before, had imported an American poetics to the University of British Columbia. Describing us as "little Tishers," and judging the journal as "ruled by U.S. rhetorical theory," Mathews found *TSC* guilty of "regional imperialism":

Wm. Notman, *Curling in Canada* invitation (1877). Reproduced courtesy of the Notman Photographic Archives, McCord Museum.

A new scholarly journal called *Textual Studies in Canada* burst on the scene from Kamloops in 1991. Some of us excitedly picked it up. A journal from Kamloops, we hoped, would declare the new liveliness and cultural density and grass roots originality of what only yesterday seemed to be one of the country places in the province only modestly ambitious to generate ideas.

The experience of *TSC* was traumatic and representative. Without editors from Newfoundland or francophone Quebec or any Commonwealth countries comparable to Canada, *TSC* has several U.S. editors [Mathews means "members of the editorial board"]. (89-90)

Apart from failing to enlist a geographically correct editorial board, we are not sure why our journal elicited such "trauma." Mathews, it seems, wanted to keep our upstart journal in its place: part of an intellectual hinterland, where "grass roots originality" remains

modest, safe from outside influences. He made no allowance that a new vernacular might be articulated in conversation with other voices; instead, he accused the journal of selling out to the "totalitarian drift which is articulated in the work and influence of the great twentieth century German philosopher and Nazi apologist, Martin Heidegger" (back cover).

Talk of treason, imperialism, totalitarianism, and Nazi sympathizers may strike some readers as "over the top"; but, the culture wars, it seems, need such a vocabulary. Like Mathews's remarks, the concluding paragraph to Chapter 1 of Crean's *Who's Afraid of Canadian Culture?* seems worth citing, for its military metaphors of invasion, soldiers, and defence tactics suggest how a rhetoric of battlegrounds and cultural warfare has shaped our continuing discussion of Canadian culture:

> Although the architects of the Canadian sell-out have been sitting on the boards of arts organizations all along, the U.S. influence arrived first through the media, and it affected popular culture long before it touched Official Culture. In fact, the upper classes in Canada resisted it at first, deploring Americanization, not so much on patriotic grounds as because they believed it to be vulgar and commercial. Still the Royal Commission on National Development in the Arts, Letters, and Sciences (the Massey Commission) warned Parliament of the impending invasion: *In meeting influences from across the border, as pervasive as they are friendly, we have not even the advantage of what soldiers call defence in depth…Our military defences must be made secure; but our cultural defences equally demand attention.* (19; emphasis in the original)

While it might be tempting to dismiss such views held by Mathews, Crean, and others as merely xenophobic, Arthur Kroker sees the linkage of anti-Americanism, technology, and aesthetics as central to Canadian intellectual history: "What makes the discourse on technology such a central aspect of the Canadian imagination," says Kroker,

> is that this discourse is situated *midway* between the future of the New World and the past of European culture, between the rapid unfolding of the "technological imperative" in the American empire and the classical origins of the technological dynamo in European history. The

Canadian discourse is neither the American way nor the European way, but an oppositional culture trapped midway between economy and history. This is to say that the Canadian mind is that of the *in-between*: a restless oscillation between the pragmatic will to live at all costs of the Americans and a searing lament for that which has been suppressed by the modern, technical order. (7)

The Canadian mind, according to Kroker, occupies a contested space and is constituted within "a great and dynamic polarity between technology and culture, between economy and landscape" (8).

Much recent Canadian art has become preoccupied with the paradox of capturing or framing the dynamics of this contested space, but to do so necessitates yet another challenge to the boundaries between high art (especially literature and painting) and popular culture (especially photography). Artworks, once fashioned as expressions of timeless verities, now frequently enact a narrative of transience and impermanence. Of course, taken as artefacts, neither literary nor visual works remain static (or pure) for long: their meaning, social status, and influence are in a constant state of flux. As Andy Warhol taught us, yesterday's soup can may become tomorrow's gallery exhibit—and soon after that it may migrate back into popular culture as a rhetorical commonplace reproduced in magazines, on posters, television, and so on. Just as we cannot really define Canadian culture without reference to European and New World cultures, so it becomes increasingly difficult to think of contemporary artistic practice that does not draw upon or itself influence multiple cultural domains. More and more, notions of "high art" and "popular culture" are taken to designate socially differentiated forms of aesthetic and/or commercial practice; and much of the work of the cultural critic now involves efforts to legitimate and institutionalize the "illigitimate."

In this chapter we want to focus on one such "illigitimate" artform: Canadian photography. We shall argue that photography's "in-between" status (occupying as it does a sometimes uneasy place in relation to both literature and painting) makes it a significant index of changing social, institutional, and aesthetic values. Specifically, we are interested in defining the cultural contact zones, where photography comes into contact with other representational forms, especially literature and painting. We argue that an understanding of vernacular expression cannot be achieved by closing either national or aesthetic borders. On the contrary, we suggest that the combination printing and multiple exposure tech-

Brenda Pelkey, "Side Garden with Castles, Mr. and Mrs. Kantor" (1988). From *"…the great effect of the imagination on the world"* (1991). Reproduced courtesy of the artist.

⊞ ⊞ ⊞ ⊞ ⊞ ⊞ ⊞ ⊞ ⊞

niques first practised in the mid and late nineteenth century establish an important *indigenous* context for understanding the collage and mixed-media forms increasingly employed by our best artists—artists often ignored by those advocating a nationalist critical agenda. Whatever merits the nationalist argument may have had as a generative support mechanism for cultural production, its usefulness is overshadowed by an unexamined print-bias and consequent antipathy toward visual culture. Instead of more warnings about an impending invasion from across the border, we need critical histories and perspectives sensitive to the multiple literacies (visual and verbal) at play in contemporary Canadian art.

Borderblur Art

For some time after its introduction in the mid-nineteenth century, photography occupied an ambiguous cultural middle ground, an "artform" as available to the amateur and the professional as it was to the artist. Early practitioners, such as Canada's William Notman, worked with the new medium as if it were a mode of painting: his studio portraits and tableaux involved elaborate set design, painted backdrops, and visual allusions to Canadian colonial painting, painting that was self-consciously seeking to construct a national identity. Photography quickly developed its own

conventions and, by the latter half of the twentieth century, its advocates had negotiated its place as a legitimate counterpart to painting in high art culture. At the same time, individual artists, no longer composing under the influence of a nationalist agenda, began to engage images of popular and mass culture, asking questions about personal, rather than communal, identity.

An important aspect of that development involved the healthy exchange of ideas, techniques, and cooperation among artists from Canada and the United States. Instead of defending the borders, many visual artists, from the 1960s to the present day, have sought to open up and explore national and formal boundaries. Even the most cursory of reviews reveals a long-standing tradition of cultural exchange: along the west coast in Vancouver, Seattle, San Franciso, and Los Angeles, artists frequently exchange facilities and mount cross-border exhibitions; the same is true of the western provinces, and in the eastern triangle made up of Toronto, Halifax and New York. Indeed, Canada Council's establishment of the 49th Parallel Gallery and the Artists' Studio complex in New York seems indicative of a major Canadian presence in North America's primary exhibition centres. Meanwhile, individual Canadian artists—such as Vicky Alexander, Mowry Baden, Michael Snow, Krystof Wodiczko, Frank Ghery, Carol Condé and Karl Beveridge—have moved back and forth between these Canadian and U.S. centres; and prominent American figures have taken active roles in Canadian artistic activity. Barnett Newman in 1959 and Clement Greenberg in 1962 were present at Saskatchewan's Emma Lake workshops—and the links established during the heydey of formal painting in Canada were carried on into the Conceptual Art movements of the 1960s and 1970s (as exemplified by the exhibitions 555,087 and 955,000 shown in Seattle in 1969 and Vancouver in 1970).

Literary culture in Canada has engaged in similar cross-border exchanges, usually associated with interdisciplinary activities. Some of the better-known participants include Frank Davey, George Bowering, Dan Mcleod, Fred Wah, and other prominent contributors to the *Tish* group of the 1960s in British Columbia; Intermedia, including the work of Fred Douglas, in Vancouver during the 1970s; The General Idea collective, the work of Victor Coleman, Stan Bevington, Greg Curnoe, et al., in eastern Canada during the 1980s—as well as numerous collective activities associated with artist-run galleries, small presses and journals (in particular, A Space Gallery, Electric Gallery, Coach House Press, *Open Letter,* and *Provincial Essays*). As Jennifer Sinclair writes, Canada's artists and authors have long been involved in what she calls "a

borderblur"—"the confluence of image, object, word, sound and technology" (5). Not surprisingly, those who practice (or even write admiringly about) such cross-border activities are the ones singled out by nationalist critics as treasonous intellectuals. If we set the hyperbole aside, we can speculate that such resistance to interdisciplinary exchange goes beyond an aversion to American taste; it is part of a larger, ongoing struggle between word and image. The photographic image seems especially problematic, for although photography developed at a time of rising nationalism in Canada, it was a technology not tied to any specific nationalist narrative. It was, and is, the ideal medium for artists wishing to challenge the authority and enforced orthodoxy of received tradition.

We do not want to suggest that it did not take some time for the visual arts community to accommodate a mixing of photography and painting. Today, however, mixed-media works that combine photography and painting are not as critically controversial as they were, say, thirty years ago. In recent decades photography has emerged from a position of questionable aesthetic status to stand side-by-side with painting as a high art. The visual arts community has embraced the photograph not so much as another variation of painting, but rather as the prototypical visual medium of the modern era. Since the emergence of Conceptual Art in the 1960s, photography has had a central place in artistic production, exhibition, and theory. As noted above, however, the story is quite different when we turn to literary culture's view of photography and the phenomenon of "borderblur." Works that combine photographic images and literary text hold a curious challenge for literary critics—and for Canadian literary culture generally.

At a time when the United States was publishing *Look* and *Life* magazines, and developing a photo-journalistic eye and ear for the American vernacular, Canadian publications preferred to illustrate their pages with pen and ink drawings. The Canadian documentary tradition had its beginnings in the diaries and journals of settlers and explorers who fashioned a genteel vision filtered through a lens of Romantic idealism. The sketch, not the photograph, provided the appropriate vehicle for documentary romance: stories in the Victorian newspapers and magazines "were affected by similar aesthetic fashions: the romance of history, the morality of poverty and other problems, the role of Providence as the author of the future, the effect of sublimity on the soul [an effect experienced in Nature and believed to be re-enacted through elevated diction]" (New, *A History* 74). As Helga Pakasaar has noted, unlike the American photo-journalists employed by the U.S. government under Roosevelt's WPA programme, photo-journalists such as

Pakasaar is right to cite the American experience and note a less visible appreciation of photo-journalism in Canada during the 1930s. That said, the Canadian interest in documentary photography made itself apparent with the founding of the Stills Division of the National Film Board in 1939.

Dorothea Lange, Margaret Bourke-White, Walker Evans and James Agee, "[i]n Canada...there was no venue for photo-journalism" (55). Certainly Canadian photo-journalism of the 1930s and 1940s did not enjoy the same artistic status conferred through the imprimatur of museums and galleries that the American genre received. We should not be surprised: for the late-Victorian sensibility, a sensibility that has persisted well into the mid-twentieth century, the photographic image seemed too raw, "low," and, for some, too ostensibly mimetic to fit comfortably within the prevailing "discourse of civility" (Weir 31) that was born during the Romantic period and fossilized in the idealism of the Victorians, and in the aesthetics of the modernists who insisted upon the "narrative poverty" of photography.[2]

This attitude toward the visual plays itself out (in some revealing ways) in the work of literary critics. Early Canadian novelists were frequently chastised for allowing their work to degenerate into "mere photograph[s]" (qtd. in Gerson 74-75). The mere photograph has long been treated as little more than a handmaiden to literature. As W.J.T. Mitchell points out,

> "Children should be seen and not heard" is a bit of proverbial wisdom that reinforces a stereotypical relation, not just between adults and children, but between the freedom to speak and see and the injunction to remain silent and available for observation. That is why this kind of wisdom is transferable from children to women to colonized subjects to works of art to characterizations of visual representation itself. (*Picture Theory* 162)

Anthologies and new editions that reprint the writing but leave out the original accompanying visual art suggest one significant aspect of this literary attitude—the same kind of attitude that allows Dennis Cooley to reflect "ironically," in footnote 12 of his article on Michael Ondaatje's *The Collected Works of Billy the Kid*, "my argument about photography doesn't take account of the actual photographs [in the book]" (237). We need to recognize, with Douglas Barbour, that a work like Daphne Marlatt's *Steveston* "is a collaboration [between a poet and a photographer], and that reading the poem apart from [Robert] Minden's series of photographs makes for an incomplete reading of the work" (225). We also need to understand (and question) the critical presuppositions that in the same article allow Barbour to present just such an "incomplete reading," ignoring Minden's photographs with the confident dec-

2 John Szarkowski, past curator of photography at the Museum of Modern Art, has been a pivotal figure in shaping a modernist understanding of photography's history as a medium without narrative potential; Geoffrey James's essay "Responding to Photographs: a Canadian Portfolio" reflects a similar attitude and situates it within a Canadian context.

laration, "Nevertheless, it is Marlatt's writing which interests us here" (226). As Stephen Melville notes, there is "something funny" about this kind of critical "chiasmus" — "something funny that seems to go on with some regularity between criticism, literature and [visual art], and something the diagnosis of which might powerfully inform our thinking about the extension of literary theory into the visual domain" (78).

Literary studies typically treats photographs as mere illustrations to be noted in passing or ignored altogether. Literary culture values imagination over image, what is recollected over what is seen. The inclusion of photographic techniques and images into contemporary Canadian literature therefore presents a highly-charged moment of cultural change, a potentially disruptive challenge to the authority of word over image. Ironically, the challenge has been characterized by many critics in terms akin to those invoked by cultural nationalists who want to stop the entry of U.S. popular culture at the border.

Frye's notion of the "garrison mentality" has become a metaphor for critical practice. In the name of verbal literacy and the preservation of high art tradition, literary culture has done its best to ignore the visual. Meanwhile, the new media, in particular photography, film, and the developing communication technologies, offer an alternative vision, one often associated with a transnational or postnational orientation and ideology. By including or otherwise co-opting images from advertising, popular culture, and news media, and by combining these images with literary and paraliterary texts, contemporary artists have begun to challenge the hegemony of word over image, high over low culture.

An aesthetics of "borderblur" does not fit comfortably within print-based definitions of Canadian culture, but it is nonetheless a crucial component of that culture. As author bpNichol states, "the visualness of writing is not new; unfortunately it seems to be news to some people." Nichol offers a preliminary catalogue of borderblur art:

> Greg Curnoe's large-scale canvases composed entirely of words as well as those incorporating language as part of the composition; …Steve McCaffery's multi-panel typewriter text 'Carnival'; …sean o'huigin's visual poems;…[the work of] Jack Chambers, Michael Sowdon, John Boyle , David Bolduc, Roy Kiyooka, photographers David Hlynsky, Rich/Simon, Jim Laing, Marilyn Westlake, etc., etc. ("Primary Days" 20)

Brenda Pelkey, "Tree" and accompanying text panel. From *Dreams of Life and Death* (1994). Reproduced courtesy of the artist. Photograph by Donald Lawrence.

We would probably want to add reference to Michael Ondaatje's appropriation and identification with an American outlaw in his phototextual work *The Collected Works of Billy the Kid*; Carol Shields's use of the diary form and family photography album in *The Stone Diaries*; Carol Condé and Karl Beveridge's phototextual narratives of contemporary labour history; Brenda Pelkey's striking mix of photography and poetry in her *Dreams of Life and Death*; and the whole genre of "artists' books," books that present themselves as artworks in and of themselves.

These works and their images tend to draw more upon North American popular culture, critiques of mass cultural consumption, and the rendering of authentic personal experience than upon Canadian nationalist ideology. To some, like Mathews and Dobbs, such new narrative strategies must seem like the final capitulation to American culture: a medium "based on total immediacy (and flying the U.S. flag) [,]…a vision of a literature (and culture) 'Americanized' in which all Canadian expression is 'post-everything except the world itself'…" (Mathews, *Canadian* 93-94). In some measure, these critics are right to complain. Art which simply rehearses the images and values of a consumer society has lit-

tle chance of contributing an original view of the world. By the same token, however, simply adhering to prescriptive, print-based conventions of narrative tradition and aesthetic decorum can be equally stultifying.

We wish to outline here an alternative perspective, one that values the narrative potential of the visual image and treats both visual and verbal components of contemporary art as coherent co-participants in the creation of meaning. We are interested in those works that engage questions of nationalism and exploitation alluded to by Dobbs, Mathews, and Kroker, but we are also wary of that which, in Rob Shields's words, "prevents contemporary Canadian society from moving beyond the narcissistic circle of identity where the other merely serves as a culturally-constructed foil for an idealized western self-image…" (26). By combining the two dominant modes of communication, and by incorporating words as more than captions (and images as more than illustrations), PhotoGraphic works implicitly acknowledge at the outset that their relationships with nature are constructed within and by the enveloping media culture. It is our contention that by developing an ear (and an eye) for these prose pictures and visual fictions we can better appreciate the Canadian inflection when we hear and see it. Moreover, we see these new PhotoGraphic works as significant examples of vernacular expression, expression with a clear (if seldom acknowledged) history and which, contrary to Mathews, et al., finds its voice not outside high, mass, and popular culture, but by playing one cultural sphere off against the other. The vernacular, often variously dismissed as naive, eccentric, and/or experimental, functions as an interruption to the movement of mainstream culture; it is an artform that, by ignoring or resisting the mainstream, offers a moment of held breath, a cultural pause, wherein we can reflect upon the normally invisible social, historical, and cultural forces that shape what we read and see.

The Secret Victorian Aesthetic

To construct an historical context as a frame for the social and the cultural is not to propose a direct causal relationship between the past and the present, though, as we will point out, in some cases there may well be connections to be made. Unlike Margaret Harker, who insists that the flurry of combination printing during the 1880s and 1890s should be regarded as "wholly alien to the late twentieth century in conception and treatment" (74), we see it as

Anonymous, engraving of 19th-century wet-plate photographer with portable darkroom (c. 1859). Reproduced by permission of the Gernsheim Collection, Harry Ransom Humanities Research Center, The University of Texas at Austin.

an important precursor to contemporary combination artforms and strategies.

In *Secret Victorians: Contemporary Artists and a 19th-Century Vision*, curators Melissa Feldman and Ingrid Schaffner frame an intriguing thesis: that many of today's *avant-garde* artists are really closet Victorians. "Predisposed toward pastiche and empirical investigation, and enthralled by technology," they say, "post-modernists disclose a decidedly turn-of-the century turn of mind" (11). Contrary to the clichés about Victorian sexual repression and crinoline conformity, the Victorian age was also one of active experimentation, confusion, wonderful eccentricity, and, above all, change. Walter Pater characterized the style of the day as one exhibiting "chaotic variety" (from his essay on *Style*, 1889); and an important aspect of that style remains a focus on the curious, the marvellous, in technology and nature. A sense of wonder seems central, a kind of startle reflex that tends to mark a moment of personal reaction and transformation.

Even in the Victorian period, though, archetectural innovation, curios, wonder cabinets, and so on, were not considered the stuff of high art. As we have suggested, old ideologies and worldviews give way grudgingly to new modes of inquiry and representation. Paradigms do not shift quickly. Among High Art's authors, artists, and guardians, the "new" is almost always viewed cautiously and often judged immature or irrelevant. The task, for example, of articulating and negotiating a photographic aesthetic or sensibility is as urgent today as it was the the early decades of the technology's introduction—in the work, say, of England's Henry Peach Robinson or Canada's William Notman. By examining how early Canadian artists struggled with the problems of visualization and representation that photography first provoked, we should gain insight into how and why these same problems continue to engage contemporary artists, authors, and critics.

There are, for example, some spatial aspects of the early composite images, perhaps regarded as problematic at the time, which bear a canny resemblance to the spatial and temporal ambiguities later employed by such artists as René Magritte and Max Ernst, ambiguities that have become central to much contemporary interest in pictorial irony and paradox. These same concerns have migrated into literary studies, in part due to the contemporary interest in (and anxiety over) permeable disciplinary and formal boundaries, and partially due to the increasing number of authors and critics exploring the implications of intermedial expression.

Like the contemporary figures interested in borderblur art, nineteenth-century photographers working with combination

printing and multiple exposure techniques, such people as Montreal's William Notman and Victoria's Hannah Maynard, tend to blur distinctions between painting and photography, narrative and illustration, subjective expression and objective representation. At a time when "Kodaking," the popularization of the captured moment, was coming into vogue, these artists were exploring an alternative vision: rather than performing a purely mimetic function, their photographs often take on a narrative aspect. These narratives are suggested both by the painterly scenes that constitute Notman's composite tableaux and, more subtly, by the performances behind the images—by the record of preliminary sketches, the cropping and painting over of images that Notman and his staff of artists used to achieve an ideal form. Similarly, Maynard "stages" or "performs" many of her photographs, managing multiple poses of herself and her nephew, allowing them to merge into one continuous image that self-consciously represents a series of exposures. Maynard's glass plates reveal a record of her entire performance, where she would mask areas and scratch directly onto the negative. Her photographs suggest a tension between a desire to create both a single, seamless photographic image and a narrative of that image's production and personal significance. In short, her work dramatically contests the notion of instantaneous photography and the privileging of the decisive moment that would later characterize so much modernist photography. For Notman, the emphasis always falls on the final product; the process of creation is deliberately downplayed, made invisible. As Martha Langford has characterized them, composite photographs of the sort that interested Notman were ones where "an image [is] constructed along predetermined lines to simulate reality" (59).

In a review of the McCord Museum's recent Notman exhibition, Langford groups composite photography with its closely related technique of combination printing, and also with montage, collage, and digitalization, mapping them out on what she calls "photography's evolutionary chart." These techniques she classes as "overt falsifications" (59) and links them to other "abuses" of the medium, including presumably the sorts of tableaux constructed and photographed by Maynard. Such manipulations of the photographic medium were even disdained by some photographers of the Victorian period, photographers like Peter Henry Emerson, who argued for a more "naturalistic," less doctored means of attaining life-like veracity (Goldberg 190). Langford indicts composite techniques for displaying a kind of premature postmodernism that puts "temporality, actuality, and factuality strictly in their place, in

Anonymous, engraving of a zoetrope, (c. 1880).

the darkest recesses of representation" (60). Similarly, in his review of the Notman exhibition, Ray Conlogue describes composite photography as "a curious form of faked group photography that enjoyed a vogue during the latter half of the 19th century before advancing technology made true group photography possible" ("Cutting Up" A13). Thus characterized, Notman's work becomes effectively marginalized as outside the High Art tradition, as something lacking aesthetic integrity; as inauthentic, phoney; as an ingenious oddity, kitsch. While one cannot deny that even some of the pioneers of these techniques later came to question their role in serious artistic practice (Henry Peach Robinson is the obvious example of one who, later in life, recanted his early experimentation with the medium), to dismiss the artform out of hand runs the risk of overlooking some of the more interesting ideas that these artists explored.

Whether or not the activities of these photographers were always successful is not the central issue: their works must be regarded as something more than just a series of technical experiments. Their work also represents an exploration of the broad aesthetic questions of their day, in particular the changing notions of temporality, representation, and subjectivity. It is our contention that the interplay between diegetic and mimetic discourse (between telling and showing) tends to highlight a narrative of negotiation among competing cultural spaces—a narrative informed by notions of photographic time, experience, and visualization first articulated in the multiple exposures, composite constructions, and combination printing techniques of nineteenth-century photography.

If one accepts the "Kodak moment" as the modernist cultural norm, then it serves as a useful point of reference for discussing aspects of time and multiple perspective in the work of Notman and Maynard. The idea of photographs forming themselves around a moment in time has a long history, with origins in the faster (more light-sensitive) emulsions and dry plate technology formulated in the years leading up to Eastman's patenting of the Kodak in 1888. From that time on the possibility of the snapshot has existed. For many years, though, snapshots were regarded as aspects of popular culture and outside the realm of Fine Art. Today, the frozen moment has been affirmed for us through a more established tradition of photographers, from Eastman through Alfred Stieglitz to Henri Cartier-Bresson and canonized by such figures as John Szarkowski and Beaumont Newhall. Cartier-Bresson, a pivotal figure within both Fine Art and journalistic photography, has provided a philosophical basis for this new form through his concept of the "decisive moment." He maintains

that "inside movement there is one moment at which the elements in motion are in balance. Photography must seize upon this moment and hold immobile the equilibrium of it" (385). Cartier-Bresson believed that by extracting a key moment from the narrative situation unfolding before him he could most clearly express the essence of that event. Thus, even though the focus is on frozen action, the underlying worldview remains linear: the image derives its energy and its meaning from the assumption that any suspended motion is only temporary—that it will soon be eclipsed by the next moment. Though Cartier-Bresson's decisive moment is a notion that postdates Notman's work by several decades, it nonetheless provides a useful point of departure for thinking about composite prints and staged tableaux.

Notman's work suggests an intriguing mixture of motives: on one hand, some of his photographs, such as "The Bounce" (depicting eight men bouncing a ninth into the air), represent the kind of frozen moment that would later fascinate Cartier-Bresson; on the other hand, his method of image making (often cutting and pasting hundreds of individual poses and arranging them into a single image) suggests resistance to technological change. His oeuvre highlights three types of images: (1) straightforward photographs—architectural views, views of cities, scenes of westward expansion, etc.; (2) studio photographs ranging from standard portraiture to elaborately staged tableaux; and (3) composite photographs assembled from a variety of negatives according to sketches drawn up by artists within the firm. The latter two types are of particular interest here.

Between 1866 and 1868, Notman produced several series of images depicting the life of hunters in the Canadian wilderness—popularizations of vernacular activities. Advertisements of the time indicate that these images could be purchased individually or as portfolios with titles such as "Cariboo Hunting" (sic) and "Moose Hunting." Unlike his usual composite strategy, which resolved many poses within a single image, these various series follow a notion of narrative where each staged image represents a moment of the adventure, that moment analogous to Cartier-Bresson's "decisive moment." As the photographic magazines of the day reported, "[t]o make these pictures, trees, rocks, snow, tents, air, light, fire, men, backgrounds, cariboo! had to be brought in and arranged to suit the chosen subject for the picture" (Carey 131). Notman added these elements into the usual studio environment, and in the process challenged Victorian high art decorum that, in theory, called for "neat, tasteful, and appropriate accessories" (qtd. in Bara 28). The pictures made by these means were accompanied

Wm. Notman & Son, *The Bounce* (1887). Reproduced courtesy of the Notman Photographic Archives, McCord Museum.

Wm. Notman, *Death of the Moose* (1866). Reproduced courtesy of the Notman Photographic Archives, McCord Museum.

with captions to direct the reading of the image. An advertisement from the time announces "Seven Photographs from Nature" to introduce the series "Moose Hunting"; it offers the following captions:

 1. Night—Asleep in the Cabane
 2. Early Morn—The surprise
 3. The Breakfast
 4. The Death
 5. The Return
 6. The Three Guides
 7. The Old Hunter. (Taylor 12)

This spare narrative provoked some elaborate readings from Notman's audience. Of "The Cariboo Hunt," for example, a writer in *The Philadelphia Photographer* responds that each image "tells a story, and the whole series combined gives a truthful account of the sports, pleasures and perils of a caribou hunt in snowy Canada" ("Outdoor Photographs" 9). Elsewhere in the same magazine, essay responses extend the narrative by providing an elaboration of each series' Romantic themes. Here's what one critic says of a series entitled "The Seals":

> "The Seals" is the gem of the set in pictorial effect and beauty. In it we have represented a huge pile of broken ice, the wily hunter climbing over it, gun in hand, and a group of seals at some distance from him, listening, with their liquid, human eyes staring, ready for a plunge into the ice reflecting water below. It hardly seems credible that such effects can be produced on the floor of a photographic glass-room. Nothing can be more successful and wonderful in photography. ("Composite Photographs" 79-80)

However innovative or ingenious his technique, Notman's notion of narrative was hardly revolutionary. An understanding of the temporal as fixed within the conventions of western perspective dominated Notman's thinking, and is one reason that art historians such as Ann Thomas have understood Notman as a conventional image-maker (5). Some of Notman's works, though, exhibit a more complex sense of the temporal than the label "conventional" seems to allow. Amongst his numerous family composites are two of the Philip Simpson Ross family. These two images are separated by twenty-eight years, the first created in 1876, and the second in 1904. During that lapse of time the family had of course multiplied, and thus in the later images their collaged bodies fill the same room that looks rather sparse in the earlier image. As with any home, particularly a Victorian one, objects have accumulated: numerous landscape paintings, wall-hangings, plates, a bookcase, and a sculpture on the mantlepiece; amongst them, on the wall is the earlier composite photograph—a self-referential token. Susan Sontag writes in *On Photography* that "to take a photograph is to participate in another person's (or thing's) mortality, vulnerability, mutability. Precisely by slicing out this moment and freezing it, all photographs testify to time's relentless melt" (14). To photograph a photograph is to participate in a narrative of simultaneity. Time progresses, but the present moment also contains the past. For the Ross family, time was not melting. Notman's family

Wm. Notman, *Moose Hunting* advertisement, from Notman's *Portraits of British Americans* (1865). Reproduced courtesy of the Robarts Library, University of Toronto.

portrait offers a careful construction that would have represented an idea more akin to stability than mutability, the stability of an assumed social order. As Langford suggests in a review of the Notman collection, questions of mortality and mutability are not really part of Notman's agenda, though such concerns have seldom been far removed from serious reflection on the photographic process.

Daguerrotyping, the first patented photographic process, and one in vogue for the first two decades of photographic production, must have provided an uneasy counterpart to Notman's sense of order. A daguerrotype is a photograph on a copper plate, generally about the size of the miniature paintings popular at the time and similarly presented in small intricate frames and cases. The daguerrotype initiated much excitement and uncertainty regarding

Wm. Notman, *Trapping the Seal* (1866). Reproduced courtesy of the Notman Photographic Archives, McCord Museum.

the nature of the image produced. Some thought the daguerrotype capable of evoking the dead (Sekula 460). Such conclusions become more understandable if we imagine holding one of these images for the first time: it would have a mirror-like sheen, coming from its polished metallic surface; and if it were turned sideways, the image, almost always a portrait, would seemingly disappear, with only a ghost-like after-image remaining. In a manner analogous to Holbein's skull, death or absence becomes apparent when the image is observed obliquely, only to return to the material world when observed frontally—when the viewer assumes the normal perspectival gaze. Numerous reasons have been cited for the decline of the daguerrotype: it was a one-of-a-kind item, not reproducible in the usual photographic sense; it involved an awkward technical process that produced images thought of as too real and without passion. We also speculate that the uncertainty of the image, its lack of substance, made it fall out of fashion; the daguerrotype presented a representational mode that could not be fixed or objectified in the way that photography has been since that time. Notman's technique, on the other hand, held little threat to Victorian sensibilities.

While Notman's composites may contest the idea of the captured moment, they nonetheless aspire to depict such a moment— sometimes a moment commemorating a private or social function, sometimes a moment set along the railway lines of the CPR thousands of miles from Montreal. We might be tempted to point out that all such composite moments fictionalize a situation, for they represent an event that did not (perhaps could not) present itself before the lens of a camera. Nonetheless, the arresting of movement within compositions follows the trajectory of photographic development from the Kodak to other amateur cameras and the advent of nitro-cellulose roll-film in the 1880s and '90s.

Where Notman's prints may allude to concerns introduced by the daguerrotype, and where they might anticipate the aesthetics of postmodern production, Hannah Maynard's multiple exposures dramatically contest the dominant representational strategies of her day, and thus they come closer to anticipating the contemporary vernacular of intermedial expression. For Maynard, the family portrait, the question of mortality and mutability, and the whole business of studio construction of meaning take a marked turn to the personal.

Hannah Maynard, an emigrant from England, opened a photographic studio in Victoria, British Columbia, after settling there with her husband Richard in 1862. She pursued a wide range of photographic practices, including standard studio portraiture, the

Wm. Notman, *Ross Family Composite* (1876). Reproduced courtesy of the Notman Photographic Archives, McCord Museum.

photographing of suspected criminals, the production of multiply exposed self-portraits and of her celebrated "Gems." These Gems were elaborate composites, produced annually between 1880 and 1895, each picturing all the babies born in Victoria during those years. The more complex of these Gems contain thousands of figures, incorporating as they do compositions from previous years, in configurations such as ornaments and fountains. Though used by Maynard as samples to advertise her studio, the Gems evoke a response akin to that evoked by the daguerreotype: as Eva-Marie Kröller notes, Maynard's work expresses "a fascination with death and the occult wide-spread in Victorian society, but too private, whimsical, sad and generally 'counter-productive' to serve as…

Wm. Notman & Son, *Ross Family Composite* (1904). Courtesy of the Notman Photographic Archives, McCord Museum.

advertisements. Maynard's 'Gems'... signal the continuingly high mortality rate among infants..." ("Nineteenth-Century" 85). The whimsical, personal nature of Maynard's work distinguishes it from emergent mainstream developments, developments generally linked to commercial progress. Here personal vision subverts the public world of commercial production. Maynard's multiply-exposed self portraits present even more private, whimsical, and significant examples of vernacular expression.

These are images where Maynard has managed to represent herself, and sometimes her nephew, two or more times on the same glass plate negative. What these photographs accomplish is a representation of time removed from the conventional photographs of her day and distinct from the photographs of Notman. Whereas Notman's composites condense multiple scenes into one depicted moment of time, Maynard's photographs offer a manifestation of multiple moments. This is not the "decisive moment" conceptualized by Cartier-Bresson; rather, it is a networking of associated

moments. The emphasis here is on lived connection, not historical progression—metonomy, not metaphor.

In one of these multiple exposures (c. 1895) we see two figures, Hannah and her nephew Maynard Macdonald, each appearing twice in the image. The "doubles" encourage us to see the image as temporally based, translocated between two moments. Such images rehearse notions related to both earlier photographic forms—the shifting image of the daguerrotype, the unstable image in a stereoscope—and the image-freezing technology of her day. David Mattison, Peter Wollheim, and Petra Watson have commented in some detail on Maynard's relationship with her contemporaries, many of whom were interested similarly in multiple imaging techniques. Spiritualism provided a common link. As Wollheim notes, interest in Spiritualism was linked to "[c]ultural trends at large in Victorian society, trends which indicate[d] a progressive decorporalization of the physical world, and de-materialization of the human body" (36). Such trends led artists such as Maynard to question unilinear perception and knowledge. Two of her multiple exposure prints illustrate a visual narrative blending personal history, Spiritualism, and an aesthetics of multiple perspective.

Each multiple was achieved by imaging a tableau upon the ground glass viewing screen of an 8" x 10" view camera and selectively masking off selected portions of the glass plate (which would become the negative). Each portion would be unmasked in turn until the entire plate was exposed. The more seamless the borders between these various portions of the overall image the more successful the multiple. Maynard and her nephew appear more than once in each of several images: they stand in front of and sometimes even interact with the background in what Watson takes to be a parody of the prescribed solemnity of the Victorian portrait studio (6). In one image we see the nephew looking up towards the tableau, while Maynard herself occupies two different sectors of the glass plate. The image features a statue, what Maynard would have called a "photosculpture," and a number of framed portrait photographs placed in an almost totemic arrangement. Each portrait is of a deceased relative, with Maynard's own daughter Lillie at the top. Claire Wilks, who has authored the only book-length study of Maynard, observes that such tableaux border "on the grotesque." Wilks's description of the tableau in question is revealing:

Looking girlish for her age (she is 60 in this photograph) and nicely nipped at the waist, [Hannah Maynard] sits to

Hannah Maynard, untitled multiple exposure self-portrait (c. 1890). Reproduced courtesy of the British Columbia Archives and Records Service.

the far left looking in on the scene through a proper lorgnette. Her dead [daughters and a daughter in law] sit between her selves: Lillie, Adelaide, and Emma. She is staring directly, with all the vanity of a handsome young woman, into the camera as Maynard [her nephew] looks up at the severed torso of himself, impaled…as a photo-sculpture shadow of himself on the pedestal. (93)

Wilks concludes that the scene is "open to several interpretations, all of them unsettling"(93)—and that, of course, is exactly the point: Maynard's representational strategies unsettle viewer expectations by implying a complex narrative of obvious personal and spiritual significance. The viewer's comfortable gaze is disrupted, challenged by both the unsettling composition and the figure of Maynard looking directly at audience.

In another photograph we see three images of Maynard herself,

Maynard's interest in the "multiple moment" has its parallel in the composite techniques developed in France during the mid 1880s by Francis Galton. Galton utilized images of numerous individuals exposed onto a single glass plate, one on top of another. Where Maynard explores the "self," such individuality is suppressed in Galton's photographs.

Hannah Maynard, multiple exposure portrait with her nephew (c. 1885). Reproduced courtesy of the British Columbia Archives and Records Service.

two "Maynards" seated at a table set for tea, and one "Maynard," an animated framed portrait, reaching out towards the others. The framed image interrupts the usual neutrality of the painted studio backdrop: she leans outward from her frame, looking down at one figure of herself while inadvertently pouring tea on her third self. This third figure, seemingly unaware of present events, looks out at the viewer with a mixture of irritation and disdain. The cascade of tea, achieved technically by scraping away the emulsion on the negative, mimics a painting of a waterfall to the left—a painting which is, of course, not a "real" painting but simply a portion of the illusionistic backdrop.

Such visual delights suggest the playful, ironic counterpart to Maynard's more personal tableaux. In addition, Maynard's photographic practices suggest a complex, sometimes idiosyncratic, fore-

Hannah Maynard, multiple exposure self-portrait (c. 1885). Courtesy of the British Columbia Archives and Records Service.

shadowing of contemporary works in visual narrative. As Petra Watson points out, "the construction of the contemporary photographic tableau, and its deployment 'as a directorial mode,' [is] not unlike early studio photography, but which now pillages its thematics and codes from the mass media and advertising, and sometimes the lingering, but emphatic conventions of painting" (8). The visual fictions and prose pictures of many contemporary Canadian artists and authors, including Brenda Pelkey, Carole Condé and Karl Beveridge, Michael Ondaatje, Carol Shields, and so many others, find their thematic and formal "source in the extravagant studio setting of the nineteenth century" (8). Although the cultural status of this "vernacular," borderblur art remains uncertain, its value as a cultural critique seems undeniable. As Victor Burgin notes, we "refer to the vernacular in order to open the art institution onto the wider semiotic in which we live, to bring about a mutual interrogation of 'art' and 'mass-media' meanings and values" (45). Perhaps more importantly, given the anti-American ethos and print-bias of Canada's cultural elite, further attention to Canada's vernacular tradition may help "legitimize" a vital dimension of our cultural practice.

Brenda Pelkey: Vernacular Theatre

With this background, we turn to the work of Saskatoon-based photographer Brenda Pelkey, someone for whom popular culture is not the enemy but the vehicle for personal exploration. In "… *the great effect of the imagination on the world*," for example, Pelkey documents a Disneyland world of "vernacular landmarks, created by homeowners who have landscaped their yards with objects, topiary and miniature architecture, to embody personal memories, fantasies, or in some cases, tributes to their belief systems" (Marzolf 5). In effect, by photographing the sites at night with the aid of movie lights and by recording the images on linked cibachrome print panels, Pelkey re-evaluates notions of consumer culture and kitsch: here the objects of vernacular expression are overtly theatricalized, made more personally relevant by embellishing them in the romantic glow of ostentatiously artificial floods and spots. In Pelkey's hands, "overt falsification," once the by-product of nineteenth-century experimentation and whimsy, becomes a means to explore authentic personal expression. As Helen Marzolf notes, "[t]he resulting images are dramatic, and convey…occupy, in Brenda Pelkey's eyes, an interstice between the documentary and the symbolic" (11). They also occupy an inter-

stice that draws together vernacular, popular, and mass culture modes of representation. There's an art historical reference at play here, for Pelkey reveals backyard fantasies as something akin to the studio constructions of Notman's winter tableaux: where Notman reconstructs Nature as an indoor sport, Pelkey shows the constructed and personally invested nature of domesticated outdoor environments. In her more recent work, *Dreams of Life and Death*, and in her bookworks, Pelkey extends the narrative impact of her images by incorporating a textual complement, where ostensibly disconnected images combine with highly personal, even lyric, textual gestures. Hers is an art of presence, of making the unconscious or the forgotten visible. As Pelkey explains, her work with image and text reflects her concern for the "inner world; how we construct both our inner sense of self and social persona. The photograph acts as a blank screen, and the text will help place the meaning for the viewer in relation to the image, but not in a didactic or aphoristic manner" ("Mnemonic" 14). A work like *Dreams of Life and Death* subordinates (or at least situates) social and aesthetic critique within a structure that dramatically foregrounds the impulses of the imagination: Pelkey engages the viewer in a physical process of reading the space that lies between her images and texts. She invites the viewer to look behind the scene.

When we first viewed *Dreams of Life and Death*, we saw the work exhibited in Regina's Norman Mackenzie Gallery, a long, ambulatory space with a continuous glass façade along its entire length. The lateral configuration of the gallery echoed the panoramic format of Pelkey's Ilfochrome photographs, each facing out toward the glass façade. The large-scale panoramic images are actually two or three separate photographs mounted on foamcore panels and abutted edge-to-edge so that the images float slightly out from the wall. The panoramas present themselves without the protection of frames, thus inviting a direct engagement with the space of the viewer.

Adjacent to each photograph sits a wall-mounted panel, a detail from the larger associated work; and superimposed onto this detail, a poetic text. The visual details and the verbal texts affect our perception of the main image, sometimes in quite obvious ways and sometimes more allusively or tangentially. These text panels project outward from the wall in the manner of a sloped shelf, prompting the viewer to, quite literally, read *between* poetic narrative and photographic panorama.

The particulars of the setting are important: when we first viewed the works, the light entering into this glassed ambulatory played with the highly reflective surface quality of the dark photo-

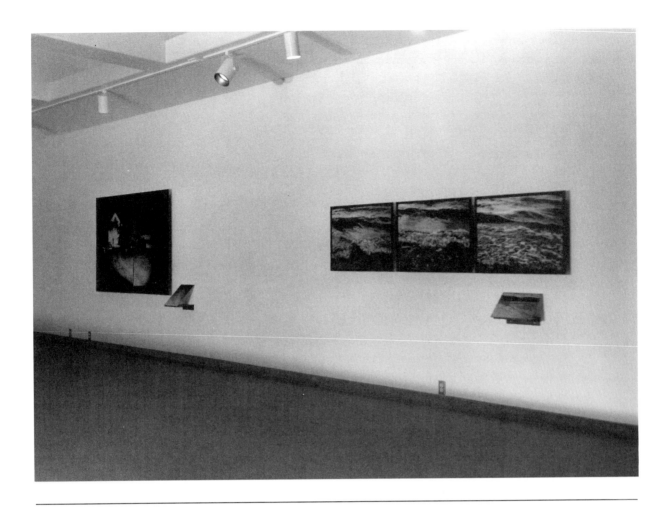

Brenda Pelkey, *Dreams of Life and Death* (1995). Installation view, Norman Mackenzie Art Gallery, Regina, Saskatchewan. Reproduced courtesy of the artist. Photograph by Donald Lawrence.

graphs, causing our own reflections and those of the windows behind us to merge in and out of each image. We found ourselves drawn into a process of image-making, a process that bears a canny resemblance to viewing those earliest and intimate photographs, the daguerreotypes of the early Victorian period. As we've already noted, the daguerreotype portrait, when viewed frontally, would show the subject gazing out at the viewer and no doubt evoke a felt sense of tangible presence and veracity. When viewed slightly askew or, like Pelkey's photographs, in a different light, the daguerreotype's surface would become mirror-like, the subject becoming elusive at the exact same moment the viewer began to see her own reflection taking shape in the silvered surface. We see Pelkey's images in similar terms, as a physical process that implicates the viewers and causes the viewers to read between image and text, always with

PhotoGraphic Encounters

Mid nineteenth-century daguerreotype in opened case. Photograph by Donald Lawrence.

their own presence, and perhaps even mortality, in mind.

Shortly after viewing her exhibition we interviewed Pelkey and asked her about reflection and mortality. She told us about a series of cibochromes depicting "reflections in people's windows." "When my first daughter was just a baby," she said, "I wheeled her around the neighbourhood and I photographed her in different reflective spaces, like in an office window, which, if seen from the right perspective, shows both outside and inside at the same time. Reflected surfaces create this wonderful meeting place, a kind of dreamscape" (Personal interview). Pelkey's dreamscapes play off light and shadow, interiors and exteriors; and they invite self-reflection.

Of Pelkey's images, the darkest one, the one most masked in shadow, is "Telephone Booth" (1994), a three-panel work presenting a wide urban panorama, very dark, with just a few details of the scene discernible. The photograph has been made with ambient nightime illumination, but with the exposure calculated for the brighter light emanating from a Sasktel telephone booth and casting outwards from the centre of the panorama. The light falls off sharply, providing secondary illumination only on the roadway and on objects in close proximity to the booth, objects such as a *Globe*

and Mail newspaper box. Recalling the compositions of early Dutch painters like Carel Fabritious, streets recede in each direction from the central booth, enhancing the panoramic effect. A stop sign and a Canada Post mailbox frame the street, now receding into darkness toward the left side of the photograph—while a 1970s Toyota Landcruiser appears silhouetted against the lights of a house, only slightly more visible on the right side of the photograph. An accompanying poetic text, printed over a close-up view of the asphalt, gives narrative voice to the scene:

No one knew why he killed himself. He was engaged to be married and just built a house.

He borrowed a gun from his cousin.

Two weeks previously he had invited me to see his new house. I had admired the kitchen taps and seen the bedroom where he later died.

When we had dated briefly he told me that he would not live beyond thirty. I thought perhaps he had been too influenced by "the movies."

He loved to honk his horn when driving by telephone booths. He told me that the person could be talking to someone in Ontario and that then his truck horn would be heard in Toronto.

The text opens with a declaration of ignorance, perhaps a gesture of community denial—"No one knew why he killed himself"—followed by a subtle assertion of community values designed, one suspects, to depict the young man as, by all appearances, thoroughly conventional. The second verse introduces a fragmentary detail, another apparently innocent gesture, but one that implicates his family and localizes the story. By the third verse, we have moved from community to family to first-person narrator. The tone remains curiously detached, even reportorial—but the details, moving from the "kitchen taps" to "the bedroom," suggest an unspoken story of failed domesticity and intimacy. The fourth verse only complicates the speaker's relationship to the dead man, for the passing reference about dating "briefly" invites us to wonder why the speaker, only "two weeks previously," would have been invited to see the newly built house of a man "engaged to be married."

The details do not fit. Yet there are gaps in the story dramatic and engaging enough to prompt a second (and third) look at image/text relations. Our first instinct is to look back at the photographic triptych, and there we find several tantalizing connections, enough for someone seeking a metaphorical resolution to freeze meaning, at least momentarily. Martha Langford, for example, sees Pelkey as an artist "inhabiting" her visual landscapes:

> The wide screen that is the picture, the human scale of the booth, the triumph of sound over time and space in both image and text: photographs and stories together always play with degrees of presence and pastness but this set of moves is particularly adept. Pelkey is grappling with a calamitous event by placing before the spectator a full spectrum of ordinary, and clearly happier, possibilities, the *what ifs* that make the final outcome so cruel.... This is also the beauty of Pelkey's work, that it crystallizes the terrible moment in its many points of promise and reflection. ("Landscapes" 54)

The "terrible moment," though, may be more fluid and spatial than Langford's phrasing allows. The focalizing agent is not the moment but the unrevealed narrative and its ability to unsettle viewer/reader response. Pelkey's works hinge upon the successful presentation of a mediating, exploratory voice.

This is the voice that Diana Nemiroff finds lacking in the politically and polemically saturated style of Carole Condé and Karl Beveridge, where the documentary collage of images and texts arranges overtly staged figures against a backdrop of domestic settings and the trappings of consumer society. The settings signal an association with a readily identifiable social cause, for which the artists act as both interlocutor and advocate. Nemiroff expresses a certain "dissatisfaction with the work," stating that "[t]he frames are like stills from a movie, lacking, in comparison with the film itself, the aspect of drama that is the active experience of the development of events over time" (10). To put the matter more colloquially, their work doesn't move her. Unlike the documentary photographs of Pelkey or of, say, the American FSA photographers, the work of Condé and Beveridge seemingly denies the role of camera as personal, if not always reliable, witness. Works such as *Standing Up* and *Class Work* refuse free play to primary material, proffering instead a "closed system of signs" (Nemiroff 11). Playing off the captured moment of Cartier Bresson, and exaggerating the

manipulated compositions of Dorothea Lange, Arthur Rothstein, et al., the implied narrative invokes a sense of premature closure: we move from the captured moment of modernism to the captioned and constructed moments of postmodernism—but with Condé and Beveridge, the orientation remains vertical, directorial. In a Notmanesque manner, Condé and Beveridge select and combine each part of the specific social puzzle, leaving the viewer/reader little room for personal or subconscious response. In Robert Kroetsch's terms, theirs is a body of work where we are supposed to "get the point."

While we sympathize with Nemiroff's critique, we feel it oversimplifies the impact of Condé and Beveridge's work, especially the work's range and collaborative nature. These are artists careful not to appropriate or misrepresent social history. That said, Condé and Beveridge would be the first to admit that their work is not, primarily, a vehicle for personal expression.

More personal in orientation, and less overtly political in scope, Pelkey's work nonetheless must address similar problems in documentary representation. In contrast to Condé and Beveridge, the backyard "kitsch," the array of ordinary, even banal, images, seem much less carefully arranged; they appear discovered, *objets trouvés*. These found or reconstructed materials remind us of the making process—that beautiful objects can be constructed and that, through reconstruction and recontexualization, the artist can reclaim the personal element that social habit or commodification too often denies. Such faith in the power of the artist to reclaim the personal lies at the heart of much recent PhotoGraphic work. As Pelkey notes,

> I think that being very personal in your art work is something that women have made more acceptable in art making. The personal rather than the abstract, heroic or transcendental. These are things I'm drawn to…; these are things that one is not supposed to acknowledge, something which is not publicly talked about or taken seriously. ("Mnemonic" 14)

As we noted in our opening chapter, coming to terms with the personal has become a preoccupation for many postmodern and postcolonial thinkers. Homi Bhabha, for example, maintains that for artists and critics alike "[o]ur attention is occupied with the relations of authority which secure professional, political, and pedagogical status through the strategy of speaking in a particular time

Carole Condé and Karl Beveridge,
cover of *Class Work* (1990).
Reproduced courtesy of the artists.

and from a specific space." The emphasis falls on "signification and institutionalization," on the "social process of enunciation." As Bhabha puts it, "the enunciative attempts repeatedly to 'reinscribe' and relocate [the] claim to cultural and anthropological priority (High/Low; Ours/Theirs) in the act of revising and hybridizing the settled, sententious hierarchies, the locale and the locutions of the cultural" ("Postcolonial" 57). PhotoGraphic works such as Pelkey's seem the artistic appositive to Bhabha's redefinition of the person-

al. We would only add that it is not enough to speak from a naïve personal perspective—no more than it is sufficient to construct art as an illustration of postcolonial theory; instead, the personal (in voice and image) must be interpolated among often competing modes and levels of discourse. What interests us in Pelkey's work is the way she roots theory in the thickets of daily experience, the way she personalizes the abstract. For to interpolate the personal signals a recognition that representation is both mediated and situated in material circumstances.

We suspect that the rhetoric of overt falsification is one such signal, though artists like Pelkey always hide more than they show—and what they hide is almost always personal. By making the falsification overt, by revealing the seams or staging the scene, Pelkey invites personal and conjectural histories. This is a rhetoric of visual and verbal paradox, what Robert Kroetsch calls "unhiding the hidden" (17), that place where artist and audience "uncreate themselves into existence" (21). Kroetsch elaborates with reference to Canadian fiction:

> It is possible that the old obsessive notion of identity, of ego, is itself a spent fiction, that these new writers [and visual artists] are discovering something essentially new, something essential not only to Canadians but to the world they would uncreate. Whatever the case, they dare that ultimate *contra-diction*: they uncreate themselves into existence. Like Heidegger, they will accept that root meaning of the word truth is un-concealing, dis-closing, dis-covering, un-hiding. ("Unhiding" 21)

Even more relevant to our present discussion is Kroetsch's take on the terms of reference introduced by Kroker: Kroetsch sees the *"in-between"* as a space for interpolation, a position where appearance meets authenticity:

> The Canadian writer's particular predicament is that he works with a language, within a literature, that appears to be authentically his own, and not a borrowing. But just as there was in the Latin word a concealed Greek experience, so there is in the Canadian word a concealed other experience, sometimes British, sometimes American. In recent years the tension between this appearance of being just like someone else and the demands of authenticity has become intolerable—both to individuals and to the socie-

ty. In recent Canadian fiction the major writers resolve the paradox—the painful tension between appearance and authenticity—by the radical process of demythologizing the sytems that threaten to define them. Or, more comprehensively, they uninvent the world. (17)

The emphasis here is on the personal—but not the personal ego of the Romantic poets or the unified self of the humanist tradition. The personal has become a matter of negotiation, authenticity, invention, and "uninvention." As Bhabha argues, ours is a "moment of culture caught in an aporetic, contingent position, in-between a plurality of practices that are different and yet must occupy the same space of adjudication and articulation" ("Postcolonial" 57). Bhabha's "moment of culture" describes the Canadian postmodern condition, always *in medias res*, the state of being *in-between*—a moment that lacks the closure and certainty of Cartier-Bresson's "decisive moment." Thus we look for the personal in liminal sites of narrative diversity and contest.

Akin to the photosculptures and Victorian drawing room scenes of Hannah Maynard, Pelkey's work speaks to a private rhetoric of emotional excess and unresolved detail. If we think of Pelkey's work in terms of a literacy narrative, we find one that teaches us to read image and text as more than supplemental illustrations of one another. Both photograph and word are compelling, beautiful, but they resist fixed meaning, leaving the viewer/reader to search the darkened space between for an as yet unrevealed, unspoken explanation. In "Telephone Booth," the Landcruiser, the Sasktel booth, the *Globe and Mail* box all speak to a public world of popular culture and mass communication. The speaker's private story, the vernacular, inhabits a space somewhere in between, in the shadows, the darkness. As Cindy Richmond observes of Pelkey's work generally, her "staging [her use of lighting] effects a subtle reversal of our visual grammar, for it is the light that seems oppressive rather than the darkness" (40). Verbally, too, the details fail to illuminate meaning, alluding instead to an absent vernacular narrative. Instead of "[crystalizing] the terrible moment," Pelkey's work releases its "many points of promise and reflection"; it resists modernist closure by spatializing the reading process, formally and thematically separating image and text, and thus dramatizing the work's metonymic potential. When we read that the dead man "loved to honk his horn when driving by telephone/booths," hoping that "his truck horn would/be heard in Toronto," we imagine a gesture of interruption—a joke, but one aspiring to bridge the space between and assert personal presence in two places at once.

Brenda Pelkey, maquette of "Telephone Booth" (1993). Reproduced courtesy of the artist. Photograph by Kim Clarke.

The honking horn suggests a melancholy, auditory dreamscape, a space or "meeting place" akin to the reflective surface of an office window, an Ilfochrome print, or a 19th-century daguerreotype. The effect is strangely redemptive, the closing lines suggesting the presence of something whimsical, a subtlety of inflection remembered and recovered.

A serendipitous invocation of personal reflection and insight is in turn reflected in Pelkey's artistic method. Hers is a process of genuine exploration, of commitment to chance, where determining locations and conjoining photograph and text have as much to do with *not knowing* as with knowing. She begins by carefully planning each photograph, "first using sketches [and] then polaroids as aids in transferring ideas and concepts from [her] interior world to the physical world" (Pelkey "Artist's Talk"). Her 1993 scrapbook details the sketch outline for *Dreams*: "All the story stuff should be dark, with light used as a harsh hard illuminating factor. Lines of single text. day light." A circled section of the notes calls for "images with no text"; the words "fragments" and "frag" are placed underneath, and are underlined. Centred at the bottom of the page we find the following list:

 – trees

 – water

 – sky

 – leaves

 – earth

The direction "close up images" brackets the list.

The preliminary notes for what later became "Telephone Booth," however, are not of a piece with the final work. In fact, the telephone booth image came later; initially Pelkey planned to photograph a domestic interior, perhaps a close-up of the kitchen sink, shot in soft focus with the "text to sit stubbornly at the bottom of the image[,] to run across the the [sic] bottom. Perhaps no punctuation." She wants the viewer "swallowed by image" (Pelkey, "Scrap Book"). On the facing page it is clear that the text has already been written—even overwritten: the 1993 manuscript contains a final line, deleted from the exhibited version, where Pelkey writes "He was still twenty-nine when he died."

Despite the pre-planning and preliminary sketching, her composing process balances intuition with practicality and opportunity. This process involves walking, driving, or cycling around the neighbourhoods of Saskatoon in search of locations to situate her narratives. When asked about the *Globe and Mail* box in "Telephone Booth" she explains,

> I didn't look for this location because there was a *Globe and Mail* box there. The fact that it was there is just a good coincidence. It was there and it seemed appropriate, and I was looking for a booth in isolation. And then, too, layering the text on the roadway was really important to me in that image: I wanted the road to be part of the text. The detail is taken out of the larger 4" x 5" negative and blown up to a really high magnification and overprinted with text. It seemed important that the text be placed there because the work is about driving by, passing, and seeing. (Personal Interview)

Such moments of surprise and discovery, as she describes them, would not surface in the traditional staged photograph. But Pelkey employs her photographic constructions as vehicles for authentic exploration and expression, where she allows room for creative dialogue with her materials. She allows the work to develop as she goes, moving from a planned soft-focus interior setting to a night exterior.

Brenda Pelkey, from *Foundry* (1988).
Reproduced courtesy of the artist.

Brenda Pelkey, from her scrapbook (1993). Reproduced courtesy of the artist.

This pursuit of authentic documentary experience has its origins in two earlier bodies of work: *Foundry* and *"...the great effect of the imagination on the world."* Pelkey speaks of *Foundry* (1988) in particular as a way of rethinking, reinventing, her relationship with documentary photography. The site of inquiry was a foundry in Sutherland, somewhere she describes as "a forgotten piece of history, invisible in our post-industrial information age." Pelkey talks of *Foundry* as a transitional work, a move from objective documentation to an intensely subjective engagement with her materials: "to rely on the transparency of the medium for its meaning did not seem for me to require enough participation on the part of the photographer; I wanted a more active presence in this process." Here she enters the foreign terrain of the industrial workplace to make images of men and their labour; but instead of seeking objective documentation, she finds ways to make the act of photographing more visible: she emphasizes the film edge by exaggerating the frame; she manipulates the exposures; she shifts the focus from the labour activity to the process of recording the place, labour, and the people involved. "By employing these strategies," says Pelkey, "I hoped to make apparent that I was offering an interpretation rather than a seemingly unmediated reflection of the place. The other worldy look to the foundry images gave me the impetus to push further" ("Artist's Talk").

In *"...the great effect of the imagination on the world"* we see a model for her later work. These photographs, presented without text, feature multi-paneled, panoramic scenes; but, unlike *Dreams of Life and Death*, Pelkey presents these works in frames, more in the manner of conventional photographs. Their subject matter, though, is anything but conventional. As we have already mentioned in passing, *"...the great effect"* shows a series of highly idiosyncratic environments, front and back yards (and the people who constructed them). They offer a kind of "folk architecture, an architecture without authority" ("Artist's Talk") and thus somehow a more genuine or authentic mode of expression—a credible challenge to the forms of mainstream modernism and popular culture.

The people putting together these domestic tableaux clearly are not constrained by mainstream or high art aesthetics; and echoing their enthusiasm, Pelkey adopts an extravagant documentary approach: taken at night, under the illumination of generator-powered klieg lights, these scenes emphasize an immediate theatricality, something not normally associated with the "truth" of documentary presentation. Historically, where such moments of theatricality have entered into documentary photographs, the truth, the authenticity of the subject, has been understood to have

Arthur Rothstein, *Dust Storm, Cimarron County* (1936). Photograph courtesy of the Gernsheim Collection, Harry Ransom Humanities Research Center, The University of Texas at Austin.

been compromised. Arthur Rothstein's *Fleeing Dust Storm, Cimarron County Oklahoma* (1936) suggests a model of such compromised truth: this much celebrated documentary photograph of the mid-1930s dustbowl became an image of falsity when viewers learned that the sharecropper and his son were carefully rehearsed, that the scene had been staged.

By embracing overt falsification, Pelkey makes it hard to consume the images as unmediated representations; in Kroetsch's terms, she "uninvents" the documentary—and in the process, she explores, perhaps seeks to legitimize, that which modernist criticism had labelled false, phoney, and kitsch. Pelkey's impulse does

PhotoGraphic Encounters

not derive from the cautionary, nationalist interests of writers like Kildare Dobbs, Susan Crean, or Robin Mathews. A photograph depicting Mel Athlack's miniature construction of the Golden Gate Bridge (in "...*the great effect*") suggests that a foreign national icon can be readily transformed into a personal symbol, one as much "at home" in the back yards of Regina as in San Francisco Bay. We see in such work those same expressions of excess and invention and storytelling and eccentricity that were present in the photographic constructions of William Notman and Hannah Maynard. In such work we are encouraged to find authenticity not in the object of representation but in the process.

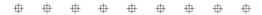

Self Disclosure

We want to end this chapter with Pelkey's "Graveyard" (see colour plate), one final poignant *envoi* to this process of uninventing the world, of redeeming the personal. Like the other works in *Dreams of Life and Death*, "Graveyard" is a photo-mural, with three adjoined panels and a separate text panel on the wall below. This scene too is photographed at night, tungsten lights illuminating a headstone situated in the centre of the centre panel. The grave-marker, of masoned stone construction, features an engraved marble front, inscribed as follows:

J. T. PETERMAN

1854-1930

Until the day dawns
AND THE SHADOWS FLEE AWAY

ELIZABETH JANE

1866-1959

Other gravemarkers lie flat to the ground and radiate outward from the central stone. Adjacent ones remain visible, while others become increasingly obscured in shadow as the light falls off quickly from the central point of illumination. A dark band of trees stands out in silhouette across the middle third of the photograph. The sky behind is intense blue, over-saturated with colour since it is photographed deliberately out of sync with the warmer colour range of the tungsten light and film.

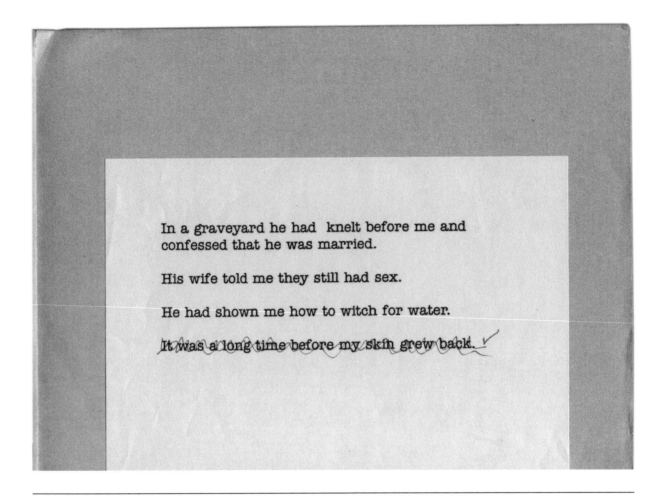

In a graveyard he had knelt before me and
confessed that he was married.

His wife told me they still had sex.

He had shown me how to witch for water.

~~It was a long time before my skin grew back.~~ ✓

Brenda Pelkey, from her scrapbook (1993). Reproduced courtesy of the artist.

Evoking images from the *carpe diem* tradition, "Graveyard" describes the death of a relationship in miniature. The four brief verses take us in and out of memory, a series of social vignettes describing graveside intimacy and confession, betrayed friendship, courtship and discovery, and, finally, reflection and painful renewal. The last verse, says Pelkey in our interview with her, "kind of flips it [the poem and the scene] a little bit…from this description to this other thing," to the unspoken story drawn from her own experience. The final sentence is "a difficult one to even say"; the manuscript version has the line crossed out ("Scrap Book"). Similarly, much else is left unsaid, or unrevealed: only during our interview with the artist do we learn that "J.T. PETERMAN, 1854-1930" signifies the gravestone of Pelkey's own great, great-grandfather:

Pelkey: I thought the verse on his gravestone was quite appropriate, but I didn't seek out my great, great-grandfather's grave. I was looking for a graveyard that was similar to the actual one where the incident took place. This really happened. This poor man. I just have to laugh and hope that he never sees the work and recognizes himself in it. Such things, looking back, are funny. The verse on the stone, "Until the day dawns and the shadows flee away," is so wonderful; it seemed to complement the story being told. On another gravestone that sits beside it—you can't see the words because it's photographed black on black—are the words "Some day we may understand." That's the gravestone of a great, great-aunt. And then there's another one on the other side photographed at an angle so you can't read either. It says, "She hath done what she could." So once I went there I could not resist that space. I knew that the phrase "Some day we may understand" was carved into one of my aunt's gravestones, but I had no clear memory of what the gravestone looked like—how it was set in the ground or whether it would actually work for the photograph. I had only a dim memory of having been to this graveyard once before. It's the Red Deer Hill Graveyard. You see, I've written it here in the scrapbook: that's the Red Deer Hill graveyard my family is buried in.

Garrett-Petts: And Elizabeth Jane would be…?

Pelkey: The wife of John Thomas. She was my great, great grandmother. So, when I went there and rediscovered all this I thought, "Oh, this is the right place, this is the right place." And isn't it interesting that it ends up being my own family graveyard? None of this is information given in the work. No one else knows this. (Personal Interview)

As she tells us the details, fills in the implied narrative, Pelkey remains aware she is changing our experience of the work. "Graveyard," as art, does not depend upon such background knowledge; but during the interview, Pelkey is intent on letting us in on her creative process—on how she works from personal experience and memory to poetic text, and through intuitive exploration to an ongoing search for the appropriate visual and vernacular space. We take her gesture in sharing such details as an act of self-disclosure and friendship. And we know that in making such a gesture, Pelkey has not told us the whole story.

Brenda Pelkey, "Graveyard." Detail.

Graveyard

In a graveyard he had knelt
before me and confessed that
he was married.

His wife told me they still had sex.

He had shown me how to witch
for water.

It was a long time before my skin
grew back.

Brenda Pelkey, "Graveyard" notes. From her scrapbook (1993). Reproduced courtesy of the artist.

Filling in the Blanks: Ekphrasis and Crossfade 5

This is a chapter in two parts, a dialogue where we explore the work of two remarkable artists: Michael Ondaatje and Fred Douglas. The first part, by Garrett-Petts, takes a close-up view of how an ostensibly empty frame, a seemingly empty narrative (introduced on page five of Ondaatje's The Collected Works of Billy the Kid)*, works to guide our reading of the entire book. In the second part, Lawrence offers an introduction to an alternative rhetoric, that of Fred Douglas's* Crossfade. *What links both artists is their attraction to vernacular materials and their distrust of frames, both aesthetic and social.*

Part 1
Michael Ondaatje and the Haptic Eye:
From Print Literacy to "Picture Books"

Not long ago Karen Day, a colleague in the Education faculty (and someone who knew of my interest in image/text narratives), drew my attention to an intriguing new book she had picked up at a children's literature conference in Australia. Garry Disher's *The Bamboo Flute* recounts the story of a young boy coming of age in the Australian outback. Of particular interest is the way the author incorporates personal and archival photographs to convey and complicate the narrative. Day told me that she sees the interplay of image and text as an invitation to "liberate the imagination" from an exclusively print-oriented focus. Shortly after our conversation, I ordered my own copy from the U.S. publisher, but when it came in the mail I found the photographs had been deleted.

When I showed my friend the American edition, she sighed knowingly and told me the following story: she had been reading aloud a series of picture books in her university language arts seminar. One afternoon she held up a copy of Pat Hutchins's *Rosie's Walk*, a book with illustrations and text arranged separately on alternate pages, and asked the class what they noticed. "Every other page is blank," suggested one of her students, apparently confident that the words, not the images, were of principal interest. The student's response lays bare an otherwise muted assumption among readers, publishers, and many educators: that the visual ele-

Cover of the Australian edition of *The Bamboo Flute* (1993). Reproduced courtesy of HarperCollins, Australia.

ments in a text may be safely ignored, marginalized, or simply edited out.

Like Day, I find myself troubled by anthologies and new editions that reprint the writing but leave out the accompanying visual art; but I'm even more troubled by the disassociation of seeing from reading. Consistently academic and, especially, literary culture exhorts us to wean "young," "lazy," or "dull" readers away from a reliance on visual aids: "illustrations in general," writes critic Marianna Torgovnick, "may be harmless enough, may sometimes even be helpful to readers who have difficulties visualizing as they read. But, like eyeglasses improperly used, they dull the average reader's visual imagination, accustoming him to relying on illustrations and not his own faculties" (96).

Yet, as Richard Kostelanetz points out, "much of the best writing depends as much on visual literacy as on verbal literacy; many 'readers' literate in the second aspect are illiterate in the first" (29). The usual argument for privileging written language over other forms of expression seems based on an implied hierarchy of discourses. In school settings, reading means reading written texts. Still, as Howard Gardner and others have argued persuasively for at least the last twenty years, written language "is by no means the only (and in many cases, not even the most important) route for making sense of the world" (87-88). Certainly, the kind of blindness that sees the illustrated page as "blank," a blindness seemingly sanctioned by pedagogies of reading tied to the print-literacy establishment, needs further consideration. For if Kostelanetz and Gardner are right, that we privilege verbal literacy at the expense of visual literacy, then as teachers and readers we may be missing out on—or even misrepresenting—what Kostelanetz describes as "much of the best writing." What Karen Day told me about reading the visual and verbal cues in Disher's book, for example, suggests what can be gained by learning to read word and image together.

Disher's book, as Day describes it, situates the photographs as a form of marginalia that can be "read into" the centre of the work. At first glance, the cropped images seem little more than a border print, a decorative frieze.

As the reader progresses through the text, however, the relationship between word and image becomes more complex—even provocative. In addition to a number of "anonymous" archival photographs, Disher inserts an image of himself taken at about the same age as the book's young protagonist. Without exploring this

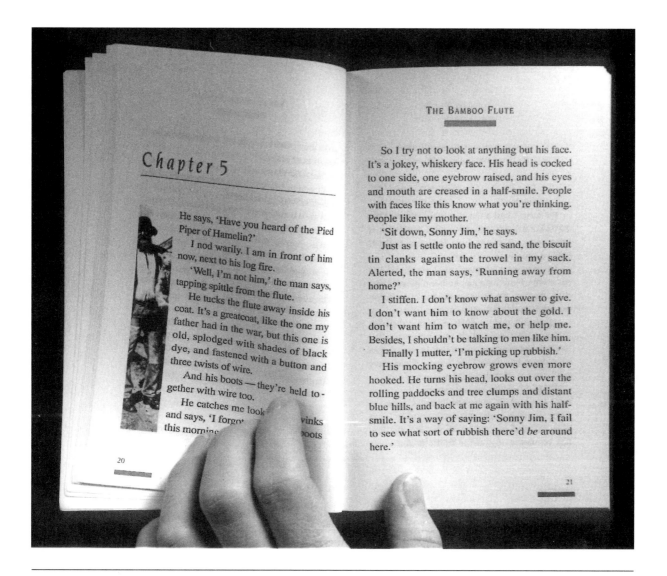

The Bamboo Flute

Chapter 5

He says, 'Have you heard of the Pied Piper of Hamelin?'

I nod warily. I am in front of him now, next to his log fire.

'Well, I'm not him,' the man says, tapping spittle from the flute.

He tucks the flute away inside his coat. It's a greatcoat, like the one my father had in the war, but this one is old, splodged with shades of black dye, and fastened with a button and three twists of wire.

And his boots — they're held to - gether with wire too.

He catches me look____ ____vinks and says, 'I forgo_____ ____boots this mornin____

20

So I try not to look at anything but his face. It's a jokey, whiskery face. His head is cocked to one side, one eyebrow raised, and his eyes and mouth are creased in a half-smile. People with faces like this know what you're thinking. People like my mother.

'Sit down, Sonny Jim,' he says.

Just as I settle onto the red sand, the biscuit tin clanks against the trowel in my sack. Alerted, the man says, 'Running away from home?'

I stiffen. I don't know what answer to give. I don't want him to know about the gold. I don't want him to watch me, or help me. Besides, I shouldn't be talking to men like him.

Finally I mutter, 'I'm picking up rubbish.'

His mocking eyebrow grows even more hooked. He turns his head, looks out over the rolling paddocks and tree clumps and distant blue hills, and back at me again with his half-smile. It's a way of saying: 'Sonny Jim, I fail to see what sort of rubbish there'd *be* around here.'

21

Garry Disher, pages 20 and 21 of *The Bamboo Flute* (1993), Australian edition. Reproduced courtesy of HarperCollins, Australia.

image in detail, let me assert the obvious: the presence of the author's boyhood image, like the famous childhood photograph of Michael Ondaatje that concludes *The Collected Works of Billy the Kid*, asserts a complex visual signature—an image of identification that links author and subject, and involves the reader in multiple interpretive tasks.

Once the emphasis on print alone is variously shifted or complicated, the book ceases to function as an unproblematic, transparent medium. Instead, it takes on a kind of sculptural quality—a quality that invites full sensory response. The book becomes something to touch, to flip through, while comparing whole images

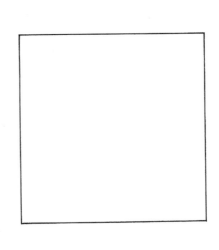

I send you a picture of Billy made with the Perry shutter as quick
as it can be worked — Pyro and soda developer. I am making
daily experiments now and find I am able to take passing horses
at a lively trot square across the line of fire — bits of snow in the
air — spokes well defined — some blur on top of wheel but
sharp in the main — men walking are no trick — I will send
you proofs sometime. I shall show you what can be done from
the saddle without ground glass or tripod — please notice when
you get the specimens that they were made with the lens wide
open and many of the best exposed when my horse was in motion.

Cover and page 5 of *The Collected Works of Billy the Kid* (1970). Reproduced courtesy of the author.

with details and matching photographs with descriptive passages. As I see it, the "liberated imagination" that Day finds in reading Disher's work is not the same imagination that Marianna Torgovnick and the print-literacy establishment seek to protect. For Torgovnick, imagination is something nurtured by print but impaired by visual illustration. Imagination requires work, and illustrations do too much of the work for the reader/viewer. What Day draws to our attention is the use of "illustrations" as oblique references, as ironic visual cues which may work the reader's imagination hard, even harder than print alone.

If we are to understand fully the reading experience Day describes (and the book seemingly advocates), then we need to begin adapting contemporary reading theory to the task. We need to adjust the print-based schema; we need to situate picture books

as part of a larger genre including artists' books, visual arts installations, and literary works that combine image and text. Perhaps the best known literary example of such mixed-media composition is one already mentioned: Ondaatje's *The Collected Works*. Via a discussion of Ondaatje's work, I'd like to extend and further contextualize the issues and insights Karen Day has initiated.

Included in the opening pages of Michael Ondaatje's fictional portrait of the outlaw Billy the Kid is a much-discussed and highly ambiguous image, an ostensibly empty narrative: a blank frame captioned with an "explanatory" quotation from the photographer L.A. Huffman. The quotation suggests that the framed white space is "a picture of Billy made with the Perry shutter as quick as it can be worked—Pyro and soda developer" (5). The juxtaposition of text and absent image presents a kind of oblique reference. Like Disher's work, the "missing" photograph seemingly invites more than a strictly "literary" reading, for the careful arrangement of poetic line, photographic image, technical discourse, and imported elements of popular culture speak to a multidimensional sensibility. In fact, when interviewed, Ondaatje himself speaks of the work in cinematographic terms, as the film he didn't have the money to make:

> [W]ith *Billy the Kid* I was trying to make the film I couldn't afford to shoot, in the form of a book. All those B movies in which strange things that didn't happen but could and should have happened I explored in the book....Certainly with *The Collected Works of Billy the Kid* design was very important. We had to determine the type, the paper design, the paper texture, where the photographs would go, things like the first page on which Billy's photograph doesn't appear. I find it difficult to write while a finished book is in the process of being printed, cos the printing itself is an art form and I'm deeply involved in it. (Solecki 20-21)

Given this emphasis, both within and without the work, on the conventions and artifacts of visual representation, it seems remarkable that so little has been said about the actual photographic elements.[1] Like Karen Day's student, many critics and teachers see only the blank space. Smaro Kamboureli, for example, in a highly intelligent and detailed reading of the work, sees the framed white

1 A number of critical studies have discussed photography as metaphor in Ondaatje's book, but very few have discussed the actual photographs and book design.

space as announcing "the 'negative' of narration," merely an empty frame having "no precise subject or origin" and on its way to becoming "the discourse of language itself" (183). However, in photographic terms, the whiteness, made as Huffman's note asserts, "with the lens wide open," does not necessarily signify a "negative," an absence; it might just as easily signify an overexposed presence. The distinction is important, for too often the literary tends to erase and over-write the visual without due regard for the conventions of pictorial or photographic representation. While the photographic certainly intersects and plays off the linguistic, it need not be elided or subsumed or homogenized as "the discourse of language itself." Surely we must question an interpretive strategy that regards the "quotations, paraphrases, and photographs" we find in *The Collected Works of Billy the Kid* as "signs of literariness" (Kamboureli, *On the Edge* 186). They are partially this, of course—but they are also much more. Where Kamboureli—and admittedly most other literary critics—wishes to "affirm the textuality of the long poem" (186), I would suggest here that textuality is not an exclusively literary domain. Indeed, insofar as "textuality," as a critical concept, denatures or otherwise subordinates the visual, I feel it impedes a full appreciation of the work—especially the material experience of reading, viewing, holding, and touching.

Despite recent acknowledgments that we are experiencing a "pictorial turn" (Mitchell 9) in our collective intellectual life, a linguistic bias continues to guide academic responses, especially when it comes to teaching and writing about works of "art" that integrate the visual elements of vernacular culture. Donald Lawrence and I have written elsewhere that not all modes of representation are created equal (see "On Integrating"). As Pierre Bourdieu has taught us, "the various systems of expression [theatrical presentations, sporting events, recitals of songs, poetry or chamber music, operettas or operas, etc.] are objectively organized according to a hierarchy independent of individual opinions, which defines *cultural legitimacy* and its gradations" (95; emphasis in the original). Some modes of expression (say classical music, or painting, or literature) appear more legitimate, and thus more literate, than others (say, jazz, or photography, or folktales—or children's picture books). When legitimate and "illegitimate" modes are integrated, as they are in photo-textual compositions such as Disher's *Bamboo Flute* or Michael Ondaatje's *The Collected Works*, a kind of class warfare is set in motion—one that tests both the assumed decorum of print-literacy and the practised patience of scholarly culture. The typical response among most literary critics and teachers of English has been to either ignore the visual

dimension altogether or to domesticate it by treating the visual vernacular as simply one more textual referent.

Manina Jones's reading of *The Collected Works*—arguably one of the most visually-aware readings to date—offers an important illustration. In defining what she calls the "documentary-collage" in Canadian literature, Jones shows how many contemporary authors construct their works as a conversation of voices and images, some quoted and some invented. Such works typically include a variety of physical references such as those one might paste into a scrapbook or travel journal or diary. According to Jones, such works elicit a feeling for "the materiality of language" (14-15). The qualification "of language" seems important here, for the materiality of other modes—of the book's physical shape or make-up, of the photographs, of the reproduced visual artifacts—is all too often treated as one more form of writing, as what she calls a "historiographic" referent. Citing Linda Hutcheon, Jones reminds us that "Unlike the historical (or real) referent, this one is created in and by the *text's writing* (hence historio*graphic*)" (qtd. in Jones 71). But what if we were to allow, as readers, the free play of these material signifiers? What if we were to acknowledge them as something other than purely linguistic, as modes of discourse with their own histories, formal implications, and potential effects on their readers/viewers?

The blank page that Day's student reported, for example, suggests a highly conventional reading, one tutored by a print-based bias against visual illustration. Ondaatje's "blank" space, on the other hand, alludes to a history of visual representation where white canvasses are seen as meaningful. As Herbert Read notes, "every modern generation (beginning with [Kasimir] Malevich) has produced its own brand of white paintings. Although the motivations differ, there is often an element of puristic purging of other painters' excesses in this" (292). Read also allows that some works represent "bridging moments," such as the *White Paintings* of Robert Rauschenberg or, I would argue, the white spaces of Michael Ondaatje, where seemingly blank surfaces are transformed into "screens on which shadows could fall" (292-93) or words show through. The white space is both emblem of absence and an invitation to consider the material presence of the page (or canvass) as object; and via the use of such visual representation, Ondaatje presents us with his version of a literacy narrative, a composition "that foregrounds issues of language acquisition and literacy" (Eldred and Mortensen 513), a composition that speaks of an authentic engagement with the material world and argues for an appropriate rhetorical response.

"There was for instance a photograph I came across of Sam Walton outside his store in Toronto which, because of its suggestiveness, made me return to it again and again for some clue to the mood of my central character Patrick Lewis. The photograph with its street reflections, torn corner, aging, was full of unknown presences and possibilities and I knew in some way the picture brought me very close to Patrick's character and world." *Michael Ondaatje—on writing In the Skin of the Lion. "The Silent Partner: Photography in Fiction."*

2 Ironically, Kamboureli, care-
ful reader that she is, notes the
visual arrangement but apparently
discounts it as only a textual
marker—not a visual one (see 189-
90).

In *The Collected Works* there are two kinds of printing at play: textual and photographic. Like a photograph, the visual arrangement of image and text invites some degree of physical interaction. If we hold up page five to the light, the source of the initial overexposure, the supposedly absent image gives way to the perfectly framed poem verso.[2]

The framed space, already meaningful as both a photographic token and a trace of the ineffable, is suddenly filled with text. Billy's image eludes us, and we shift instead to a verbal representation, a list of those killed by the outlaw, a list that includes Billy himself:

> These are the killed.
>
> (By me) –
> Morton, Baker, early friends of mine.
> Joe Bernstein. 3 Indians.
> A blacksmith when I was twelve, with a knife.
> 5 Indians in self defence (behind a very safe rock).
> One man who bit me during a robbery.
> Brady, Hindman, Beckwith, Joe Clark,
> Deputy Jim Carlyle, Deputy Sheriff J. W. Bell.
> And Bob Ollinger. A rabid cat
> birds during practice,
>
> These are the killed.
>
> (By them)—
> Charlie, Tom O'Folliard
> Angela D's split arm,
> and Pat Garrett
> sliced off my head.
> Blood a necklace on me all my life.

The dead who haunt the white space, the absent "picture of Billy," include Billy himself: he speaks to us after death, as it were, his head "sliced off" and "[b]lood a necklace" all his life. Ondaatje's story of Billy is also about the failure of both visual and verbal representation: Billy is an escape artist who moves too quickly for any photographer or writer to fix on paper. The framed white space thus functions as both ironic figure and true (or authentic) ground for reading that which refuses conventional strategies of textual response. To read Billy, to invoke his spirit, we must resist any initial desire to "put the pieces of his life story together." We must

Page 5 of *The Collected Works of Billy the Kid* held up to the light. Photograph courtesy of the author.

Detail of page 166 from *The Collected Works of Billy the Kid*. Young Michael dressed as a cowboy. Reproduced courtesy of Michael Ondaatje.

focus on the blank spaces, the visual and verbal gaps in the story. Reading *Billy* becomes an overtly physical activity, a matter of carefully examining the evidence, of comparing photographs, of tracking down references, of turning the pages with deliberate intent. The placement of the words, the use of white space, the incorporation of actual and staged photographs: all these elements evoke a complex sensory and intellectual response. Billy, like the seemingly empty space on page five of Ondaatje's book, remains invisible only to those who rely on words alone to explain it all.

The book establishes its own visual rhetoric and rhythm, for, 100 pages later, the frame image is recited, this time including the author—quite literally: the final image in *The Collected Works* shows young Michael dressed as a cowboy in his birthplace, Ceylon. The author enters the blank frame in a gesture both vernacular and authentic, one alluding to the author's lifelong fascination with outlaws, one evoking and validating a younger Ondaatje's enthusiasm while acknowledging that this brand of authenticity means "dressing up" reality. It is important, even a little startling, to discover this "actual" photograph. Like the historical image of General Custer and the 7th Cavalry (reproduced on page 13 of Ondaatje's text), the image's apparent veracity—its authenticity—affects our response.

John Stephens's work on children's picture books calls attention to the "base modality" (or truth value) of such disjunctive visual and verbal representations. In language alone, factual, documentary depictions carry the highest modality; hypothetical and overtly fictional texts evoke the lower modalities. Thus realism (realistic writing) seems conventionally "normal," and more experimental (postmodern) modes, modes which draw attention to themselves, tend to provoke reader unease—a sense that the narrative has deviated from the norm.

Stephens points out an important difference in our response to visual images: part of the convention of reading picture books is to consider visual abstractions—that is, "low modality" images—as the norm. We learn as small children, says Stephens, to regard "exaggerated or attenuated" images as the normal complement to verbal narrative. These images announce themselves as illustrations. In contrast, high modality representation—photographs and photo-realist painting—appear hyper-real; they disturb the conventional flow of image and text, and "tend to stand at a greater distance from consensus reality than does language" (5).

Similarly, in a composition like Ondaatje's *The Collected Works*, ostensibly high modality reference points, such as a documentary photograph of the author (or of the 7th Cavalry), encourage desta-

bilization. Somewhat counter-intuitively, for postmodern narratives, the more realistic the image the more disruptive, and thus suspect, its presence.

The void of Ondaatje's white square may represent the potential space of twentieth-century abstraction's blank canvas, but, for Ondaatje, it does not seem an ideal standing in place of the daily, physical experiences of his characters—or, in the case of *The Collected Works*, the accounting of "the killed." Rather, it is a vernacular space that remains incomplete without such anecdotal information, a space which cannot be fully accounted for without a recognition of the book's physical form. Only when held up to the light can Ondaatje's *tabula rasa* be seen to contain the text behind. Once understood in this way, the text below the frame becomes something more than a key to the empty image; it can be seen instead as one part of a tripartite arrangement which includes the frame and the text behind.

The white square thus provides a narrative representation of the "subjunctive space," that meeting place of interests and attitudes identified by David Summers and described by Shelley Errington. Most art historians and, I suspect, most literary critics look "within the frame for meaning." A few look behind the frame to spot the "daily practices that were poured into the object." And still fewer look in front of the frame to see "the performative context"—or what Donald Lawrence and I have defined as the rhetoric of visual and verbal response.

Central to this rhetoric is an understanding of how an artist like Ondaatje takes a classical verbal trope, ekphrasis, and reverses the ekphrastic principle, thus further complicating an already complicated visual/verbal conundrum. According to Murray Kreiger, the ekphrastic principle operates

> not only on those occasions on which the verbal seeks its own more limited way to represent the visual but also when the verbal object would emulate the spatial character of the painting or sculpture by trying to force its words, despite their normal way of functioning as empty signs, to take on a substantive configuration—in effect to become an emblem. (9)

Kreiger (and later, W.J.T. Mitchell) sees such ekphrastic ambition as a nostalgic, "ultimately vain attempt" to recover the lost "dream

of an original, pre-fallen language of corporeal presence" (10). A special form of detailed description, ekphrasis aspires to suspend the movement of narrative and freeze the moment in time and space. G.E. Lessing's famous dictum (in *Laocoön*) has long influenced our understanding of how the visual and the verbal should be separated: painting and poetry should make use of different means and symbols; the verbal arts are, by nature, temporal, while the visual arts are spatial.

Given this background, what Ondaatje accomplishes, through the complicity of the reader's sleight of hand, seems quite remarkable: the white square, already meaningful in an art historical and photographic context, may be said to capture and re-represent the written text as both palimpsest and appositive. That is, the framed space is supplemented by the perfectly positioned text, which in turn temporarily "stands in for" the space. The poem takes on "a substantive configuration"—in effect becoming an emblem—without directly trying to emulate spatial character at all. It is the white square that takes on verbal character—in effect becoming a narrative.

Ondaatje's visual rehabilitation of a verbal trope offers a visual literacy narrative worth further consideration as a model for reading vernacular constructions, such as artists' books and other forms of visual literature. Robert Morgan, for example, sees "the play on systems in artists' books as a mediumistic as well as a conceptual concern." Some works, he says, are more visual and thus concerned with physical structure; others are more conceptual, "concerned primarily with the content of ideas" (207). Morgan is careful to acknowledge that a systemic focus in no way covers all the variations possible, but it does enable him (and us) to describe in some detail two important systems at work in artists' books, the narrative and the concrete:

> Narrative systems work in relation to a theme which may be either literary or visual. They tend to unfold sequentially, but not necessarily according to serial logic. Concrete systems, on the other hand, tend toward logic and seriality. Concrete systems tell no story; rather they present an interrelationship of elements as formal design. (211)

I'm not sure why a concrete system, as Morgan describes it, would be devoid of story, but I do like the way Morgan's model, an updated version of Lessing's, helps frame the kind of issues we've been discussing. The concrete (overtly visual and physical) employs the

logic of collage; the concrete tends to focus reader/viewer attention on the here and now. The narrative system alludes to references and stories beyond the text; "a narrative system implies other levels of meaning *behind what is there*" (211; emphasis added). One is spatial, static; the other, temporal, fluid.

What Ondaatje's "artists' book" does, of course, is collapse the kind of distinctions made by Lessing and Kreiger, at least at the moment when text and image are brought together by the reader. And perhaps resistance to high art injunctions about the purity of form is one way of defining the vernacular in contemporary art-making. For vernacular compositions characteristically ignore, transgress, undermine, or reconceptualize high art norms and ideals. Malevich's symbol of visual purity becomes, in Ondaatje's readers' hands, a vehicle for verbal contamination and vernacular intercession. The white space becomes an invitation to look both behind, below, and in front of the frame.

My comments on *The Collected Works* are meant (1) to suggest an alternative to the usual "literate mode" of inquiry, and (2) to contemplate a literacy narrative that teachers and researchers at all levels might well consider. Echoing Susan Sontag in *Against Interpretation*, Roger Cardinal and others are beginning to articulate a strong case for what Donald Lawrence and I described in our introduction as "perceptual response," the kind of reading which refuses a narrow linguistic or thematic focus "and instead roams over the frame, sensitive to its textures and surfaces" (qtd. in Ray 158). Such an interpretative strategy is fully in accord with an ancient interpretive tradition of "haptic inquiry," a tradition that Claude Gandelman has traced, via Descartes and Berkeley, to the ancient idea that "vision is a form of touching"(5). From the Greek *haptikos*, which Gandelman translates as "capable of touching," the haptic eye finds both pleasure and meaning in texture, grain, and physical arrangement; it seeks a tactile understanding as a sensory complement to linguistic ways of knowing; it holds the page up to the light.

The poet and critic Phyllis Webb believes that we may have literally "lost touch" with this sensual pleasure of reading—that our academic attention to the words on the page has distracted us (and our students) from a rich, texturally-aware experience. She suggests that when reading poetry, for example, a "sense of touch turned on by the eyes…is charged by the poem's thingness, its design and structure" (56). She encourages greater sensitivity to the sort of

thing that interests Ondaatje, the page's "design effect," the "type used, colour of ink, ratio of black or blue or brown or red to white or grey or ivory;…the dribble of type in a concrete outburst, decorative typographical devices, as well as pictograms, hieroglyphs, drawings." All this creates "texture," and the "function of texture, visual and aural, is to give pleasure, create interest, and involve the reader or listener in the [work's] meaning and effect" (56-57).

It is this haptic mode that has encouraged reading researchers such as Beth Berghoff to argue that "working in multiple sign systems expands rather than narrowly defines what counts as 'reading' and knowing" (522); and some variety of haptic response is surely at play in the kind of aesthetic experience Day wants us to feel when responding to books like *The Bamboo Flute*: a highly engaged, sensory, deep reading of the work. In this context, we'd do well to remind ourselves that

> [t]he isolation of a text for academic scrutiny is a very specific form of reading. More commonly texts are encountered promiscuously; they pour in on us from all directions in diverse, coexisting media, and differently-paced flows. In everyday life, textual materials are complex, multiple, overlapping, coexistent, juxtaposed, in a word, "inter-textual." (Johnson 67)

The problem, then, is that scholars have been slow to translate complex theory into an array of reading practices; and, as a consequence, schools and universities do not normally teach "inter-textual" reading as a legitimate mode of response. Creative works that challenge conventional close reading strategies tend to be either ignored as literacy narratives or read out of context. I suspect such classroom biases all too frequently convince students that reading is something removed from their everyday experience.

Literacy researcher and reading specialist Perry Nodelman argues against an exclusive focus on print. Indeed, he suggests that literary competence begins with a recognition of the essential "doubleness of picture books" (a variation of the "double vision" common to contact zone art). Such books, he says, engage us in three potential stories: "The one told by the words, the one implied by the pictures, and the one that results from the combination of the first two" (2). According to Nodelman, "This last story tends to emerge from ironies created by differences between the first two" (2). Learning to read for differences becomes a prerequisite to achieving literary competence:

The doubleness of literature…requires us to become involved in, even to identify with, its characters and situations but also to stand back and understand those characters and situations with some objectivity. In the clear-cut doubleness of their words and pictures, picture books… can offer inexperienced readers an introduction to one of the most rewarding of literary competences. (30)

Thus, picture books tutor the eye, teaching us to modulate between positions of engagement and detachment.

Stephen Behrendt goes further, arguing that the combination of words and images creates "a third 'text,' an interdisciplinary 'meta-text' in which verbal and visual elements each offer their own particular and often irreconcilable contributions" (45). Berhrendt states the case bluntly: "as soon as illustrations are introduced into a book, the book-as-text becomes a very different sort of text." In short, illustrations do more than merely illustrate: like Ondaatje's framed white space, they are "'teachers' that instruct us in more comprehensive and interdisciplinary ways of reading" (47). The visual elements function as a form of embedded interpretation, elucidating or otherwise complicating our responses.

There are many ways that we might take up the challenge of teaching and responding to image/text works beyond the elementary grades. We can consider picture books, of all kinds, as part of a mixed genre that ranges from comics and graphic novels to artists' books, mixed-media installations, home pages and Web sites on the World Wide Web. We can also consider the images in terms of their art historical significance, bringing to our readings an enhanced understanding of how visual styles and conventions have developed. Even more pressing, however, is the need to consider ways to teach and validate the integration of visual and verbal literacies. Nodelman and Behrendt's focus on "response" offers an important point of departure, for the acknowledgment of visual literacy heightens reader awareness of reading as a perceptual act.

The first step toward developing a new reading pedagogy involves a repositioning of the visual and the verbal, a recognition that visual's familiar decorative and illustrative functions are complemented by other important (and multiple) narrative roles. In terms of *The Bamboo Flute* and *The Collected Works of Billy the Kid*, the visual elements encourage an enhanced emphasis on notions of margin and centre, figure and ground, and negative and positive; in addition, the presence of visual elements allows consideration of how pictorial and photographic representation vari-

"Literature and photography have been crossing each other's representational borders ever since Edgar Allan Poe acclaimed the invention of the daguerreotype in his essay of 1840. Their imbrications occur even in the language we use—from the etymology of the word *photography* (writing with light) to the current term *visual literacy*."
Marsha Bryant—"Introduction" to Photo-Textualities: Reading Photographs and Literature.

ously competes, coheres, or otherwise colludes in the telling of the story.

More technically, we might take our cue from Nodelman and Behrendt and ask questions about how the visual elements work rhetorically, that is, how the visual figures influence the reader's sense of engagement and detachment. The preceding discussion of Disher and Ondaatje suggests four readily available categories of image/text relations: (1) repetition, (2) substitution, (3) reversal, and (4) destabilization:[3]

- *Repetition*, a rhetoric of vernacular, popular, mass, and high art cultures, can be used merely to illustrate the text, or, when used as a form of visual anaphora, it can add an ironic aspect by moving from simple duplication (visual paraphrase) to multiple representation. Andy Warhol's celebrity images and *mise en abyme* representations of photographs within photographs, stories within stories, are examples of such dramatic repetition. Simple illustration enhances imaginative engagement, while the *mise en abyme* disturbs the narrative flow and encourages the "double reading" described by Nodelman.

- *Substitution*, a rhetoric drawn from mass and popular cultures, is suggested by Ondaatje's image of the empty frame: the moment we hold up page five to the light and see the white space fill with words, we experience the rhetoric of substitution. More generally, substitution occurs when the image takes on a metonymic relationship to the written text—where the container (or frame) represents the contents, where the image gains meaning by virtue of its association (or contiguity) with the text. Simple substitution will likely go unnoticed by most readers: metonymy has become a commonplace strategy among advertisers, where a commercial image is associated with positive qualities, personalities, and/or lifestyles. Overt substitution, however, will likely prompt readers to adjust their interpretive schemata and cause initial detachment from the narrative.

- *Reversal*, a rhetoric most commonly limited to the high art sphere, is a form of visual irony, where the image either contradicts or recontextualizes the words on the page. Recognizing Ondaatje's framed white space as both "empty" and meaningful suggests an example of reversal

3 Claire Dormann sees repetition, reversal, substitution, and destabilization as the "four fundamental rhetoric operations" of visual rhetoric. See her "A Taxonomy" for a useful overview of how metaphors are used in web design and "user interface." These four rhetorical commonplaces, usually reserved for stylistic analysis of texts rather than reader response, correspond to Aristotle's *topoi* on "relationships." See Corbett, especially 94-143; see also Renato Barilli's *Rhetoric*. An excellent source for examples of rhetorical analysis is Brian Vickers's *In Defence of Rhetoric*.

in action. Such visual/verbal tension encourages even further reader detachment.

- *Destabilization*, a rhetoric of high art or vernacular accident, occurs when the repetition, substitution, or reversal, is pushed to an extreme via hyperbole, ellipsis, irony, or antithesis. When the visual/verbal relationship radically contradicts expectations, or quite simply does not make initial sense, the reading experience becomes unstable. At such moments, readers tend to force coherence and worry the texts into meaning.

These categories provide a framework for understanding shifting response positions.

Attending to these four rhetorical fundamentals suggests one alternative way to detail and talk about reader engagement and detachment; and, as Nodelman suggests, attending to such image/text relations can only help encourage the kind of metacognitive awareness identified as a prerequisite for literary competence in general, and reading literacy narratives in particular.

The Collected Works presents a sequence of spaces, typographical and narrative gaps that, if viewed as important elements of the rhetorical response situation, the reader may confidently fill in with meaning. I do not want to suggest that Ondaatje's text somehow "contains" or formally "determines" reader response; rather, I would argue that a reader well-versed in visual rhetoric will tend to value (and thus see) the text differently. I also argue that, if read as a literacy narrative, Ondaatje's text helps construct, even tutor, a heightened level of perceptual response.

Finally, though, the educational potential of this alternative reading strategy remains tied to the scholarly validation of visual/verbal relations—for such validation helps shape response and establishes a clear, institutionally sanctioned interpretive schema. What we learn to value often determines *what* and *how* we see. With Roger Cardinal and Robert B. Ray we can, as teachers, critics, and researchers, move our terms of critical reference beyond those already established by language-centred theorists. As Ray puts it, we need to be wary of critical ways of seeing that "define the new technology (photography, film [and image/text compositions]) in terms of the old ([written] language), and thereby restrict our capacity to admit the full implications of the revolution surrounding us" ("Afterword" 158). Perhaps the word "revolution" goes too far, for ours is not the first age to feature a visual and perceptual emphasis in popular and high art cultures; it remains nonetheless urgent to work out an appropriate critical and

pedagogical response to works that present themselves in modes other than the "purely verbal." The "world-as-text" metaphor, when employed too enthusiastically (or uncritically) by scholars and/or teachers, tends to downplay questions of agency, materiality, and perceptual response. Instead the "literate (i.e., "textual") mode," the art of close reading the words on the page, should be recognized and taught as simply one of an array of possible responses—to picture books, literary texts, PhotoGraphic works, and other mixed-media constructions.

Now. Some things about this ms:

1. Havent reread it since I got it back, but thought I shd get this off to you quick. will send correct on$ if any in the next few days.
2. You will note some changes of course, esp odd bits here and there in prose passages. a 𝗳𝘅 fewpoems chañed violently.
3. for openers - I think we shd drop the Jarry quote tho I love it and replace it with the photographers letter. I think it suits the poem more specifically than jarry and links up with the 'photo imagery' elsewhere. Trying to capture billy etc. *(handwritten annotation)*

4. a few others dropped since I saw you, they are 𝘅 clipped together at the back of the main ms you'll find. Ms is getting nice and tight now I feel, yip!

what else? not much. we should get together before you go.. when? June 1st? can come up to T anytime

Michael Ondaatje, correspondence regarding page 5 of *The Collected Works of Billy the Kid*. Coach House Press Fonds. National Library of Canada. Reproduced courtesy of the author.

Part 2:

On Fred Douglas and Crossfade

I want to take up Will Garrett-Petts's invitation to discuss the notions of visual narrative and perceptual response, especially as they relate to the work of West Coast artist Fred Douglas. But first let me add a few comments on Ondaatje's *The Collected Works of Billy the Kid*. The near-empty canvas of Kasimir Malevich's painting *Suprematist Composition: White on White* might well be considered a primary visual reference for Ondaatje's open frame. The oil painting presents a cool white square inscribed in the larger, warmer, white field which fills his square canvas. This sparse gesture marks the beginning of a tradition of art making in this century, a tradition which has sought to replace the subject matter of previous centuries with the material and spiritual purity of abstraction, purifying art of the "whole series of feelings which were alien to it" (Malevich 346).

While *White on White* has long been seen as the founding work of a tradition of Minimalist and Conceptual art (I'm thinking of work by such artists as Robert Smithson, Michael Snow, and Ian Wallace), Malevich has described another canvas that more closely echoes Ondaatje's list of the dead and the open frame which precedes it:

> The black square on the white field was the first form in which non-objective feeling came to be expressed. The square = feeling, the white field = the void beyond this feeling. (qtd. in Chipp 343)

The void of Ondaatje's white square similarly represents the potential space of twentieth-century abstraction's blank canvas. Ondaatje juxtaposes two opposing traditions of twentieth-century literature and art: that of the documentary collage and Suprematism. He seems to point toward a bridging of these traditions while invoking a third: the vernacular frame of the snapshot.

Both gestures, Malevich's and Ondaatje's, seem designed to "unsettle" the viewer and help us see the world differently. This same disruptive aesthetic pervades the artmaking of Fred Douglas, an important figure in Canadian art, who, for the last thirty years, has seldom exhibited or published his work. Instead, Douglas has worked intuitively, inductively, seeking significance through teaching students and making art as an extension of his own complex but resolutely vernacular aesthetic practice. In Douglas we find an informed (Douglas would eschew the label "scholarly") artist who,

though aware of (and intrigued by) the currents of contemporary theoretical debate, has sought to keep his own work apart, to preserve its integrity, its personally invested, if idiosyncratic, strength of purpose.

From the outset, Douglas's work has informed but never really conformed. In the 1960s, though an active and influential member of Vancouver's arts community, Douglas found himself at odds with the language-based poetics of the *Tish* group. To the UBC crowd—in particular, Frank Davey and George Bowering—Douglas's earthy wit and fondness for vernacular subject matter, including the performance-based orality of the Beat poets, seemed anachronistic. The times were alive with serious talk of "breath lines" and "projective verse"; notions of authorial presence and projection were becoming increasingly theorized and aestheticized phenomenologically as something created "in the process of writing."

Davey, in a journalism piece for *Delta Magazine*, makes a clear distinction between Douglas's "bohemian" voice and the new "academic" style centred around the newsletter *Tish*. He identifies Douglas as belonging to a group flourishing "within the abstract-hung walls of the shabby West End houses":

> Somewhat connected with the Vancouver Art School, and somewhat with the unemployment and social assistance offices, but mostly wandering on their own, these people, John Newlove, Fred Douglas, Roy Kiyooka, have acquired the reputation of beatniks—but more by their life than by their writings.

Davey praises their work's "nearness to 'life,'" and "their fierce independence and experimentalism displayed in painting, music, ceramics, sculpture, prose, and marriage, as well as in poetry." In contrast, the *Tish* group is associated with Williams, Pound, Creeley, and Olson, "those learned poets who have not forgotten they are men." The *Tish* poets are said to "have a more academic background than the 'bohemian' group; they are almost all associated in some way with the university, and several have degrees" ("The Present Scene" 1-2).

The bohemian rebuttal is offered by John Newlove, who, in a newspaper article of that same period, cites Douglas in the same breath as Mike Matthews, Gerry Gilbert, Avo Erisalu, and bill bissett as "perhaps the best and the best-known" among the poets working outside the university. The article notes that "except for

public readings and a trickle of publications here and there," writers like Douglas seemed "to exist mostly underground, their work circulating furtively by manuscript passed from hand to hand among friends." Douglas is described as "violently witty," as one who composes "in a wild, cascading torrent of images, imprecations and rhythms that overwhelm the listener" ("Poetry Scene" 17). Such notoriety did not go down well with some of the young rival poets, especially when Lawrence Ferlinghetti, who had heard him at a literary reading in San Francisco, proclaimed Douglas "the only exciting new voice working in Vancouver" (Douglas "Personal Interview").

Only recently has Douglas sought public and academic recognition for his art. He has begun to speak out against what he sees as an exhausted, overly self-conscious, overly settled, "over-coded" artistic practice. With a wry sense of humour, and with terms of reference that both echo and extend the four cultural spheres we introduced earlier, Douglas now defines his own work by what it is not:

> Fine art, also called: high art, advanced art, academic art, contemporary art, gallery art, public art, avant-garde art, serious art, as well as film and video. Fine art comments on other art. Fine artists sell their work to collectors through galleries, apply for government grants and make proposals for public art for which they receive commissions. They show their films and videos at universities and art galleries through 16mm projectors and on video monitors. It is not necessary to sell work to be a fine artist. ("Contradictions" n.pag.)

It is also not "commercial art," that is, "applied art, design, advertising art, fashion, movies and architecture"; and it is not "folk art," which he describes as "innocent art, naïve art, and craft." He finds himself interested less in categories than in "crossovers and other ambiguous forms":

> mail art which is sometimes fine and sometimes folk. Child art, [which] can become fine art under the category of art brut, [but] which also contains insane art,…[which] can also be folk. Tattoo art,…a kind of commercial art or folk art. Skateboarder art,…exhibited and performed as part of the urban environment. Public art,…art that has very little or no interest to the public. Performance art,…a

school-marmish version of happenings, which is an art of the recent past. Photo-based art [which] can be either fine art or craft. [E]thnic art, kitsch art, cartoon art,…architecture, pornographic art, illustrative art, retrogressive art,…

He sees a world populated by "interior decorators, set decorators, flower arrangers, fashion consultants, art consultants, arts administrators, and lots of others that [he] can't think of right now." In the midst of this catalogue of forms, motives, ambitions, professional agendas, and gatekeepers, he says, modestly, "I'm trying to divine a way of making my art part of the world." That way involves making things "that can be in everyday life. Things like business cards, menus, posters, letterheads, etc." He is interested in "remnants and how their fluttering presence persists"; he wants to praise "the frail condition that has used up its future," including "its deceptions and disappointments" ("Contradictions" n.pag.).

Douglas seeks a moving space for his pictures and stories, one that fades across these vernacular forms. The stories, complex interactions between photographic images, anecdotal texts, and drawings, reflect Douglas's experience of growing up in Vancouver, the city where he has lived just about all his life. In creating stories not about but *from* this urban environment, Douglas extends an interest that he has observed in the work of such early B.C. photographers as Phillip Timms, Mattie Gunterman, Leonard Frank, and Claire Downing. In writing about the work of these photographers for *Eleven Early British Columbian Photographers*, a 1976 exhibition at the Vancouver Art Gallery, Douglas notes that:

> These people, with their ideas of nature, art, the individual, and the community, were actually going to live in this rain forest; and as they did the place altered—through their activities, and through their perceptions of it. The trees, the ocean, the sky, the ferns and the mud took on new form; and in turn so did the settlers. When we look at their photographs we can see a new culture emerging. (7)

This new, emergent culture of Vancouver is recollected by Douglas in "The Long Street," the opening chapter of *Excerpts from Cars, Clothes, Houses and Weather Conditions*, a small bookwork produced to accompany his exhibition *Redeemed Plates* at Calgary's Illingsworth Kerr Gallery (1997). Douglas provides a history of Hastings Street, beginning "[a]t its most westerly point, where it merged with the shoreline…." There "sat a large office

ELEVEN EARLY BRITISH COLUMBIAN PHOTOGRAPHERS

building erected in 1930. Its cheerful art-deco countenance seemed quaint in comparison to the larger glass-walled buildings that had grown up around it" (15). Later we are told that "[f]or its last few blocks the street was bordered by salmonberry bushes with a forest of alder trees behind them. Finally the street ended where someone had placed a large boulder at the edge of the forest. At this point the road turned south. It was no longer Hastings Street" (16). What lies between Douglas's description of these geographical boundaries of Hastings Street is an account of the other points of reference along the way, "a shopping district," "a sparse area with anonymous buildings," "a statuary workshop," a statue that "depicted two male athletes," etc. In Douglas's history, however, these are not just monuments; they are, instead, catalysts for mem-

ories—in this case of the parade which began each year, moving down Hastings Street to the statue marking the entrance to the fairgrounds. Today, the fair and the past life of Hastings Street have been replaced by a new building and a new statue, "a large hemispherical building held up by air." "The building," B.C. Place Stadium, "held some of the events that had previously taken place at the old fairground," but Douglas notes that "the atmosphere of a fair had been left behind—the farm animals and the vegetables and the products of people's hobbies and walking through" (16).

By beginning *Excerpts from Cars, Clothes, Houses and Weather Conditions* with this story of Hastings Street, Douglas provides the reader with a tangible sense of a real place, the same place that one can imagine Leonard Frank and Philip Timms inhabiting in earlier generations. This story is not simply a nostalgic lament for a Vancouver lost some time prior to the EXPO of 1986. Douglas would be wary of such a gesture. Rather, the narrative moves beyond nostalgia to become a "melancholic pursuit." Celeste Olalquiaga offers a useful distinction between mere nostalgia and the artistic potential of melancholy:

> Nostalgia and melancholy represent two radically opposite perceptions of experiences and cultural sensibilities. One, traditional, symbolic and totalizing, uses memories to conceptually complete the partiality of events, protecting them with a frozen wreath from the decomposition of time; the other, modern, allegorical and fragmentary, glorifies the perishable aspect of events, seeking in their partial and decaying memory the confirmation of its own temporal dislocation. (298)

The second perceptual mode, the melancholic, informs Douglas's story, presenting to the reader of *Excerpts from Cars* ideas of an emergent culture and its inevitable decay as something echoed allegorically (that is, "not illustrated") by the accompanying visual images. These are images of Douglas's *Redeemed Plates*, those works that make up the gallery exhibition.

For some time Douglas has sought out and photographed old brass plates or plaques, curiosities that depict domestic scenes and landscapes in the style of seventeenth- and eighteeth-century picturesque paintings. Once the objects of serious collection, they came into fashion in the 1930s, and again in the 1970s, but now show up in second-hand sales. As Douglas explains (in language that echoes Olalquiaga), "Things die in a complex way. They disappear into their atmosphere & fade out of sight. Occasionally they

Fred Douglas, *Redeemed Plates* series (1997). Reproduced courtesy of the artist. Photograph by Kim Clarke.

will arise from this detritus to be re-born as collectables. In this state they have a more vivid if less substantial life." He goes on to explain that it "is the initial dying of things that has interested" him:

Things that may never achieve a re-incarnation as collect-ables…exist in an underworld so they can no longer speak, drifting as shadows occluded by other shadows. The plaques are such things. They were re-collected (re-deemed) from such places as thrift stores, garage sales, etc. Perhaps a garbage dump is a place where civilization returns to nature. These are sites of regeneration as much as dereliction. ("A Dialogue" 3-4)

As Liane Davison writes, these re-deemed plates "are 1970s kitsch versions of 1930s-40s kitsch versions of 17th-century Dutch and 18th-century English paintings" ("Ruminating" 8).

Douglas's method of photographing the plates emphasizes the physicality of their bas relief. The photographic prints are chemi-cally toned and hand-coloured such that the images on the plaques become reminiscent of the look of older glass Christmas tree orna-ments—with the colouring more accentuated on the highlights and in areas of more lavish detail. One such image, associated in the book with surreal stories of urban warfare, is derived from a plate featuring a small ship under sail, perhaps a Spanish galley of the sixteenth or seventeenth century. Curiously, just as the protag-onist Aikenhead has only an ambivalent involvement with the "war," the ship seems to be only marginally warlike, appearing per-haps to be more of a mercantile vessel. From the side of the ship's hull a number of oars reach out into the water and the foreground of the plate's composition. The relief pattern of the water is rhyth-mic and rippled, echoing the pattern of the ship's planked hull. The clouds above are billowy, echoing the ship's sails. The colour-ing of this plate is restrained, with a translucent layer of crimson oil accentuating the ship and its sails. In contrast, the border in this case presents a complex patterning, something like a cascade of small leaves or flower petals, painted onto the dark background in a mixture of greens and blues. Whereas a number of the back-grounds fade into or otherwise obscure portions of their associated plates, this background seems to flow around its plate, much like the passage of water around the tip of an oar. One of the more som-bre photographic images, it does not have a direct, analogical con-nection to the story of the war aviators, but, instead, works in the manner of Owens's horizontal allegory, asking the viewer/reader to make a link between the workers aboard Aikenhead's war glider and the absent crew of this galley. The links that do exist pull the reader back and forth throughout the book, for they may recall the description of the "cheerful art-deco" building at the start of Hastings Street. We are reminded that on the building's façade

were "bas-reliefs, depicting aeroplanes, dirigibles, ships and other such accomplishments of modern science and industry," which, like the sculpted plates, "now seemed antique" (*Excerpts from Cars* 15).

As with all of Douglas's coloured photographs, and like his stories, there is no consistent correspondence between the details of the colouring and the details of the photographed objects. In this way there is a slippage that allows a viewer to enter into the image in the same manner that a reader might find open points of entry into the larger image-text narratives. Where any such slippage or void occurs, Douglas is apt to fill it rather than preserve its openness. For, unlike the white spaces that Ondaatje has carefully worked into his composition of *The Collected Writings of Billy the Kid*, Douglas seeks to complicate pictorial space, adding in rather than taking out information. The wide photographic borders that surround the circular or ovoid form of the plaques provides a field for a painterly combination of airbrushing, direct painting, and calligraphic brushwork. These borders, each with their own compositional logic, are patterned in a manner that recalls those menus, posters and letterheads that Douglas takes to be a central form of vernacular visual expression. Though no two are the same, the borders may be characterized as having either a lighter, jovial quality to them, or, conversely, a character that is heavier, perhaps with a leafy quality, and sometimes with colour schemes and brushwork that carry a suggestion of foreboding. In these ways the border enters into the plaques, inflecting the images with the same range of emotions that make up the text; sometimes with an obvious correspondence across these various realms, sometimes not. In one instance Douglas has taken two photographs of the same plaque and has toned and painted each in an individual manner, such that the original genre image takes on either a more festive or a more melancholic countenance (see colour plate).

In the exhibition, each of the hand-toned and coloured prints is displayed in a shallow glass-fronted case that is suspended from the wall by aircraft cable, the ends carefully crimped around stainless-steel thimbles, and slipped over two eye-hooks. These boxes are important in establishing a physical presence for the work, perhaps a substitution for the physicality of the plates themselves. Yet, like the painted photographs, the physicality is tentative: the boxes are, quite literally, held in suspension. Inside these cases, the images are also in suspension, floated in the frame rather than contained by a conventional mat. In this manner the prints maintain a quality of objectness more than of illusion.

Fred Douglas, *Menu for Sunset: An Apparent Story Illustrated with Pictures* (1996). Cover image, "A Loosely Executed Painting." Reproduced courtesy of the artist. Douglas calls the form of this work a "farrago," a medley or unsorted mixture.

In the bookwork, the photographs appear as colour reproductions. A means of reading the photographs, and of placing the plaques into the realm of vernacular expression, is presented to the reader early in the story, in the references to the Statuary Workshop on Hastings Street. In this shop the workers make "sentimental replicas of pastiches of copies of reproductions of statues of Roman gods" (16). The plaques are such things: initially nostalgic in their fabrication and consumption, they are redeemed by Douglas's investiture of personal meaning. Such a personal reclamation seems essential, for as Olalquiaga states, in releasing the allegorical potential of such objects, the artist saves them from being lost or discounted as simple souvenirs:

The souvenir does not automatically recall the remembrance, conjuring the lived moment and from there unleashing mythical time. Like the cultural fossil, the sou-

venir is unable to bring back anything beyond the imme-
diate perception that triggers the process of remembrance.
Despite being centered around time (*souvenir* is French
for remembering), the souvenir's capacity to move within
the temporal dimension is limited by that second death—
commodification—which attempts to restrict its signifi-
cance to a specific dream image, hindering the imaginary
return to mythical time that remembrances effortlessly
achieve. For the latter to happen, the souvenir must wait,
perhaps forever, to become part of a personal universe.
(78).

The plates' distance from the original sources of their imagery
interests Douglas, especially how their apparent fragmentary status
casts them as ruins. His practice implicitly opposes a vertical read-
ing of the plates, one which consumer culture has imposed, where
their most recent form occludes and silences each previous point
of historical origin in succession. In the images and texts which
make up both exhibition and book, Douglas reinvests the narrative
potential of the plates' genre scenes, releasing their stories outward,
in a manner that acknowledges their horizontal potential.

Such methods of storytelling and pictorial composition, methods
that Fred Douglas has been working out in such recent bodies of
work as the *Redeemed Plates* and *Crossfade*, are articulated force-
fully in his earlier and most extensive project to date: *Menu for
Sunset*. This work marks a culling together of the vast range of
ideas and materials that Douglas had been accruing in his four
decades as an artist; it also represents the catalyst for his more
recent bodies of work. The primary elements of *Menu* are
Douglas's photographs and a story made up of thirty-seven short,
anecdotal texts.

Menu for Sunset was first exhibited in its entirety in 1996 at the
Surrey Art Gallery—and the realization of the work for this exhi-
bition is an interesting story in itself. Douglas initially conceived of
the work, simply titled *A Story*, as a large coffee table book. These
coffee table books, featuring the work of such accepted photogra-
phers as Ansel Adams and Lee Friedlander, or painters such as
Toni Onley, exist somewhere between the realms of high art and
popular culture, and also belong to the tradition of the *livre
d'artiste*. Such a form, had it been completed, would have placed
the complex, vernacular nature of his story in an ironic relation-
ship to high art tradition. Despite interest in the project, the costs
associated with producing the work in this form prevented publi-
cation. Instead, Douglas conceived of the book becoming a gallery

Fred Douglas, two framed pages from *Menu for Sunset* exhibition. Pencil drawing. Reproduced courtesy of the artist.

installation, with each two-page spread framed separately, and all forty-one of them exhibited around the space of the gallery. The book-as-installation is, for Douglas, not a substitute for his conjectural bound book, but rather an alternative reading experience for the viewer. As part of the exhibition, the Surrey Art Gallery published a small artist's book in lieu of the standard exhibition catalogue. This bookwork, which has been called Douglas's "first novel," provides the complete and edited version of the text and features as its illustrations a number of small and cursory drawings that, like the rest of his work, Douglas has been accumulating over time. These drawings are each framed separately and placed in the gallery space as an introduction, a preface of sorts, to the exhibition. The installation as a whole, then, is one which "crossfades" between the form of the book and the gallery installation.

Within each frame sits a page layout, as Douglas had initially planned for the coffee table book. The left page is made up of a full 11" x 14" photograph, some straight black and white prints, with

others toned and coloured and sometimes airbrushed to varying degrees of complexity and obscurity. The right page consists of an anecdotal text, and two more images, sometimes toned, with the bottom of one and the top of the other always overlapping. In a gesture which prefigures *Crossfade*, this overlap allows for some dissolving of one image into the next.

On the surface, *Menu* appears as a chaotic interweaving of both very banal imagery and imagery that is exotic, dreamlike, and eccentric. As one delves more deeply into the work, however, the subtlety and intricacy of its interwoven connections seem quite simply astounding. Such interweaving takes place within and between each image, whether textual or photographic, but also across time. The composition of the work, in the manner of a

scrapbook, allows for the inclusion of any image or story, however recent or long forgotten. The structure of *Menu for Sunset* is, as Donald Kuspit has said of collage, "based directly on its incompleteness, on the sense of perpetual becoming that animates it.... What counts is that it remains incompletely constituted, for all the fragments that constitute it. There is always something more that can be added to or taken away from its constitution, as if by some restless will. The collage seems unwilled, and yet it is willful" (43).

The book version of *Menu for Sunset* seems equally "willful." It tells the story of an unnamed man moving from nostalgia to melancholia. Nostalgia, introduced in Chapter 10 at the moment the man discovers his wife is having an affair, reduces the man's world to a banal soup of peach-coloured wallpaper, heavy maroon drapes, "loosely executed" paintings, and conversations "as dreary as a soap opera." Several "white canvas and wood chairs" decorate the house where he'd once lived as a child, and where now, at a party, he confronts his wife. We are told that the "parlour and the living room [are] now one large, white room"; and the kitchen is "also white and very pristine." The family house, like his marriage, loses meaning, fades into white: "He realized that there wasn't a vestige left that he could identify with." When he leaves both party and wife, he begins to drive "aimlessly," everything merging "into an almost undifferentiated grey field" (24-25). Even the street and sidewalk seem "like a warm, grey stream that he [is] moving through." At this point, nostalgic longing becomes absorbed into a "melancholy continuity"—until the man's attention is distracted by yet another "white" object:

> at the top of a hill, under a street light, his eye was attracted to what seemed to be a white smear. He focussed his attention in the direction it came from and saw a roadway leading to a house where a man in a white shirt bent over what at first glance looked like a motionless smoke, but then appeared to be a small smooth dog with fur the colour of a pigeon that was barely distinguishable from the asphalt. It could have been sleeping but there was something too flaccid or collapsed about it, like a piece of old clothing. The man looked down at the motionless creature, then bent over and took the front legs in one hand and the back legs in the other. The dog hung limp and lifeless from his hands as he moved it to the grass of the boulevard. He gazed down at it, then leaned over, scratched its ear and caressed the side of its face, then stood up and looked down at it again. (27-28)

However maudlin the scene, its melancholy aspect is not of a piece with the oppressive nostalgia evoked during the party—a nostalgia that permeates the man's previous life. Before the party, he and his wife Dorothy were in harmony with their surroundings, "confusing their bodies with the floral pattern of the bedspread" (14) and feeling a "commonality with the displayed objects" in shops and in their home. They shared a "sense of belonging to the same world as the things that appeared around them" (16). The perfect consumers, they become defined by the objects they own, taking pleasure in acquisition and arrangement. Even before losing his wife, the man has lost his sense of self, gazing "immobile and unfocussed…into the spaces between the objects" (17). Together they inhabit a blank space, what Douglas describes as "a pause…in the flow of the duration" (14). The pause or "space between" fills the man with panic born of "an awful passivity": he recognizes that "[t]hey'd absorbed the qualities of the life around them and had in turn been absorbed by that life." They find themselves in a seemingly hopeless "stasis," where "[e]very stance [becomes] a pose,

Fred Douglas, "Nostalgia." From *Menu for Sunset* (1996). Images reproduced courtesy of the artist.

Fred Douglas, *The Van* (1986) at
Harbourfront. Inside and outside of
an opened invitation. Reproduced
courtesy of the artist.

[where] even their moans sound phony" (18-19). Their marriage
has become a stilled life, their possessions mere objects, fossils
lacking even a nostalgic valence and thus compulsively replacable,
meaningful only in terms of their colour or shape or position on a
shelf.

In contrast to the static nostalgia for domestic objects, the dead
dog, also described as "motionless" and "flaccid," evokes a senti-
mental gesture from its owner: scratching the ear and caressing the
face, the man rehearses a physical sign of loss, a final touch to say
goodbye. The gesture is real, the body warm; and at the moment
of touching, one senses that the dog is "part of the world." Unlike
the couple's objects, or "their gestures and the expressions on their
faces [which seem]…separate from the stuff of their utterances"
(19), the owner's gesture of grief seems too immediate to be called
nostalgic. This scene provides the man with a lesson on how to
read (and interact with) the past, how to read the past back into the
present.

Significantly, five chapters after "Nostalgia," we are introduced
to "Arcadia: A Melancholy Chore," where the man is given the job
of reclaiming a graveyard. He attempts to "make the scene of hor-
ror into an apparently pleasant place," and in the attempt learns
that "everything [is] wounded and [is] either healing or dying" (33-
34). This wounded state, this sense of loss, need not provoke nos-
talgia and inertia: like the "white smear" of the dog owner's shirt
(or the white space in Ondaatje's *Collected Works*), absence can be
read positively as an invitation to narrative. In general terms, nar-
rative may mean the telling of a story, but, for Douglas, it means
entering into an imaginative relationship with the object of loss. As
Douglas explains, "We have become detached and disinterested.

We dare not look at things except from afar and through the leveling processes of reason. I believe that we have lost something, or are losing it—call it imagination, innocence, love...." Douglas offers an intercession of narrative, prose pictures and visual fictions that seek to redeem the ordinary, that seek to establish a personal, imaginative relationship with the daily. "I've tried to make an optimistic art," says Douglas, "but I can see that it is melancholy." Melancholia, though, is preferable to nostalgia—and in Douglas's hands, such a sensibility contributes a life-affirming artistic practice that takes form somewhere between a "quandary and a dialectic" (qtd. in Davison "Afterword," 68-69).

In *Menu for Sunset*, the man moves from "mere collector" and "categorizer" (31) to someone suddenly aware of his role in bringing the objects of nostalgia—what Douglas describes as a "fantastic second-hand market" of "spent glamour" (38)—back into the world. He finds a new love, a woman introduced in the language of the personal ad: "She enjoyed theatre, art, dancing, music, the outdoors, walks, and serious conversation" (45). Together they transcend such mass culture stereotypes and move around the country in a van.

Let me take a moment to reflect upon this image of the new Arcadia, the van, for it provides in miniature some understanding of Douglas's method, and his personal investment in the imagery. We are told in the story that "[s]tepping inside this vehicle was like going into a golden dream. The wood panelling [is] a golden colour [are] the cabinets with ochre drawer pulls." Other details about this "futuristic looking van" include its "gleaming white countertops" and its "chrome trim." The text references a photograph, another van and a small model boat which appear together

as an implausible means of entering Paradise. This van is pictured in a dream-like tableau, one created on the lawn of Douglas's actual North Vancouver home. In this image, stuffed animals stand amidst an array of the van's contents—and a wispy, fuchsia-coloured cloud that has been airbrushed overtop of the photograph. The airbrushing works against any tendency that a viewer might have to stabilize the image as an illusion of nature. Douglas's image acknowledges playfully both the tableaux of William Notman and tradition of commercial postcards (where such an illusion of nature is sought).

We are reminded of another van image, of a van precariously but beautifully perched on the apex of a scrap heap. The parallel is an important one, for the van itself, like the images of the copper plates made fifteen years later, was salvaged, redeemed. The Morris van we see in the photographs was reconstituted by Douglas—with the help of his father, who had worked as a mechanic. Prior to its incorporation in *Menu for Sunset*, the van was exhibited at the *October Show*, the unofficial "Salon de la Refuse" of Vancouver artists whose works were excluded from the Vancouver Art Gallery's inaugural exhibition, *Vancouver Art and Artists, 1931-1983*. The van was shown with all of its things arranged around in the manner of a still life painting. To Douglas, though, the work did not seem complete. What was missing was something of its historical presence: he wanted the van to have some place in the real world.

This sense that something was missing came to Douglas while driving the van back from Toronto, where it had been exhibited at Harbourfront. The daily activity of setting up the van and its contents for display had seemed to Douglas forced and artificial. As he would later write in *Crossfade*, "It's not that displaying things in white viewing-rooms is necessarily a bad practice but there is something anticlimactic about such exhibitions. The work doesn't get a chance to become real. It seems a process of retiring work rather than introducing it" ("Contradictions" n.pag.).

Some years ago, when first asked about the van, Douglas told a story about his return trip from Toronto and about this need for his work to exist in what we have been calling the "vernacular" of the real world:

> It didn't seem complete to me. I thought, "I must camp in it or do something," and now, as I look back on it, and I did drive and camp in it, just to give it a history. It was as phony as everything else, but it has an artistic history now. Its paint is pitted and things have happened to it. It has

been in the world, and yet, there is no real justification for
it being there. I didn't know that at the time. (Personal
interview with Calvin Whyte)

Only by working with his images (and redeemed objects) in this
manner can Douglas recirculate them as "story."

The final unexpected movement in *Menu* plays off the old
notion of what a visitor from another world might say about pres-
ent conditions. Chapter 29 introduces two strangers, aliens, with
faces like dolls: "They wore silver shoes and from their costumes
hung many small handy things: peelers, scraper, storage vessels,
mixers, beaters, cutters, things with lights inside them, and other
things for purposes that couldn't be determined" (54). Collectors
themselves, the aliens' interest in the ordinary recontextualizes the
kitchen gadgets, investing them with imaginative possibilities.

When the aliens leave in an impossible craft, in an enormous box-kite, "a huge, irregular structure of boxes hovering in the clear blue sky," their spacecraft influences "craft" on earth:

> The people on the street looked up in awe as the great kite floated away. The memory of this unusual object influenced furniture design and even some sculpture for years to come. (62)

Their influence on the man and his new partner is still more profound.

Before leaving, the aliens offer to take the couple with them. The earthlings hesitate, asking for time to "get their things in order." Once back in their camperized van, they find it impossible to box up, contain, their possessions. We are told that "[w]hat seemed to be dishes became the memories of meals and locales and situations" (61). When they do try to leave, "swooping and spinning through the sky," the couple's nostalgia turns to melancholy, to a profound understanding of their place in the world:

> As they looked down at the diminishing scene they were filled by a melancholy sense of loss, a feeling of being about to relinquish something precious—they weren't taken by the thrill of escaping and no new sense of freedom filled them—as much as they were inspired by the promise of adventure in a perfect place; this sense of loss drew their affections back down to earth. (63-64)

Like his unnamed protagonist, Douglas employs the rhetoric of melancholic allegory to invest "lost" objects with human significance. As I've already noted, to do so means investing the object with story. But the story is not there to explain; Douglas is not interested in text as caption: "The writing is not an envelope to put things in, nor is it a layering of things. It doesn't contain anything, but things emerge from it. It is an un-containing of things—a fluttering, a dispersal, a profusion. It is an inter-tidal zone" (qtd. in Davison "Ruminating," 11). The curator for *Menu*, Liane Davison, draws "a parallel between the process of 'reading' Douglas's work and how we make meaning of other experiences in our ever-changing present." Do we embrace narration as an unstable process (for both artist and audience)? Or do we seek to fix meanings, preserve narrative in conventional forms as "nostalgic collectables" (11)?

For Douglas (and to paraphrase Robert Kroetsch), the fiction makes the ordinary real again. The artist's role becomes one of "unhiding the hidden," "un-containing" that which has been trapped by cultural inertia or fashion. Finding and revitalizing the "fluttering presence" languishing dormant in the everyday means confronting the neglect or indifference or misreading that everyday objects suffer. The first stop for an artist like Douglas is to personalize his relationship with the object. Redemption, though, means resituating the object of attention in an "inter-tidal zone" of imaginative exchange, giving the object new life by reinserting it into the ebb and flow of other multiple and intersecting narratives. Douglas calls this process a "crossfade" of words and pictures. "Once it is a story it remains one or fades," says Douglas in his preface to *Excerpts from Cars*; and, as Douglas's work teaches, the crossfade may occur when word and picture meet, or when an object of attention is redeemed via imaginative intervention.

Pretexts for Artists' Books: A Visual Essay

<div style="text-align: right; font-size: 3em;">6</div>

During the course of our research, we became familiar with a number of artists' books—some famous, such as those by Michael Ondaatje and Michael Snow, but most relatively obscure, limited-run editions of often self-published works. These books come in all shapes and sizes, with many hardly resembling "books" at all. The artist's book, "[n]either an art book (collected reproductions of separate art works) nor a book on art (critical exegeses and/or artists' writings)," is, as Lucy Lippard characterizes it, "a work of art on its own conceived specifically for the book form…" (45). In reviewing such works, we found ourselves less interested in defining the form of the artists' book than in how artists' books reference multiple vernacular forms of storing and sorting out personal memories. We began to look for works that raise questions surrounding the authenticity of personal storytelling and narrative construction. In particular, we were drawn to those which employ PhotoGraphic strategies, interweaving conceptual and other aesthetic problems with the personal, the local, the vernacular. Diaries, journals, family albums and scrapbooks seem to provide a shared, readymade pretext for such works. Characteristically, such forms of personal and family recording exhibit "naturally" the migration of vernacular materials and artistic interests across various cultural spheres.

The Proffitt Family Scrapbook

This "album" began in scrapbook form with the Proffitt family of Lancashire, and has since been passed down to Jacky Foraie of Kamloops. Photographs documenting headstones and other traces of family ancestry have been used by family members to trace their "history back from 1604 to the beginning of photography" (Foraie "Personal Interview"). From such histories, families of the Victorian era assembled often elaborate photographic albums from *cartes-de-visites* and cabinet photographs.

A. WALMSLEY POOL ST., BOLTON.

Jacky Foraie makes an interesting distinction between more formal albums such as the Clapperton family album pictured above and the scrapbook that we are looking at. The scrapbook, she told us, "wasn't the original family album. That had gone missing. The original was a big leather-bound one with those hard pages. My dad remembered it with tissue in between each page and it was for the more formal portraits." Such official albums as this served as testimony of a family's lineage and were drawn from families such as the Proffitts, whose men were all "registered as master craftsmen, buckle makers and artisans." Such a vertically oriented narrative construction elides the daily pursuits of such professions and, instead, presents those same orderly conventions that were found within the standard parlour portrait. This miscellany is, then, the less official archive of the Proffitt family, an archive where snapshots and other documents mix with those formal portraits that were "spares," "just extra pictures" that had not found a place in the official family album. The scrapbook, thought to have been put together by the women of the family, three spinster sisters in the Bolton, Lancashire area (around the time of the Second World War), allows for a much more expansive, laterally oriented chronicling of the family than the official, leather-bound album would have permitted.

The covers themselves, made up of advertising posters, have about them a look more of dailiness than decorum. In addition to the studio portraits there are a number of whimsical images: Lucy, the great-aunt, dressed in a pantomime of the figure from a Quaker Oats box; the Proffitts as a family of greengrocers, standing in front of their shops. Many of these photographs, along with such other things as a hand-drawn family tree, are loose or in envelopes tucked inside.

The fragmentary images were deliberately torn from the scrapbook in the 1970s by William Proffitt, as images to show to his granddaughters in Canada. These fragments, and the act of their removal from the scrapbook, disrupts any sense of the scrapbook as a fixed form, functionally or aesthetically. It is, instead, a more malleable mode of expression, one in process, subject to change, and representative of more than one cultural sphere.

Between the Vernacular and the Conceptual:
Lucy Lippard's *955,000*

In 1969, Lucy Lippard curated 557,087, an exhibition at the Seattle Art Museum that was followed, in 1970, by 955,000 at the Vancouver Art Gallery; the exhibitions' titles derived from the respective populations of those cities. This exhibition, of central importance in establishing Vancouver's link to conceptual art practice, included such artists as Carl Andre, John Baldessari, Jonathon Borofsky, Greg Curnoe, Hans Haacke, Joseph Kosuth, Sol Lewitt, N.E. THING Co., Ed Ruscha, and Jeff Wall, to cite just a few of the sixty-two artists included. A listing of the participating artists is printed on four index cards, of which there are 120 in all. These cards constitute the primary document for this exhibition and serve as its catalogue. In addition to the four cards that list the participating artists, a similar number refer self-reflexively to the cards themselves and to the two exhibitions.

The remaining cards constitute individual creations by the artists involved in the exhibitions; these are variously created with text, photographic and hand-drawn imagery, and mixed-media combinations. The stack of cards corresponds to Lucy Lippard's conception of the artist's book in that it is not quite a book but is book-like. In this respect the card/catalogue echoes many aspects of conceptual art and of artists' books from the period. Central to such conceptual and minimalist practices of the 1960s—performance art, environmental art, and video—was a resistance to the creation of a material object. In such experimental activity we find commonly an emphasis on an experiential, time-based approach, often resulting in no material object at all. In all mediums, alternative forms of composition emerged in order to achieve these goals. One thinks of the films of Andy Warhol, and the sculptures of Carl Andre or Donald Judd, where the ordering principle, Donald Judd has written, "is not rationalistic and underlying, but is simply order, like that of continuity, one thing after another" (qtd. in Krauss 224). This metonymic or horizontal approach provided a means of avoiding what Krauss has termed "relational composition," the rational composition of earlier artistic movements of Europe and North America—a conception analogous to the linear chronology, the lineage, that is emphasized by those "official" photographic albums of Victorian and Edwardian families.

42 new cards have been added to this catalogue since the Seattle showing, 29 to cover artist's projects altered for Vancouver (3 artists were added in Vancouver), 1 title card, 2 additional bibliography, 1 list of artists shown in Vancouver, 1 for the Landart film, 6 installation shots of Seattle, unfortunately incomplete, particularly in regard to the works shown outdoors.and
The Seattle show could not have been completed without the ardent and intelligent cooperation of Anne Focke. In addition, I would like to thank the following people, not previously acknowledged; Bert Garner, Jim Manolides, David Hughbanks, Robert Dootson, John Denman, Virginia Wright, Fred Kanina and Tore Hoven.
Due to weather, technical problems and less definable snafus, Michael Heizer's piece was not executed in Seattle; Sol LeWitt's and Jan Dibbets' were not completed; Carl Andre's and Barry Flanagan's instructions were misunderstood and the pieces were not executed wholly in accord with the artist's wishes. Richard Serra's work did not arrive in time.

Though the cards may be stacked vertically and organized by some rational method, they are more likely to be randomly arranged, or perhaps spread out in no apparent arrangement at all. In this manner, the cards, like the events that they document, are not definitive and, instead, constitute a lateral, open-ended form of composition. Considered in these terms, the cards that represent Lucy Lippard's 995,000 constitute an unsettled activity operating between various cultural realms both outside the established high art culture of the day and (by moving toward a more conceptual practice) a step away from the daily activities of North American experience.

ROELOF LOUW BORN 17/2/36 RESIDENCE LONDON
WOOD PIECE/EXECUTED HOLLAND PARK/10'67
MATERIAL/A MIN OF 300(PREFERABLY MORE)
APPROX. 3' x 1" x ¼" WOODEN SLATS
SHOULD BE USED/THESE CAN BE PURCHASED
FROM MOST TIMBER MERCHANTS (USED FOR
PLASTER LATHING)
PROCEDURE FOR EXECUTION/THE SLATS
SHOULD BE DROPPED (SCATTERED) AROUND
TREES IN LOTS OF 2-6 PIECES AT IRREGULAR INTERVALS OVER AS EXTENSIVE AN
AREA AS POSSIBLE WITHOUT THERE BEING
A DEFINABLE PERIMETER

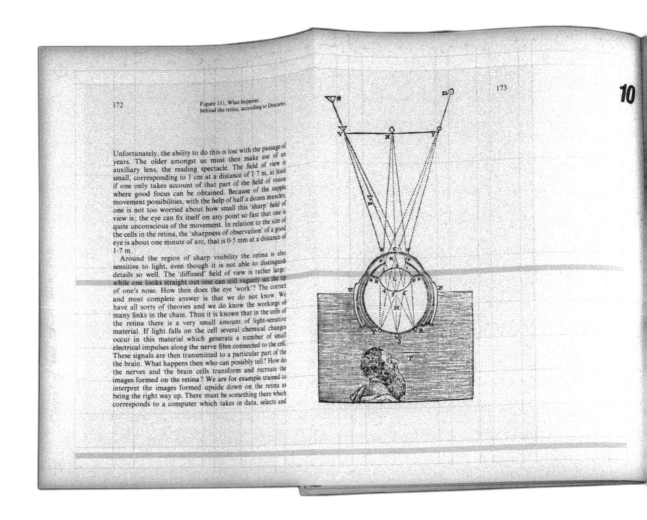

Figure 111. What happens behind the retina, according to Descartes.

172

173

Unfortunately, the ability to do this is lost with the passage of years. The older amongst us must then make use of an auxiliary lens, the reading spectacle. The field of view is small, corresponding to 1 cm at a distance of 1·7 m, at least if one only takes account of that part of the field of vision where good focus can be obtained. Because of the supple movement possibilities, with the help of half a dozen muscles, one is not too worried about how small this 'sharp' field of view is; the eye can fix itself on any point so fast that one is quite unconscious of the movement. In relation to the size of the cells in the retina, the 'sharpness of observation' of a good eye is about one minute of arc, that is 0·5 mm at a distance of 1·7 m.

Around the region of sharp visibility the retina is also sensitive to light, even though it is not able to distinguish details so well. The 'diffused' field of view is rather large; while one looks straight out one can still vaguely see the tip of one's nose. How then does the eye 'work'? The correct and most complete answer is that we do not know. We have all sorts of theories and we do know the workings of many links in the chain. Thus it is known that in the cells of the retina there is a very small amount of light-sensitive material. If light falls on the cell several chemical changes occur in this material which generate a number of small electrical impulses along the nerve fibre connected to the cell. These signals are then transmitted to a particular part of the brain. What happens then who can possibly tell? How do the nerves and the brain cells transform and recreate the images formed on the retina? We are for example trained to interpret the images formed upside down on the retina as being the right way up. There must be something there which corresponds to a computer which takes in data, selects and

5

Brutalizing the Card. 26/30 Univers 45

Brutalizing the Card.

few rabbits!

SLEIGHT OF HAND

4th Draft. All information accurate as of 02-014-1980.

INTRODUCTION

The art of sleight of hand, otherwise known as legerdemain, prestidigitation, and/or manipulation,

8

7 8 9

11

Stabbing a Friend in the Stomach light green

Between Objectivity and Representation:
Miles DeCoster's Sleight of Hand

Miles DeCoster's *Sleight of Hand* (1980) offers a playful take on chance, perception, and the ordering of information. In this bookwork, documents attempting scientific objectivity, such as Descartes's theories and diagrams of vision, interweave with the elusive and disappearing rabbits that come from the more illusory realm of magic and performance. It is in the space between objectivity, representation, and misrepresentation that DeCoster's work situates the image. In an extract from a found text, and under the title "The peculiarity of pictures," DeCoster observes,

> Pictures have a double reality. Drawings, paintings and photographs are objects in their own right—patterns on a flat sheet—and at the same time entirely different objects to the eye. We see both a pattern of marks on paper, with shading, brush-strokes or photographic "grain," and at the same time we see that these compose a face, a house or a ship on a stormy sea. Pictures are unique among objects; for they are seen both as themselves and as some other thing, entirely different from the paper or canvas of the picture. Pictures are paradoxes. (106)

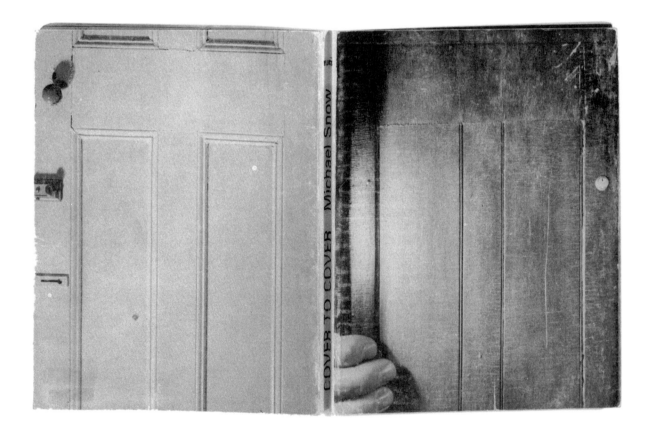

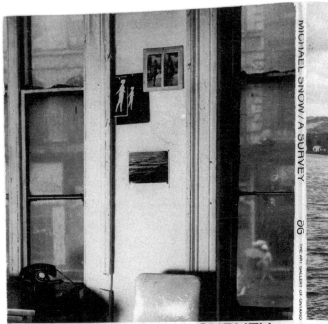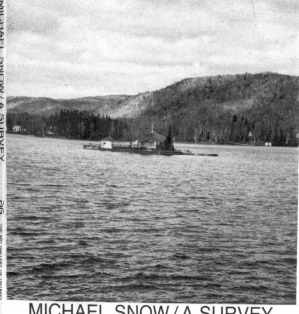

MICHAEL SNOW / A SURVEY MICHAEL SNOW / A SURVEY

Against Narrative:
Michael Snow's *Cover to Cover* and *A Survey*

The conceptual, often reductive, approach represented by the index cards of 955,000 and by the investigation of perception that DeCoster's *Sleight of Hand* invites, is carried on in two artists' books by Michael Snow. In *Cover to Cover*, the minimal, experiential aspects of his films and sculptures are worked out in the material terms of a book intended to thwart any narrative response to the perceptual experience at hand. *A Survey*, by contrast, seems much less reductive, invoking a collage-like mixing of "decidedly autobiographical" materials that configure Snow's practice as an artist in and around images and stories of his family history. It is the only one of his works that Snow acknowledges as being autobiographical ("Personal Interview").

 Cover to Cover dispenses with any overt story, instead focusing upon a subject who is in the process of examining the same book that the reader has in her hands. The apparent narrative of the work, as Snow describes it, "is not one that will electrify you" and is "a negligible one" in which "some person," Snow, "is in some house and goes, by driving, to a gallery and pulls up a copy of the book that you're looking at." The book provides details which ostensibly help locate the story, signs indicating the Canadian Film Makers' Distribution Centre, or the Summerhill TTC Subway entrance. But while such locational markers are evident, they remain unimportant, serving only as a background for two photographers, Keith Lock and Vince Sharp, who are continually visible behind Snow as he moves through these various locations. The work, composed entirely of photographs, does not encourage any lateral reading of such detail; instead, it absorbs those details within a unified composition that unfolds spatially, like a Moebius strip that continues to unfold upon itself, both echoing and mocking the reader's attempts to unravel Snow's

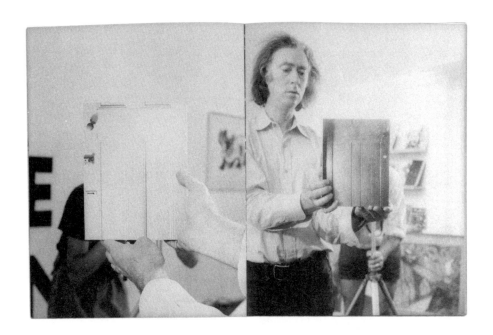

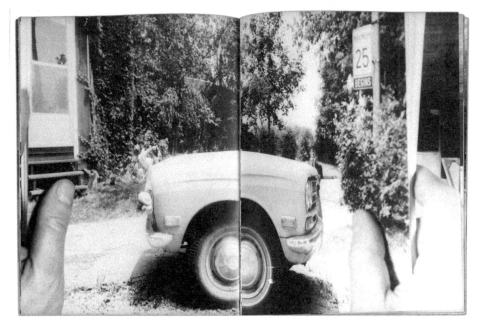

minimal narrative. In such works, Snow seeks "ways of structuring time that [are] precisely not narrative" and which "[come] face to face with" what he calls "a pretty common hallucination, which is representation" (Lawrence "Personal Interview").

The texts which make up *A Survey* are similarly self-reflexive, providing the reader with a means of interpreting the book's structure. Snow has placed "a survey" of his works as a conceptual artist, works

which he declares removed from emotion and sentiment, within the personal landscape of his family. In "Origins and Recent Work," one of several texts incorporated into the book, Dennis Young states that "Another root of [Snow's] activity, more deeply submerged but vital to an understanding of his mind, also originates in childhood—specifically in his experiences of Lac Clair, the site of his family's summer cottage. The moods and changing light and water of Lac Clair, and even the name, with its connotations of clarity, illumination, serenity, and intellectual lucidity (at once highly personal and archetypal) have time and again claimed acknowledgment from Snow's art" (Young 15).

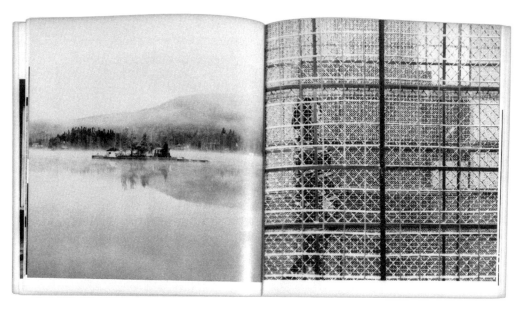

The undulating nature of Lac Clair's waves is echoed on the page facing this text, where a number of *A Survey's* critical texts overlay one another, creating a visual and intellectual palimpsest, a parallel to the water's depths. This page of overlapping texts is similarly echoed later in the book, when one of the images of Lac Clair, its surface in complete tranquillity, is situated adjacent to a close-up of Snow's installation BLIND—its documented texture visually similar to the overlaid texts. This, along with such other works by Snow such as *Scope, Sight, Authorization*, and *Wavelength*, explores the act of perception in a variety of sculptural, filmic and photographic forms—and each is archived in *A Survey*. In subsequent pages BLIND is revealed as a series of grid-like barriers, each placed in succession along the length of a gallery space. The physicality of these barriers, represented in *A Survey* by images of the gallery's visitors negotiating their way through the space, is metaphorically tied to a significant aspect of Snow's personal life: his father's blindness.

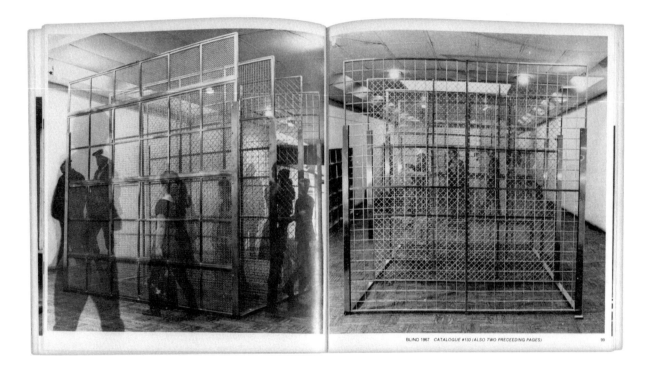

BLIND 1967 CATALOGUE #133 (ALSO TWO PRECEEDING PAGES) 99

The tension between the screens' tactile and visual sensations is alluded to on the next page when the reader is presented with a close-up image of a Braille pattern. In a work supposedly devoid of narrative content we find the following account (intermixed among images of Snow's sculptures and other photographic and textual accounts of his family life):

> His father was Gerald, Bradley Snow (1895-1964) of Toronto. A civil engineer and a Lieutenant in the Toronto 48th Highlanders in the 1914-18 war, who later worked on surveying for the Canadian Northern Railway and for construction firms in Quebec and Ontario, and was a chief engineer in the building of the Glen Road viaduct in Toronto. In 1934, supervising construction of a tunnel in Montreal, he was blinded by a dynamite explosion, losing first sight of one eye, then some years later the sight of the other. Through study with the C.N.I.B. he became expert in Braille and typing as a consulting engineer. (10)

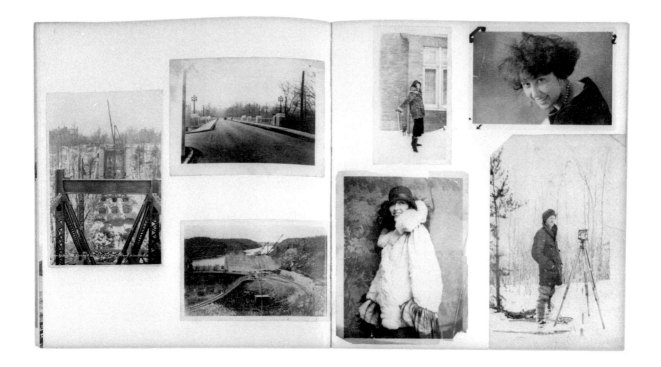

A *Survey* provides a personal basis for many of the formal explorations that constitute the bulk of Snow's work. The book's careful interweaving of elements presents a hybrid, something that draws upon conventional forms of biography, exhibition catalogues, critical texts, and family albums. In a gesture contrary to his entire aesthetic exploration, *A Survey* places the conceptual artist, Michael Snow, within the vernacular realms of family life and the family album. The concluding photograph of himself, as a young boy, must have been taken sometime close to the event recounted in the "Family History." In Snow's image, showing his younger self lying on the ground, two disproportionately large shoes fill the foreground, framing his face as he looks out toward the viewer. In an adjacent text Snow recollects,

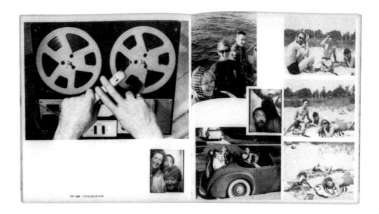

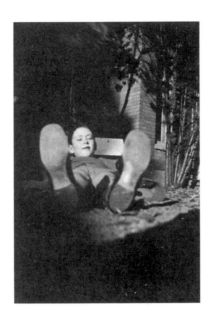

I'd heard that if you took a photo of this position the feet would appear gigantic. So I asked my sister Denyse to take this of me (1936). I also did a pastel version. (Snow 127)

This early interest in the optics of photographic perception must have been overlaid with the shock of his father's accident. As Dennis Young notes, it was with this sort of "photographic experiment" that Michael Snow's "involvement with the ways and means of art began [at the age of seven]" (*A Survey* 15). In *A Survey*, Snow allows entry to the vernacular of the family album and the anecdote, effectively interrupting a body of work that he understands as otherwise representing a modernist approach, one that he specifically defines as working against autobiography and narrative storytelling.[1]

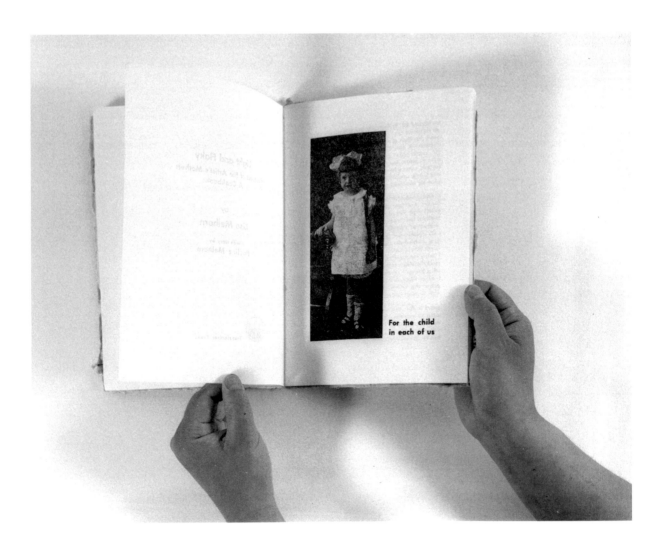

Lise Melhorn-Boe's Artist's Books:
A Vernacular Response to Family Albums

Lise Melhorn-Boe's bookworks show a more direct interest in the vernacular realm of family albums, diaries, and scrapbooks. In works such as *Light and Flaky, Good Girls Don't, Sad Little Girl,* and *Family Album,* Melhorn-Boe invites the reader to engage those forms of personal documentation that commonly lie outside the sphere of high art.

Light and Flaky, Portrait of the Artist's Mother: A Cookbook (1982) is a small book, hand-printed and bound in an edition of one hundred and ninety. Its covers are light green, of rough paper made by the artist "from linen & cotton tea-towels, table-cloths, aprons and dish cloths," and its parchment pages are hand-stitched to this cover with thread of a dark green colour (*Light and Flaky,* endsheet). This colour is echoed in the text and photographs throughout, both printed on a relief press and thus leaving a discernable physical trace of the letter type. The whole book imparts its importance as a physical and aesthetic construction.

In the book, the artist's mother, Pauline, narrates her own life story, told through recollections associated with cooking. These recollections are interwoven with her favorite recipes and with half-toned photographs, which a reader presumes to be of Pauline, taken during her childhood at a time close to the book's creation. One of the photographs shows Pauline, dressed in a military uniform of the 1940s, holding up a string of cut-out paper dolls, their physical simplicity a precursor of the sensibility carried into Melhorn-Boe's books (other books by Melhorn-Boe are shaped around the form of such cut-out dolls).

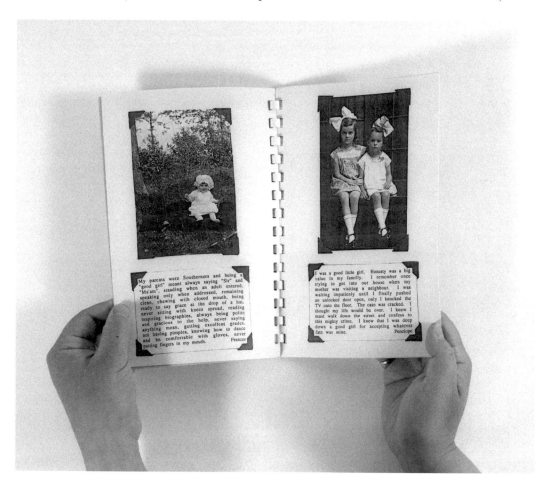

in side by side containers; Aunt Nan had put nearly a cup of salt in each! Getting rid of the evidence so her crabby mother wouldn't see them was next to impossible. We tried burning them in a little old iron stove - we just had enormous clumps of large crystals, which we dragged out to the garden, and covered with earth and tears.

Where we lived, the local cooks fried out pork scraps and poured them over codfish, yellow butter beans, dandelion greens, green beans - anything. Oatmeal porridge for all I know!

We never ate spaghetti or macaroni - in fact my mother had a kind of grudge against cheese. I had to grow up and go out into the world for that. All I can remember are little boxes of Velveeta.

I also had never eaten a green pepper or a fresh mushroom until I hit the big-time. Once I experimented with a flaked-fish and nutmeg dish; my

father was incensed. Had I lost my mind? Nutmeg belonged in apple pie and nowhere else. What was wrong with salt, pepper, and butter?

My mother was more innovative, and often made up things, like a prune pie and a grapenut custard.

I went into the airforce where I met people from every country. I always figured asking them about food was the best way to learn about them. My room-mate Lily, a Ukrainian girl, managed to get the camp kitchen one night to show me how to make pirogies. My first international cooking.

Like many veterans, after the war I went to university, where I enrolled in Household Economics as I thought this would give me a chance to be creative. Little did I know about the chemistry (failure), math (do-overs) and biology. Two years - but I did learn from Clarabel O'Blenes all there was to

More Than a Steamed Fish Recipe

One summer while at Metis Beach, on the south shore of the St. Lawrence River, one of our men arrived at the door one evening with a large freshly caught cod. We had a German cook then; I cleaned the fish and Minni placed it on a rack in a large pan with about 1 inch of water; slathered it with butter, salt, pepper and lots of lemon juice. She covered it and put it in the oven. The resulting self-made sauce was ambrosial, and I have done my salmon this way ever since. I well recall once when we'd planned to serve a lovely fresh Gaspesian salmon, when someone rushed into the kitchen yelling, "My God. Pat Dooley has covered his potatoes with the fish sauce!" It was to have done for ten people!

Lesson: Don't put the sauce on before the main dish.

Beef Stew Recipe

Flour 2 1/2 lb. of stewing beef (shank)
Brown in butter and oil: put in a heavy dish,
Saute lightly chopped onion. Add to beef.
Pour 3/4 bottle of beer over.
Add chervil, cumin seed, and bayleaf.
Cook at 350° F for several hours.
Thicken gravy.
Serve over noodles or with good bread and salad.

Corn, Rice, and Beef Casserole Recipe

This was designed for three hungry girls.
Cook 1 c. rice.
Brown 1 lb. of ground beef.
Combine beef with 1 can of corn.
Add salt, pepper, and a touch of basil.
Pop it all into a covered dish.
Top with a bit of butter.
Put in oven at 350o for 20 min.

The girls always wolfed this down; but Kurt was very insulting: he called it a depression dish.

Family Album (1994) presents the childhood recollections of a number of women, each recollection a small typed text situated below a childhood photograph, seemingly depicting women presenting their stories. A short text at the end of the book, presented, like the others, in photo-corners, complicates the straightforward appearance of Melhorn-Boe's work by informing the reader that the photographs are all from Melhorn-Boe's own extended family and, therefore, are not necessarily of the women whose stories are being told. The reader is left to wonder whether the photographs are simply an arbitrary selection or whether this is a more complex narrative that does not reveal all of the artist's secrets. Such excerpted narratives are carried into more spatially constructed, three-dimensional bookworks; such works as Melhorn-Boe's *Sad Little Girl* (1995), where the string of paper dolls pictured in *Light and Flaky* becomes a cabinet-like construction; or *Come Into My Parlour* (1986), where the work's fan-like construction allows for a number of women to relay their experiences about beauty parlours and barber shops:

When I was 3 or 4, my grandmother took me to a barber. He thought I was a boy so gave me a boy's haircut. My grandmother felt very badly & was sure my mother would be upset. I thought it was something of a joke and hid behind a chair when my mother arrived, hoping to surprise her with maximum dramatic effect! (1)

I feel WONDERFUL! I could easily be one of those women who gets her hair done once a week.

I've never got into the expensive line of conditioners and shampoos that hairdressers flog. As a result, my hair can be below Farrah Fawcett standards. Once, when having my hair trimmed in Montreal, the hairdresser said, "your hair is sick." (2)

The colloquial presence of the women's stories, and the pink perm rod that keeps the work together, maintain a direct link to material, vernacular culture. Once unsnapped, and the fan unfolded, the fragmentary stories function in the same manner as those in *Photo Album*, that is, metonymically, as a way to raise questions about the social codes impressed upon young girls. The work is also interested in recording the range of individual responses to those social codes.

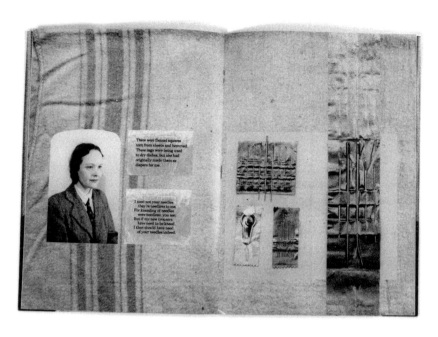

The Mixing of Vernacular Voices: Corrine Corry

Two artists' books by Corrine Corry test the boundaries between vernacular expression and the realm of high art culture. In *The Palace of the Queen* (1987) Corry creates a bookwork that, like Lise Melhorn-Boe's, pulls together family photographs with such ephemera as a sewing kit, notes from fortune cookies, ticket stubs, etc. These are brought together in a poetic reflection upon the passing of the artist's mother and the way in which a woman's identity is passed from generation to generation. *Letters to Dad* presents a counter-sensibility, one that is less celebratory of familial relations and, instead, places the artist's relationship with her father within a series of reflections upon memory, perception, and psychoanalytic therapy.

Enclosed inside *The Palace of The Queen* are two photographs, in the format of a postcard with rounded corners. More specifically, these are each lenticular images, like those postcards that are divided by vertical striations and which, depending upon how the card is held, display one of two different views. These two images combine the vernacular form of the lenticular postcard with studio portraits, perhaps of the sort that would have been taken upon graduation from a school or college. These are black-and-white images that a viewer takes to be a merging of Corrine Corry and

her mother in corresponding stages of their lives, the two images held in suspension. In looking at these images, in turning them slowly from side to side, the viewer is provided with an experience similar to that of looking at a daguerreotype portrait of the mid-nineteenth century. As with these images, the subject of a daguerreotype portrait seemingly vanishes as the image is turned sideways, the viewer's own reflection appearing as a substitute image on the mirror-like surface of the silvered copper plate.

In a bookwork otherwise formatted and printed in an exhibition catalogue style, the artist has appended an original handwritten note. This note, situating notions of material wealth against the more personal inheritances of a family, provides an authentic vernacular moment that serves to bridge the gap that exists between the artistic culture (in which forms such as the exhibition catalogue belong) and those snapshots, notebooks, and other traces of daily life.

The later *Letters to Dad* is presented as two acts of a play: Act I, "The Deceitful Daughter," and Act II, "Caustic Junctions." Though the idea of a theatre program is the pretext for this work, the form invoked here is one closer to pages from a scientific journal, with graphic images of human perception—including the idea of images seen obliquely in a "caustic curve,"—and a layout style that is reminiscent of journals of scientific inquiry. Such additions as family photographs and, in "Act II," a handwritten note, interrupt this graphic look.

In "Act I," Corry notes that "Family photographs have been a part of my life, a story I have understood since I was a child. They speak of intimate moments and of celebrations. But there are other stories" (6). These other stories speak to the darker side of her family, to questions surrounding a father's relationship with his daughter, questions of incest. The personal photos and dialogue provide a foil for excerpts from scientific and psychoanalytic texts. In this mixing of texts, questions of perception and the process of reading become central. The narrative gesture is reminiscent of *The Handmaid's Tale*, where the narrator's uncertain memory invites reader participation: "People have memories of me which are not the same as my own, and I have invented so many stories about my past, and my future, that I no longer know if I still have a true memory" (10). Principles of uncertainty are reaffirmed by excerpts taken from such

looking at the sky through the leaves.

Being under wooden stairs with a friend and looking up at the light coming through the cracks.

Light skips across the water, momentary points of burning light. I change my mind.

Grandma tells me to go to sleep on the bus, but I can't. She tells me to make my mind blank. Maybe she describes a long black tunnel. I imagine and go to sleep. I vividly remember entering that blackness.

Light ripples in netted flashes. A web flowing across the surface and touching the bottom, reflecting itself upon the rocks without being visible within the body of the water.

My sister remembers that she had a dog when she was very young, or she used to remember that. She did not have a dog.

Glass casts no visible shadow.

out of the car and cried. I watched a leaf fall and cried. I opened a book and cried. I washed my hands and cried. I folded the laundry and cried. I never

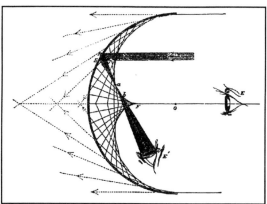

All rays reflected in a section of a concave mirror touch what is called a *caustic curve*. The brightest and most distinct image is formed at the cusp of the curve *(F)*, when seen by an eye *(E)* on the principle axis. In the case of images seen obliquely, there is always some blurring. This is because the point of contact with the *caustic surface* is not the same for all rays entering different parts of the pupil of the eye. – modified from *A Textbook of Heat, Sound, and Light*, J.D. Everett.

used to cry before. Now my face is always wet and MY BODY ACHES.

ously seen and not seer on 'getting there'.

But surely they were state of distr; silent packaج secreted witl are readily r controlling p which binds i

Can you tel: from the sw attend to the

She was fo A little girl v tom, sitting in a dirty, ui room. Afrai fear that she least disappє thing happ other room? ¹ ber."

Don't listen. I Is someone lc Who?

Your power i; hear. Don't see.
Your power is obliviousі

authoritative texts as Gillian Cohen's *Memory in the Real World*, Muriam Dimen's *Power, Sexuality and Intimacy*, and Monte Davis's *Catastrophe Theory*. Corry is, however, careful to select passages that will remain elusive rather than fixed, offering no firm recipe for reading:

> As I watch the water splash against the rocks, or if I even take a photograph of the splashing, I know that I can see much more than I can say. As I watch my mind shifting across these words, recalling memories too numerous to retell, following those which bring me nearer to myself, I know that I am losing many important moments. Touching a pattern more complex than I can articulate. (From Cohen's *Memory*, qtd. in *Letters* 10)

These moments of "caustic junction," moments that Davis says "are formed where several bright lines of light come together, as they do in the rippling network sparkling across the side of [a] clinker-built boat" (qtd. in *Letters* 10) are, for Corry, the coming together of personal and theoretical inquiry. Just as she turns to the realm of academic culture to understand her own past, she affirms that all such methods of inquiry are rooted in personal and ephemeral experience. Her understanding of perception, like her artist's books, always present a double vision:

> I do not look directly at myself as I look at you, as you can look at yourself. (I use a mirror to see my genitals.) I operate with a double vision, but I know that my life is lived at the edges of these optics, in the blurred ring between the two. (11)

Fred Wah's *Limestone Lakes Utaniki*

Fred Wah's "Utaniki" (or "poetic diary") references such travellers' journals as *Basho's Journey to the North Provinces*. A collaborative work, written by Wah but designed by Peter Bartl, *Limestone Lakes Utaniki* records seven days of hiking, observing, photographing, getting lost, and writing poetry—all in seven separate text and colour Xerox foldouts, reminding the reader of "the maps folded up" in the speaker's pack. Wah plays off the vernacular voice of diary observations against the more overtly aesthetic, high art presentation style of his poems (which lend a kind of formal punctuation to an otherwise casual prose narrative). The modular construction echoes the index card arrangement of Lippard's 955,000.

Notes

1 Personal interview with Donald Lawrence, in which Snow says, "Besides narrative I have basically been opposed to autobiography"; he goes on to say that works such as *Venetian Blind* and *Authorization* are "precisely a turn against my depiction."

Thawing the Frozen Image/Word: Vernacular Postmodern Aesthetics

7

In this chapter we seek to define an emerging postmodern aesthetic, one tied to notions of language's material presence, through an exploration of the frozen words trope. Using Canadian pictorial art as a general foil, we focus on how Canadian postmodernist writer Robert Kroetsch engages in a vernacular interrogation of visual/verbal boundaries.

Fixity and Flux: The Frozen Words Trope

In a postmodern climate, one of the most tabooed concepts would seem to be stasis, in conjunction with notions of containment. As such it is not difficult to see why postmodern writers have a curious love/hate relationship with the image: insofar as the image is regarded as an example of fixity and arrested time, it becomes the mode of representation most to be avoided; yet insofar as the notion of containment pertains to disciplinary boundaries, then enlisting the image in mixed-media compositions would seem to be the best way of blurring or otherwise resisting such constraints. Of course, what also comes into play here is the status of the written word itself: does it belong on the side of the visual mode of representation, or on the side of the oral and the unfixed or fluid?

Significantly, in articulating this dilemma, postmodern critics, authors, and artists have not only inadvertently pointed to what may constitute a way out of this bind, but in the process have also resurrected an old trope for describing it. Thus in describing the double bind that affects much recent postmodern literary expression, Steve McCaffrey observes: "Classical discourse is our inheritance; lodged within the bastions of grammar, it represses all manifestations of libido within rigid vessels of content, *freezing energy into representation*" (94, emphasis ours). The trope, in short, is that of the "frozen words," a graphic metaphor of fixity and flux that dates back to Plutarch and has long informed vernacular, visual, and, more recently, literary notions of language's inability to freeze permanently our lived experience. Plutarch first introduced the notion of frozen words in his discussion of "hearing," where he

"It must have been, look, here's a picture, a snapshot. The snapshot, hinting of artlessness, asserting against art the reality of reality."

"Bowering: the poem become notation. Kiyooka: the book become book....The poet, then, not as maker, but as bookmaker." *Robert Kroetsch—The Lovely Treachery of Words.*

The Laocoön Group, 1st Century.
Roman copy, perhaps after
Agesander, Athenodorus, and
Polydorus of Rhodes. Vatican
Museums, Vatican State. Reproduced
courtesy of Scala Art Resource.

describes a city so cold that "words were congealed as soon as spoken"; after some time, when the weather changed, the words "thawed and became audible" (Bartlett 137). The trope marks one of the first recorded examples of "graphic materiality" (McCaffery 99), of language's potential material presence; later it became a staple European conceit, quoted by Joseph Addison, where he attributed it to *Mandeville's Travels*, and echoing variously throughout the written texts of Castiglione (155), Rabelais, Baron Munchausen, Samuel Butler, John Donne (cit. in Grey's annotations, *Hudibras*), and collections of coffee-house jokes, such as Captain William Hicks's *Coffee-House Jests*. More commonly, though, the trope is associated with a vernacular tradition of oral tales and jokes told in and about the extremes of northern weather (see Thompson; Baughman; Fowke & Carpenter).

What differentiates the frozen words trope from such high art notions as G.E. Lessing's "pregnant moment" (9) in sculpture or Henri Cartier-Bresson's "decisive moment" (385) in photography or Diderot's "perfect instant" in painting (qtd. in Burgin 19), is the emphasis on orality and flow: unlike the arrested moment's focus on visual stasis, the frozen word *embodies* the visual, the literate, and the oral in a form where meaning is located not in the moment but in the moment's release. If words can freeze like water, then, under the right conditions, they can also flow like water; and, not surprisingly, the resulting rhetoric of water, word, image, and oral flow suggests a potent postmodern formula for dislocating the written word from the page and reconceptualizing the perceived stasis of the image.

By reason of climate and geography, the Canadian literary and visual arts scene has been especially involved in the use of northern tropes and interarts strategies. Early modernist authors and painters, from Frederick Philip Grove to Lawren Harris, draw upon images of frozen water and the myth of the North to articulate a vision where arrested motion—physical, social, and psychological—becomes a recurrent thematic refrain. For many recent artists, however, images of northern purity and stasis no longer carry the same appeal. Postmodernists like Robert Kroetsch, Fred Douglas, Roy Kiyooka, Murray Favro, and Liz Magor, for instance, seek instead to animate both image and text (via multi-media installations and PhotoGraphic constructions), all the while playing off and critiquing the established modernist paradigm of the arrested moment. In this context, Kroetsch's work has been singled out for its "ambivalence" toward the mixing of word and image, for "the refusal to pick sides, the desire to be on both sides of any border, deriving energy from the continual crossing" (Hutcheon 162).

It is this "continual crossing" that locates his practice within the context of recent movements in Canadian visual art; and it is with reference to this context that we can best understand what could be called an emerging postmodern aesthetic, one that conjoins the material presence of language with both the arrested moment of visual representation and the flow of vernacular expression.

In this chapter, therefore, we will begin by outlining the issues informing such an interarts context through an examination of Kroetsch's debt to visual arts theory and practice; then turning to the surrounding visual arts scene, we will consider how artists' photographs, sketchbooks, and journals variously interrupt and critique the visual privileging of the arrested moment. This vernacular critique, we argue, becomes more deliberate in those postmodern constructions that merge image and text, enacting in a tactile sense the interplay of stasis and motion described by the frozen words trope. In the concluding sections of the chapter we return to notions of narrative and flow, this time by way of the tall tale in general, and the notion of words (and images) freezing and thawing in particular. Here we highlight Kroetsch's 1978 experimental novel, *What the Crow Said*, as a key narrative document for explicating the dynamics involved in animating "frozen" representational forms.

Robert Kroetsch, *Breakup at Mills Lake* (1949). Reproduced courtesy of the author.

Picture-Space

Kroetsch, like many other postmodern writers, is clearly attracted to the narrative potential of photography, as illustrated in the series of personal snapshots that accompany his first collection of critical essays. The vernacular mode of self-representation, evidenced in the photo of Kroetsch standing atop an ice jam, carries over into his written work. Like oral storytelling, photography hints at an *ostensibly* artless, certainly vernacular, mode of expression—a corrective to the high art, Old World aesthetic that Robert Kroetsch and other postmodern artists have so frequently criticized (see chapters 1 and 3). For Kroetsch, the photograph, especially the snapshot, is part of what he calls the "great-given," the flow of vernacular culture, the "particulars of place" that the writer may draw upon: "newspaper files, place names, shoe boxes full of old photographs, tall tales, diaries, journals, tipi rings, weather reports, business ledgers, voting records—...archaeological deposits" (*Lovely Treachery* 7). These are the tokens of lived experience; personally invested, these forms of vernacular expression stand apart from the words and images of mass, popular, and high art cultures.

"The scrapbook becomes a model. A paradigm. It tells us how to organize ourselves. It tells us how to think about what we are." *Kroetsch—A Likely Story.*

Conceptually, the photograph provides a trace or token of personal experience: a trigger for the memory, a visual citation that leads out from the written word. Aesthetically, as E.D. Blodgett argues, Kroetsch has long been interested in the physical nature of his craft, "in the integrative arrangement of texts on the page: the page, by becoming a picture-space, immediately makes of history, memoir, and the play of origin a static activity in the temporal sense" (201).

But more needs to be said about Kroetsch's aesthetics of picture-space and its potential to animate, rather than freeze, representation. In the visual arts an understanding of the picture space has, in recent decades, merged with notions of space in sculpture and installation. Contemporary artists have sought to situate the photographic image, for example, within a variety of physical environments, which, like the artists' book or any other image/text construction, serve to complicate the photograph's status as artifact and illusion. Thus, to appreciate fully the pictorial aspects and implications of Kroetsch's work, we need a complementary narrative of the visual vernacular in Canadian art.

Much of Kroetsch's writing gestures toward interarts practice. "When I am writing," he says, "I often think of novels visually....I get a sense of the visual presence of a chapter kind of thing. In my own work I've liked non-literary verbal things, like newspapers.... Or I used *The Ledger*, I used the *Seed Catalogue*: those are models which I was taking from around me, but they all stayed pretty close to language" (*Labyrinths* 166). One can hear the note of ambivalence in his disclaimer "but they all stayed pretty close to language." Still, that closeness to language has not stopped him from experimenting with the picture-space of the artists' book. One thinks, as Kroetsch points out, of the first edition of *The Seed Catalogue*, where the long poem is literally written over images of reproductions from two *McKenzie's Seeds* catalogues (dated 1916 and 1922); or of the other long poem he references, *The Ledger*, where, in the original Applegarth Follies edition, Kroetsch incorporates a period map of his grandfather's Ontario home (taken from an 1880 illustrated atlas). Over the top of the map Kroetsch inscribes by hand both a circle around Kieffer, Ontario and the words "Yes, that's the place. RK." Kieffer, then, is identified through word and image; and even the gesture of circling "Kieffer" and underlining the word "place" seems to carry a sense of collaboration among visual sign (the map), signature ("RK"), and word ("place"/Kieffer").

Elsewhere, however, Kroetsch has invoked the idea of the visual image not as a complementary means of documenting place and

Robert Kroetsch, *Revisions of Letters Already Sent* (1991). Reproduced courtesy of the author.

lived experience, but as an element of iconicity or picture-space to be transcended. For, as Smaro Kamboureli rightly points out, "whereas the reality of the poet's origins is re-enacted by what Blodgett calls the 'picture-space,' the awareness Blodgett describes is not necessarily static. Kroetsch's 'dream of origins' is fundamentally a dream of motion, a dream of dream-as-desire defined by dislocation" (106). Kroetsch himself has been highly critical of those literary authors who insert photographs simply to balance off the text, achieving only "equilibrium or stasis" (*Labyrinths* 126). Static representation is, as we have noted, anathema to Kroetsch; and insofar as visual images fix viewer/reader attention on the page, introduce a false sense of balance, or otherwise interrupt the dream of motion and dislocation, they become elements to be distrusted and avoided. Such distrust or, more precisely, ambivalence, goes to the heart of what Kroetsch has defined as the prevailing postmodern "Canadian poetics," one that depends upon "a use of and a distrust of communal kinds of language" (155). The visual vernacular too is something to be distrusted and used, for whatever its potential to arrest narrative motion, the visual also holds the potential to "thaw" words seemingly frozen on the page.

One little-known work, *Revisions of Letters Already Sent*, for example, plays off the notion of the "letter" as both linguistic symbol and mode of correspondence. Published first as a long poem and, then, as a form of mail art, printed and re-presented in an

envelope (replete with Kroetsch's face as stamp in the top right corner), *Revisions* offers a visual and verbal model of letters (or, in this case, "a letter") in motion. Kroetsch not only literally revises and extends a poem published in two installments (and in conventional form) a year earlier; he reconceptualizes the work, emphasizing its material form by creating, in collaboration with the artists at disOrientation chapbooks, a kind of physical pun. As Martin Kuester notes of "The Stone Hammer Poem," Kroetsch's work "is admirable not only as a poem but also as a structural model of how historical myths [and stories generally] are constructed, the stone hammer becoming an object" (27). In his collaborative reworking of an earlier poem, and in the accompanying copyright notice appended to *Letters*, Kroetsch establishes a record of the work's construction and reconstruction. The transformation from conventional publication to the picture-space of an artist's book both alludes to and makes room for the artistic text as dynamic artifact.

Similarly, the 1979 long poem *The Sad Phoenician*, a series of twenty-six set pieces, offers another dream of language in motion, of language in this case carried away on water, in the holds of ships. Punctuated by visual representations of the Phoenician alphabet (and interleaved with degraded English text), the long poem asserts,

> It was the Phoenicians who moved writing from the
> temple, down to the wharf. Not, I'll make you a god;
> rather, I'll make you a deal.
> They wrote down the sound, not the picture. That
> was the astonishing thing. They wrote down the
> sound. They freed the reader from the wall.
> Fenollosa and Pound were mistaken when they
> praised the ideograph and returned us to the arrested image.
> The Phoenicians—they'd heard that one
> before. Hey, they said, the ship is leaving. . . .
> The poem as hubbub. Freed from picture, into the
> pattern and tumble of sound. Poetry as commotion:
> a condition of civil unrest. Now listen here.
> The poet, not as priest, but as lover. (qtd. from back cover)

Here Kroetsch directly addresses the notion of freeing voice from hieroglyph, the word from the page. Like the frozen word thawing and entering into daily discourse, the printed image and text are said to be freed "into the pattern and tumble of sound." Kroetsch's work claims for writing the give and take of oral conversation: "hubbub," "commotion," and "civil unrest"—a vernacular space

Robert Kroetsch, *The Sad Phoenician* (1979). Reproduced courtesy of the author.

where image and text, viewer and reader, are "freed…from the wall" of arrested convention. He uses a folk art form to represent and interrogate high art theory. On the one hand, he represents his notion of writing as a contest between sound and picture, animating the printed word via allusion to oral discourse and visual quotation of the Phoenician alphabet. On the other hand, he uses actual visual tokens (the Phoenician letters taking on the status of illustrations) to represent his story of freeing word from picture. What we see here is Kroetsch's continuing, if ambivalent, fascination with visual representation. That is, while his work echoes a commonplace literary distrust of the visual, it nonetheless invokes the visual as a necessary reference and presence both within and without the text. Kroetsch's "ambivalance," his distrust and use of all aspects of communal discourse, asks that his works be read in a broad semiotic context, one that places him in the company of other artists who have also sought to expand the picture-space beyond the page—other artists exploring the physical and conceptual boundaries of material form.

Kroetsch has been very precise about his debt to visual arts practices, especially in his comments on collage and the scrapbook as compositional strategies. "Collage," he says, "has been a major technique in the art of the twentieth century. The great modernist artists—Picasso is one of many—discovered that by cutting pieces out of newspapers and pasting them into their paintings they could at once reflect their contemporary worlds, explore the arbitrariness

N.E. THING CO., *Reflected Landscape* (c. 1968). Reproduced courtesy of Ian Baxter, Art Gallery of Ontario, Toronto.

of those worlds, and make statements about the possibilities of the future" (*Likely Story* 132). What intrigues Kroetsch is how the process of finding, juxtaposing and layering emphasizes both the aleatory moment of creative discovery and the shaping consciousness of the author. He identifies the scrapbook as the particular collage form employed in his own writing: "We gather scraps together to make a scrapbook, and in the process we explore one of the ways in which we make meaning in the twentieth century" (135). "The scrapbook," he says, "becomes a model. A paradigm. It tells us how to organize ourselves. It tells us how to think about what we are" (146).

The "scrap" may be found in the form of "small moments that come to have a great significance" (133); or in the form of nearly sixty years of photographs interspersed throughout Kroetsch's first collection of essays (in the 1983 special issue of *Open Letter*, one of three that the journal has devoted to Kroetsch's work); or in a repeated phrase or image or action or motif. "There is also in the scrapbook," as Kroetsch explains, " the notion of the interrupted story, or, more significantly, the digression" (146). Digression here is both temporal and spatial, a rhetoric of delay that postpones any arrival at final meaning and thus keeps the story in motion—open-ended, not pinned down. As in collage composition, he is interested in "placing stories or images side by side in such a way that they suggest a possible meaning without insisting on it" (146). Such

placement encourages digression and indicates to the reader "what is being left out in order to make the story hang together" (146). Again, this is an interest he shares with his contemporaries; and one senses from Kroetsch's frequent essays on fellow writers and artists that his own notions of scrapbook composition have been worked out in conscious dialogue with others.

George Bowering, the subject of much Kroetschian commentary, explains how the logic of interruption informs his own work. Bowering notes that nearly all his books contain what he calls "a baffle." A "baffle" implies the interposition of obstacles, as in a plate or screen, or some other contrivance, that regulates or redirects the flow of liquid. "I always set up certain restraints or something," says Bowering, "as for instance in *Harry's Fragments*, in which I follow Heraclitus's fragments in order, and in which I have to write a scene that takes place in the city I was in that day of writing. Or the short story about a guy breaking the ten commandments in order. Or the alphabet-based books, etc." (*Canliterati* 19 Jan.). The baffle may also come by way of an obscure or tricky reference designed to interrupt the flow of reading, at least for the informed reader: "I like to write arcane things that few readers will twig to. I am always delighted when some critic gets something that the others have been too quick [to see] going by" (*Canliterati* 11 Jan.)—a form of citation that is difficult to see. For the aware critic, the arcane reference, once identified, functions as a baffle that redirects the flow of narrative beyond the page. These baffles, of course, need not all be textual; the photograph, as metaphor and artifact, likewise works to redirect and complicate the narrative.

It is important to remember that photography can be seen as both frozen moment *and* as an invitation to narrative. Consider the work of the west coast arts collective N.E. THING CO. Their series of reflected landscapes, first exhibited in the late 1960s, depicts the 2,500,000 gallon flow of the Seymour River, dutifully documenting that flow in the form of photographs, diagrams, charts, and written texts. The exhibit, a form of documentary collage, suggests the scrapbook aesthetic articulated by Kroetsch. A key photographic image from that exhibit, *Reflected Landscape*, 1968, by Iain Baxter, offers an intriguing *mise en abîme*: in the middle of the large photo transparency depicting the water rushing over slippery rocks sits a mirror, which in turn reflects an image of the nearby river bank. The reflected image provides an interrupting gesture, a kind of still life that, balanced precariously in the midst of the flow, freezes the scene, framing it—if only momentarily—in the manner of European landscape painting. The reflected image alludes to a reality and a set of representational

Detail of *Reflected Landscape*.

strategies beyond the frame of Baxter's photograph. Ironically, we are reminded that neither image of the surrounding flow nor the frozen image captures the actual flow of the Seymour; instead, the framed reflection sidesteps or, to use Sherrill Grace's term, "side-cites" (17) the immediate scene—alluding as it does to the river bank, to the edges where land and water meet. In the process of responding to the work, we recognize "that the photograph is bogus too, that it is a substitute, a mere 'reflection' of nature caught in the mirror of the camera's eye" (Knight 30). These key elements of stasis and motion, frozen moment and flow, find their literary counterpart in a work like Kroetsch's *Badlands*, a novel with two narrative streams and where the photographic moment is included as part of an overall aesthetics of interruption and "side-citing."

Kroetsch says that in writing *Badlands* he was thinking "physically" in terms of piecing together archaeological fragments: "it's no accident that I wrote *Badlands*.…I like the sense of fragment and what the fragment does—the demands fragment makes on us for shaping, for telling, for imagining" (*Labyrinths* 167). Photography becomes a metaphor for displacement and fragmentation. In Chapter 22 of *Badlands*, in the middle of the novel, we are introduced to the photographer Sinnott sitting in his portable darkroom, "a remodelled Model-T, motionless in the middle of the river." Like Baxter's reflected landscape, the floating car presents a dislocating moment in the narrative, for, clearly, cars do not belong in rivers; and if they do end up in rivers, they should either sink or float—but they should not come to "a standstill in the middle.…" The motionless "Model-T," (another "letter" arrested) symbolizes the photographer's desire to make "T"ime stand still in what he regards as a world where "Everything is vanishing" (112). For William Dawe, the paleontologist, Sinnott's dream of preserving the moment runs contrary to his conviction that "Nothing vanishes. Everything goes on" (117). Throughout the novel this opposition between transience and permanence, motion and stasis, establishes a creative tension or "baffle." The resulting perceptual confusion and deception—suggested by Sinnott's observation that he and Dawe "are both charlatans" (119)—informs the images invoked.

Sinnott remains either in motion or motionless, depending on the point of view: "He was moving his camera, then standing still, his head under the focussing cloth; and he was trying to get a good picture of the figure that was galloping and yet standing still too, in relation to the boat" (120). The visual paradox continues when another character, Web, is described as engaged in an "enduring chase, chasing that which was not ahead of him but beside him,

behind him, glancing back to see if he could catch up" (121). What is being described here is narrative—the ebb and flow and redirection of narrative that evades the constraints of time and place, that allows Anna Dawe, one of the novel's two narrators, to have "followed her guide so bravely she had preceded him to his goal" (148). For the characters, the Badlands become a baffling landscape, where "the muted and failed sky let down across them, across the water, a silence they could see" (133).

The desire to move from silent moment to narrative motion must be seen as central to Kroetsch's art. Kroetsch himself says that this insight came to him early in life—in one of those scrapbook moments "that come to have a great significance"—on a winter's day in Heisler, Alberta.

Robert Kroetsch, family photograph taken in Heisler, Alberta (1934). Reproduced courtesy of the author.

Stasis, Flow, and the Vernacular

In his recent collection of autobiographical essays entitled *A Likely Story*, Kroetsch offers a verbal snapshot of the moment he became a writer, a moment when, as a young boy, he reached his hand into a holy water font at Wanda church. Like his characters who begin to visualize "silence" across the Badlands river, Kroetsch's personal insights and moments of silent reflection are often linked to images of water. Water, especially the rapids and the tributary rivers of the North, has always been closely allied to writing for Kroetsch. When negotiating the Providence Rapids with Vital Bonnet Rouge, a near-blind river-boat pilot, Kroetsch becomes the pilot's eyes and learns to read the landscape "as if [his] life depended on it." He learns to read the river as "a shifting narrative of itself"; and swept up and "into that narrative…once there, once…inevitably and unavoidably there," he finds himself compelled "to write the narrative, too" (*Likely Story* 39). In the Wanda church a younger Kroetsch learns something about the limitations and possibilities of narrative. As Kroetsch recalls, Father Martin would regularly bless the holy water: "I had learned that holy water was well water that had been transformed by a ritual blessing. It had been transformed by the priest's words. Words were all the priest had to work with, except for a minimal motion of his right hand, raised in a gesture that I might now see as writerly" (47).

Given the extreme cold, the Father's breath freezes as he speaks (57), and at the end of mass on a particularly cold prairie morning, "Bobbie" Kroetsch dips his fingers into the font mounted on a tall pedestal, only to discover that "the holy water [is] frozen." He is thrown into a crisis of belief:

In that instant, at an age which I cannot now reconstruct, I was launched into a crisis of belief from which I have probably never recovered. I could not see into the font. But I discovered the contents of that marble basin as a reach of unshimmering ice, a sloughlike landscape of scorching cold, a typological forecast of the frozen lake I would find, years later, at the end of Dante's luminous protrayal of the Inferno. (58)

The priest, we are told, "had not succeeded in transforming the ordinariness of the water in that font" (59). The "Word" frozen presents a silent symbolic rejection of the priest's authority. Ironically, the failure to transform the ordinary inspires a new faith, one not based upon the ritual imposition of words on water, but upon a sudden sense that old ways of seeing and speaking are not enough—that imported "truths" do not have authority over the everyday. As Kroetsch writes elsewhere, "The meta-narratives—religious, artistic, social, economic—do not hold. Even the great European meta-narrative about 'nature' does not hold here, as nature turns into wind and moving dust and an unreachable horizon" (*Lovely Treachery* 25). For the little boy in the church, the unreachable horizon becomes the frozen holy water in a raised font; for the adult writer, each act of writing involves a rehearsal of that watershed moment:

> When I set out to write a story or a poem...I approach again the door and exit, there in the biting cold of a prairie winter morning, in the Wanda church. I am a small boy, in a brand-new overcoat that marks and embarrasses me as a privileged child, and I reach one hand over my head, beyond my line of vision, toward the water in the font— toward that open mouth of water.

Writing requires a different kind of belief, a "mixture of knowledge and self-deception and innocence" that inspires Kroetsch to reach out, to find himself again surprised "into the impossibility of words—by the perfect and beautiful ordinariness of water" (*Likely Story* 64).

Kroetsch's story of the frozen font, which he casts as part confession, part "manifesto" (64), offers a wonderfully articulate counterpoint to the key modernist trope of that other water image, the "great river"—the St. Lawrence. According to W.H. New, the "Great-River Theory" reflects a European cast of mind, where "the 'natural' character of power relationships was seemingly confirmed

On history seen through the lens of the picturesque:

"When one looks back through such picturing, the situation seems to have been stable and harmonious. It is an inevitable illusion of a kind of recollection. From the perspective I'm taking, it can be seen that chaos had occurred before anyone could recognize it, long before anyone could recognize it."

Fred Douglas—in a footnote to "The Bewildered." Excerpts from Cars, Clothes, Houses and Weather Conditions.

PhotoGraphic Encounters

by an appeal to conventional images" (162) such as the great river and its associated tributaries. In Canada, New explains, historians like Donald Creighton and novelists like Hugh MacLennan invested the St. Lawrence "with a theory of landscape that they inherited from the past, one that they only partly adapted to local circumstances" (165). According to the "Laurentian Thesis," Upper Canada's great river established Ontario as a place of cultural centrality:

> The Upper Canada Loyalists occupied the land's edge as much as the coastal dwellers and the Lower Canada riversiders did—they even saw the Great Lakes as seas—but in their metropolitan minds, they occupied the *centre*, the *heart*. Having wrested control of the great river from French Montreal, they acknowledged the enormous Western river basins only as a periphery to their own. (New 168)

The extent to which the Laurentian Thesis imposed a cultural frame that effectively froze out the rest of Canada was (and is), of course, a matter of degree. For the dominant culture, stasis, the status quo, is generally preferable; and, not surprisingly, the aesthetics most closely allied with such a culture tend to privilege familiar images of sublime grandeur—of nature in harmony, of time at rest. We should be wary, however, of reading too much into a single, if highly influential, "thesis." Within the Canadian visual arts, for example, the Laurentian Thesis can be employed as a basis for examining a number of interwoven traditions, particularly with respect to formative developments in landscape representation. However, such an examination must not rest solely on the premise of a single imported (European) aesthetic being adapted to local circumstances: no single European tradition may account for all the stylistic and thematic developments in colonial and modernist painting—a fact complicated by the advent of photography, which threw the very basis of pictorial representation into question.

Before considering such complications, though, it is useful to examine the the Great River Theory as it relates to what have become the central figures of the Canadian landscape tradition: Tom Thomson and the Group of Seven. Roald Nasgaard has argued convincingly in *The Mystic North* that the paintings of Thomson and the Group were strongly linked to the expressive painting movements of central Europe, and to the Symbolist movement of northern Europe—as well as to some lingering aspects of 19th-century academicism (e.g., neoclassical notions of

"I'm fascinated by the content where we are literally in a new world telling ourselves about it, making each other up, inventing each other in this new world. We have this remarkable, beautiful body of material but I don't think the forms have yet emerged as anything very useful.... In fact, the oral form is often what I'm now calling *extended anecdote*. I have to go back and rehear Alberta in a quite different way." *Kroetsch—Labyrinths of Voice.*

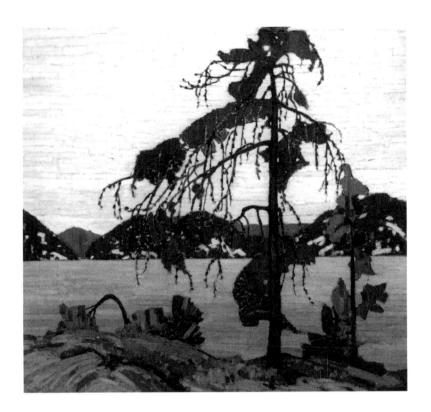

Tom Thomson, *The Jack Pine* (c. 1916-1917). National Gallery of Canada, Ottawa.

form and beauty). Nasgaard's contextualization of Thomson and the Group's paintings as a matter of movements (rather than a single movement) offers an antidote to the almost mythical status with which they are imbued in most conventional accounts. As Scott Watson notes, even Thomson's death by drowning in 1917 has accumulated a "Wagnerian" hue, one that has certainly affected the critical reception of the paintings—as in this account of "Petawawa Gorges":

> Magnificently unified, subtle and totally free of any "showmanship," it is in its depiction of the annual rebirth of the river perhaps the most profound picture painted by any of the [Group] until after the war. Probably even more than those almost sacred icons, "The West Wind" and "The Jack Pine," "Petawawa Gorges" is the measure of our loss. For when Thomson drowned in Canoe Lake in July 1917 he was unquestionably approaching the fullness of his powers. (Reid 145)

Like Watson, other recent critics such as Marcia Crosby and Matthew Teitelbaum, have looked upon the legacy of these paintings differently, situating them within the discourse of postcolo-

nialism. For Teitelbaum, icons like Thomson's *The Jack Pine* are not only about heroic individuality, but they are also territorial markers (like survey stakes), representing not just an aesthetic but also a social and political expansion of interests outward from the urban regions of central (Laurentian) Canada (71). Lawren Harris's paintings of Canada's arctic (from the 1930s) represent the farthest reaches of this territorial expansion and, in Harris's terms, are tied to aspects of national and geographically-bound identity. Harris states this clearly and, in the process, he relocates "the source," moving it from the Laurentian valley to "the great North"—and thus to the region of imagination:

> the great North and its living whiteness, its loneliness and replenishment, its resignations and release, its call and answer—its cleansing rythms [which at] the top of the continent is a source of spiritual flow that will ever shed clarity into the growing race of America, and we Canadians being closest to this source seem destined to produce an art somewhat different from our Southern fellow—an art more spacious, of greater living quiet, perhaps of a more certain conviction of eternal values. (qtd. in Teitelbaum 181)

In many respects, the (spiritual) flow that Harris speaks of here is at odds with the fixed formal structure of his paintings, paintings

George Back, *Barren Ground Brown Bear* (c. 1916-1917). National Archives of Canada, Ottawa.

that are fully in line with the overall project of modernism. In making such a claim, we do not want to argue for an easy conflation of modernism and formalism of the sort criticized by art historians such as Ann Davis (6). Rather, we understand the modernist practice of Harris and other members of the Group of Seven as a spiritual search, which as Davis observes, "sought to reconnect, to unify, the individual, the nation, the continent, and ultimately the universe to the One, to God" (162). This northern myth of purity, loneliness, and replenishment achieved an effective spokesperson in Harris, "thereby demonstrating its ideological utility and longevity and its iconographic power" (Grace 14). In Davis's account (68-69), the landscape becomes a vehicle for a universalizing aesthetic—but what such accounts gloss over are the "particulars of place," those more locally defined visions (and voices) that characterize the vernacular alternative.

These particulars, the vernacular of the recorded landscape, are found in the sketchbooks, journals, and other preparatory work of the Group of Seven and their contemporaries. If we look back farther, to the previous century, we encounter the northern "artist/explorer" rather than the "artist/academic" (see Richards 13). There we see less of a split between the daily experiences of the artists and their craft. Such journals as those kept by Robert Hood and George Back, artists attached to expeditions seeking the Northwest Passage in the first half of the 19th century, present a view of the North different from that represented via the Group's modernism. The situation of the artist/explorers encouraged broad aesthetic considerations to be overlayed by textual and pictorial accounts of daily life. As critics such as Constance Martin, I.S. MacLaren, and Sys Birgit Richards observe, these earlier artists

contended with a wide range of aesthetic expectations, where their expeditions' needs for factual topographic studies were mediated by European pictorial conventions of the Romantic and the Picturesque.

Under the pragmatic pressure for direct observation, the filter of imported aesthetics frequently gave way to new representational forms; for someone like Back, it is the immediacy of his impressions, and the empirical nature of his visual and textual anecdotes that help to establish his more vernacular take on the landscape. Back's study of a bear on an ice floe, typical of many such journal/sketch pages, speaks of a direct experience with the landscape that does not fit easily with the dominant conventions of European landscape painting. Even Back's more thoroughly worked landscape views carry this same immediacy, creating a rift that distinguishes the explorers' journals from European canvasses. The form of the journal, like works informed by the scrapbook aesthetic of Kroetsch, allows for sketches of bears to intermingle with maps and landscape views that, in turn, are more thoroughly rendered in preparation for later engravings. Together, this multiple and mixed visual perspective, along with the textual narratives of artists such as Back, provide not just a "landscape view," but a complex testimony to the artist's presence within that landscape. Such an "indigenous" exploration of the many competing representational modes exhibits a direct expression of the vernacular form, one which many contemporary artists and writers now self-consciously engage in their work.

This vernacular mode was not confined to explorers' journals. A comparable mixing of pictorial modes existed in the urban centres of the Laurentian Valley. There, however, the practice of such artists as Cornelius Krieghoff was tied more closely to expectations of the academy. Vernacular subject matter was rendered less idiosyncratic through the employment of more conventional formal expression; or, as Dennis Reid puts it, Krieghoff "simply sought out picturesque genre subjects with local flavor" (65). Perhaps more importantly, Krieghoff's interest in local detail and anecdotal materials was further complicated by an emerging form of image-making: photography.

William Notman, Montreal's preeminent photographer of the mid- to late-19th century, employed a mixing of modes and styles culled variously from the emergent photographic studios of Europe and the paintings of colonial artists. In his efforts to represent the vernacular of the Laurentian landscape, Notman not only studied (and, in fact, collaborated with) artists such as Krieghoff, but he brought the subjects, the trappers and woodsmen of

William Notman, *The Bounce*
(c. 1887). Reproduced courtesy of the
Notman Archives, McCord Museum.

Krieghoff's paintings, into his studio. With all their personal objects around them, these subjects enact their lifestyles in front of the lens and magnesium illumination of Notman's photographic apparatus. Some of these outdoorsmen emerge as conventional photographic portraits, to be placed in albums along with members of Montreal's social elite; others are fitted into elaborate photographic composites, group portraits and events culled together from as many as hundreds of individual negatives and commonly finished with a painted surface applied over top of the photographic image (for a more detailed discussion of Notman's composite process, see Chapter 4). These staged tableaux, whether presented as a single image or as a component of one of the composites, represent Notman's attempt to wrestle the new medium of photography in amongst the many representational modes then existent in the Laurentian valley.

One composite in particular, *The Bounce* of 1887, is interesting to consider from these varying perspectives. It represents a social custom among the local snowshoe clubs of tossing a guest into the air, and in this respect is tied to many other of Notman's composites of snowshoer gatherings. However, whereas many of those are related to the pictorial compositions of Krieghoff, this one is not: instead, in emphasizing the time-based gesture of the toss, it anticipates—via the composite technique of sketching, posing, photographing, cutting and pasting, and, finally, re-photographing—the frozen moment of photography, something fully realized a year later, in 1888, with Eastman's patenting of the "Kodak" camera. With advancing technology Notman's frozen moment was later worked into a fully articulated aesthetic philosophy via Henri Cartier-Bresson's understanding of the "decisive moment," that photographic ideal where "the elements in motion are in balance" (Cartier-Bresson 385). Somewhere between the vernacular subject matter of Notman and the aesthetics of Cartier-Bresson's decisive moment lies the vernacular form of the snapshot, that seemingly "artless," potentially "baffling" invitation to conversation and narrative. More recent artists take this narrative potential of the photographic image even farther, thus providing a rich visual context within which verbal artists' concern with stasis, flow, and the vernacular can be read.

⊕ ⊕ ⊕ ⊕ ⊕ ⊕ ⊕ ⊕ ⊕

Writing on Water

Where Lawren Harris's modernism, despite its ties to the transcendental, relied upon the fixed material form of the framed canvas as

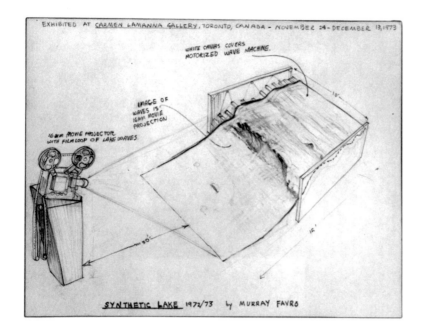

Murray Favro, sketch for *Synthetic Lake* (1972-73). Reproduced courtesy of Murray Favro. Art Gallery of Ontario, Toronto.

its medium, Murray Favro's *Synthetic Lake* (1973) works against this notion of the frame. In his construction, Favro sets the lake in motion, bringing to a very physical level the flow that is so often employed as subject and metaphor in the Group of Seven's work. For a visual artist like Favro, the physical construction is also the exploration. For the viewer, the physical impact of Favro's *Synthetic Lake* is unavoidable: a large and elaborate wooden construction supports a canvas surface that undulates, like waves, as the construction goes through its pattern of mechanized movement. On the canvas surface of "the lake" Favro projects a film loop of waves crashing upon a beach, the waves, with the flickering effect of their projection, never stable, always in flux. Favro's construction is idiosyncratically put together and, in this sense, speaks in the vernacular voice—with an inflection of tactile exploration. Yet, despite its physicality, Favro's "lake" is largely a perceptual experiment, something which, like the work of Michael Snow or N.E. THING CO., has its basis in conceptual art practices of the 1960s. Though breaking away from the more rigid forms of the modernist period, artists such as Snow, Baxter, and Favro did not at this time fully engage the "conversational" manner of narrative construction, conversation of the kind suggested in the work of George Bowering, and which is the interest of many contemporary artists such as Liz Magor and Roy Kiyooka.

In a 1982 installation entitled *Eighteen Books*, an intriguing sculptural counterpart to the PhotoGraphic works of contemporary

"Kiyooka, not the poet fascinated by art (Doug Jones), but the visual artist as poet, the sound of sight/site."
Kroetsch—Lovely Treachery.

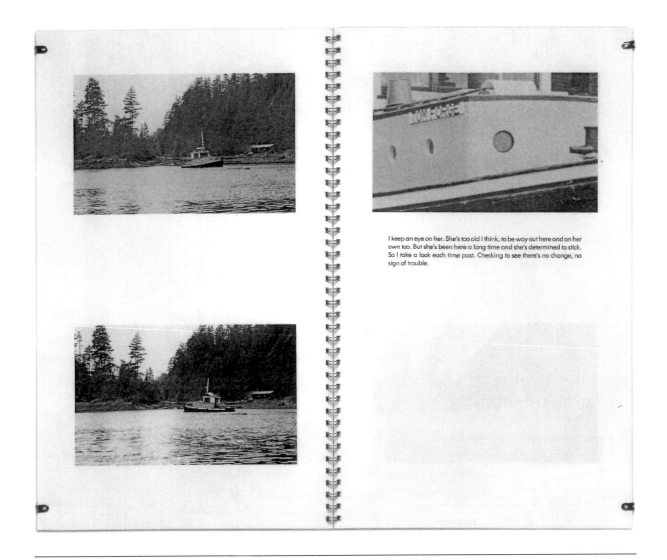

I keep an eye on her. She's too old I think, to be way out here and on her own too. But she's been here a long time and she's determined to stick. So I take a look each time past. Checking to see there's no change, no sign of trouble.

Liz Magor, *Eighteen Books* (1982). Page spread. Reproduced courtesy of Liz Magor. Vancouver Art Gallery.

writers, water is alternately used by Liz Magor as a vehicle for and against communication. In this installation there are two distinct components, which are themselves in dialogue with one another, in a manner parallel to Favro's overlaying of film and sculpture. On the wall we see seventeen copies of a book produced in series by Magor. Opened to each page in succession they show the entire sequence of images and texts in the book as a whole. On the floor below is a lead ocean or beach (constituting the eighteenth book), its physical materiality juxtaposed with what many traditionally regard as the illusionistic space of the photographs in the accompanying books. Textual and graphic embossings on the lead surface recall the lead type of the early printing presses and reiterate the piece's central story of an elderly woman in a coastal community seeking to send out a distress signal to a friend who passes by each day on a tug boat. This is a local narrative of failed communication. In the central image of the surrounding books, the rectilinear window of the woman's cabin comes together with the round window of the tug—the two geometrical images together forming "the international distress flag motif which inspires one of [Magor's] original lead book pages" (Watson and Farrell-Ward 10). In the photo/textual narrative the woman comments:

> Every day I could hear the Tom Forge going back and forth, but nobody showed up. Looking at something else I guess, staring at the water I suppose.

A towel intended as a distress signal to the "Tom Forge" is placed on the beach rather than in her window, where it would be visible from the water. Magor's text reads: "She put out a distress flag, but she just put it on the beach, lying flat on the beach. That's okay for planes but not for boats…" (102). The woman seems to lack a sense of what can and cannot be seen. Meanwhile, from a very different water-based perspective, the speaker on the "Tom Forge" views the water as a means of mobility, a means of communication, though not always a clear one:

> It's difficult to get out of here. There's no way by land, you go by water to get in and to get out. It's such a lot of bother getting down to the water on the low tide that I wait for the highs. I do all my coming and going on the high tide.

The land is constructed as an obstacle both metaphorically in the work's narrative and physically with the placement of the lead

ocean/beach in the space of the gallery (the particular configuration varies from one gallery setting to another). In a letter to Scott Watson and Lorna Farrell-Ward, the curators for the exhibition, Magor muses:

> I'm thinking of changing the set-up in the gallery so that there is only access to the lead ocean (the beach).... This would be better in terms of making the printing on the lead harder to read and therefore more vestigial, and it is more like being at the edge of the water and unable to march across it. (qtd. in Watson & Farrell-Ward 12)

As the curators themselves go on to observe:

> Magor places the viewer inside a metaphor; the viewer must read the gallery floor, on either side of the 'lead ocean' as 'beach'. From the beach, the words in the ocean (the ocean of language? the ocean of Moby Dick?) become 'vestigial'—traces. First, the metaphor is literal, but then the beach and ocean themselves are metaphorical of a relationship between language and meaning, in the sense that we are presented with distance, movement and a question of legibility.

These questions of legibility, of "distress," and of the metaphorical surface of the water are taken up also by Roy Kiyooka in a photo-essay entitled "letters purporting to be abt tom thomson," a project he undertook for *artscanada* (February/March 1972). On the cover of the issue we see a detail from Canadian painter John Boyle's *Midnight Oil*, a close-up of Tom Thomson standing in a small boat. Inside, the nine pages of text and image present an interweaving of personal and historical reflections surrounding Tom Thomson's drowning in Canoe Lake in 1917—as we've already noted, a mythical point of departure for much imagery of the Canadian landscape since that time. In Kiyooka's "letters," images of and by Thomson and the Group of Seven are juxtaposed with (and overlayed by) his own personal photographs of the east and west coast of Canada. Significantly these are images of where the water meets the land, of Peggy's Cove and Long Beach (on Vancouver Island). Kiyooka's texts—poems in the form of letters to Anne Trueblood Brodzky, who was at the time editing *artscanada*—document the construction of this image/text work at the same time as they place Tom Thomson (as well as Emily Carr and the Group of Seven) as figures central to Canadian mod-

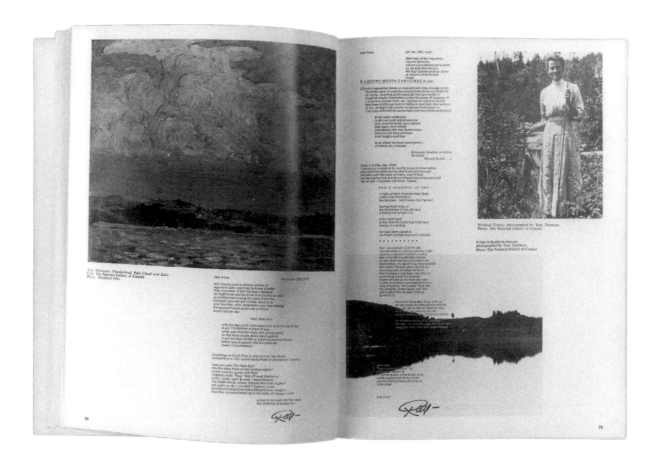

Roy Kiyooka, "letters purporting to be abt tom thomson" (1972). Page spread from photo-essay. Reproduced courtesy of the estate of Roy Kiyooka.

Double exposure, northern lake, photographed by Tom Thomson.
Photo: The National Gallery of Canada

dear Anne, dec. 31st 1971

(one night before sleep
i ask myself what old i dream
that might picture
for me what tom in his dreams
also] dreamt

the dream:

floating –
on his back in the middle of
canoe lake at sunset

his body cradled by
cold-clear water – he rolls over
on his belly & stared

into deeper waters
where his eyes meet old trout's –
& hang on til night fell

(as far as it goes this is
the only dream of tom's on record:
im told only fishermen have
this dream. *fishermen & the fish* they
dont catch)

heres lorine niedecker

As praiseworthy

the power of breathing (Epictetus)
while we sleep. Add:
to move the parts of the body
without sound

and to float
on a smooth green stream
in a silent boat

& home is
ah cliché!) where the heart dwells unbidden
where alibis are few.
& far is no further than an ear: yrs

30

Roy Kiyooka, "letters purporting to be abt tom thomson" (1972). Detail from photo-essay. Reproduced courtesy of the estate of Roy Kiyooka.

ernism. The images and texts come together in the work at the point where two of Thomson's lake photographs are introduced.

In the first of these two photographs the tone of the lettering is alternately positive (that is, black) against the sky and negative (white) against the land, echoing the formal structure of the photographic process. The second photograph, a double-exposed one by Thomson, shows the shadowy figure of a canoeist overlaid by the image of the lake and surrounding landscape. Overtop, a further layer, the text, speaks:

> dear Anne
> (one night before sleep
> i ask myself what cld i dream
> that might picture
> for me what tom in his dreams
> also) dreamt
>
> the dream:
> floating—
> on his back in the middle of
> canoe lake at sunset
>
> his body cradled by
> cold-clear water—he rolls over
> on his belly & stared
>
> into deeper waters
> where his eyes meet old trout's—
> & hang on til night fell
>
> (as far as it goes this is
> the only dream of tom's on record:
> im told only fishermen have
> this dream. *fishermen & the fish* they
> dont catch)

Later in the work another photograph shows Thomson standing above his own reflection, the bow of his canoe jutting into the image's frame. Adjacent to this image Kiyooka writes:

> after another mugup tom
> got his gear together and hiked over
> to the canoe. he stood beside it
> beside the still water thinking how easily
> he could disappear into it—if the light

was right. he thot of the small hand mirror
he shaved by and laughed. his laughter
smasht it to bits
that night when tom got back to his tent
he simply swept up all the pieces
next morning he askt someone going into town
to get him another small hand mirror

The mirror, like the mystery of Thomson's disappearance, recalls the nature of the first photographic process, the daguerreotype. Those early photographic images, exposed on tiny sheets of silvered copper and enclosed in elaborate cases, were also elusive. Their images, when viewed from the correct angle, "if the light [is] right," present a clear picture of the subject, almost always a portrait. When viewed too obliquely, the image seemingly disappears, replaced by the mirrored surface of the silvered plate. If Kiyooka's "letters purporting to be abt tom thomson" offers a reflection upon Thomson's place within the origins of Canadian modernism, it is also about a time when the whole project of modernism itself was in a state of flux. Kiyooka's highly personal inquiry is styled as an act of correspondence, where words, Kiyooka's "letters," transform (and are transformed by) a complex of images quoted and created. This, then, is a conversation, first between Kiyooka and his editor and, second, between Kiyooka and Thomson. The work offers a sympathetic gesture of identification—even while it enacts a vernacular alternative to the constraints of modernist form.

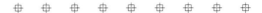

Tall Tales and the Narrative Flow

Kroetsch too aligns himself with vernacular modes of expression, especially the tall tale and the myths of the North. A recent critical essay on Kroetsch's writing begins with the following epigraph, taken from F.R. Scott's "Laurentian Shield": "This land stares at the sun in a huge silence / Endlessly repeating something we cannot hear." In the essay, Sherrill Grace notes that "Using Scott's words to introduce a discussion of Kroetsch enables [us] to do two things: to identify the existence of a context, a tradition, and a master narrative of nation that constructs, defines, and tells Canada as North; and to suggest that Kroetsch has helped write that narrative, to articulate the syntax of Scott's arctic sentence, to tell that northern tall tale of nation" (13). That narrative, as Grace also maintains, "stretches back in unbroken narration, at least, to the 18th century when it served a British imperialist agenda. It became a

visible/audible, self-conscious narrative of nation (Canada)…with the Canada First Movement in the last century when it was endorsed in popular verse and celebrated in influential paintings" (14). Neither Grace nor we offer a comprehensive discussion of this complex "tale of nation," but we would point out that European declarations of centre and periphery seem hopelessly out of place in the company of such vernacular artforms as we have been considering—especially in a northern Canadian landscape where both words and water freeze.

The new art that Kroetsch's work exemplifies seems part of a rhetoric of conversation, rather than a rhetoric of display. Indeed, according to folklorist John Niles, an aesthetic commitment to freezing and thawing narrative arises more or less naturally out of the oral tradition of memorization and performance. "How," he asks, "can we reconcile the fact of memorization with the fact of…creative instability" among the highly variable versions of oral tales told and ballads sung? He answers with what he calls, in "a Northern mood," the "'theory of the recurrent thaw'":

> According to this notion, creativity enters the ballad-singing process chiefly during the initial "thawing" stage or formative period when a singer is in the process of learning a song. Once the song is learned well enough to be added to the singer's active repertory, it remains largely "frozen" in a memorized form and will stay relatively fixed, except for lapses of memory.

As he sees it, the life of a song or story is not marked by slow, incremental change; "[o]n the contrary…long frozen periods of stable memorization are interrupted by periods of thaw during which its constituent elements…become partially fluid" (91-92).

Little wonder that such a trope should find its way into contemporary Canadian narrative, and Kroetsch's work in particular, for the notion of words freezing and thawing not only provides a convenient way of describing the process of oral composition and performance, but it also invokes a line of critical theory currently in the northern air. Richard Cavell explains:

> As Bakhtin relates in the sixth chapter of *Rabelais and his World*, Pantagruel's journey to the underworld is modelled on Jacques Cartier's voyage in 1540 to Canada…and it is significant that we have the famous scene of the frozen words, of language decontextualized and therefore subject to infinite recontextualization. The horizontal relationship

of New World to Old can thus be seen to be directly related to the vertical one of low culture and high, such that the poetics of carnivalization applies as well to this geography of the imagination. (207)

Postmodern authors and artists feel compelled to draw upon old sources in an attempt to provoke new habits of mind; and, perhaps in reaction to the self-consciously elevated rhetoric of high art culture, these "sources" tend to be peripheral, frequently derived from an oral and visual vernacular: tall tales, kitchen talk, conversation, and personal narrative, plus family photographs, snapshots—the "great-given," which serves as an anodyne to both the imported ideals of European culture and the "televisual flow" of popular culture that Raymond Williams and others have identified as the background noise of our contemporary world. Although he remains deeply suspicious of the European high art ideal, Kroetsch, like the other artists we've been discussing, is no advocate of kitsch for kitsch's sake: he is interested in the flow of vernacular culture, not in the products of popular fashion and mass marketing. The attraction of photography, for example, is that, as a form of vernacular expression, it leads us back to the oral tradition: "The snapshot suggests the magic of recovery, the metaphysics of time stopped, the validation of art by art denied. And it admits, through its lack of intentionality, that even in knowing we cannot know" (*Lovely Treachery* 69). The apparent artlessness of the amateur "take," like the frozen font, invites the flow of words. The frozen moment leaves out more than it captures, and thus alludes (if only obliquely) to the larger, as yet unspoken, narrative.

As the work of Pelkey, Ondaatje, Douglas, Baxter, Favro, Magor, Bowering, Kiyooka, and others illustrates, the emphasis has shifted from text to intertext and mode: the voice of authority has given way to multiple, often competing, voices—to vernacular discourses (both visual and verbal) variously invoked, juxtaposed, and "recited." Kroetsch's preferred source is a model of discourse drawn from vernacular culture: the oral tradition of exaggerated language, over-blown images, unbelievable characters, bizarre actions, and fabulous settings. His alternative to the (modernist) great river discourse of "central" Canada is a literacy narrative told in the style of the tall tale; in particular, the narrative subtly incorporates an intertextual play upon the notion of words freezing in winter and then tumbling back aloud in the spring. This frozen words trope, which, as we have noted, has gained irregular currency from early Roman times to the present day, allows Kroetsch to "re-cite" a classic tale and adapt it to local circumstances.

In the oral tradition, the trope finds a home in travellers' tales, jokes, lies, and tall tales—usually campfire tales about extremes in weather. According to Mody C. Boatright, the flourishing of "liars' tales" and the frozen words motif demonstrates how imported tropes are adapted by an oral culture to confront with humour the awesome forces of nature and a formidable geography. But, in the tradition of "loading the greenhorn," such tales also perform the social function of gulling an uninitiated member of the community—usually an easterner who hears the fantastic story, and returns home, perhaps to retell the story as the "truth." The western cowboys and miners feign ignorance of their own weather, seeking wisdom from European authorities—Paul Bunyan, for example, looks to England for a "frozen word interpreter" (Shephard 100-01). And displaying a wonderful flair for the intertextual, the following Texan tall-tale dialogue plays off literary trope against oral tale, folk humour against erudition:

> "Speakin' of things freezin'," said Red, "I've seen words freeze. Once we was out in a blizzard cuttin' drift fences, and tryin' to point the herds to the canyons. And we'd yell and cuss the critters, but we couldn't even hear ourselves. Well, sir, we finally got the brutes into the brakes and was on our way back when it started moderatin'. All of a sudden we heard the dangest mess of yellin' and cussin' and cow-bawlin' that you ever heard tell of. Presently we recognized the very words we had spoke on the way down."
>
> "It seems to me," said Lanky, "that I learned a story something like that from Addison and Steele."
>
> "Doubtless," said Red, "doubtless you did. This that I was tellin' you happened right over here on Addison and Steele's outfit. I was workin' for 'em at the time." (qtd. in Boatright 50-51)

Documenting a specifically Canadian context for the frozen words trope, Herbert Halpert's "Tall Tales and Other Yarns from Calgary" describes Western Canada as one of the last frontiers: a meeting place for cowmen from the southwestern states, moving through Wyoming and Montana, up the Fort Benton trail and into southern and western Alberta. Halpert, a source familiar to Kroetsch (Personal Interview, 1990), speaks about the chinook winds and their effect upon Calgary temperatures as explaining, in part, the appeal of frozen words stories; and, in addition to offering multiple examples of frozen words tales, Halpert concludes that as "might be expected, most of the folk tales found were carried in

from elsewhere, but the majority of them have been thoroughly changed to fit local conditions" (31).

Contemporary fascination with words frozen and thawed suggests an ironic reevaluation of the Gutenberg legacy and the assumed permanence of the written word. Where once the frozen words motif provided a staple resource for liars' stories and travellers' tales, it has now become an integral metaphor for an understanding of the text as a fluid process of social interaction among author, reader, text, and context. Moreover, by blurring distinctions between the ontological status of oral and written (and, elsewhere, visual) discourse, contemporary writers and artists like Kroetsch challenge what Walter Ong calls the "programmed rejection of the oral, mobile, warm, personally interactive lifeworld of oral culture" that underlies Plato's "entire epistemology" (80) and still influences modernist thought.

⊕ ⊕ ⊕ ⊕ ⊕ ⊕ ⊕ ⊕ ⊕

What the Crow Said

In the final work we address here, Kroetsch's *What the Crow Said*, the interplay of words and water links a variety of forms (essay, poem, novel, folk motif, and autobiographical moment) in the kind of side-citing we noted earlier during our discussion of *Badlands*. If, as he asserts, the scrapbook is the paradigm, Kroetsch's *What the Crow Said* should be read as an assembly of voices—an even more complex enactment of the hubbub and commotion alluded to in *The Sad Phoenician*. Here, as we have seen in other works, the frozen words trope acts as generative metaphor and muse.

A novel that defies conventional plot summary, *What the Crow Said* presents a pattern of tall tales, multiple voices, and disjointed plot lines that overlap and interrupt, without ever resting into coherent narrative. The characters too seem far removed from conventional narrative constraints, the logic of their representation tied more to the flow of narrative invention and performance than to any modernist mimetic ideal. The town of "Big Indian," where much of the novel's action is set, seems more muse than setting: as the pun embedded in the town's name, (BigIn)dian, suggests, Kroetsch is interested in the process of invention—in "beginnings." This is a world where one character "invents" spring (49), another "invent[s] motion itself" (201), where "bees" are said to have "started everything" (7), and where the only constant is the freezing and thawing of water, word, and image.

In *What the Crow Said* we note the multiple echoes of story told

"A birthday party for me. Lots of hockey talk. Young Pat McGill is succeeding as a player on the west coast. Comic stories of the violence of the audience, not the players. Cousin Lorne out from the city. Drinking a bit, the men. And swapping stories is a way that once again makes me realize where the method of *What the Crow Said* comes from."
Kroetsch—*The Crow Journals.*

and retold via Kroetsch's essays and journals; we are encouraged to "hear" the opening lines of Kroetsch's travel book, *Alberta* (written ten years before the publication of the novel), which begins with the observation that "[s]pring is not seen, but heard, in Alberta" (2); we are privy to the whole novel revisited in *The Crow Journals*, a metanarrative on the process of writing (published two years after the novel); and we encounter the insistent voices of oral storytellers in the novel itself, where the folk motif of frozen forms thawing into motion informs the story's narrative flow. Kroetsch's river is no St. Lawrence Seaway bringing what W.H. New calls a "European social structure…[to] the so-called New World" of the west (173); for Kroetsch, the river is a narrative waiting to be released. More importantly for our purposes, and as Robert Lecker notes, *What the Crow Said* returns us to the same "pressing theoretical question" that preoccupied Kroetsch in *Badlands*: "What are the means by which the author and his narrators manage to break free from mimesis into new, expressive forms that celebrate the projection of meaning, rather than its reflection?" (96-7).

Kroetsch's goal in *What the Crow Said* is to animate the "oral, mobile, warm, personally interactive lifeworld"—all the while aware that to do so in writing means, to some extent, freezing it into literary form. What he gives us in his 1978 novel is the book as analogue to oral tale, an elaborate working out of the "use and distrust" of ekphrastic representation.

Water and words are linked early in novel, with the opening image of "the meandering river still locked in ice" (7) and Vera Lang (i.e., true language) "[l]ocked into silence" (8). Martin Lang is described as a "frozen corpse…locked to the plow" (31); the winter creates "snow-locked farms" (45); and Liebhaber busies himself, early in the novel, with "lock[ing] up the form" of his newspaper story. This is a novel full of "frozen forms" (25), "frozen brassieres and bloomers" (926), and, significantly, "frost-strangled lungs" (27). Father Basil, in a scene that recalls Father Martin and the anecdote of the frozen font, "his breath freezing in front of his mouth as he spoke from the altar" (51), reports that the "world is out of motion. We inhabit a strangled universe" (52). The Father's conviction that "[w]e've got to bust her loose!" (52) parallels Kroetsch's own conviction that, unless we break free from old ways of narrating the world, our literature will stay, in the words of the novel, "dumbfounded into an unending winter" (19).

As Kroetsch presents it, the response of his character John Skandl to the apparent chaos and unending winter of his world is like that of modernists who are tempted to impose meaning prematurely, to fix reality in familiar and ostensibly static forms. "Ice,"

we are told, "was the only thing in the world that Skandl really understood" (45), and finding himself in need of an epistemological "center" (45), he constructs a tower of ice as "a beacon, a fixed point in the endless winter" (33). Perhaps the ultimate image of frozen words, this modern-day tower of Babel, built amidst the "babble and chaos of voices" (49), signifies the desire to control reality through the language of fixed forms. As Kathleen Wall so aptly puts it, Skandl is a "[p]re-deconstructionist man, [who] believes his phallic signifier is transparent, its meaning utterly clear"; and she goes on to observe that the attempt to impose order and freeze meaning proves "a sterile proceeding...one that the earth eventually defies by sending spring thaw" (92).

In Kroetsch's novel, rival images of order, such as the frozen tableau of Martin Lang ploughing the snow, provide both inspiration and uncanny competition for Skandl's tower of ice. Lang's frozen form presents a parody of the modernist ideal: a perfect example of representational art captured without the creating hand of an author. Skandl cannot tolerate such meaningless form and thus frees Lang violently, smashing at the frozen legs with a hammer (32). Ironically, before his frozen corpse can be thawed for burial, Lang(uage) is lost, only to return as a spirit haunting the other characters during periods of spring thaw.

As the novel progresses, all attempts to freeze form are undone by the subversion of motion. The ice tower is literally undercut by moving water, "a strip of black water" (58) that sends blocks of ice plummeting down. The comfortable rules and order of an ice-hockey game give way to the chaos of Gladys Lang's impregnation by "everybody" (75) on the ice. And even the frozen river eventually thaws, creating Liebhaber's "terrible flood" (154) and the terrible collision at the centre piling of the old CN bridge. At that moment, creation and motion converge, and Marvin Straw, finding himself participating "in an act of creation born of the water itself," discovers that he has "invented motion itself" (201).

For Liebhaber, editor of the town's newspaper, the story will not stand still long enough for him to write and edit the text, "lock up the form" (16) and meet his deadline. Subsequently, he turns to other pursuits and, like Straw, redirects his creative energy towards water. In an effort to end the drought and make it rain, he fires packages of bees from a cannon to "fertilize the barren sky" (182). As Peter Thomas notes, the bees that rape Vera suggest "a typical Kroetschian pun on Bee-ing and Bee-coming" (103); but, to continue the pun, the bees are also "letters" ("B"s), a kind of naturalist's answer to Gutenberg's movable type. Their return in the hailstorm that follows suggests a final, quite wonderful variation on

the frozen words (frozen letters) motif: "Lumps of ice, some of them the size of baseballs, hurtled from the sky. Often, inside a huge hailstone, was a bee, frozen into perfect stillness, magnified by the convexity of the encasing ice" (193). In keeping with the pattern of words and forms thawing into conversation or motion, we are told shortly thereafter that "Word spread slowly through the rain-soaked town…" (196).

Kroetsch's use of the frozen words trope suggests more than the simple appropriation of an oral folk motif, for, as its widespread visual counterpart signifies, the trope embodies an important, perhaps central, characteristic of the Canadian postmodern: the desire to tap into the flow of vernacular expression, the "great-given." As Liebhaber's ironic attempt to "lock up the form" on his printing press reminds us, Gutenberg froze oral language into print—the same way that photography may be seen to have frozen nature onto a silvered photographic surface. Ironically, and as Kroetsch's work helps clarify, the modernist ideal of arrested form has become hopelessly out of place in the current heated intellectual climate, one committed to notions of process, thaw, and flow. Nor will the image itself stand still, for, as Victor Burgin argues, it is no longer possible to speak of "purely visual" or "purely verbal" media; "even the uncaptioned 'art' photograph, framed and isolated on the gallery wall, is invaded by language in the very moment it is looked at: in memory, in association, snatches of words and images continually intermingle and exchange one for the other" (51). The reason that the frozen moment or word remains attractive for artists like Kroetsch, therefore, is not because of any latent modernist fascination with an imagist poetics—as he says in *The Sad Phoenician*, "Fenollosa and Pound were mistaken when they / praised the ideograph and returned us to the arrested image"—but because such a freeze up always precedes the recurrent thaw and flow of narrative. The interruption of the temporarily frozen moment only heightens our anticipation of the flow and, to paraphrase Blodgett, highlights the integrated arrangement of representational modes on and off the page; it is part of the grammar of delay and dislocation, the erotics of narrative. The frozen moment in image or text today must be seen as an illusory gesture, "a gesture that," as Kroetsch says in his story of the frozen font, we "might see now as writerly" (*Likely Story* 47).

Finally, the frozen words motif, with its rather literal take on notions of visible language, suggests an important counterpart to more traditional forms of ekphrastic expression. Here words do not simply displace or supplement a visual representation; they are instead the principal subject of their own representation. To visu-

Garrett-Petts: You are generally regarded as somebody working in the high art realm, and yet you choose your materials rather deliberately from vernacular culture. Is there a conflict, or a potential for conflict, between your position and your interests?

Kroetsch: That's an essential question for me. I'm certainly seen as a high art writer, that's for sure. I like that, the intellectual activity of writing. But more and more I want to come out on the side of the vernacular. I feel a kind of resonance.

Garrett-Petts: What's the attraction?

Kroetsch: There are a number of reasons. One of them is that I think my political sympathies are aligned with the vernacular. I've lived in a high art, academic world, but you'll note that I've never written much about that world in my fiction.

Robert Kroetsch—Personal interview (1998).

alize the trope means accepting, if only imaginatively, the physical presence of spoken words. Drawn from a tradition of coffee-house jests, tall tales, and folk art, the frozen words motif thus offers a vernacular inflection to an ongoing interarts debate on language's corporeal presence and its semantic debt to visual mediation. What the frozen words trope adds to a high art notion of the arrested moment is a renewed emphasis on vernacular materials and conversational flow: it reminds us that visual or verbal freezing, most commonly associated with an ideal of sculptural and photographic representation, inevitably gives way to narrative thaw; that the visual moment is only fully meaningful when inhabited by story. (Here, of course, we are reminded of Ondaatje's "empty frame" and Douglas's notion of "crossfade." See Chapter 5.) Conversely, it reminds us that, as Horst Ruthrof puts it, "Without corporeal signification language means nothing" (22): linguistic expression, like the thawed word of Plutarch's jest, is activated by and tied to "nonverbal signification" (Ruthrof 252). Not only, then, does the notion of frozen words offer an intriguing new metaphor for an old interarts concept, but it seems the ideal starting point for an exploration of both the thematic and formal possibilities of an interarts practice committed to dislocating the site of its own inscription. What we are witnessing in much mixed-media representation, artists' books, experimental novels, and PhotoGraphic construction is the working out of a new aesthetic, one preoccupied with the rehabilitation of vernacular materials, the assertion of visual values within the text, and the interrogation of visual/verbal boundaries.

Authenticity and the Vernacular Moment

<div style="text-align: right">8</div>

In this concluding chapter we want to revisit some old ground, specifically the roles of the vernacular and the decisive moment in contemporary art. In writing this book, a process spanning six years, we've resisted the temptation to impose definitions, preferring to work inductively, letting (as much as possible) our interest in the works and our conversations with the artists and authors direct our writing. We began with a heuristic—first worked out on a paper napkin in a Tim Horton's doughnut shop—detailing our sense that any work of art may be informed by all four cultural spheres (high art, mass, popular, and vernacular), and that any work can migrate from one sphere to another. It is fair to say that our appreciation of the vernacular as a key critical term has developed significantly—and today we are especially attracted to Henry Sayre's notion of the "vernacular moment" as a postmodern alternative to the frozen moment of high modernism.

With Sayre, we see attention to the vernacular sphere, to the intercession of vernacular narrative, as a means for authors and artists (and critics) to reconceptualize old notions of artistic purity, in particular those notions tied to a modernist rhetoric of the frozen moment. As Victor Burgin points out, "the vernacular…was quite simply anathema to modernism, whose raison d'être was its opposition to modern 'mass culture'" (45). Art forms seen as "insensible to the values of genuine culture" were, from the late 1930s on, dismissed as "kitsch"; for modernists like Clement Greenberg—and, again, as Burgin points out—kitsch became defined variously as "the faked article," "debased and academised simulacra," "commercial art and literature," "ersatz culture," and, apparently, as any manifestation of mass culture (qtd. in Burgin, 2-3; 45). Yet kitsch, or what we prefer to call the vernacular, has more recently shown itself as the sphere where artists and authors turn to either find or articulate the personal, the "genuine," the authentic. Only by distinguishing, however tentatively or hypothetically, the vernacular from its cousins, mass and popular culture, can we see the full range of artistic sensibilities at play.

We conclude, then, by looking at three examples of vernacular documentary: a collaborative long poem about a small fishing community off the coast of British Columbia; a personal exploration of what it means to inhabit two cultures, two voices, at once; and a series of family stories which combine family memories fossilized but discontinuous in the form of translated death certificates, reenacted photographs, and facsimiles of anecdotal family documents. All three PhotoGraphic works draw upon the vernacular muse for their inspiration.

Defining the Vernacular

Though we are wary of pinning down the term vernacular, we remain convinced of its value as a site for creative inquiry. Early on, like Dennis Lee and Dennis Cooley, we were taken with the sheer vigour of vernacular language, the vernacular as linguistic register,

vernacular (vərˊnækjʊlər), *a.* and *sb.*
Also vernaculer. [f. L. *vernacul-us*
domestic, native, indigenous (hence
It. *vernacolo*. Pg. *vernaculo*), f. verna
a home-born slave, a native.]

A. adj. 1. That writes, uses, or
speaks the native or indigenous lan-
guage of a country or district.

2. a. Of a language or dialect: That is
 naturally spoken by the people of
 a particular country or district;
 native, indigenous.

3. a. Of literary works, etc.: Written
 or spoken in, translated into, the
 native language of a particular
 country or people.

4. a. Of words, etc.: Of or pertaining
 to, forming part of, the native lan-
 guage.
 b. Native or natural to a particular
 language.

5. Connected or concerned with the
 native language.

6. Of arts, or features of these:
 Native or peculiar to a particular
 country or locality, spec. in ver-
 nacular architecture, architecture
 concerned with ordinary domestic
 and functional buildings rather
 than the essentially monumental.

7. Of diseases: characteristic of,
 occurring in, a particular country
 or district; endemic. *Obs.*

8. Of a slave: That is born on his
 master's estate; home-born. *rare.*

9. Personal, private.

"a sturdy, flexible tone, which draws on the resources of daily speech" (Lee xxviii). Cooley suggests that we "divvy up" language (he specifies prairie poetry) into two areas, "eye" poetry and "ear" poetry: "What I mean by 'ear' poetry," he says, "would correspond roughly to 'vernacular' and what I am thinking of as 'eye' poetry would compare to work commonly put in opposition to 'vernacular,' namely work that respects some combination of imagist, metaphoric, or expressive precepts" (*Vernacular Muse* 1-2). Significantly, Cooley sees vernacular writing as highly rhetorical and "anything but metaphoric": "instead of speaking in soliloquy [that is, vertically], it enacts roles, presents selves (plural rather than singular in its loyalties), rhetorically appeals to some audience, real or imagined. Imploring, scolding, teasing, begging, cajoling, exhorting, praying—it addresses someone [reaches out horizontally] and seeks to act on [teach?] an audience" (7). For Cooley, though, so-called "eye" poetry, that, say, "written by someone who in the past was actively drawn to the visual arts" (15), only contaminates the page with self-conscious pauses, measured use of white space, and traces of artistic self-sufficiency. Cooley's (and Lee's) focus is on words, not images or visual literacy; and though we feel a strong affinity for his position, we see this tendency to marginalize the visual as an unnecessary limitation. After all, we have ample evidence of a visual, PhotoGraphic vernacular at play.

W.H. New extends the linguistic focus, moving discussion from colloquial rhythms to a recognition of vernacular language as "a shifting contact line between groups that hold and assert power and those that don't but want to." Speaking in the vernacular, in a "native" or "local" or "slave" language, means challenging literary decorum—both verbally and visually. New adds an intriguing afterthought; he notes that the "voices…of a resistant and oppositional art in Canada characteristically use the vernacular—'the people's speech'—but the aim of such resistance is more often to partake in power than to erase power itself" (*Land Sliding* 212). Indeed, it seems open to question whether the vernacular, if defined as oppositional art, can partake in power while remaining true to its vernacular roots. Sometimes it is enough to reference, frame, or otherwise include the vernacular as a nostalgic or melancholic token of loss.

As we noted in our introduction, the contact zone (New's "contact line") invites gestures of resistance from those who feel linguistically alienated or colonized. From a postcolonial perspective, like the one asserted by Sylvia Söderlind, a "literature that emanates from a situation of linguistic colonization is often preoccupied with vindicating a forgotten or devalued vernacular…" (8).

Rehearsing the work of French linguist Henri Gobard, Söderlind suggests that the speaking or writing subject emerges, becomes visible, when articulated amidst four conflicting languages: the vehicular, the referential, the mythic, and the vernacular. The *vehicular* is the lingua franca of commercial communication, the language that facilitates transaction of information, goods, and services; the *referential* is the language of education and culture, the archive of history, custom, and artistic convention; the *mythic*, an extreme version of the referential, is the sacred language of belief and community consensus; and the *vernacular*, defined as affective, local, linked to region or territory, is the language of communion. Within this "tetraglossic" schema, the vernacular plays a double role: it both marks the "here and now," opening and maintaining personal contact between speakers, and it also marks a voice no longer "at home" within the dominant vehicular and referential languages of mass, popular, and high art cultures.

But despite the talk of opposition and resistance, the contest between the vehicular and the vernacular is no contest at all: the vernacular has voice but no power; it functions as a deferred memory, a "sign of loss," or as a mythic hope of recoverable communion situated somewhere between the vehicular and the mythic. Logically, for it to be recognized as vernacular, it must remain apart from, and thus subordinate to, the dominant discourse. According to E.D. Blodgett, "For the poet, the vernacular is not a viable option in itself, but can only be articulated as a code among others. It is the basis for the movement toward the mythic, the discourse in which the vernacular is sublated in a process of figurative reterritorialization" ("Towards" 627). Blodgett holds out hope that attention to these four languages may serve as a "possible means to find both the subject of the place and the place of the subject" (628).

Like Blodgett we remain hopeful—and intrigued by the notion of the vernacular as a "trace," as an absence that can be recovered only with reference to other cultural domains and modes. The vernacular, by definition, must remain in motion, in process, unstable, for we suspect that once it is pinned down or legitimized as a fixed genre, it changes. It becomes conventional, easily subsumable within the prevailing discourses (principally the vehicular and the referential). Henry Sayre characterizes this shared hope as a matter of "pursuing authenticity," of searching out "the vernacular moment" as an alternative to the arrested moment of high art.

Sayre sees the vernacular moment in terms of performance and storytelling: performance situates the vernacular between "creativity and commerce," a particular junction that makes notions of

The four languages provide an important complement to the four cultural domains described in Chapter 1. The common element is the "vernacular."

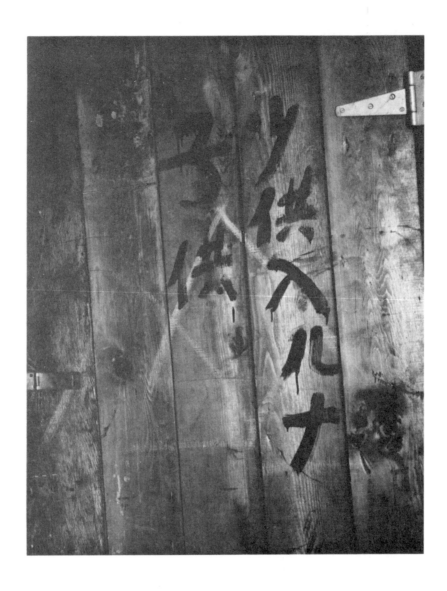

Graffiti, "Children Keep Out," 1973

Robert Minden, interleaved image from the second edition of *Steveston* (1984). Reproduced courtesy of the artist.

PhotoGraphic Encounters

authenticity problematic. The sense of absence or questionable authenticity, though, acts positively as an invitation to narrative, as a trigger for storytelling. By focusing on the vernacular moment, Sayre offers an alternative, perhaps an anodyne, to postmodern cynicism and the seemingly endless cycle of ironies that treat "authenticity" as a naïve, antiquated idea. Authenticity can be documented (especially via photography, says Sayre), and the authentic vernacular impulse can be recovered, even shared (via narrative), by a ready audience.

Sayre tells the story of Lee Quinones, a New York graffiti artist, who "bombed" a ten-car train with Merry Christmas murals twelve feet high and five hundred feet long. Quinones is quoted from a personal narrative where he describes in vivid detail the immediacy of the creative moment, the sense of being there. This story, as Sayre presents it, is something of a cautionary tale, for soon after the graffiti event, Quinones's authentic impulse and talent is co-opted by commercial interests, which, seeing a market for Quinones's work, begin wide-scale promotion. His work enters mainstream culture and begins to circulate in "graffiti boutiques" (143).

Jean-Michel Basquiat (SAMO) embodies another tale of the "fallen" vernacular, of authenticity corrupted by the commercial lure of popular, mass, and high art cultures. Another New York graffiti artist, Basquiat "became the first black artist to grace the cover of the *New York Times Magazine*"; his painting is described as "rooted in lived, as opposed to learned, experience: direct, not mediated...." But Basquiat too falls victim to the colonizing forces of "SoHovian commerce," losing confidence in his art, feeling used by white society, developing a drug habit, and dying of a heroin overdose at twenty-seven years of age (144-46). Sayre calls this intersection between authentic individual creativity and market forces, this "point of collision," one version of "the *vernacular moment*" (146). He concludes that there is "at the vernacular moment, a sort of double movement, between desire and destruction, financial reward and aesthetic impoverishment" (148).

At first, Sayre's stories seem little more than thinly disguised parables told by someone nostalgic for lost origins, what Michael Jarrett has described as part of the "rhetoric of degeneration" (190), a familiar script charting how authentic expression (frequently coded as "ethnic") "constitutes an initial raw material which is then appropriated and reduced in cultural force and meaning by contact with a white industry" (191-92). Jarrett rejects this colonization model, arguing that "it cannot account for innovation"; it fails to explain how "authenticity" arises (192). Similarly—and this

is what makes his contribution important to our present discussion—Sayre situates authenticity not in the work but in the work's performance, its "left over" narrative: "The act of creation, of personal expression, is no longer an *originary* act—that is, a first instance; it is, rather, *exemplary—worth* saving, *worth* repeating. It has the authority of evidence. It is, finally, in the full sense of the word, *telling*" (158). The vernacular, then, is not something contained by a work or object; it is, rather, a shared moment where the narrative performance is variously released, rehabilitated, recirculated, and/or re-created. As Sayre explains it, "the authenticity that we discover at the vernacular moment" exists temporally in the hearing or reading or viewing of narrative, "when the aura of originality is supplanted by the aura of the authentic, the exemplary" (159).

It seems to us that there are numerous ways that artists might employ narrative to variously *move toward* or *out from* such moments. We have already seen how a writer like Ondaatje tends to use vernacular materials, especially photographic moments, as points of entry for fictional identification and fabrication. Bowering relies more on accidental composition, trusting in the narration to shape and carry the moment. For Douglas, the vernacular moment occurs when a fossilized history (trapped as an object of representation) "enters the world." Like Kroetsch, and somewhat like Pelkey, he seems intent on the moment's release. In the examples that follow, we want to discuss three variations of the vernacular moment in action, in works where the vernacular becomes manifest as (1) catalyst, (2) muse, and (3) subject of personal redemption.

From the Moment Outward

Daphne Marlatt sees the vernacular moment, photographic or experiential, as an invitation to writing. The initial moment functions as a silent partner or catalyst: "[L]ike most poets," says Marlatt,

> I tend to work from the moment outward and I don't know what the shape of that moment is until the poem concludes. And memory is just one of the currents in that moment, like the reflexiveness of reacting to whatever is coming up in the mind, in the moment. The focus is not so much on looking back as on moving towards something

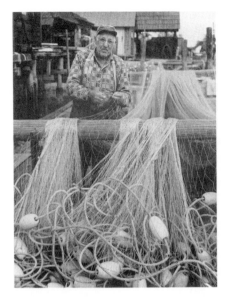

Hideo (Henry) Kokubo, fisherman, 1974

Imagine: a town

Imagine a town running
 (smoothly?
a town running before a fire
canneries burning

 (do you see the shadow of charred stilts
on cool water? do you see enigmatic chance standing
just under the beam?

 He said they were playing cards in the
Chinese mess hall, he said it was dark (a hall? a shack,
they were all, crowded together on top of each other.
He said somebody accidentally knocked the oil lamp over, off
the edge

 where stilts are standing. Over the edge of the
dyke a river pours, uncalled for, unending:
 where chance lurks
fishlike, shadows the underside of pilings, calling up his hall
the bodies of men & fish corpse piled on top of each other (residue
time is, the delta) rot, an endless waste the trucks of production

Daphne Marlatt and Robert Minden, *Steveston*. Top, pages 26 and 27 of first edition (1974). Below, pages 12 and 13 of second edition (1984). Reproduced courtesy of the author and artist.

the poem will put together. It seems to have to do with the construction of something against nothing, against the emptiness that underlies it all, all the phenomena, whether it's the phenomena being referred to in the writing or the phenomena of the language at play in the moment. ("From the Moment" 77)

As Dennis Cooley notes, "Marlatt takes a terrible risk" writing in such a style: "Answerable to itself, observant of its own processes, expressive though it may be, and much as it may mirror certain experiences, it puts special demands on readers and risks losing them." Cooley recognizes, even commends, Marlatt's desire to recreate *in the writing* her feelings of immersion and immediacy, but, he says, "there are times…when Marlatt has turned her writing so much in on itself, so preferred reflexive to referential language, that her work loses power, erodes a certain kind of meaning, and reduces access to it." Cooley's comments go to the heart of what we see as Marlatt's particular vernacular challenge: "how do you write a poem that is true to its minute, convoluted coming into existence, *and* that can snag on readers' bones?" "Can fidelity to source," asks Cooley, "ensure resonance to audience?" ("Recursions" 71).

Marlatt and Minden's collaborative work presents us with an intriguing variation on the literacy narrative proffered by Sayre. In 1972, when Marlatt first began documenting Steveston, British Columbia as part of a Reynoldston Research and Studies Aural History Project, the town as cultural and historical artefact was already in the process of disappearing. Today, Steveston bears little resemblance to the place first documented in *Steveston Recollected* and later recreated in Marlatt and Minden's poetic documentary, *Steveston*. Referential and vehicular discourse dominates: tucked in behind Gilmour Island, on the South Arm of the Fraser River, many of the buildings, floats and shore structures of Finn Slough are more weathered and less cared-for than when Marlatt and Minden documented them, but they are still in existence. The bigger changes have taken place further down river, along Cannery Channel and in the area surrounding the adjacent town site of Steveston. The town centre boasts an increasing number of condominiums, now taking the place of farmland and the older buildings. New cultural forms have accompanied the suburban expansion: Richmond's nearby six-storey "Silver City River Port" cinema complex, antique shops, specialty coffee shops, and a large shopping and dining complex constructed on boardwalks above the fish boat wharves—constructed in a manner that mimics the

Daphne Marlatt and Robert Minden, *Steveston*. Pages 34 and 35 of first edition (1974). Reproduced courtesy of the author and artist.

older, mostly vanished canneries. Along the Channel, most of the Cannery buildings and wharves are gone, or exist in a dilapidated state. Now the "Britannia Heritage Shipyards," like the "Gulf of Georgia Cannery National Historic Site," exists as a gesture of official reclamation, an attempt to reclaim the community's history. To the west of the Gulf of Georgia Cannery the salt marsh that was once the site of a large saltery is now Garry Point Park. Along the path that encircles the point sits a monument to the fishermen of Steveston, a large stainless-steel sculpture of a net-mending needle, of the sort that is seen being used by the fisherman in one of Minden's photographs.

But the "authentic" Steveston presented itself, even in 1972, as a vernacular moment in transition. As W.J. Langlois (Director for the project) puts it in the introduction to *Steveston Recollected*, "It was obvious that Steveston, as it had existed for over 70 years, was in the process of being overtaken by expanding metropolitan Vancouver" (xiii).

The aural history project (which began first, but was published

"Sure, Steveston's part of Richmond now and I've a feeling you'll have a City of Vancouver right clean through here, right down to Tsawwassen. It'll be just like, say, Oakland. You got some districts there that have just got the name to their districts, that's all. Don't think they can stop it."
Harold Steves, Sr.—"Postscript," Steveston Recollected.

Donald Lawrence, photograph of Steveston today (2000).

"The photos, and this is the gift of their suddenness, thrust up into our mutable present with the definitive reality of fossil moments lifted from a time and place we can never go back to. In the photograph, the subject, always somewhere/someone else, looks out at us from a distance we try to bridge by looking back into the frame. But the poem exists in continuing time—in the time it takes to read it, we recreate the forward-streaming of its sentences, its thought, all that it touches upon."
Daphne Marlatt— "On Distance," Postscript to Steveston (1984).

after *Steveston*) is, as one might expect, full of voices and detailed description—and some measure of personal response. As Langlois notes, "*Steveston Recollected* is an unusual book. Ms. Marlatt has made extensive use of aural history interviews and combined them with her own subjective impressions of the people and the community. The historical character of Steveston is also reflected in the contemporary photographs. This book provides an intimate view of Steveston through the real voices of the Japanese-Canadians" ("Introduction" xiii). "Historical character," "real voices," and the promise of an "intimate view": such objectives sit a little uneasily with the interjection of Marlatt's "own subjective impressions"; nonetheless, the emphasis falls on capturing and preserving the moment before it passes, before it is lost to encroaching urban development.

Steveston offers Marlatt greater freedom of expression, but the shift in form and purpose also shifts the vernacular focus. In *Steveston*, the vernacular moment seems less a matter of subordinating subjective impression to conventions of historical documentation, or of authenticity versus commercial development: in *Steveston* the vernacular moment becomes a matter of creativity versus critical self-consciousness. The vernacular depends upon at least the appearance of unmediated expression, of a raw (as opposed to cooked) performance. Can so theoretically interested and committed a figure as Marlatt write herself into such innocence? We don't think so. Yet, at the same time, and to take up the

Walker Evans, page layout from *Let Us Now Praise Famous Men* (1936).

question Cooley posed earlier, we sense that by remaining "true to its minute, convoluted coming into existence" the long poem sequence does indeed resonate as an authentic expression, as an aesthetic position bred in the bone of the author.

Minden's role is crucial here: his photographs reference both the shared documentary material and documentary impulse that drew Marlatt and Minden to the Aural History Project when it was recommissioned by the Provincial Archives of British Columbia in 1973. Marlatt had already begun the preliminary documentation under contract with Reynoldston; Minden came a little later, when the Provincial Archives took over the project. Together,

"It began with a notebook I took with me on the trip up to Prince George, a little black notebook Roy had given me, in which, on the first page, I jotted down an exchange we had on the train. The page went:

The story, she said.

Who is telling this story, I want to know how it's going to end.

She wants to know who is going to tell the story, he said.

(Who's here? there? Is anyone there? Who knows?)

Just one of those stoned jottings. Later, when we got back, I added:

The story is being told right here. And began to continue telling it, in hospital where I'd gone for a minor operation, & then later at home, writing an account of our trip, or the story of the story, I mean of the collaboration. In the meantime, Carole was typing up the 2 versions, interleaved page by page, & I think you got a copy of it—the 2 versions that we wrote on the trip.... But the story I wrote was written from memory, that is I didn't reread the collaboration til after it was all done....

I also just realized I'm now giving you the story of the story of the story. The story is what continues..."

A letter from Daphne Marlatt to Barry McKinnon—(August 4, 1974). Daphne Marlatt Papers, National Library of Canada, Box 5, f. 10. Reproduced in "Correspondences," Line 13 (1989): 5–31. The letter was written not about the composition of Steveston, but about the writing of another collaborative project: The Story, She Said.

Marlatt and Minden were part of a team employed to record "the thoughts, feelings, and life-stories of the individuals" who were seen as the "very substance" of recent Japanese-Canadian history (Langlois xiii).

Before starting the project, Marlatt had viewed and admired an exhibition of Minden's street photography. A little later she would review Walker Evans's work for the counter-culture newspaper, *The Grape*, where she wrote that viewing Evans's photographs was like finding "yourself caught in Hale County, Alabama, caught by the faces of those sharecroppers Walker Evans and James Agee lived with to write LET US NOW PRAISE FAMOUS MEN (originally commissioned by FORTUNE Magazine which couldn't print the *reality* Agee and Evans came up with...." She praises Evans's "respect" for his subjects, respect which "shows itself in the economy and unselfconsciousness (as art) of these photographs" (16).

"Unselfconsciousness" is a revealing word, for, though meant as a compliment, it is the very antithesis of Marlatt's own art. One suspects that she saw in the work of Walker (and Minden) an authentic (i.e., "unselfconscious") manner and felicity to fact (a fascination with objective detail and human presence) missing in her own poetry. Minden's faith in the veracity of the photographic image (as art) may not have been (or be) Marlatt's, but his style of representation provided a secure basis for documentary practice, the kind of practice that characterizes Marlatt's own contribution to *Steveston Recollected*.

The presence of Minden's photographs, which would remain unchanged as they moved from one book to another, would in turn link *Steveston*, the poetic sequel to *Steveston Recollected*, to a recognized tradition of photo/textual collaboration. Indeed, the epigraph to *Steveston*, "seeing to perceive it as it stands...," provides a direct reference to James Agee and his collaborative work with Walker Evans, *Let Us Now Praise Famous Men*; and like Agee and Evans, Marlatt and Minden decided to divide the first edition of their book into two halves, a photographic section followed by Marlatt's poem. In the second edition, the photographs interweave with the text. As Marlatt explains in her 1984 postscript,

having gained some distance on that book [the first edition], we see its story as a single narrative told in two distinct modes that converse with each other. Ten years ago we wanted to highlight the difference, the distance between our two "takes," although we had been working collaboratively for over a year and despite the fact that both

Fisherman, Canadian Pacific camp, 1974

photography (as its name asserts) and poetry can be seen as different forms of writing, one with light, the other with words. (92)

In the second edition she sees "the book as a whole," where the "photo creates a lucid hole in time, an arrested moment in the flow of the poem" (94). As "forms of writing preoccupied with imprint," she says, "both the photos and the poems can be read as traces of the literal 'scratching' place or person make on the (writer's) imagination—in the very imprint or inscription writing itself is, that mark of presence printed on a rock, a page" (95).

By referencing and dramatizing such "scratching," Marlatt develops a rhetorical strategy where the *act* of writing becomes a supplementary vernacular, a way of referencing aesthetically and thus moving outward from the moments of first encounter with Steveston's vernacular materials. If it were not for the institutional

"Monday July 30th
Robert sez he's not a photographer:
that the photos are (my words) visi-
ble records of an invisible process—
not the end-product but a vehicle for
him for getting at something else—
magic, alchemy—manifesting the
internal drama that goes on—making
them (or it) visible to themselves—
but my poems don't do that because
I recognize my mediumship—I mean
there's my view of it too—my own
subjectivity, & I don't mean self-
expression. If anything, I work by
identification, at least partly. What
else that's going on is a perception of
(a similar) design that they are
embedded in—I want to get all the
levels of that interaction which is so
huge it includes not only environ-
ment but the invisible forces of the
world—by which I mean forces of
birth & destruction, regeneration,
death."
*Daphne Marlatt—Steveston Journal
typescript, Daphne Marlatt Papers,
National Library of Canada, Box 17,
F4.*

(that is, referential) context of its production, we might be tempt-
ed to see *Steveston Recollected* as the true vernacular gesture. But
while the collective research provided wonderful raw material for
her poetry, the "true" first draft appears in an unpublished, private
work, her Steveston *Journal*. In her journal writing Marlatt metic-
ulously documents her research journey, including small pencil
sketches, conversations with locals and with Minden, detailed
descriptions of scenes and lists of key words, all reflecting her
attempt to get the hard core of detail right. But the *Journal* too
seems remarkably self-aware—not simply a protocol of the process,
the entries reflect and theorize contemporaneously with the docu-
mentation. What becomes clear when we read the *Journal* is that,
for Marlatt, immediacy, immersion, and writing are coterminus.
The Steveston *Journal*, while not written for a public audience, is
as much a "performance" as *Steveston*. For Marlatt, we suspect, the
Journal became *Steveston*. The process is allegorical.

In her book *The Artificial Kingdom: A Treasury of the Kitsch
Experience*, Celeste Olalquiaga argues that "[l]ike ruins, allegories
need a previous text from which to unfold, although their devel-
opment may unchain a series of new meanings that can ultimate-
ly render this founding relationship incidental" (126). For Marlatt,
that "previous text" is not simply or primarily the landscape of arte-
facts, images, and stories she encountered while walking the
Steveston docks; the foundational text is that inscribed in her
unpublished Steveston *Journal*, intermediary writing that enacts
documentation as both noun and verb. For Marlatt, the story of
Steveston exists fundamentally in the telling, in its signifying
process, and not in the town's residual testimony of gill nets, oil
lamps, old wooden houses jammed on pilings, straw hats, slickers,
and cannery machinery. These are the nostalgic tokens of loss and
endurance and quiet dignity that appeal to Minden's eye, quick to
catch the formalist moment, to preserve the scene as souvenir. Like
the portraits taken by Evans, Minden composes his images, hold-
ing the subject in equilibrium until the exposure is complete.
Door frames provide stabilizing elements for the subjects to lean
against, and, in a restrained tone, reference the places where the
people of Steveston live and work. Other images focus on the activ-
ities around the canneries and the net mending floats of Finn
Slough. Some of these are close studies of detailed textures: one
image, "Graffiti, 'Children Keep Out,'" composes the framing
carefully, revealing the hasp unlocked and, in the upper corner,
the hinge askew. Where Minden's photography seeks to fix the
moment, Marlatt's writing renders this founding moment
incidental.

As Marlatt says repeatedly in interviews (and throughout her body of work), "language makes it real" (Williamson 50). She feels that language "is incredibly sensual," that it provides "the actual material of [her] existence as a writer" and a scaffolding for consciousness itself: "Consciousness precedes action, because if you don't act with consciousness you act irresponsibly and you may end up supporting exactly the thing that you're trying to undermine. So you have to have consciousness, and consciousness is constituted by language, so you have to look at the language first of all" (51-56).

Her linguistic-based vernacular elides, flows around, the kind of realist visual detail, the signs of loss, that Minden's lens seeks to capture. Yet Minden's frozen moments do more than interrupt the narrative—though a rhetoric of interruption is certainly effected via the juxtaposition of his images with Marlatt's text: their implied modernist aesthetic offers an uncomplicated formalism, a faith in the power of visual affirmation curiously out of place in the surrounding river of words. Minden's photographs seek to suspend time, to capture as cultural artefact representative actions or attitudes—and thus, by implication, to recuperate the essential past via its faithful representation in the present, in the art photograph. When first published as a separate section, the photographs act as pretext or visual introduction for the poem that follows. When interleaved and set in the context of Marlatt's surrounding poetry (as they are in the 1984 edition), the object of representation seems to shift: that is, his photographs not only represent objects, they become objects.

We think it significant that following the first publication of *Steveston*, Minden re-collected his photographs as *The Steveston Portfolio*, advertised as a "collection of eight original photographs made during 1973 and 1974 in Steveston, British Columbia, a Canadian fishing community at the mouth of the Fraser River." The *Portfolio*, limited to thirty numbered copies, featured "eight prints, each approximately 7" x 9",…personally processed to archival standards, mounted on fine rag board 13" x 16", signed, and…contained in a handsome cloth-covered acid-free case" (advertisement for the portfolio, provided by the artist in personal correspondence). Terms like "original," "personally processed," and "signed" all speak to a notion of authenticity, but one tied to traditions of connoisseurship rather than vernacular representation or expression. Once processed to archival standards and contained in a handsome case, they become displaced images, highly collectable high art souvenirs, ones far removed from the initial site of their making. Minden's photographs aspire to transcend the vernacular

Notes during course of Inez passage: July 4ᵗʰ?

"in the beginning ... slept like babies"
that; what progress destroys — the play, the give ; take of our
elemental surroundings. our interaction w/ it — w/ progress
our world becomes a man-made (—willed) world, nature
outlawed outside city limits (woman skulking in the ditch —

another passage < river in graveyard (Indian) — in those deep ditches, watery women)
what are the characteristics of this outlawed (forbidden) woman/nature?
 in tune/harmony w/ growth around her — measured & sensual pleasure
Steveston: still at the point in (time) *(present)* where man interacts w/
nature still, tho less & less (feeling itself (by individuals w/ much
gear — gardening, small farming — arrive by land) — but its
history as a town, like all towns, is the gradual outlawing of
nature, relegating her to outside city (man) limits — building on
top of her (BC Packers' office over graveyard), supermarkets (denying
the claim of life w/ false abundance) consumer soc. etc.), housing
developments (synthetic gardens) — *covering* hiding ditches

—→ go talk to that ecology expert on the river
 Robert's photos: portraits of people in the town at the turning
 point — what in their faces *turns* this development for nature to
 synthetic lobster? a species that is closing in on itself
 my work: to clarify the context/habitat for these portraits. all
 that surrounds them

Daphne Marlatt, Steveston *Journal*, page 39 above, and typescript version of *Journal*, page 21 at right. Daphne Marlatt Papers, National Library of Canada. Reproduced courtesy of the author.

```
boats--their wake, the weight of displaced water proud furling round them--
   measure of space covered--sense of going, moving forward
```

 Wed. Aug. 15th

```
our connection with ground: the wrestle & struggle with it (to survive), as well
as a mythic rootedness in place, plus the way we misuse & despise its body--
exploitation as the last, post-pioneer phase.
              Koko as counter to that: as erotic connexion
(humus back into the soil)
     "gentle & fierce at the same time": keepers of the earth.
```

 Wed. Aug. 23rd

```
what Robert's working on in photographing: the encounter, or "facing" what (who)
he photographs: involves the reverse of documentary (which is the invisible
observer, the impartial objective eye non-participant & supposedly therefore catching
the naked truth--a phallcy since every observer subtly alters, by the act of
observation, the observed), involves placing himself, his eye (personality),
within thepicture (which is a record of the interaction then between himself &
'subject' (both are participants) is not reverse of what I'm doing in writing, which
is not face to face but speech to speech (the equivalent on auditory level of
R's facing)--where before poetry was always the poet (his speech) present as he
interpreted the world (his subject) rather than his subject there, now what I'm
trying to do is include others' speech, the actual presence of those others in
the world--so that my poem about Inez for instance also is by her, uses her words--

  --it is a collaboration just as R's portraits are an encounter--so are the poems
encounter--my speech encountering theirs, my reality colliding with theirs (my
views with theirs)
```

moment of fishing community and poem, referencing both nostalgically as prior contexts for meaning.

Admittedly, it is still possible to read the images thematically, as subordinate to the poem's "intent," for example. Brenda Carr sees the 1984 edition as an important feminist revision, where three photographs of white male shopkeepers are deleted and replaced with "three new photographs of Japanese-Canadian women, as well as one of the dominantly female staff at Christine's Café, and two of a Japanese fisherman and couple." The changes, what Carr calls "reframing," is taken as a political statement, one that deliberately "decreases white male representation in the book, and increases women and minority representation" (89). Carr sees these changes as an illustration of Marlatt's emerging feminist poetics. When we asked Minden and Marlatt about the "politics of

"They were deleted probably because I felt they were inferior images and didn't have the same visual strength of place that the images I included did."
Robert Minden—on the deletion and replacement of images in the 1984 edition (Marlatt and Minden, Personal Interview).

selection and placement," they expressed great interest in Carr's reading; and without discounting it as a critical response, they pointed out that the decision to substitute new photographs was Minden's, and that, as a photographer, he was more concerned about exhibiting the "best photos" and less concerned about the politics of representation.

Like Carr, we remain intrigued by the coincidence of image and text—how the juxtaposition of photographs and poems opens spaces for thematic critical speculation. Overall, however, we think this collision (or collusion) of modernist and postmodernist aesthetics precludes any significant reciprocal or illustrative role for the photographs. They become instead the momentoes of objects and people documented by author and artist, written down in Marlatt's *Journal* but written out as the principal focus of her long poem. In *Steveston* the PhotoGraphic bookwork, however, their visual reiteration imports a representational style lost in the translation from notebook to poem, and, for the reader/viewer, the photographs become exhibits, allegorical markers alluding to a shared but differently experienced vernacular moment.

Minden's work exhibits a rhetoric of nostalgia, where Marlatt expresses the melancholic. Taken on their own terms, that is, by aligning themselves respectively with modernism and postmodernism, both effectively defer questions of authenticity. For Minden, authenticity of the image is assumed, even authenticated through signature and specially numbered editions; for Marlatt, authenticity is a matter of remaining true to the language, a matter of getting the words right. What matters here is that both remain true to their respective world views. Minden believes that his photography can capture the moment and, in the process, make an otherwise invisible drama visible; Marlatt's "mediumship," she tells herself in her *Journal*, involves "subjectivity," "identification," and "perception of (a similar) design" (*Journal* transcript 20). As Olalquiaga writes, "What matters most for the distinction between nostalgia and melancholia is not the validity of the memory referent, but the type of cognitive process (essential or experiential) through which an event is reconstituted as a memory" (294).[1]

Marlatt and Minden combine (in a remarkably enduring work of art) two very different cognitive processes; their story is "very much the result of [and we would add, *about*] differences in [their] sensibilities and modes of working" (Marlatt, "On Distance" 93). Marlatt sees the photographs as radiating presence "in a way that is immediately apprehendable,…a sense of identity…crystallized in an instant." Her own writing she sees as lacking "this sense of actual presence": her poems "run through layers of time, levels of

1 Minden seems very aware of the issues surrounding his own documentary practice. In a later work, *Separate from the World: Meetings with Doukhobor-Canadians in British Columbia*, he transcribes and interweaves personal interviews with subjects photographed. Printed beside a photograph of "William Dutoff, Holding his Wedding Picture," the text reproduces Dutoff's critique of Minden's project:

> Without diminishing the significance of your work, it's after all just a photography project. But for us it's our life and not just for ourselves as individuals, but it's the life of our community. (20)

Minden accepts such a view as an honest response, as one more detail to document; and he acknowledges that he sees Dutoff as photographic subject, appearing

> first as a small upside-down figure on the groundglass of my view camera. I had set up the Deardorf outside on a tripod near the Yale Hotel, and watched the delicate images of a small white-haired man gradually increase in size. We exchanged cautious glances, shy smiles—like a slow careful dance. It was some time before we spoke. (16)

meaning, into their own conclusion" (93). In Olalquiaga's (and our) terms, *Steveston* works by reconstituting "Steveston" as event, by juxtaposing and interweaving two modes of allegory: "events can be reconstituted as memories through an allegorical process that favors the intensity of experience over its abstraction…. The focus of allegorical memory is not on the originating event or its representation, but rather on that very intensity and immediacy that places the event squarely in the present. However, since the event is already gone and lived intensity is by definition fleeting and therefore ungraspable, allegory has no option but to attempt crystallizing transitoriness itself—that fugitive experience which it so desperately longs for" (296). Minden's photographs focus on representing the crystallized moment, while Marlatt's poetry crystallizes transitoriness by foregrounding the experience of writing. *Steveston* presents a complex arrangement of nostalgia and melancholia, of memory both fixed and fugitive.

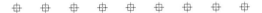

The Vernacular as Accidental Muse

Sharyn Yuen's *Sojourner* provides an intriguing counterpart to *Steveston* (see colour plates). Yuen, a Chinese-Canadian artist, explores issues of cultural representation and personal identity from an "in-between" point of view. Where Marlatt and Minden cast themselves as outsiders, as documentary artists looking in on and responding to a foreign culture, Yuen is a "jook kaak": a name conferred on her by the Chinese community, meaning a bamboo knot or someone caught in the middle of two cultures. As she explained to us in a recent interview, "When I lived in Montreal, in Chinatown during the early '80s, everybody would call me 'Jook Kaak,' a term I'd never heard growing up on the West Coast. It was my father who told me that 'jook' means bamboo, that 'kaak' is a knot. So he says to me, 'You're in the middle. You're Chinese-Canadian.'" When we asked her how the nickname made her feel, she told us, "It was probably the first time I questioned being both Chinese and Canadian. It wasn't until I started a body of work, around 1986, that I started to process why I was called Jook Kaak."

Yuen's position complicates notions of the vernacular, for, as someone born in Canada but into a Chinese-speaking household, she finds herself looking outside her local circumstances for self-definition. Though her mother has lived in Canada for fifty years, she does not speak English. "For her," says Yuen, "there's no need, not in Victoria because she lives within the Chinese community—and when you have six kids, you don't get to step out that often."

"I found 2 bones washed up on the sand, tide out, drizzle, 12 tankers sitting desolate, waiting to be loaded. Looking at the bones, one that looked something like a jawbone, its outside layer eaten away by salt, the marrow cells sucked dry, I wondered who or what it had belonged to, felt a little fear, despite the poem, & realized we are so serious, that the touch in words, in relating, between persons or any living thing, has something of play in it, delight, even in contact, that excitation, excitement (to put in movement, call forth, arouse) & how easily I forgot it, calling into static categories, trying to freeze meaning (that transformational current!) when all *that* is (the freezing) is the detritus of movement (life), leaving me lonely with the bones in my hand."
A letter from Daphne Marlatt to David Wilks—Daphne Marlatt Papers, National Library of Canada, Box 6, f. 24. Reproduced in "Correspondences," Line 13 (1989): 5–31.

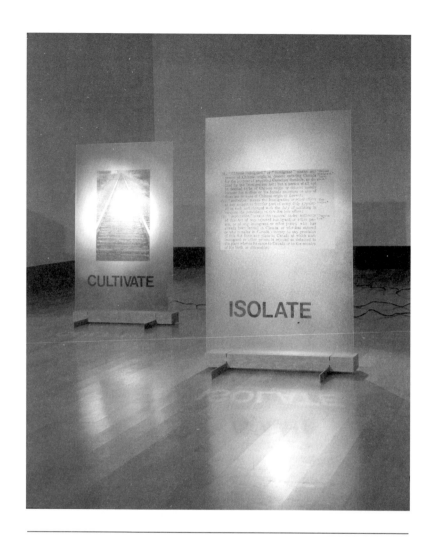

Sharyn Yuen, installation detail of *Sojourner* (1992), *PhotoGraphic Encounters: Prose Pictures and Visual Narratives*. Kamloops Art Gallery (October – November, 2000). Photographs by Kim Clarke. Reproduced with the permission of the artist and the Kamloops Art Gallery. Collection of the Kamloops Art Gallery.

Unless otherwise indicated, all quotations are from a personal interview with the artist in her Vancouver studio, May, 2000.

She credits her mother for keeping the Chinese vernacular alive, acknowledging that when she was younger she didn't want to speak Chinese. "Now it's my nieces and nephews, the grandchildren, who don't speak the language," she says. Yuen can speak Chinese fluently herself but cannot read the language. Images too pose their own translation difficulties.

While growing up, family photographs offered an array of mute attitudes, unheard, even untellable, stories dependent upon Yuen's mother for their interpretation. Many of the stories remain silent

or incomplete, and, like the family photographs, testify to the gaps in Yuen's understanding of her place in the world. At nineteen her mother married a man from Canada and they lived in China for three years, until World War II broke out. She didn't see him again for twelve years, not until she emigrated to Canada, at age thirty-four, with two children in tow. When Yuen was younger, she tried to probe her mother for stories about this period, but her mother would only cut off discussion, saying, "Well, that's the way it was. That's what you did." The family album alone could not tell Yuen the stories she wanted to hear.

Yuen learned to "resist family photographs." She turned instead to the library and to searching out historical documents, finding stories not taught in school and not spoken about at home. "I began to realize that there was a certain history that I needed to work out for myself—and also to uncover for my mother's own healing, for other immigrants of my mother's generation to heal." Like George Bowering waiting for a good wind to carry his story, the kind of personal excavation that Yuen initiates requires a measure of trust, a felt sense that the narrative will resolve itself as much through coincidence and accident as through artistic premeditation. Her first major work *Jook Kaak* features eight 2' x 3' panels with black and white photo-emulsion and text printed on hand-made paper. She introduces the work with a brief paragraph about how she travelled to her mother's village in China:

> The two main objectives were to meet my mother's family and see the life in my ancestral homeland. I gained a number of insights that answered some questions—as well as raising new ones. I share with the viewer the search for Namcheng (the village), the environment, the emotions, and the reality of the event. (Yuen, "Jook" 51)

Beneath each double-exposed photograph Yuen writes a brief narrative, more a fragment of text than a description of the image. During the interview she elaborates:

> All of the photos in the 1986 work were taken with a Nikon camera that I had just bought, one of the first fully automatic 35 mm. cameras. You put in the film and it did its own thing, so, when I arrived at the village, I started taking pictures. I then popped in another roll, or what I thought was an unexposed roll, but somehow I used the same roll twice. So it double exposed, right? I didn't know all this at the time. The intensity of the experience was

"Today," says Yuen, "she tells me it almost killed her. When she came to Canada, her intention was to drop off the children with my father and then go back home. She was thirty-four, with a community and a life in China. Still she had this obligation to bear her husband's children—and how do you return home overseas when you have no money and you don't speak the language? So you arrive in Canada, you stay, and you are reunited with your husband."

overwhelming, and the whole event lasted all of 45 minutes before the cab driver says, "We have to go now." It had taken six hours to get there, and it would take six to get back, and all I had was less than an hour.

For Yuen, the photos are a record of the place, and they are about a response to the place. "The whole work is about the moment when you come to a realization," she tells us. "It was there that I understood 'jook kaak': I was in a location that was physically unfamiliar, but it felt emotionally familiar at the same time. It is that space of being 'in between.' That sense of being present was overwhelming, and I was left wondering how to hold onto something that important but that brief. It took a while to digest this experience."

In fact, the artwork came much later. When she first saw the double exposures she didn't see them as valuable to her art. She cursed, and then became still more upset when her brother (who was travelling with her) told her it was alright, that he had pictures too. Attached to an old style notion of documentation, she wanted "the real thing," her "own experience," not images shot by her brother.

When she returned to Canada with the failed images she put them aside. She continued her interest in papermaking, and it wasn't until she had the paper in hand that the Namcheng photos became important. "And just like that I thought I had something, the pictures spoke to me again. There was that layering of images,

like the layering of cultures. A gift. Conceptually, the piece came together. It wasn't planned, but it happened."

When first exhibited (1986) the images were hung on a gallery wall. Recently another gallery has asked to show them again, this time to be displayed in maple display cases with plexiglass tops. "They are to become archival," says Yuen.

> The idea wasn't mine; it was the curator's suggestion. And I thought that, well, they should be recontextualized: since they were produced 14 years ago, and I liked the idea that they are going to be enclosed. Not to close a chapter or a lid, but to indicate that they have some history—but in a contemporary context. There they'll be, leaning against linen backings, under glass so you can't touch them anymore. The images will be laid down, resting.

It would be easy to impart premeditated significance to the accidental images, seeing the double exposures as a ready metaphor for Yuen's dual cultural experience. The images do suggest some of this, of course—hence their after-the-fact attraction. But the confusion of emotions and expectations—this is what holds Yuen's long-term interest and makes the photographs more than metaphorical tokens salvaged from a potentially nostalgic moment. As Paul Wong writes about both *Jook Kaak* and his own experience, "I have witnessed this emotional journey, the years of assumptions and the confusion of expectations mixed with sheer excitement of the moment that happens all too quickly" (11). It is not the moment but the moment's effect; *Jook Kaak* is also about the process of thinking and of personal discovery—of thinking through images by working with them physically.

Her papermaking provides an ideal venue for physical meditation. Another kind of "jook kaak," a meeting place of Oriental papermaking techniques and Western photography, her photographic works on paper require intense labour. To begin, the paper is cast in single sheets on large screens. Pulp, created in industrial blenders, must then be spread onto the screens, and selected sections are hand-painted with Liquid Light, a commercially available photographic emulsion. Once painted, those sections of the paper become light sensitive, ready to receive the photographic image projected by means of an enlarger. The exposed sheet must be treated first with a developing solution to bring out the image, and then a fixing agent to make the image permanent. The notion of art as physical labour is important to Yuen. The tactile nature of her handmade papers links her work to a craft tradition: she knows

Revelation occurs at unexpected moments:
"My sister printed a photograph for me that I'd never seen before. I had gone through every family photo album when doing my early work, but I hadn't found this one. 'Where did you get this photograph?' I ask, and she tells me, 'Mother gave it to me.' For some reason it upset me that this photograph had been hidden. So I took the photograph with me when I visited her in Victoria and I put it on my mother's coffee table. My mother looked at the photo and said, 'Who's that?' I go, 'That's you.' And she goes, 'That's not me. Look at that woman with that hairdo. She looks crazy, she looks like a madwoman.' I tried to tell her that it was her, but she kept saying, 'No, that's not me.' So I left and came back later that day, and that's when she told me the story about first coming to Canada. 'Oh my god,' she said. 'Those are the early years when I first came. That's when I was bearing your third sister, here, and that's when we were living on the farm in Colwood, and that's when the times were really difficult.'"

that this physical vernacular, the texture of the paper, will come through the photographic image, palimpsestically; and that reciprocally, the paper must be transformed to accept the image. Such activity promotes a particular kind of thinking:

> I know I'm *thinking* when I do my work, whether it's working visually or writing, when I'm engaged in my practice. But during the physical process, there are sudden moments where I find a thread and I recognize a beginning. There's a part of me, when working, that I know I can look to for new inspirations....Sometimes I find that I must switch off, leave the work alone. Much of my art reflects ten years of local history research, and sometimes, as an artist, I want to turn my back on all this. But even if I try I find that the old thread comes back, resurfaces. It's still within me and I've still got to work with it. The more you resist, the more insistent the story becomes.

The kind of thinking that Yuen describes has something in common with the experiental focus of melancholic allegory. Like Marlatt and Minden, she is looking back at the past, seeking to recover some object of personal loss, a piece of family history perhaps—or some narrative thread picked up accidentally, incidentally as it were. Olalquiaga argues that this process is primarily "cognitive," and many would see *Jook Kaak*, or a later work like *Sojourner*, as primarily political; but, for Yuen, the process of working out the narrative seems much more personal and physical, seems indeed to depend upon physical exertion as experiential muse. Yuen translates her interest in personal, formal, and social identity from the experiential to the physical realm of the gallery installation.

Like *Jook Kaak*, *Sojourner* invokes an emotional journey of a subject in transit. As mentioned, the work is generally discussed as a strong political statement where the artist "contemplates the immigration policies that mar Canada's history..." (Gagnon "Can-Asian, eh?" 5). The images and texts—including an extract from the Exclusion Act, which prohibited Chinese immigration to Canada from 1923 to 1947—demand such a response. Yet, when interviewed, Yuen speaks more about the work's physical construction, taking, it would seem, the surface-level message for granted. Like several of the other artists we've discussed in this book, she is wary of works where the message becomes overly fixed or "monumental"; she prefers to think of her artwork as "becoming political," rather than starting off that way. "Yes, it's very political, but for

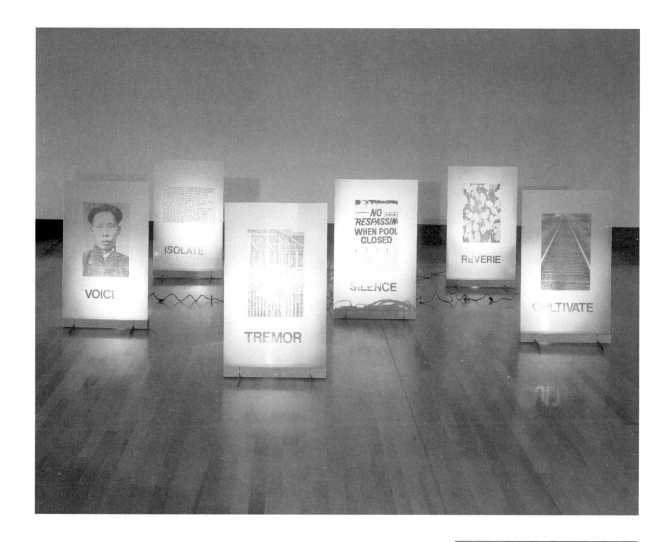

me it's still about family." She is interested in the rhetorical situation her work creates, beginning with the images: "I want the viewer to see the images first. I want them to deal with what they see." She speaks of "pulling the viewer in" and of "experiencing the handmade paper," or *Sojourner*'s glass plates, as physical objects. The paper and glass give voice to her personal labour, so when a piece works, "people get confused about how to place it. Should it be read in a craft context? As high art, about how the images are placed? Or as something radical and political?"

Sojourner consists of six glass panels, each standing in a shallow groove cut into a 2" x 3" wooden base. Two shorter lengths of steel flat bar are placed across the bottom of each base as support. The glass panels are each inscribed with a single word and a photographic image. The texts, SILENCE, VOICE, ISOLATE, CULTIVATE, TREMOR, and REVERIE, are achieved by first placing Letraset dry transfer letters onto the lower third of the glass and

Sharyn Yuen, *Sojourner* (1992). *PhotoGraphic Encounters: Prose Pictures and Visual Narratives*. Kamloops Art Gallery, October-November, 2000. Photograph by Kim Clarke. Reproduced courtesy of the artist and the Kamloops Art Gallery. Collection of the Kamloops Art Gallery.

then sand-blasting around them. The production of each glass sheet would require Yuen to stand and blast away for hours at a time. The various photographs were added later by exposing images onto photographic transfer film and placing the transfers into the open ground glass field left above each word. A small halogen light fixture provides illumination from behind each panel, with the lights sitting on the floor. The back light causes the panels to glow when seen in the dimmed gallery space; the lights cause a shadow of the glass to be cast on the floor, thereby projecting the words into the physical space of the viewer. In a wonderfully sensitive reading of the work, Monika Kin Gagnon likens the effect to "that of tombstones, a graveyard in which various fragments of Chinese-Canadian history resonate" ("Can-Asian" 5).

Like so much of Yuen's work, though, this piece did not begin as either a nostalgic lament or a political critique of historical memory and racism. *Sojourner*, as we know it, began as something of an afterthought. Yuen was in the middle of an artist's residency program at the Banff Centre. She had completed casting fifty panels of handmade paper, and she found herself looking for another project. While making the paper she became fascinated with Banff's transient community of artists, especially the intensity of their conversations and interpersonal relations. "All the words in the *Sojourner* piece," she says, "were words written down as documentation of the people in Banff—about their state of mind in this utopian setting, about their not wanting to leave this place, not wanting to go home." When the offer of an exhibition on "dual cultures" came her way, Yuen realized that the words she had sandblasted into glass had potential significance outside their original context: she took words from a contemporary experience and, like the displaced persons she represents in *Sojourner*, relocated them as elements in a new discourse of thematically linked images.

Knowing the story of *Sojourner*'s construction does not negate or compromise the work's political (referential) appeal; instead it complicates the meaning, invoking the rhetoric of horizontal allegory, suggesting one more aspect of the work's hidden vernacular imprint. For Yuen, articulating the vernacular moment means physically embracing the aleatory.

Redeeming the Subject

We wanted to end this book with a discussion of Ernie Kroeger's work for a variety of reasons. A Canadian-born artist of Ukrainian descent—and as someone who sees family documents as archives

Ernie Kroeger, *Mom and Dad* (1977, 1986). Reproduced courtesy of the artist.

to be explored, understood, reproduced, rearranged—Kroeger has long embodied for us the "aura of the authentic, the exemplary," his art a working *with* and *through* the vernacular moment. In addition, he has studied creative writing with Robert Kroetsch, is familiar with and has an affinity for the artwork of Fred Douglas, and has exhibited his own work alongside that of Brenda Pelkey.

We had planned to discuss his major PhotoGraphic narrative, *Family Stories*, as an example of the scrapbook aesthetic articulated by Kroetsch and illustrated by many of the artists' books we survey in Chapter 6. Like Kroetsch, and like Yuen's *Jook Kaak* series, Kroeger uses images and texts (a miscellany of personal documents, physical memories) to narrate his family history, tracing his heritage by photographing his parents at home in Winnipeg and then travelling to the site of their displacement in the Ukraine. The work, a visual narrative, is mostly displayed as diptychs, pairs of pages from an incomplete book. In one of his "artist's statements," he says, "I have collected a large amount of material that has developed a life of its own and is often chaotic, fragmentary, and resistant to organization. The information is disconnected and constantly changing and never seems to have fixed meaning" (*Search, Image and Identity* 52). In short, *Family Stories'* use of vernacular materials, its suspicion of fixed moments and meaning,

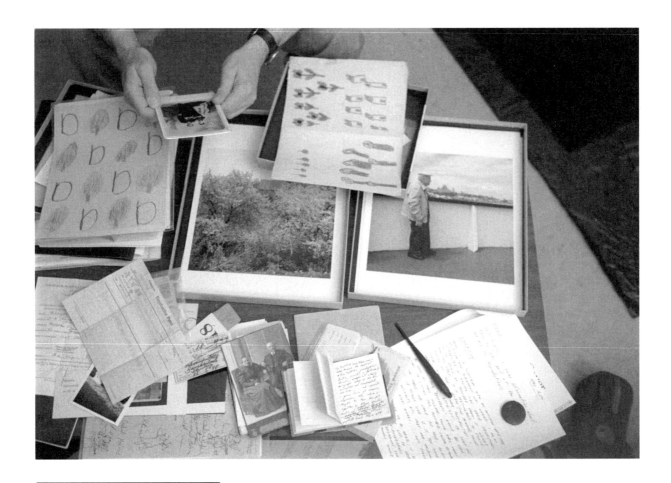

Sorting through Ernie Kroeger's original family documents. Photograph by Donald Lawrence.

Unless otherwise indicated, all quotations are either from a series of personal interviews with the artist or from his unpublished journal notes. June, 1995 and May 2000, Kamloops, B.C.

and its intercession of personal narrative make it a wonderful example to consider. We thought we understood it.

However, when we received and started to inventory Kroeger's artwork for the exhibition we were co-curating at the Kamloops Art Gallery, Kroeger surprised us. We had told all the participating artists that we were interested in exhibiting both their finished works and something of their process, perhaps by way of manuscript drafts, notebooks, sketches, maquettes, and so on. We also asked to interview the artists about their work. Kroeger shipped his major pieces crated, direct to the Gallery; but he brought with him to the interview a small cardboard box full of all the original family documents—including letters; a Canadian Pacific envelope with bright texts and graphics representing modern transportation; baggage tags, immigration documents, boarding cards for the "Scythia"; a 7" x 9" child's notebook with Ernie Kroeger's early writing lessons, and an inserted sheet of further letters and words dated "October 10, 1961"; a stack of photographs; his mother's poetry, written by hand in what looked like a school scribbler; his

grandfather's death certificate; a telegram from Stuttgart, dated "25.9.48," with the text translated in block capitals, "=STAY WHERE YOU ARE AWAIT LETTER=DAD REMPEL+"; a colourful folded guide of services for guests of "Hotel Zaporizhya"; his father's travel diary, written in Russian; the family's landing certificate, where the family name is officially changed from "Kröger" to "Kroeger." In effect, he presented us with the original sources for what had become his most extensive work to date, sources that until that moment had only been exhibited in facsimile form—in photographs or as colour photocopies. He asked whether we would like to keep the box, look through it so we might suggest objects or artefacts to exhibit as an accompaniment to *Family Stories*. "You won't lose it?" he asked. "It's important to me."

As we looked through the documents, we talked about his notion of "fixed meaning." Kroeger had read an earlier version of our chapter on frozen words (published as a journal article in *Mosaic*), so he already understood part of our immediate interest in his work. It became clear that he wanted to discuss the concept further, that it was something unresolved and in process. He handed us an old photograph, a small family snapshot showing his father jumping off the bow of a spritsail dory, with his grandfather seated at the oars and his uncle seated in the stern. The image he explained was one he thought we'd want to see, something that had silently informed his earlier work and that he was only now trying to write about.

He had determined from looking closely at the image that the boat is anchored, and thus the raised sail and his grandfather's use of the oars would seem more a theatrical pose than a true captured moment. The photograph (dated on its back, "Juli 1929") would have been taken with a type of folding tourist camera, while the print appears to be on what was called "printing-out-paper" or, more colloquially, "P.O.P." prints of this sort were of common interest to amateur photographers during the 1920s and 30s. The P.O.P. process sandwiches the negative together with the printing paper in a wooden and glass frame. The exposure had to be made in sunlight, over a period ranging from a few minutes to half an hour, depending upon the density of the negative and the intensity of daylight. From time to time the photographer would open one half of the printing frame to check the exposure, the other half holding the paper and film in registration. Once properly exposed, the photographer would fix the print and tone it with a gold chloride solution. Sometime during this process, perhaps as a result of holding the picture before it was completely dry, a fingerprint became fixed on the paper, just at the top of the sail.

Kroeger also showed us a second P.O.P. print. Tonally darker, with less contrast and thus more obscure than the first, it shows the family picnicking by the shore, the same boat's spritsail serving as a lean-to shelter (see colour plate). It is with reference to these photographs that we now want to discuss *Family Stories*.

The image of his father caught in mid-air has been used before, once in a magazine "excerpt" from *Family Stories* (*Blackflash* 13.1, 1995), and, according to Kroeger, "as an introduction to earlier exhibitions of the work." Such playful insertion of "fragments" is part of Kroeger's method; as he explains, in what amounts to a remarkably specific literacy narrative,

> The structure of the work reflects the process of my research and collecting mimics the way memory works and the way thoughts arise spontaneously. The non-linear nature of the material is represented in a narrative form that moves easily back and forth between past and present. Each piece is constructed in the form of two opposing pages reminiscent of a book that has been opened arbitrarily to a certain page. The pieces are connected, though not in a direct, linear way. The pages are meant to be seen as fragments of an incomplete book: an incomplete story. ("Artist's Statement" 52)

The only published text on this particular photograph accompanies the *Blackflash* excerpt, where Kroeger writes pointedly, "The story begins in Ukraine where the Dnieper River makes a big arc before emptying into the Black Sea. That is where the photograph below was taken in July 1929. It shows my father diving off the prow of a boat. My grandfather is rowing and my uncle is steering. Apparently the photograph was a setup and taken by my grandfather's cousin in exchange for a boat ride" (11).

The water, the family exchange and staged joke, the interest in photography, the fingerprint fossilized as accidental signature, the father's leap caught in mid air, the "recycling" of the boat's sail as picnic shelter: all these elements were there at the beginning, where the "story begins." Kroeger's notes, all unpublished and in typescript form, show repeated attempts to "read" the photograph and tell its story:

> I've jumped off that photo a hundred times.

> I remember seeing this photo in my father's album when I was young. I don't know when my father first showed it to

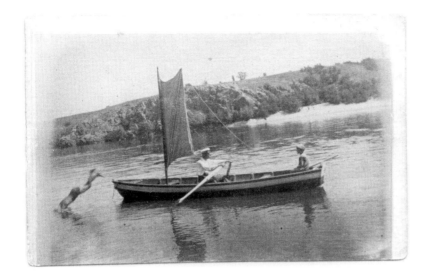

Ernie Kroeger, "The Boat Photograph" in *Old Photos & Artifacts*, inventoried and exhibited as part of *PhotoGraphic Encounters*, Kamloops Art Gallery, October 2000. Reproduced courtesy of the artist.

me. Where were we sitting? I remember all the rooms and furniture. Maybe we were sitting on that old maroon couch. Maybe I was sitting on his lap with my brother. Maybe Mom had gone out and he was home alone with us turning one black page after another. This is the house where I was born. That's me diving off the front. I was a good diver and swimmer. We used to swim across to the big island and jump off the cliffs.

My uncle wrote an article for the *Mennonite Mirror* about his father and forefathers who were clockmakers. He used this photograph in the article but decided to tidy it up — to make it look right by cropping my father out of the picture. It's crazy my uncle said, and tried to fix it. Doesn't make any sense. There were too many things wrong with it for it to serve a useful purpose. So he doctored it, but when my father saw it he was furious. How could you cut me out like that? You're telling the story of our family and you cut me out! He didn't let him forget that for a long time.

The reflection of the sail encloses ripples like a double exposure. It reflects the fingerprint in the sail. Whose fingerprint is that? Probably the photographer's handling it too soon — before it was completely dry. Maybe he was in a rush to claim his boat ride. Maybe he only printed it at the last minute as photographers are wont to do and had to rush drying it.

Each narrative take reflects a different aspect of Kroeger's own artistic practice: the photograph as jumping off point, the son as recorder of his father's stories, the family history of writing and rewriting, the repeated allusions to clock time and history, the "doctoring" and rearranging to suit the truth of fiction, the optics of double exposure, the accidental delight of the personal signature imprinted on the sail, and Kroeger's compulsive deferral of a final fixed meaning. "The surface of water is as illusory as that of a photograph," he writes later in his notes. "Pleasant and soothing to look at, but hiding more than it reveals." Like Kroetsch, Kroeger sees the vernacular moment as an archival exploration, as "unhiding the hidden."

The notes are annotated with changes and corrections, margin thoughts to consider later and revise. He writes, "I could connect this with a photograph my mother took at Bethania of the Red River flooding in 1950." He discusses the boat's design, how his grandfather drew up the plans at 1:2 scale and how he made the builders rebuild it, catching their mistakes early on. Kroeger reveals how he made a tracing of the boat, trying to work out its dimensions, its original colour. He notes, "My father said it had four modes of propulsion: sail, oars, poles and someone (him) walking along the shore and pulling it with a rope." On another page he writes of the photograph as absent space, an echo of Ondaatje's blank frame:

> I've had the photo for several years now and feel a bit guilty when I think of the blank space in my father's photo album—the photo corners still there marking where it should go back. But I don't want to give it up.

Most of the notes are prose fragments; intensely felt and carefully shaped, they provide an almost uncomfortably candid view of the artist at work. We get the impression in talking with Kroeger that his fleeting sense of guilt is genuine, and that if he can't give up the photograph, he feels a family obligation to fill the "blank space" with stories. In the process, he will resituate the photograph, moving it in facsimile form from its vernacular home (his father's photo album) to a high art setting (the art magazine and gallery). First, though, he must work through what he calls his "research heap—hidden": "It's a good story I'm telling. I can see that now after having struggled to pile it all up—to finish the piling before beginning to tell the story." At the top of the pile, there's a poem entitled "Retouching a Photograph," several more occa-

sional notes, and one final prose section, a remarkable piece revealing an artist's eye in the process of redefining his own vernacular moment:

> My eye moves quickly round the photo—inside a frozen moment. The space between my father's left foot and the tip of the prow line up. From there I follow the curved line of the boat to the back where Artur sits paralyzed, ready to steer on father's command, alert and slightly afraid. I think he's also holding the line of the sail that curves to the top. A little arc takes me to the top of the mast then slides down through the hull to the reflection, zig-zags back up to the oar and then angles along the oar to grandfather's hands. His eyes are focussed on the space between his hands to keep it even, even if it is only for a photograph. He's beyond criticism. He's the head of the family. Tickling the back of his neck is the lower point of the sail. The line curves back to the mast then back up in a diagonal, back to Artur, back along the other side of the boat to my father's foot, along his body and disappears into the water.
>
> Saccade is a term for the flick of the sail. Also for one of the eyes' movement.

"Saccade" describes the back and forth movement of the eye during reading, that recursive "zig zag" motion where we link that which has been given with that which is new. Meaning occurs not by fixating on a single letter, syllable, or word, but by keeping the eyes in motion. Kroeger finds meaning and his vernacular moment in the "flick of the sail" and in how that movement connects allegorically in a recursive arc of images, anecdotes, power relations, interpretations, misrepresentations, and family memories.

This "back and forth between past and present" has something in common with Fred Douglas's notion of narrative as a "fluttering": both artists resist freezing the moment, seeking instead the moment's release into narrative—or, in Kroeger's case, into the circulation of family stories. His project, the excavation of a family history—and an Old World patriarchial family history at that—might lend itself to a kind of vertical representation, a sense of family order. The speaker voices unquestioning acceptance of the grandfather's authority; he feels a sense of guilt and duty, and he shares his family's burden of the suffering experienced during the Soviet revolution. There is something of this reflected in the com-

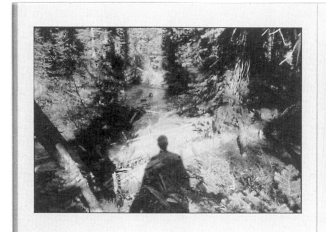

Ernie Kroeger, *I want to have sublime feelings* (1991). Reproduced courtesy of the artist.

paratively austere colouring of his photographs, and their role as reenactments of earlier events. What moves the work from nostalgic (that is, vertical) retracing to melancholic (horizontal) allegory is that saccade of personal narrative, the presence of Ernie Kroeger as participant observer and teller of the tale, someone who searches for his origins in people, places, and objects that embody a double-voiced mix of popular, mass, and vernacular cultures.

This is a focalizing position missing from his early documentary work, the *Broadview Road Project*, where he creates relatively straightforward, celebratory images of people living on a single block of Calgary's Broadview Road. In this work, as Robert Enright observes, "Kroeger has no interest in working out the secrets hidden between the lives of these people;…[t]his world is pretty much as it appears" ("The Indescribable" 54). A little later, though, in the work that precedes *Family Stories*, we see a much more ironic and involved "authorial" presence, one already anticipating and exploring many of the issues he is only now working out with reference to the 1926 photo.

His 1991 diptych *I want to have sublime feelings* links romantic aspiration to the unexpected image of a forest clearing, an enclosure rather than the open space or mountain top panorama classically associated with the sublime. The photographer's shadow intrudes ironically, introducing an autobiographical presence and immediacy not usually associated with inspiring landscapes recollected in tranquility. Other images from this series, first exhibited in *Rephotographing the Land* (1992), offer a humorous critique of the scenic and the picturesque.

With Joanne, Iceline, for example, is taken with a Widelux

Ernie Kroeger, *With Joanne, Iceline* (1990). Printed using black and white film on coloured paper. Reproduced courtesy of the artist.

panoramic camera, the design allowing for a panoramic scan without the obvious peripheral distortion of a wide-angle lens or the accompanying effect of increased apparent distance between photographer and subject. With such a camera, the lens scans from side-to-side (saccade-like) during the "moment" of exposure. A vertical slot, or baffle, that travels behind the lens allows the light to reach only that part of the film that is in line with the lens' optical axis during the exposure. Within this frozen moment, then, the exposure is in continuous motion. The panorama encourages a horizontal reading, while Kroeger's playful jump, echoing his father's leap from the boat, offers an ironic, playful vertical gesture impossible to maintain. What holds our attention is not the composed instant but the attitude, the impromptu visual wit and implied narrative. As Kroeger explains, "I depend a lot on spontaneity and serendipity. Many of the photographs [in this series] are done with a sense of play, capturing the spirit of a specific moment" ("Artist's Statement" 19).

These photographic self-portraits, with artist caught in mid-air, jumping up from a large rock or over a stream, may also be read as Kroeger's attempt to revitalize "an environment that has quite possibly been over-photographed," over-invested with an imported vertical aesthetic. Noting that "[t]here is a large historical inventory of stories and photographs of adventure and exploration which has contributed to the romantic ambience of the Rockies," he sees

Ernie Kroeger's Widelux camera.

Ernie Kroeger, *Crossing the Great Divide* (1988). Photographed in collaboration with Kate O'Neil. Reproduced courtesy of the artist.

his work as "a response to this history and an attempt to deal with some of the stereotypes about the mountains" (19). Taken at points along Alberta's Great Divide, Kroeger's "rephotographs" reference images from the latter nineteenth and early twentieth centuries, photographs by William MacFarlane Notman, Mary Shaffer, Mary Vaux, and, most notably, Byron Harmon. They also reference, more indirectly, the *Second View: The Rephotographic Survey Project* undertaken a decade earlier.

During the three years of their project, from 1977 to 1980, Mark Klett, Ellen Manchester and JoAnn Verburg sought out and "rephotographed" those sites made famous by the photographs of Americans William Henry Jackson, Timothy O'Sullivan, and others during the previous century. This project, which remains of considerable interest to Kroeger, was, in part, designed to record the differing pace of geological and cultural change. Verburg notes a further interest, one more specifically linked not just to what those nineteenth-century photographers photographed, but to how they photographed. "What would happen," she asks in considering Jackson's 1873 photograph "Mountain of the Holy Cross," "if you went back and photographed it? Just in terms of the syntax of photography" ("On the Rephotographing" 5). What the photographers of the *Second View* came to appreciate, and became fastidious in replicating, were the careful positioning and minute optical adjustments of the view camera. What they reproduced was not a snapshot of the landscape but, rather, a carefully articulated composition, a distinctly referential syntax.

Such faithful replication of archival views holds little interest for Kroeger. If the *Second View* survey project wanted to know

Ernie Kroeger, "Die Alte Eiche"
(1991). From *Family Stories*.
Reproduced courtesy of the artist.

whether "there is something about documentary photography that is in fact repeatable" (6), Kroeger's work argues that we repeat the past at the expense of our vernacular presence. Instead, he places himself into the landscape, insisting that every double take becomes a kind of double exposure where representation is affected by personal response and choice. This is, of course, the same commitment Kroeger shows in his treatment of "The Boat Photograph," where each successive revision necessitates a "re-see-ing"—an imaginative reanimation rather than a replication.

The reanimation of family stories means keeping artefact and personal response in circulation. In the most recent showing of *Family Stories*, Ernie Kroeger's contribution to *PhotoGraphic Encounters* at the Kamloops Art Gallery, "The Boat Photograph" and many of his other artefacts are displayed in glass-topped plinths. It is the first time that the actual artefacts have been included in this way, and their presence affects viewer/reader response to the works on the surrounding walls, complicating the stories conveyed. As displayed, the artefacts announce themselves as the source for the "Documents," sheets of colour Xeroxed paper (hung in pairs or groups of four) that have on them a miscellany of short texts and reproductions of the actual documents, some Xeroxed directly and

Ernie Kroeger, "Postcard of the Old Oak" (c. 1900). From *Family Stories*. Reproduced courtesy of the artist.

some reproduced as small attached C-prints. These sheets are pinned onto foam-core panels, which have been covered with black velvet, such that a small border of the velvet is visible around and between each of the sheets (see colour plate).

The selection of these "Documents" shifts from exhibition to exhibition and is contingent on larger, framed photographs, C-prints, presented in wide, archival mats and wooden frames about three feet square. Taken with a medium format camera, the colour photographs have a crispness and precision to them that complements the tenuous and, at times, obscure look of the "Documents" (see colour plate). The framed photographs, mainly of his parents and places associated with the geography and history of his family, hang singly or in close pairings, with some placed quite near to a document panel.

The relationships between these photographs and artefacts is a complex, un-settled one, playing the high-art form of the framed colour photographs against the more provisional form of the tacked "Documents." Despite the horizontal pull of this narrative arrangment, it is still possible to read the installation as an incre-

mental narrative tied, rather traditionally, to a guiding theme. Ray Conlogue, for example, sees the interest in *Family Stories* coming "largely from history, not art." He focuses on the image of an empty field where Kroeger's family village used to be, finding it "not exceptional in itself." It "becomes compelling," though, when the documentation fills in the image, "when we read how in 1919 his grandfather was hacked to pieces by revolutionaries not far away. It becomes moving when a bit of a grand-uncle's letter is appended to the photos: 'Tell them the nightingale still sings'" ("Family Viewing" 8). The problem with such otherwise sympathetic readings is that they privilege a vertical orientation, relegating the horizontal (allegorical) pull of the narrative to, at best, a supplementary function. Kroeger's stories, we would argue, tempt such a response, but they also invite a more tentative, exploratory shuttling back and forth *between* groupings of images and texts.

One of these groupings serves as a useful introduction, showing how the vertical and the horizontal come together and contest one another in a story of "Die Alte Eiche" (The Old Oak). The grouping as a whole references the traditional art historical categories of the diptych or the triptych, functioning as both at the same time. On the left side we see one of the large colour photographs of the tree as it appeared in 1991. To the right is the "Document" panel, with its own pairing of two more pieces: a page of text and a reproduction of the same tree, a postcard from a century or so before. The texts reads:

> Die Alte Eiche
> I took this photograph in the Spring of 1991 during a visit to the place my parents were born. In August, 1995 the *Globe and Mail* reported that the Ukraine's most famous tree, the 700 year old Zaporizhia Oak, had died. The tree started to die when a special drainage system built around it broke and remained unrepaired the previous year. Experts unsuccessfully tried to save the oak with treatments that included burying goat carcasses and chicken dung near its roots.

> The postcard shows the same tree at around the turn of the century. My father was born only a few kilometers away in the town of Rosenthal. Someone who thought this information was important to remember wrote on the back of the card: "It was said that children of the village played hide-and-go-seek in its branches."

Ernie Kroeger, "My Mother at Her Grandmother's Grave" (1993). From *Family Stories*. Reproduced courtesy of the artist.

The postcard features a commercially produced image of a popular culture icon. "One of the Ukraine's most famous trees," the old oak is shown with its full foliage. In the area that is left around the tree certain details are evident: a fence woven from the boughs of surrounding trees and some kind of horse-drawn farm implement, perhaps a hammer-mill. These details, and the card itself, speak to the time of Kroeger's great grandparents, before the Russian Revolution and, in contrast to the more recent photograph, could be taken to be a nostalgic image of prosperity, one suggesting the fullness of the family. The much larger and more recent colour photograph situates the tree much closer, in the present, and defoliated. In the spaces on either side of the trunk and below its branches we see evidence that the farm represented in the postcard has been transformed into a park of sorts, with crushed gravel pathways encircling the tree, which now appears without life.

This pairing of images seems, like the historical form of the vanitas, a musing on life and death, a symbolic representation of mortality. The viewer is tempted toward such a metaphorical reading. The old oak and the family photographs suggest the almost too obvious metaphor of the family tree. But the nostalgic cliché won't

Ernie Kroeger, "Dneiper at Nikolaipol" (1991). From *Family Stories*. Reproduced courtesy of the artist.

work: though death is an important aspect of the exhibition, the family itself is not dying. Neither is it represented as a fixed monument or the subject of souvenir postcards. Something other than a vertical narrative logic is at play.

The ostensibly matter-of-fact tone of the text panel "hides" an equally complex juxtaposition of competing viewpoints. The German title, "Die Alte Eiche," for example, lends a formal, archival context to an otherwise informal narrative. Kroeger tells us that the photograph was taken on "a visit," and that four years later he read of the tree's demise. Unlike other Canadians who might have read this story in the *Globe and Mail*, Kroeger has actually seen, even photographed the tree. Though the *Globe*'s use of the definite article raises the Oak to "given" status—that is, not "an Oak," but "*the* 700-year-old Zaporizhia Oak"—most readers would not share Kroeger's personal interest. What others might read as a quaint but familiar tale about evil technology (the unrepaired "drainage system") defeating Old World icons (both the revered tree and the failed vernacular remedies), Kroeger "reads" the story differently. He sees the tree as a more personal landmark defined in proximity to his father's birthplace. He collects postcards of

images already taken. He is among those "who thought this information was important to remember." Where some might see the reference to children playing "hide-and-go-seek in its branches" as little more than a nostalgic observation of loss, we suspect that Kroeger invokes the reference as one more horizontal allegory: after all, his *Family Stories* is all about seeking and "unhiding" the hidden.

Once we uncover personal information, our reading changes. Consider how, in one pairing of the framed photographs, we see Kroeger's mother standing over her grandmother's grave. This image, a personal reflection upon death and ancestry, is paired with a simple, poetic image of a small stream, what is actually the headwaters of the Dneiper river. The stream, like the grave, suggests a strong association with the homeland as "a source"; yet, as Blake Fitzpatrick discovers, Kroeger's great-grandmother was a woman Kroeger's mother "never knew and who died in Canada before Kroeger's mother arrived." Any initial understanding of the river as both source and image of continuity becomes unsettled; and Fitzpatrick thus reads this pairing as one more example of "temporal discontinuity," where Kroeger produces "image/texts unresolvable into neat chronological histories" (4).

Kroeger's framed photographs and "Documents" do not abandon what we have been calling vertical narrative; they simply render such traditional readings incomplete. That said, some measure of traditional response is necessary, for one cannot write family stories without invoking universal themes. Kroeger himself notes a certain nostalgia for the past history of his family; as he says in an "artist's statement" for an earlier showing of these works at Calgary's Stride Gallery,

> I have come to recognize similarities between my parents and their parents and between my parents and myself. These moments have revealed a profound sense of kinship where I feel an almost visceral connection to the past.

Vernacular moments inevitably invoke identification, and thus appeal to common themes. What Kroeger seeks is to keep such moments in motion by encouraging a shuttling back and forth between the vertical and the horizontal. He is counting on us to read vertically for aesthetic coherence and horizontally for the array of lateral associations available. When those associations become personal we move away from an interest in the arrested moment and enter into the vernacular moment of Kroeger's narrative.

In responding to *Family Stories*, an exhibition of an unfinishable book in progress, we are invited to set aside learned reading habits, especially our expectations of a "finished" narrative form. Family stories occur randomly, in response to questions posed while looking at old photographs, or when visiting a place where one's parents were born. Family stories are conversational, non-linear, not governed by generative metaphors or literary convention. What links the scenes, anecdotes, photographs, and documents in Kroeger's work is the focalizing presence of the artist remembering, researching, collecting, arranging, and otherwise sorting out his life. It is important to Kroeger that the arrangement change with each exhibition, that the stories remain fluid. To read *Family Stories* fully, then, we must enter into this same fluid process, retracing the way memory works. In this way, we are encouraged to participate as "co-authors" learning to compose, learning the process of composition. Like Kroeger's notebook drafts on "The Boat Photograph," *Family Stories* is about revisiting and reworking the past; it is about moving back and forth "easily" between past and present. As a literacy narrative, it teaches in the telling that life is revision.

Conclusion

To some extent the kind of project we are engaged in here (and the kind of practice we argue engages the artists we've represented) contradicts much contemporary criticism and theory. A postmodern aesthetics of borderblur is more commonly said to celebrate narrative fragmentation and heteroglossia, thus effectively prohibiting talk of personal perspective and authenticity. As Susan Bordo puts it, too often "the spirit of epistemological *jouissance* obscures the located, limited, inescapably partial, and *always* personally invested nature of human 'story making'" (144). The kinds of visual and verbal narratives we've been looking at advocate a postmodern alternative. Simply pointing out that truth is unknowable, they seem to say, does not relieve artists (and readers) of the personal responsibility for negotiating provisional (fictional) truths; and in the process they successfully acknowledge in what ways the truths we advocate imbricate other competing interests—rival narratives drawn from our experience of popular, mass, vernacular, and high art cultures.

What links all the artists featured in *PhotoGraphic Encounters* is their commitment to narrative, their shared sense that the past has present-day significance, that it can be "unhidden" and made a

part of our lived experience. Their work shifts our focus from originality to authenticity, from the unique frozen moment to the shared vernacular. Their work speaks to us in the vernacular moment, horizontally, asking us to participate in ways that other cultural spheres do not.

In her novel *Fugitive Pieces*, Anne Michaels calls this moment the "gradual instant," a meeting place of past and present where the palimpsest of history only becomes fully meaningful when read physically, when it "touches" us in the vernacular. The work of artists like Fred Douglas, Ernie Kroeger, Robert Kroetsch, Daphne Marlatt and Robert Minden, Michael Ondaatje, Brenda Pelkey, and Sharyn Yuen touches us. Such work also teaches us: it advocates a place for the vernacular in high art—and, more importantly, it validates our presence as readers and viewers in the vernacular moment.

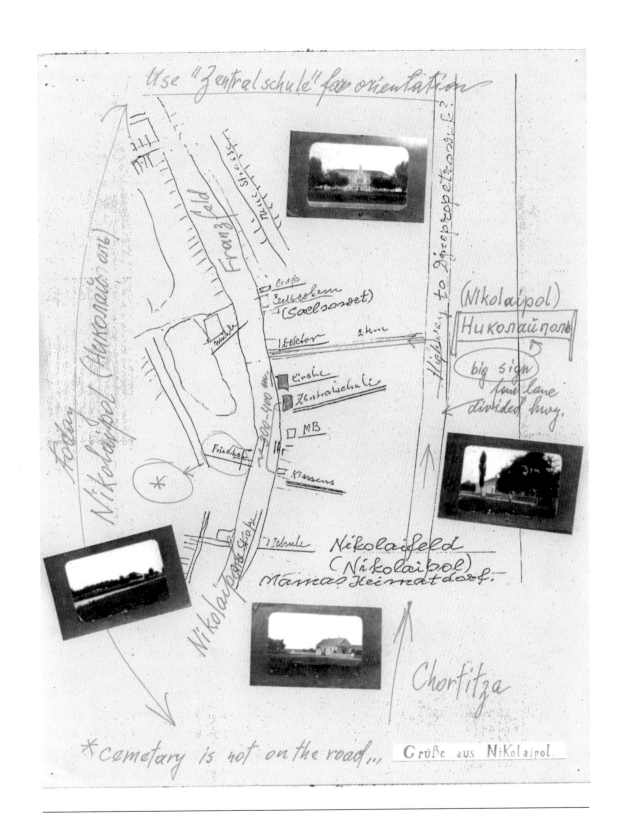

Ernie Kroeger, "Document" (1995). From *Family Stories*. Reproduced courtesy of the artist.

Appendix
Blurring Boundaries:
PhotoGraphic Encounters, the Exhibition

PhotoGraphic Encounters: Prose Pictures and Visual Fictions

Organized by the Kamloops Art Gallery
Guest curated by Donald Lawrence and Will Garrett-Petts
October 15 to November 26, 2000
Weyerhaeuser Gallery

George Bowering	Daphne Marlatt	Brenda Pelkey
Fred Douglas	Lise Melhorn-Boe	Michael Snow
Roy Kiyooka	Robert Minden	Fred Wah
Ernie Kroeger	Michael Ondaatje	Sharyn Yuen
Robert Kroetsch		

Brenda Pelkey, *Telephone Booth* (detail) from *Dreams of Life and Death*, 1994

Kamloops Art Gallery

The Kamloops Art Gallery gratefully acknowledges the financial support of The Canada Council for the Arts, the Museums Assistance Program through the Department of Canadian Heritage, the Province of British Columbia through the British Columbia Arts Council, the City of Kamloops, the Government of Canada Human Resources Development, corporate donations and spornsorships, foundation grants, general doantions and memberships.

Members' Preview and Opening Reception
Saturday, October 14 at 7:30 pm
Reading by Daphne Marlatt at 8:00 pm

Panel Discussion
Sunday, October 15 at 1:00 pm
Fred Douglas, Daphne Marlatt and Sharyn Yuen
Moderated by Donald Lawrence and Will Garrett-Petts

Curators' Tour/Lecture
Monday, October 23 at 7:00 pm
Donald Lawrence and Will Garrett-Petts

Reading by Robert Kroetsch
Thursday, November 9 at 7:00 pm

101 - 465 Victoria Street Kamloops British Columbia V2C 2A9 Tel: 250 828-3543 Fax: 250 828-0662 E-mail: kamloopsartgallery@kag.bc.ca www.galleries.bc.ca/kamloops

As a visual person working in the visual arts field, I have been indoctrinated with "picture theory," the hybrid practice of combining text with imagery which gained momentum in the visual arts during the 1960s. The works of Conceptual artists such as Joseph Kosuth, Robert Morris, Joyce Wieland, and so many others have already firmly established "language and art" as an important thematic concern—one that both blurs and complicates the visual and verbal arts.

Therefore, in terms of visual art trends and preferences, I approached the *PhotoGraphic Encounters* project with a bias. I wanted to see, and see discussed, something new in the visual arts; more specifically, I confess I wasn't initially moved by the idea of another re-reading of text-based photography. However, after spending time with the *PhotoGraphic Encounters* manuscript, the "pre-text" for the exhibition, I found myself oscillating between the hybrid intermeshing I knew so well and the provocative literary concerns I had not previously considered. *PhotoGraphic Encounters* pushed me in a different direction, and the gallery component of this project has, as a result, taken on a new and compelling meaning.

The invitation for the *PhotoGraphic Encounters* exhibition, Kamloops Art Gallery, October 2000.

A few years ago, critic and curator Andreas Hapkemeyer noted of another image/text exhibition (*Image and Word, Photo and Text*) that "one of the great accomplishments of the avante-garde was its success in liberating art from its centuries-old dependence upon literature." After reading *PhotoGraphic Encounters* I'm tempted to observe that the greatest accomplishment of photography, when integrated as more than an illustrative component of a literary work, is the potential liberation of literature from itself. What both the literary authors and the visual artists explore here is the narrative potential of visual imagery to create a "third text" or "Third Space"—that place where, according to Garrett-Petts and Lawrence, the narrative impulse disrupts the frozen moment of high modernism.

The literary works chosen—Robert Kroetsch's *The Ledger*, in which the visual presence of the original family ledger plays so important a role; or Daphne Marlatt and Robert Minden's *Steveston*, where photograph and word mark very different understandings of the vernacular moment—reference visual images as integral narrative elements. Similarly, the works of the principal visual artists employ and/or reference vernacular materials, creating shared moments where, as viewers, we find ourselves participants in a narrative performance.

It is this shared sense of intimacy and the use of the vernacular (particularly the vernacular's focus on memory) that informs the works by Fred Douglas, Ernie Kroeger, Brenda Pelkey, and Sharyn Yuen.

Some of the works in the exhibition, such as Brenda Pelkey's "Telephone Booth," find their power in strategies used within film-making by using codes that act as signifiers or triggers for memory and communication. Other works, such as Sharyn Yuen's *Sojourner*, enact the ritual of memory, adroitly avoiding the pitfall of over-indulgence that can result in a victimized narrative.

Kroeger and Douglas also use memory as a signifying tool, one always in danger of becoming fossilized by the camera. In a subtle and sometimes light-hearted manner, they both push the use of text to rehabilitate seemingly frozen moments of narrative.

The colour-plate section of this book references the exhibition held at the Kamloops Art Gallery from October 15 to November 26, 2000. By publishing this portion of the book we hope to create another type of dissemination, one that will allow the work to linger beyond the confines of the gallery walls, while providing the reader with an opportunity to revisit the Third Space the authors discuss.

Susan Edelstein
Curator, Kamloops Art Gallery
October 2000

Colour Plates

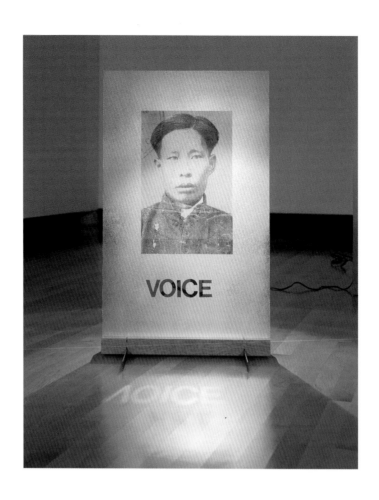

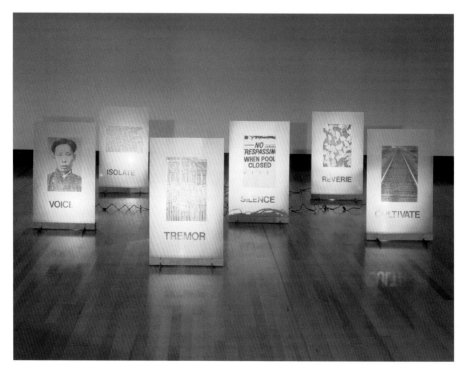

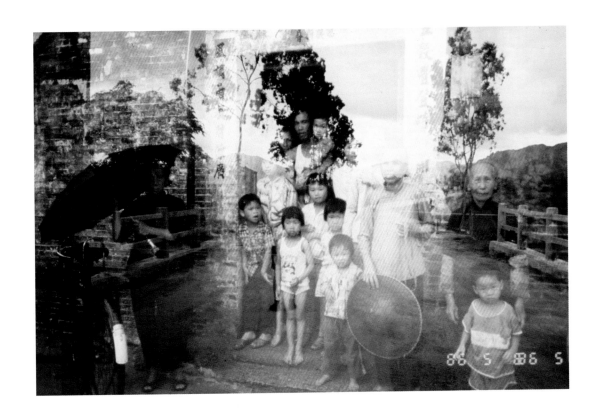

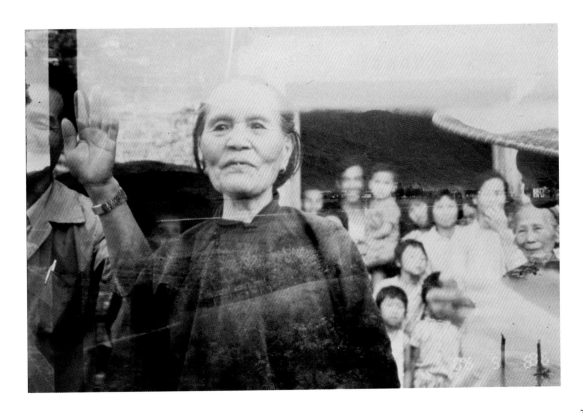

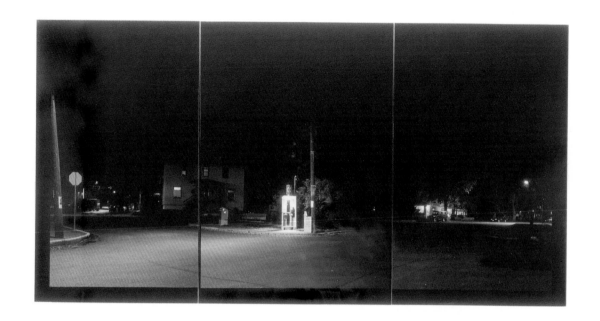

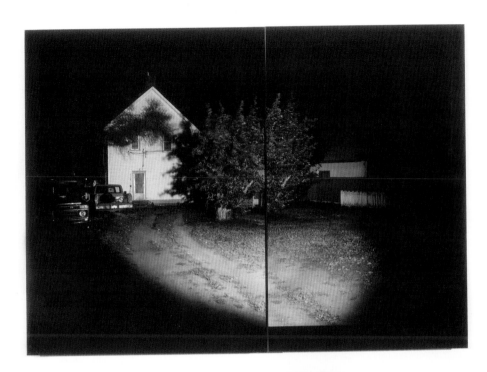

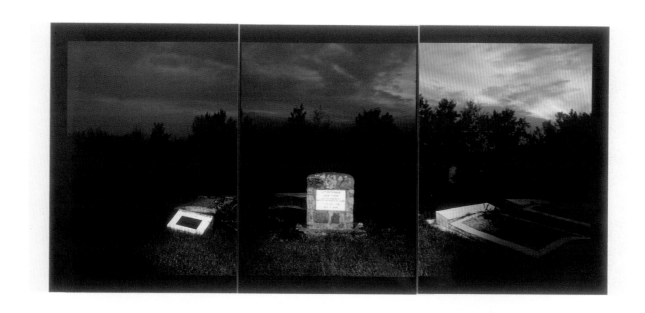

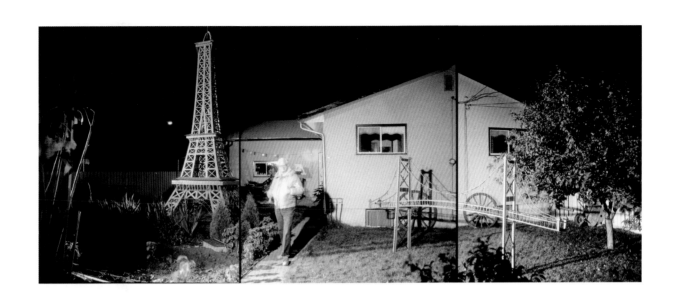

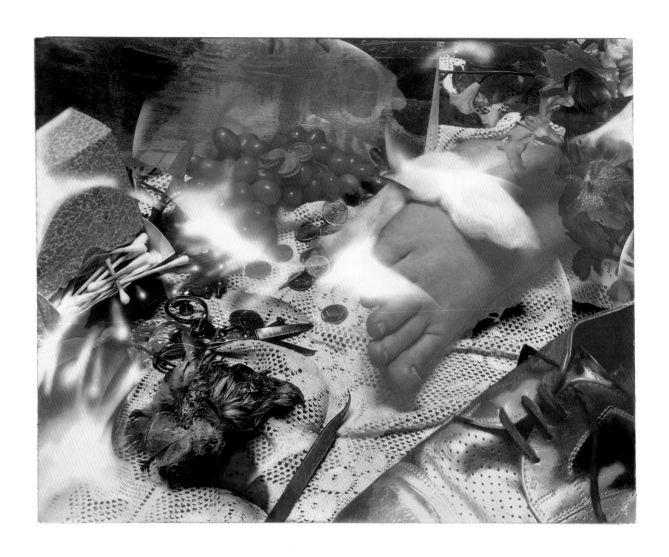

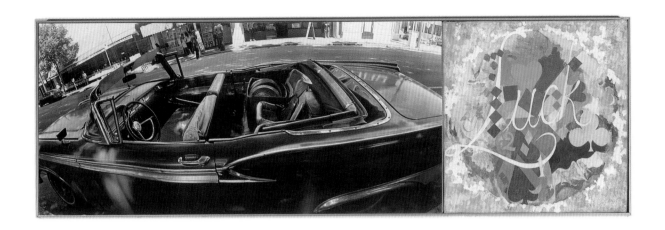

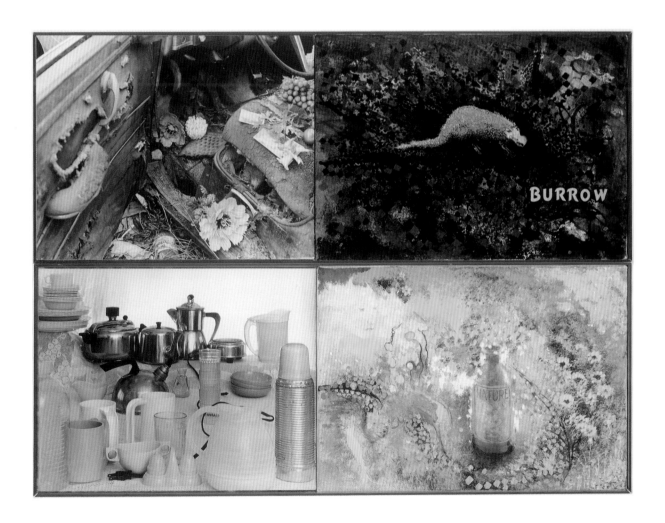

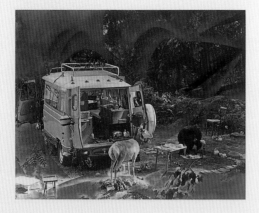

chrome trim. Everything folded out into
something else: couches into beds, cabinet tops
into cutting boards, and for everything there was a
compartment. It was equipped with a stove, a
sink and a fridge. Everything was laid out
logically and harmoniously.

He also bought a small boat which he could
tow behind the van. It had a cabin into which one
could crawl. The aft part of this cabin had a hatch
which could be slid back, making an open area in
which one could stand and prepare meals and
cook on the small gas stove. It also had a sink set
in a countertop and some cupboards. The rest of
the cabin was taken up with a table and a couch
which folded into a bed.

With the van and boat he began touring an
area known for its lakes and wineries, many of
which were situated right on the shores of the
lakes. His procedure was to establish a campsite
on the shore then sail off to one of the wineries,
spend a leisurely time tasting, to finally return
with a favourite bottle and make dinner.

At one of these campsites he met a woman.
She'd set up a tent next to his van. They became
friends. She was a shy but affectionate, fun-loving
and sensuous blend with blue eyes with a good
sense of humour and an open mind. She enjoyed
theatre, art, dancing, music, the outdoors, walks,
and serious conversation.

24. EATING GOLDSPRING:
They both enjoyed cooking and they began to
alternate as dinner hosts for each other. He was
enchanted with her way of preparing and serving
meals. She set her table in the cosy Hungarian
style, with a real tablecloth and real napkins, which
contrasted with her white china. In Salzburg
where she'd come from there were lakeside
restaurants that she'd gone to with friends many

24

pushing and twisting in hysterically convulsive
laughter. Finally they stood up, weakened by
laughter, and gazed at each other, then threw
themselves trembling together again. He stared
blindly into the crowd and waved two fingers,
clearly not for victory or peace but perhaps simply
to count, as if the failing were proof of some
important truth. They held still for a moment,
then as the music mounted and blasted, and the
other dancers began to sway, they flew back into
their furious dancing. The crowd began to shriek
and yell with the music, proclaiming nothing, as
they flung themselves in violent twists and turns.
They arched their bodies in diverse ways and
gesticulated with their limbs. Referring only to
themselves they spun and careened through
space. Colliding and holding onto each other they
bumped into people and furniture to final
exhaustion.

They still laughed, but more quietly, as they
walked from the floor, bemused and giddy. He
stared at the three fingers of his own hand as he
raised it to the crowd.

25. PICNIC
He drove the van to a park by a beach where they
slept until late morning when they were
awakened by the noise from a large picnic. They
arose, sat on the grass amongst the picnickers, and
listened to a band play old favourites. As the day
went on and the sun was at its hottest, the
picnickers' energy dwindled and people lay
around amidst the debris which speckled the dry
grass like old flowers, and listened to the music as
it hummed and merged with the ambient
murmurs, giggles and sighs.

The couple began to dance around their
blanket, but wildly as they had on the previous
night, but in a slow and measured way. Tired,

25

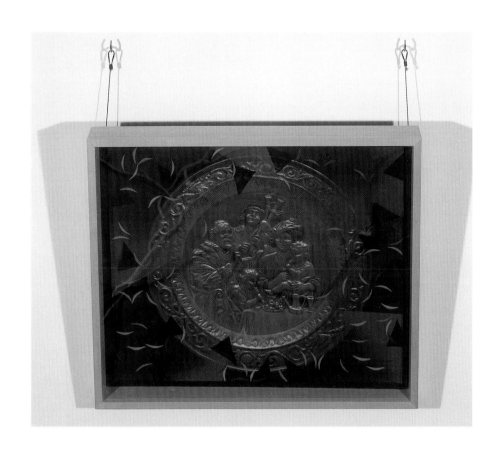

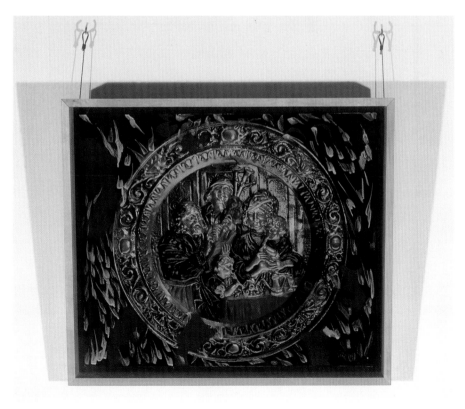

310

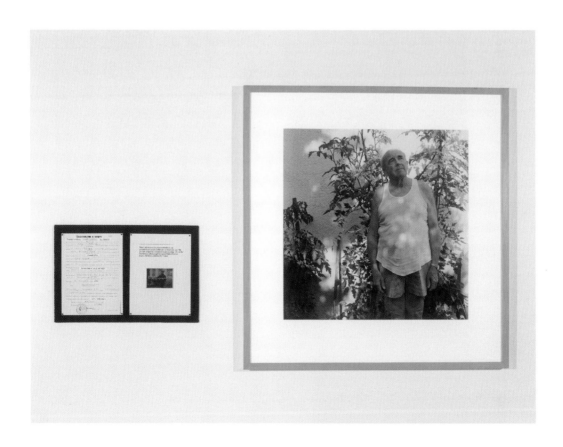

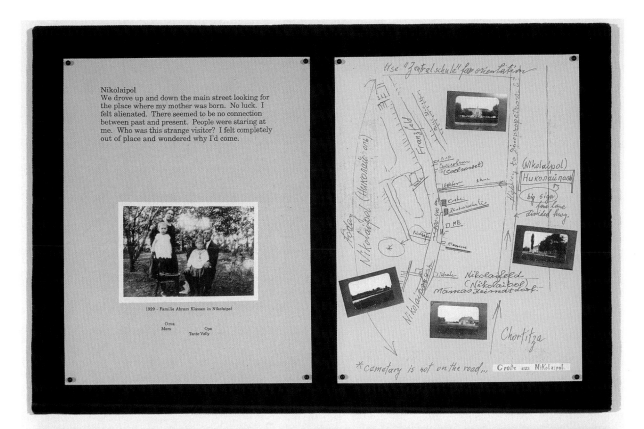

Nikolaipol
We drove up and down the main street looking for
the place where my mother was born. No luck. I
felt alienated. There seemed to be no connection
between past and present. People were staring at
me. Who was this strange visitor? I felt completely
out of place and wondered why I'd come.

1929 - Familie Abram Klassen in Nikolaipol

Oma
Mom Opa
 Tante Vally

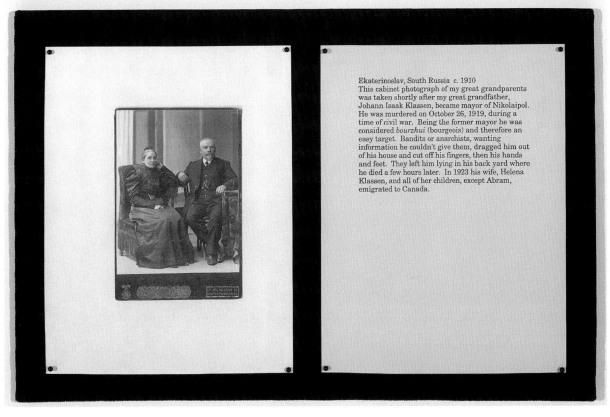

Ekaterinoslav, South Russia c. 1910
This cabinet photograph of my great grandparents
was taken shortly after my great grandfather,
Johann Isaak Klassen, became mayor of Nikolaipol.
He was murdered on October 26, 1919, during a
time of civil war. Being the former mayor he was
considered *bourzhui* (bourgeois) and therefore an
easy target. Bandits or anarchists, wanting
information he couldn't give them, dragged him out
of his house and cut off his fingers, then his hands
and feet. They left him lying in his back yard where
he died a few hours later. In 1923 his wife, Helena
Klassen, and all of her children, except Abram,
emigrated to Canada.

Works Cited

Addison, Joseph. "From My Own Apartment, November 22."
Tatler 1710. *The Tatler or Lucubrations of Isaac Bickerstaff,*
Esq. in Five Volumes. Vol. 5. London: Crowder, Ware,
and Payne, 1772. 236-42.

Agee, James and Walker Evans. *Let Us Now Praise Famous*
Men. 1939. Boston: Houghton-Mifflin, 1980.

Allor, Martin. "Between Discourse and Rhetoric: Textuality
and Epistemes." *Communication* 2 (1990): 65-71.

Aristotle. *The Rhetoric of Aristotle.* Trans. Lane Cooper.
Englewood Cliffs, NJ: Prentice-Hall, 1932.

Aronowitz, Stanley, and Henry A. Giroux. *Postmodern*
Education: Politics, Culture, and Social Criticism.
Minneapolis and Oxford: U of Minnesota P, 1991

Atwood, Margaret. *Bodily Harm.* Toronto: McClelland and
Stewart, 1982.

——. "End to Audience." *Dalhousie Review* 60 (1980): 415-
33.

——. *The Handmaid's Tail.* Toronto: McClelland and
Stewart, 1985.

——. *The Journals of Susanna Moodie.* Toronto: Oxford
UP, 1970.

——. and Charles Pachter. *The Journals of Susanna*
Moodie. Toronto: McFarlane, Walter and Ross, 1997.

——. *Lady Oracle.* Toronto: McClelland and Stewart, 1977.

——. *Second Words: Selected Critical Prose.* Toronto:
House of Anansi Press, 1982.

Austin, J. L. *How to Do Things with Words.* New York:
Oxford UP, 1962.

Bal, Mieke. *Double Exposures: The Subject of Cultural*
Analysis. New York: Routledge, 1996.

Baldwin. C. S. *Ancient Rhetoric and Poetic.* New York:
Macmillan, 1924.

——. *Medieval Rhetoric and Poetic.* New York: Macmillan,
1928.

Balibar, Etienne, and Pierre Macherey. "Literature as an
Ideological Form: Some Marxist Propositions." Trans. Ian

McLeod, John Whitehead, and Ann Wordsworth. *Oxford*
Literary Review 3 (1978): 4-12.

Bara, Jana. "Through the Frosty Lens: William Notman and
his Studio Props, 1861-1876." *History of Photography* 12:1
(1988): 23-30.

Barbour, Douglas. "Daphne Marlatt and Her Works."
Canadian Writers and Their Works: Poetry Series. Eds.
Robert Lecker, Jack David, and Ellen Quigley. Oakville:
ECW, 1992. 187-259.

Barilli, Renato. *Rhetoric.* Trans. Gulianna Menozzi.
Minneapolis: U of Minnesota P, 1989.

Bartlett, John. *Familiar Quotations: A Collection of Passages,*
Phrases and Proverbs Traced to Their Sources in Ancient
and Modern Literature. 14th ed. Ed. Emily Morison
Beck. Boston: Little Brown, 1968.

Batsleer, Janet, et. al. *Rewriting English: Cultural Politics of*
Gender and Class. New York: Routledge and Kegan Paul,
1986.

Baughman, Ernest. *Type and Motif-Index of Folktales of*
England and North America. The Hague: Mouton, 1966.

Behrendt, Stephen C. "Reader and Texts in the Eighteenth-
Century Illustrated Book: Illustrations as Teachers."
Garrett-Petts and Lawrence, *Integrating* 45-68.

Belsey, Catherine. *Critical Practice.* New York: Routledge
and Kegan Paul, 1980.

Berger, John. *Ways of Seeing.* London: British Broadcasting
Corporation and Penguin Books, 1972.

Berghoff, Beth. "Multiple Sign Systems and Reading." *The*
Reading Teacher 51 (March 1998): 520-23.

Bergmann, Harriet F. "Teaching Them to Read: A Fishing
Expedition in *The Handmaid's Tale.*" *College English* 51
(1989): 847-54.

Berlin, James. *Rhetoric and Reality: Writing Instruction in*
American Colleges, 1900-1985. Carbondale: Southern
Illinois UP, 1987.

Beveridge, Karl and Carole Condé. *Class Work*. Toronto: The Communications and Electrical Workers of Canada, 1990.

——. *Political Landscapes*. Toronto: Toronto Photographers Workshop, 1998.

Bhabha, Homi K. *The Location of Culture*. New York: Routledge, 1994.

——. "Postcolonial Authority and Postmodern Guilt." *Cultural Studies*. Eds. Lawrence Grossberg, Cary Nelson, Paula Treichler. New York: Routledge, 1992. 56-66.

Bhabha, Homi K. and Victor Burgin. "Visualizing Theory." *Visualizing Theory: Selected Essays from V.A.R., 1990-1994*. Ed. Lucien Taylor. New York: Routledge, 1994. 454-63.

Blodgett, E.D. "The Book, Its Discourse, and the Lyric: Notes on Robert Kroetsch's *Field Notes*." *Open Letter* 5th ser. 8-9 (1984): 195-205.

——. "Towards an Ethnic Style." *Canadian Review of Comparative Literature* (September/December 1995): 623-38.

Boatright, Mody C. *Tall Tales From Texas*. Dallas: Southwest P, 1934.

Bogdan, Deanna. "A Case for Re-Educating the Imagination." *Textual Studies in Canada* 2 (1992): 211-14.

Booth, Wayne. "Freedom of Interpretation: Bakhtin and the Challenge of Feminist Criticism." *Critical Inquiry* 9 (1982): 45-76.

Bordo, Susan. "Feminism, Postmodernism, and Gender-Scepticism." Nicholson 133-56.

Bourdieu, Pierre. *Photography: A Middle-brow Art*. Trans. Shaun Whiteside. Stanford, CA: Stanford UP, 1990.

Bowering, George. *Baseball: a Poem in the Magic Number 9*. Toronto: Coach House, 1967.

——. *Burning Water*. Toronto: General Publishing, 1980.

——. *Caprice Notebook*. Bowering Papers. National Library of Canada.

——. *Canliterati* Listserv, 11 Jan. 1996: n. pag. Online. Internet.

——. *Caprice*. Markham: Penguin Books, 1988.

——. *Craft Slices*. Ottawa: Oberon, 1985.

——. *Errata*. Red Deer: Red Deer College, 1988.

——. *Imaginary Hand: Essays by George Bowering*. Edmonton: NeWest, 1988.

——. [With photo-collages by Roy Kiyooka]. *The Man in Yellow Boots*. Mexico City: Ediciones El Corno Emplumada, 1965.

——. *The Mask in Place: Essays on Fiction in North America*. Winnipeg: Turnstone, 1982.

——. "Modernism Could Not Last Forever." *Canadian Fiction Magazine* 32/33 (1979-80): 4-9.

——. "The Painted Window: Notes on Post-Realist Fiction." *The Mask in Place* 113-27.

——. Personal Interview. Kamloops, 15 Feb. 1990.

——. *Selected Poems: Particular Accidents*. Ed. Robin Blaser. Vancouver: Talonbooks, 1980.

Brent, Doug. *Reading as Rhetorical Invention: Knowledge, Persuasion, and the Teaching of Research-Based Writing*. Urbana: National Council of Teachers of English, 1992.

Britton, James. "The Composing Processes and the Functions of Writing." *Research on Composing: Points of Departure*. Eds. Charles R. Cooper and Lee Odell. Urbana: NCTE, 1978. 13-28.

Bryant, Marsha. *Photo-Textualities: Reading Photographs and Literature*. Newark: U of Delaware P, 1996.

Bryant, Donald C. "Rhetoric: Its Function and Scope." *Quarterly Journal of Speech* 39 (1953): 401-424.

Bryson, Norman. "The Politics of Arbitrariness." *Visual Theory: Painting and Interpretation*. Bryson, et al. 95-100.

Bryson, Norman, Michael Ann Holly, and Keith Moxey, eds. *Visual theory: Painting and Interpretation*. New York: Harpercollins, 1991.

Bullock, Chris. "Changing the Context: Applying Feminist Perspectives to the Writing Class." A paper presented at the Conference on College Composition and Communication, March 20, 1987, Atlanta, Georgia.

Burgin, Victor. *The End of Art Theory: Criticism and Postmodernity*. Atlantic Highlands, NJ: Humanities Press International, 1986.

Burke, Kenneth. *A Rhetoric of Motives*. Berkeley, Los Angeles: U of California P, 1969.

——."Rhetoric—Old and New." *Journal of General Education* 5 (1951): 202-09.

Butler, Samuel. *Hudibras*. Ed. Dr. Grey. London: Charles and Henry Baldwyn, 1819.

Campbell, Joseph. *The Inner Reaches of Outer Space: Metaphor as Myth and as Religion*. Perennial Library ed. New York: Harper & Row, 1988.

Carey, M. "On Photographic Perspective." *Philadelphia Photographer* 3 (May 1866): 131-36.

Carr, Brenda. "Re-casting the Steveston Net: Re-calling the Invisible Women from the Margins." *Line* 13 (1989): 83-95.

Cartier-Bresson, Henri. "The Decisive Moment." Goldberg 384-86.

Castiglione, Baldesar. 1528. *The Book of the Courtier*. New York: Doubleday, 1959.

Cavell, Richard. "Bakhtin Reads De Mille: Canadian Literature, Postmodernism, and the Theory of Dialogism." *Future Indicative: Literary Theory and Canadian Literature*. Ed. John Moss. Ottawa: U of Ottawa P, 1987. 205-11.

Caws, Mary Ann. *The Art of Interference: Stressed Readings in Verbal and Visual Texts*. Princeton: Princeton UP, 1989.

——. "Literal or Liberal: Translating Perception." *Critical Inquiry* 13 (1986): 49-63.

——. *Reading Frames in Modern Fiction*. Princeton: Princeton UP, 1985.

Charland, Maurice. "Rehabilitating Rhetoric: Confronting Blindspots in Discourse and Social Theory." *Communication* 11 (1990): 253-64.

Chipp, Herschel B., ed. *Theories of Modern Art: A Source Book by Artists and Critics*. Berkeley: U of California P, 1968.

"Composite Photographs." *Philadelphia Photographer* 4 (March 1867): 79-80.

Condit, Celeste Michelle. "Interpolating Rhetoric, Politics and Culture: 'Hail' or 'Greetings'?" *Communication* 11 (1990): 241-52.

Conlogue, Ray. "Cutting Up 19th-Century Canada." *Globe and Mail* 24 May 1994, natl. ed.: A13.

——. "Family Viewing." *Globe and Mail* 22 October 1994, natl. ed.: C8.

Cooley, Dennis. "'I am her on the edge': Modern Hero/Postmodern Poetics in *The Collected Works of Billy the Kid*." *Spider Blues: Essays on Michael Ondaatje*. Ed. Sam Soleki. Montreal: Véhicule, 1985. 211-239.

——. "Recursions Excursions and Incursions: Daphne Marlatt Wrestles with the Angel Language." *Line* 13 (1989): 66-79.

——. *The Vernacular Muse: The Eye and Ear in Contemporary Literature*. Winnipeg: Turnstone, 1987.

Corbett, Edward P.J. *Classical Rhetoric for the Modern Student*. 3rd ed. New York: Oxford UP, 1990.

Corry, Corrine. *Letters to Dad*. Toronto: n.p., 1993.

——. *The Palace of the Queen*. Toronto: Mercer Union, 1987.

Crean, Susan. *Who's Afraid of Canadian Culture?* Don Mills, ON: General Publishing, 1976.

Crosby, Marcia. "Construction of the Imaginary Indian." *Vancouver Anthology: The Institutional Politics of Art*. Ed. Stan Douglas. Vancouver: Talonbooks, 1991. 267-91.

Daly, Brenda. "Women as Image-Makers: An Integrated Approach to Teaching the Visual and Verbal Arts, with Margaret Atwood, Claude Breeze, Helen Lundeberg, Fred Marcellino, and Joyce Wieland." Garrett-Petts and Donald Lawrence, *Integrating* 106-29

Davey, Frank. *Margaret Atwood: A Feminist Poetics*. Vancouver: Talonbooks, 1984.

——. "The Present Scene." *Delta Magazine* (1962): 1-2.

Davis, Ann. *The Logic of Ecstasy: Canadian Mystical Painting, 1920-1940*. Toronto: U of Toronto P, 1992.

Davidson, Arnold. "Future Tense: Making History in *The Handmaid's Tale*." *Margaret Atwood: Vision and Forms*. Eds. Kathryn Van Spanckeren and Jan Garden Castro. Carbondale: Southern Illinois UP, 1988. 113-21.

Davison, Liane. "Ruminating on Redeemed Plates." Fred Douglas. *Excerpts from Cars* 7-11.

Day, Karen. "From the Eighteenth-Century Illustrated Book to Contemporary Children's Picture Books: Teaching the 'Third Text.' Garrett-Petts and Lawrence, *Integrating* 69-75.

DeCoster, Miles. "Sleight of Hand." *A Book Working: Six Books by Six Artists*. Eds. Shelagh Alexander, Paul Collins, Judith Doyle, John Greyson, Tim Guest. Toronto: A Space, 1980. 89-108

Derrida, Jacques. *Dissemination*. Trans. Barbara Johnson. Chicago: U of Chicago P, 1981.

Dobbs, Kildare. "Canada's Regions." *Profile of a Nation*. Ed. Alan Dawe. Toronto: Macmillan, 1969.

Dolby-Stahl, Sondra K. "A Literary Folkloristic Methodology for the Study of Meaning in Personal Narrative." *Journal of Folklore Research* 22 (1985): 45-69.

Dormann, Claire. "A Taxonomy of Visual Metaphors." 9 May 1999 <http://www.cti.dtu.dk/visual-rhetoric/vr-vr%2798.html>

Douglas, Fred. "A Dialogue with Fred Douglas." Interview by D. Achong. Vancouver: Access Gallery, 1995.

——. "Contradictions." *Crossfade*. Curated by Deborah de Boer. Rogue Art Gallery, Eaton Centre, Victoria, B.C., 1999. N. pag.

——. *Excerpts from Cars, Clothes, Houses, and Weather Conditions*. Calgary, Alberta: Illingworth Kerr Gallery, 1997.

——. "Introduction." *Eleven Early British Columbian Photographers: 1890-1940*. Vancouver: The Vancouver Art Gallery, 1976. 7.

——. *Menu for Sunset: An Apparent Story Illustrated with Pictures*. Surrey: Surrey Art Gallery, 1996.

———. Personal interview. Vancouver, 13 May 2000.

———. Personal interview [with Calvin White]. Unpublished transcript. 10 July 1988.

Dragland, Stan. "Wise and Musical Instruction: George Bowering's *Caprice*." *West Coast Review* 23 (Spring 1988): 74-87.

Eagleton, Terry. *Literary Theory: An Introduction*. Oxford: Basil Blackwell, 1983.

Ede, Lisa, and Andrea Lunsford. "Audience Addressed/Audience Invoked: The Role of Audience in Composition Theory and Pedagogy." *College Composition and Communication* 35 (1984): 140-54.

Edwards, Carol Pope, et al. "Adults and Children with Hundreds of Languages: Using Insights from Reggio Emilia in a Course on Creativity." Garrett-Petts and Lawrence, *Integrating* 19-34.

Eldred, Janet, and Peter Mortensen. "Reading Literacy Narratives." *College English* 54.5 (1992): 512-39.

Emerson, Peter Henry. "Naturalistic Photography: 1889." Goldberg 190-96.

Enright, Robert. "The Indescribable Lightness of Being Photographed: Ernie Kroeger's Broadview Road Project." *Border Crossings* 7.1 (1988): 54-61.

Errington, Shelly. "Real Artefacts: a Comment on 'Conceptual Art.'" Bryson, *Visual Theory* 265-73.

Esrock, Ellen J. "A Proposal for Integrating Readerly Visuality into Literary Studies: Reflections on Italo Calvino." *Word & Image* 9 (1993): 114-21.

———. *The Reader's Eye: Visual Imaging as Reader Response*. Baltimore and London: The Johns Hopkins UP, 1994.

Fahnestock, Jeanne, and Marie Secor. "The Rhetoric of Literary Criticism." *Textual Dynamics of the Profession: Historical and Contemporary Studies of Writing in Professional Communities*. Eds. Charles Bazerman and James Paradis. Madison: U of Wisconsin P, 1991. 76-96.

Fee, Margery. *English-Canadian Literary Criticism, 1890-1950: Defining and Establishing a National Literature*. Doctoral Diss., York U, 1981.

Feldman, Melissa E. and Ingrid Schaffner. *Secret Victorians: Contemporary Artists and a 19th-Century Vision*. London: Hayward Gallery Publishing, 1998.

Fish, Stanley. *Doing What Comes Naturally: Change, Rhetoric, and the Practice of Theory in Literary and Legal Studies*. Durham: Duke UP, 1989.

Fitzpatrick, Blake. *Retraced Histories: Vid Ingelevics, Ernie Kroeger, Wendy Oberlander*. Peterborough: Artspace, 2000.

Fogel, Stanley. *A Tale of Two Countries: Contemporary Fiction in Canada and the United States*. Toronto: ECW, 1984.

Foraie, Jacky. Personal Interview. 15 March 2000.

Fowke, Edith and Carole Henderson Carpenter. *A Bibliography of Canadian Folklore in English*. Toronto: U of Toronto P, 1981.

Fowke, Edith. *Tales Told in Canada*. Toronto: Doubleday Canada Ltd., 1986.

Fox, Roy F. "Where We Live." *Images in Language, Media, and Mind*. Ed. Roy F. Fox. Urbana: NCTE, 1994. 69-91.

Gagnon, Monika Kin. "Belonging in Exclusion." *Yellow Peril Reconsidered*. Ed. Paul Wong. Vancouver: On Edge, 1990. 13-16.

———. "Can-Asian, eh? Three Hyphenated Canadian Artists." *Dual Cultures*. Kamloops: Kamloops Art Gallery, 1993. 3-12.

Gandelman, Claude. *Reading Pictures, Viewing Texts*. Bloomington and Indianapolis: Indiana UP, 1991.

Gardner, Howard. *Art, Mind, Brain: A Cognitive Approach to Creativity*. New York: Basic Books, 1982.

Garrett-Petts, W.F. "Developing Vernacular Literacies and Multidisciplinary Pedagogies." *Miss Grundy Doesn't Teach Here Anymore: Popular Culture and the Composition Classroom*. Ed. Diane Penrod. Portsmouth, NH: Heinemann, Boynton/Cook, 1997. 76-91.

Garrett-Petts, W.F., and Donald Lawrence. "The Idea of Water: Frozen Words, Frozen Images." A paper delivered at The XI International Biennial Conference of the Italian Association for Canadian Studies. Siena, Italy, 21 Nov. 1996.

———, eds. *Integrating Visual and Verbal Literacies*. Eds. W.F. Garrett-Petts and Donald Lawrence. Winnipeg: Inkshed Publications, 1996. 1-17.

———. "On Integrating Visual and Verbal Literacies." Garrett-Petts and Lawrence, *Integrating* 1-17.

———. "The New Vernacular: Alternative Frontiers in Narrative Representation." *Alternative Frontiers: Voices from the Mountain West*. Eds. Allen Seager, Leonard Evenden, et al. Montreal: Association for Canadian Studies, 1997. 127-58.

Gerson, Carole. *A Purer Taste: The Writing and Reading of Fiction in Nineteenth Century Canada*. Toronto: U of Toronto P, 1989.

Giltrow, Janet. "Fast Forward Man." *Canadian Literature* 89 (Summer 1981): 118-20.

Giroux, Henry A. *Border-Crossings: Cultural Workers and the Politics of Education.* New York and London: Routledge, 1992.

Goldberg, Vicki, ed. *Photography in Print: Writings from 1816 to the Present.* New York: Simon and Schuster, 1981.

Grace, Sherrill. "Kroetsch and the Semiotics of North." *Kroetsch at Niederbronn.* Spec. issue of *Open Letter.* 9th ser. 5-6 (1996): 13-24.

——. *Violent Duality: A Study of Margaret Atwood.* Montreal: Véhicule Press, 1980.

Graff, Gerald. *Professing Literature: An Institutional History.* Chicago: U of Chicago P, 1989.

Halpert, Herbert. "Tall Tales and Other Yarns from Calgary, Alberta." *California Folklore Quarterly* 4 (1945): 29-49.

Hamon, Philippe. "Rhetorical Status of the Descriptive." Trans. Patricia Baudoin. *Yale French Studies* 61 (1981): 1-26.

Hapkemeyer, Andreas, and Peter Weiermair, eds. *Photo Text Text Photo: The Synthesis of Photography and Text in Contemporary Art.* Bozen and Zurich: Museion, Museum für Moderne Kunst and Edition Stemmle, 1996.

Harker, Margaret F. *Henry Peach Robinson, Master of Photographic Art, 1830-1901.* Oxford: Basil Blackwell, 1988.

Harris, Robin S. *A History of Higher Education in Canada, 1663-1960.* Toronto: U of Toronto P, 1976.

Hicks, Emily D. *Border Writing: The Multidimensional Text.* Minneapolis: U of Minnesota P, 1991.

Hicks, William. *Coffee-House Jests.* London, 1677.

Hoffman, Katherine. "Collage in the Twentieth Century: An Overview." *Collage: Critical Views.* Ed. Katherine Hoffman. Ann Arbor: UMI Research Press, 1989.1-37.

Hubert, Henry A. *Harmonious Perfection: The Development of English Studies in Nineteenth-Century Anglo-Canadian Colleges.* East Lansing: Michigan State UP, 1994..

Hubert, Henry, and W.F. Garrett-Petts. "Foreword: An Historical Narrative of Textual Studies in Canada." *Textual Studies in Canada* 1 (1993): 1-30.

Hutcheon, Linda. *The Canadian Postmodern: A Study of Contemporary English-Canadian Fiction.* Toronto: Oxford UP, 1988.

——. *Splitting Images: Contemporary Canadian Ironies.* Toronto: Oxford UP, 1991.

Irving, Lorna. *Sub/Version.* Toronto: ECW, 1986.

Ivins, William M. Jr. "Prints and Visual Communication." Goldberg 387-93.

Jackson, Leonard. *The Poverty of Structuralism: Literature and Structuralist Theory.* London and New York: Longman, 1991.

James, Geoffrey. "Responding to Photographs: A Canadian Portfolio." *Artscanada* (December 1974): 1-7.

Jansen, Patricia. "Arnoldian Humanism, English Studies, and the Canadian University." *Queen's Quarterly* 95.3 (1988): 550-66.

Jarrett, Michael. *Sound Tracks: A Musical ABC.* Vols. 1-3. Philadelphia: Temple UP, 1998.

Jay, Martin. "The Rise of Hermeneutics and the Crisis of Ocularcentrism." *The Rhetoric of Interpretation and the Interpretation of Rhetoric.* Ed. Paul Hernadi. Durham, NC and London: Duke UP, 1989. 55-74.

Johnson, Richard. "What is Cultural Studies Anyway?" *Social Text* 16 (Winter 1986/87): 38-80.

Jones, Manina. *"That Art of Difference": Documentary-Collage and English-Canadian Writing.* Toronto: U of Toronto P, 1993.

Kamboureli, Smaro. *On the Edge of Genre: The Contemporary Canadian Long Poem.* Toronto: U of Toronto P, 1991.

——. "A Window onto George Bowering's Fiction of Unrest." *Present Tense.* Ed. John Moss. Toronto: N C Press, 1985. 206-31.

Kiyooka, Roy. "letters purporting to be abt tom thomson." *artscanada* (February/March 1972): 25-34.

Knight, Derek. *N.E. Thing Co., The Ubiquitous Concept.* Oakville: Oakville Galleries, 1995.

Kostelanetz, Richard. "Book Art." Lyons 27-30.

Krauss, Rosalind E. *Passages in Modern Sculpture.* Cambridge: MIT Press, 1977.

Kreiger, Murray. *Ekphrasis: The Illusion of the Natural Sign.* Baltimore: The Johns Hopkins UP, 1992.

Kroeger, Ernie. "Artist's Statement." *Rephotographing the Land.* Curated by Susan Gibson Garvey. Halifax: Dalhousie Art Gallery, 1992. 18-19.

——. "Family Stories (an Excerpt)." *Blackflash* 13.1 (1995): 9-16.

——. Personal Interview. 10 June 1995.

——. Personal Interview. 28 May 2000.

Kroetsch, Robert. *Alberta.* New York: St. Martin's, 1968.

——. *Badlands.* 1975. Rpt. Toronto: General Publishing, 1982.

——. "Contemporary Standards in the Canadian Novel." *Essays on Canadian Literature* 20 (Winter 1980-81): 7-18.

——. *The Crow Journals.* Edmonton: NeWest, 1980.

——. *The Ledger*. London: Applegarth Follies, 1975.

——. *A Likely Story: The Writing Life*. Red Deer: Red Deer College, 1995.

——. *The Lovely Treachery of Words: Essays Selected and New*. Toronto: Oxford UP, 1989.

——. Personal interview. 30 Oct. 1990.

——. Personal interview. 23 May 1998.

——. "Revisions of Letters Already Sent." *Textual Studies in Canada* 1 (1991): 148-49.

——. *Revisions of Letters Already Sent*. Calgary: disOrientation chapbooks, 1991.

——. *Robert Kroetsch: Essays*. Eds. Frank Davey and bp Nichol. Spec. issue of *Open Letter* 5th ser. 4 (1983).

——. *The Sad Phoenician*. Toronto: Coach House, 1979.

——. *The Seed Catalogue*. Winnipeg: Turnstone, 1977.

——. "Unhiding the Hidden: Recent Canadian Fiction." *Open Letter* 5:4 (1983): 17-21

——. *What the Crow Said*. Don Mills: General Publishing, 1978.

Kroker, Arthur. *Technology and the Canadian Mind: Innis/McLuhan/Grant*. New York: St. Martin's, 1984.

Kröller, Eva-Marie. *George Bowering: Bright Circles of Colour*. Vancouver: Talonbooks, 1992.

——. "Nineteenth-Century Photography and the Canadian National Image." *Zeitschrift der Gesellschaft für Kanada-Studien* 2, 9 (1985): 83-91.

——. "Postmodernism, Colony, Nation: The Melvillean Texts of Bowering and Beaulieu." *University of Ottawa Quarterly* 54 (April-June 1984): 53-61.

Kuester, Martin. "Prairie History and Beyond: Kroetsch's Archaeologists." *Kroetsch at Niederbronn*. Spec. issue of *Open Letter* 9th ser 5-6 (1996): 25-32.

Kuspit, Donald B. "Collage: The Organizing Principle of Art in the Age of the Relativity of Art." Hoffman 39-57.

Lacombe, Michèle. "The Writing on the Wall: Amputated Speech in Margaret Atwood's *The Handmaid's Tale*." *Wascana Review* 21.2 (1986): 3-20.

Langford, Martha. "Composite Deceptions." *Border Crossings* 13 (August 1994): 59-61.

——. "Landscapes of Imminence: The Photographs of Brenda Pelkey." *Border Crossings* 17.4 (October 1998): 50-54.

Lecker, Robert. *Robert Kroetsch*. Boston: Twayne, 1986.

Lee, Dennis. *The New Canadian Poets, 1970-1985*. Toronto: McClelland and Stewart, 1985.

Lippard, Lucy. "The Artist's Book Goes Public." Lyons 45-48.

Lobb, Edward. "Imagining History: The Romantic Background of George Bowering's *Burning Water*." *Studies in Canadian Literature* 12 (1987): 112-28.

Lotman, Yury M. "The Text within the Text." Trans. Jerry Leo and Amy Mandelker. *PMLA* 109 (May 1994): 377-84.

Lynes, Jeanette. "Keeping the Vandals at Bay: George Bowering and Reader-Response Criticism." *Open Letter* 7th Ser., no. 5 (Summer 1989): 67-79.

Lyons, Joan, ed. *Artists' Books: A Critical Anthology and Sourcebook*. Rochester: Visual Studies Workshop Press, 1985.

MacDonald, Mary Lu. "A Very Laudable Effort: Standards of Literary Excellence in Early Nineteenth Century Canada." *Canadian Literature* 131 (1991): 84-98.

MacLaren, I.S. "Commentary: The Aesthetics of Back's Writing and Painting from the First Overland Expedition." *Arctic Artist: The Journal and Paintings of George Back, Midshipman with Franklin, 1819-1822*. Ed. C. Stuart Houston. Kingston: McGill-Queen's UP, 1994. 275-310.

MacLulich, T.D. *Between Europe and America: The Canadian Tradition in Fiction*. Oakville: ECW, 1988.

Magor, Liz and Joey Morgan. *How to Avoid the Future Tense*. Banff: Walter Phillips Gallery. 1991

Mailloux, Steven. "The Turns of Reader-Response Criticism." *Conversations: Contemporary Critical Theory and the Teaching of Literature*. Eds. Charles Moran and Elizabeth F. Penfield. Urbana: National Council of Teachers of English, 1990. 38-54.

Malevich, Kasimir. "The Non-Objective World." Chipp 341-346.

Marlatt, Daphne. "Correspondences: Selected Letters." *Line* 13 (1989): 5-31.

——. "From the Moment Out." Interview by Kevin McGuirk. *Windsor Review* 27.1 (1994): 76-84.

——. "On Distance and Identity: Ten Years Later." Postscript. *Steveston*, 1984. 92-95.

Marlatt, Daphne, and Robert Minden. Personal interview. 18 Feb. 1998.

——. "Photography: Walker Evans." *The Grape* 31, August 16-23, 1972: 16.

——. *Steveston*. Vancouver: Talonbooks, 1974.

——. *Steveston*. Edmonton: Longspoon, 1984.

Marlatt, Daphne with Maya Koizumi. *Steveston Recollected: A Japanese-Canadian History*. Victoria: Provincial Archives of British Columbia, 1975.

Martin, Constance. "Perceptions of Arctic Landscapes in the Art of British Explorers, 1818-1859." Unpublished MA thesis. U of Calgary, 1981.

Marzolf, Helen. "*...the great effect of the imagination on the world*": Brenda Pelkey. Ed. Helen Marzolf. Exhibition Catalogue, November 9 - December 15, Regina: Dunlop Art Gallery, 1991.

Mathews, Robin. *Canadian Literature: Surrender or Revolution*. Toronto: Steel Rail Educational Publishing, 1978.

——. *Treason of the Intellectuals: English Canada in the Post-Modern Period*. Prescott: Voyageur Publishing, 1995.

Mattison, David. "The Multiple Self of Hannah Maynard." *Vanguard* 9, 8 (October 1980): 15-19.

McCaffery, Steve. *North of Intention: Critical Writings, 1973-1986*. Toronto: Roof Books and Nightwood Editions, 1986.

McCarthy, Dermot. "Early Canadian Literary Histories and the Function of a Canon." *Canadian Canons: Essays in Literary Value*. Ed. Robert Lecker. Toronto: U of Toronto P, 1991. 30-45.

McCormick, Dell J. *Paul Bunyan Swings His Axe*. Ohio: Caxton Printers, 1936.

Melhorn, Lise. *Come Into My Parlour*. Toronto: Transformer, 1986.

——. *Light and Flaky: Portrait of the Artist's Mother: A Cookbook*. Toronto: Transformer, 1982.

Melhorn-Boe, Lise. *Family Album*. Toronto: Transformer, 1994.

Mellen, Peter. *The Group of Seven*. Toronto: McLelland and Stewart, 1970.

Melville, Stephen. "Reflections on Bryson." Bryson, *Visual Theory* 74-78.

Michaels, Anne. *Fugitive Pieces*. Toronto: McClelland and Stewart, 1996.

Miki, Roy. "Inter-Face: Roy Kiyooka's Writing." *Collapse* 2 (December 1996): 51-61.

——. "Self on Self: Robert Kroetsch Interviewed." *Line* 14 (Fall 1989): 108-142.

Minden, Robert. *Separate From The World: Meetings with Doukhobor-Canadians in British Columbia*. Ottawa: National Film Board of Canada, 1979.

Mitchell, W. J. T. *Picture Theory: Essays on Verbal and Visual Representation*. Chicago and London: The U of Chicago P, 1994.

Morgan, Robert C. "Systemic Books by Artists." Lyons 207-22.

Morton, Donald. "The Crisis of Narrative in the Postnarratological Era: Paul Goodman's *The Empire City* as (Post)Modern Intervention." *New Literary History* 24 (Spring 1993): 407-24.

Moss, John. "Life/Story: The Fictions of George Bowering." *Essays on Canadian Writing* 38 (1989): 85-98.

——. *Reader's Guide to the Canadian Novel*. 2d ed. Toronto: McClelland and Stewart, 1987.

Murray, Heather. *Working in English: History, Institution, Resources*. Toronto: U of Toronto P, 1996.

Nasgaard, Roald. *The Mystic North: Symbolist Landscape Painting in Northern Europe and North America, 1890-1940*. Toronto: Art Gallery of Ontario, 1984.

Nemiroff, Diana. "Maybe its [sic] Only Politics: Carole Condé and Karl Beveridge." *Vanguard* 11, 8 & 9 (1982): 8-11.

Neuman, Shirley and Robert Wilson, eds. *Labyrinths of Voice: Conversations with Robert Kroetsch*. Edmonton: NeWest, 1982.

New, W.H. "The Great-River Theory: Reading MacLennan and Mulgan." *Essays on Canadian Writing* 56 (1995): 162-82.

——. *A History of Canadian Literature*. London: Macmillan, 1989.

——. *Land Sliding: Imaging Space, Presence, and Power in Canadian Writing*. Toronto: U of Toronto P, 1997.

Newlove, John "The Poetry Scene: It's Alive, Man, in B.C. — But the Poets Are Unknown." *The Vancouver Sun* 26 July 1963: A17.

Nichol, bp. "Primary Days: Housed with the Coach at the Press, 1965 - 1987." *Provincial Essays* 4 (1987): 19 - 25.

Nicholson, Linda J. Introduction. *Feminism/Postmodernism*. Ed. Linda J. Nicholson. New York and London: Routledge, 1990.

Niles, John. "Context and Loss in Scottish Ballad Tradition." *Western Folklore* 45 (April 1986): 83-109.

Nodelman, Perry. "The Eye and the I: Identification and First-Person Narratives in Picture Books." *Children's Literature* 19 (1991): 1-30.

Ohmann, Richard. "Speech, Literature, and the Space Between." *New Literary History* 4 (1972): 47-64.

Olalquiaga, Celeste. *The Artificial Kingdom: A Treasury of the Kitsch Experience*. New York: Pantheon Books, 1998.

Ondaatje, Michael. *The Collected Works of Billy the Kid*. Toronto: Anansi, 1970.

———. "The Silent Partner: Photography in Fiction." *Photo Communiqué* (Fall 1987): 36-40.

Ong, Walter J. *Orality and Literacy: The Technologizing of the Word*. London and New York: Methuen, 1982.

"Outdoor Photographs Taken Indoors." *Philadelphia Photographer* 3 (May 1866): 9-11.

Owens, Craig. "The Allegorical Impulse: Toward a Theory of Postmodernism." Ed. Brian Wallis. *Art After Modernism: Rethinking Representation*. New York: The New Museum of Contemporary Art, 1984. 203-35.

Pakasaar, Helga. "Formulas for the Picturesque: Vancouver Pictorialist Photography, 1930-45." *Vancouver: Art and Artists, 1931-1983*. Ed. Luke Rombout. Vancouver: The Vancouver Art Gallery, 1983. 49-55.

Pelkey, Brenda. "Artist's Talk." University College of the Cariboo, November 28, 1994.

———. "Mnemonic Obsession: Recent Photographs by Brenda Pelkey." Introduction by and interview by Dan Ring. *Blackflash* 11, 1 (Spring 1993): 12-14.

———. Personal Interview, Saskatoon, 22 April 1995.

———. "Scrapbook." [Collection of the artist.] 1993.

Pennell, Joseph. "Is Photography Among the Fine Arts?" Goldberg 210-13.

Perkins, D.N., and Howard Gardner. "Preface: Why 'Zero?' A Brief Introduction to Project Zero." *Journal of Aesthetic Education* 22, 1 (Spring 1988): vii-x.

Prinz, Jessica. *Art Discourse/Discourse in Art*. New Brunswick: Rutgers UP, 1991.

Quartermain, Peter, and Laurie Ricou. "Extra Basis: An Interview with George Bowering." *West Coast Review* 23 (Spring 1988): 52-73.

Radcliffe, David. "On the Critical Value of Categories: a Response to David Summers." Bryson et al. 260-64.

Ray, Robert B. "Afterword: Snapshots, the Beginnings of Photography." Marsha Bryant 152-59.

Read, Herbert. *A Concise History of Modern Painting*. New York: Praeger Publishers, 1974.

Reid, Dennis. *A Concise History of Canadian Painting*. Toronto: Oxford UP, 1973.

Richards, I. A. *The Philosophy of Rhetoric*. 1936. New York: Oxford UP, 1976.

———. *Speculative Instruments*. London: Routledge and Kegan Paul, 1955.

Richards, Sys Birgit. "The Art of Nineteenth-century Explorer-Artists in the Arctic Regions of North America, with a Catalogue Raisonné of their Sketches, Paintings, and Prints in the Collections of the Arctic Institute of North America and the Glenbow Museum, Calgary, Alberta." Unpublished MA thesis. U of Calgary, 1994.

Richardson, John Adkins. "The Visual Arts and Cultural Literacy." *Journal of Aesthetic Education*. 24:1 (Spring 1990): 57-72.

Richmond, Cindy. "Brenda Pelkey: Picturing Home." *ArtsAtlantic* 15.4 (Spring 1998): 36-40.

Rooke, Constance. *Fear of the Open Heart: Essays on Contemporary Canadian Writing*. Toronto: Coach House, 1989.

Root, Marcus Aurelius. "The Camera and the Pencil." Goldberg 148-51.

Rorty, Richard. "Hermeneutics, General Studies, and Teaching." *Synergos: Selected Papers from the Synergos Seminars*. Vol 2. Fairfax: George Mason UP, 1982. 1-15.

Ruthrof, Horst. *Semantics and the Body: Meaning from Frege to the Postmodern*. Toronto: U of Toronto P, 1997.

Rutledge, Kay Ellen. "Analyzing Visual Persuasion: The Art of Duck Hunting." Roy F. Fox 204-17.

Sayre, Henry M. "Pursuing Authenticity: The Vernacular Moment in Contemporary American Art." *South Atlantic Quarterly* 91:1 (1992): 139-60.

Schoemperlen, Diane. *Double Exposures*. Toronto: Coach House, 1984.

———. *Forms of Devotion: Stories and Pictures*. Toronto: HarperCollins, 1998.

Sekula, Allan. "On the Invention of Photographic Meaning." *Photography in Print: Writings from 1816 to the Present*. Ed. Vicki Goldberg. New York: Simon and Schuster, 1981. 452-473.

Shephard, Esther. *Paul Bunyan*. 1924. New York: Harcourt, 1952.

Shields, Rob. "Imaginary Sites." *Between Views and Points of View*. Ed. Mary Anne Moser. Exhibition Catalogue, June—September, Banff: Walter Phillips Gallery, 1991. 22-26.

Sinclair, Jennifer Oille. "Editor's Note." *Provincial Essays* 4 (1987): 5 - 6.

Söderlind, Sylvia. *Margin/Alias: Language and Colonization in Canadian and Québécois Fiction*. Toronto: U of Toronto P, 1991.

Solecki, Sam. "An Interview with Michael Ondaatje (1975)." *Spider Blues: Essays on Michael Ondaatje*. Ed. Sam Solecki. Montreal: Véhicule, 1985. 13-27.

Sontag, Susan. *Against Interpretation*. New York: Anchor Books/Doubleday, 1990.

———. *On Photography*. New York: Farrar, Straus and Giroux, 1973.

Snow, Michael. *Cover to Cover*. Halifax: Press of the Nova Scotia College of Art and Design, 1975.

———. Personal Interview. 8 November 1996.

———. *A Survey*. Toronto: Art Gallery of Ontario, 1970.

Stafford, Barbara Maria. *Artful Science: Enlightenment Entertainment and the Eclipse of Visual Education*. Cambridge: MIT Press, 1994.

Stephens, John. "Modality and Space in Picture Book Art: Allen Say's *Emma's Rug*." ts. Forthcoming in *CREArTA* 1. 1 (2000).

Talbot, William Henry Fox. "Some Account of the Art of Photogenic Drawing." Goldberg 36-48.

Taylor, Fennings. *Portraits of British Americas* [Portraits by William Notman; biographical sketches by Fennings Taylor], Pt. 8. Montreal: Published by W. Notman, J. Lovell, printer, 1865.

Teitelbaum, Matthew. "Sighting the Single Tree, Sighting the New Found Land." *Eye of Nature*. Eds. Daina Augaitis and Helga Pakasaar. Banff: Walter Phillips Gallery, 1991. 71-87.

Thacker, Robert. "Gazing Through the One-Way Mirror: English-Canadian Literature and the American Presence." *Colby Quarterly* 29 (1993): 74-87.

Thomas, Ann. *Fact and Fiction: Canadian Painting and Photography, 1860-1900*. Montreal: McCord Museum, 1979.

Thomas, Peter. *Robert Kroetsch*. Vancouver: Douglas and McIntyre, 1980.

Thompson, Stith. *Motif-Index of Folk Literature*. 6 vols. Blomington and London: Indiana UP, 1966.

Torgovnick, Marianna. *The Visual Arts, Pictorialism and the Novel: James, Lawrence, and Woolf*. Princeton: Princeton UP, 1985.

Tuve, Rosemond. *Elizabethan and Metaphysical Imagery*. Chicago: U of Chicago P, 1947.

Ulmer, Gregory. "The Object of Post-Criticism." Hoffman 383-412.

Valverde, Mariana. "As if Subjects Existed: Analysing Social Discourses." *Canadian Review of Sociology and Anthropology* 28.2 (1991): 172-87.

Verburg, JoAnn. "On the Rephotographing of the Mountain of the Holy Cross." *New Observations* 108 (1995): 5-8

Vickers, Brian. *In Defence of Rhetoric*. Oxford: Clarendon, 1988.

Virilio, Paul. *The Vision Machine*. London and Bloomington: British Film Institute and Indiana UP, 1994.

Visser, Carla. "Historicity in Historical Fiction: *Burning Water* and *The Temptations of Big Bear*." *Studies in Canadian Literature* 12 (1987): 90-111.

Wah, Fred. *Limestone Lakes Utaniki*. Red Deer: Red Deer College, 1989.

Wall, Audrey Nixon. "Gender-Bias Within Literature in the High School English Curriculum: The Need for Awareness." *English Quarterly* 24, 2 (1992): 25-29.

Wall, Kathleen. "What Kroetsch Said: The Problem of Meaning and Language in *What the Crow Said*." *Canadian Literature* 128 (1991): 90-105.

Wallace, Ian. *Work 1979*. Vancouver: Vancouver Art Gallery, 1979.

Watson, Petra Rigby. *The Photographs of Hannah Maynard: 19th Century Portraits*. Vancouver: Charles H. Scott Gallery, Emily Carr College of Art & Design, 1992.

Watson, Scott and Lorna Farrell-Ward. "Mise en Scène: A Mutually Interrupted Text." *Mise en Scène*. Ed. Lorna Farrell-Ward. Vancouver: Vancouver Art Gallery, 1982.

Watson, Scott. "Disfigured Nature: The Origins of the Modern Canadian Landscape." *Eye of Nature*. Eds. Daina Augaitis and Helga Pakasaar. Banff: Walter Phillips Gallery, 1991. 103-12.

Webb, Phyllis. *Nothing But Brush Strokes: Selected Prose*. Edmonton: NeWest, 1995.

Weir, Lorraine. "The Discourse of 'Civility': Strategies of Containment in Literary Histories of English Canadian Literature." *Problems of Literary Reception/Problèmes de reception littéraire*. Eds. E.D. Blodgett and A.G. Purdy. Proc. of a Conference: Towards a History of the Literary Institution in Canada, 16-18 Oct. 1988. Edmonton: The Research Institute for Comparative Literature, U of Alberta, 1988. 24-39.

Whalen, Terry. "Discourse and Method: Narrative Strategy in George Bowering's *West Window*." *Canadian Poetry* no. 22 (Spring/Summer 1988): 32-39.

Wilks, Claire Weissman. *The Magic Box: The Eccentric Genius of Hannah Maynard*. Toronto: Exile Editions Ltd., 1980.

Williamson, Janice. "Sounding a Difference: An Interview with Daphne Marlatt." *Line* 13 (1989): 47-56.

Wilson, Robert R. "Diane Schoemperlen's Fiction: The Clean, Well-Lit Worlds of Dirty Realism." *Essays on Canadian Writing* 40 (Spring 1990): 80-108.

Wollheim, Peter. "Hannah Maynard: Participant and Portent." *Canadian Forum* (March 1981): 35-36.

Wong, Paul, ed. "Yellow Peril Reconsidered." *Yellow Peril Reconsidered*. Vancouver: On Edge, 1990.

——. "Yellow Peril Reconsidered." Wong 6-12.

Yuen, Sharyn. "*Jook Kaak*." Wong 50-51.

——. Personal interview. Vancouver, 18 June 2000.

York, Lorraine M. "'Violent Stillness': Photography and Postmodernism in Canadian Fiction." *Mosaic* 21 (1988): 193-201.

Young, Dennis. "Origins and Recent Work." *Michael Snow A Survey*. Toronto: Art Gallery of Ontario, 1970. 15-16.

Index

W.F. Garrett-Petts is Associate Professor of English and Chair of Journalism at the University College of the Cariboo, where he teaches Canadian literature, cultural studies, and rhetoric. Co-editor of *Textual Studies in Canada* and coordinator of the Centre for Research on Multiple Literacies, he has published widely on reading theory, literature, and interarts practices. His recent books include *Writing about Literature* (Broadview, 2000) and *Integrating Visual and Verbal Literacies* (Inkshed Publications, 1996). With Donald Lawrence he co-curated an exhibition of "prose pictures" and "visual fictions" at the Kamloops Art Gallery, Kamloops, British Columbia.

Donald Lawrence is a nationally recognized artist teaching photography, photographic theory, and other studio-based disciplines at the University College of the Cariboo. His own artistic practice explores aspects of personal narrative in a wide range of forms: from anecdotal, illustrated travel journals to complex, mixed-media installations. Interests such as these are brought together in his most recent work, where a series of handmade underwater cameras form the starting point for an exploration of sub-tidal waters familiar from a long-standing interest in sea kayaking. His work has been shown in exhibitions across Canada, in such centres as Calgary, Montreal, Toronto, Vancouver, and Whitehorse. Lawrence has lectured about his work and other theoretical topics in galleries and at conferences, including several international venues.